SILENT
POETRY

SILENT
POETRY

**DEAFNESS,
SIGN,
AND VISUAL
CULTURE
IN MODERN
FRANCE**

NICHOLAS
MIRZOEFF

PRINCETON UNIVERSITY
PRESS

Library of Congress Cataloging-in-Publication Data
Mirzoeff, Nicholas, 1962–
 Silent poetry : deafness, sign, and visual culture in modern
 France / Nicholas Mirzoeff.
 p. cm.
 Includes bibliographical references (p. 265) and index.
 ISBN 0-691-03789-2 (cloth : acid-free paper)
 1. Sign language—History—19th century. 2. Art, French. 3. Art,
Modern—19th century—France. 4. Deaf—France—Means of
communication—History—19th century. 5. Deaf artists—France—
History—19th century. I. Title.
HV2471.M57 1995
305.9′08162′0944—dc20 94-42545
 CIP

Edited by Timothy Wardell

Designed by Carol S. Cates

In memory of
Eliusha Mirzoeff and Harry Topper

For my parents, grandparents,
and Kathleen

CONTENTS

ACKNOWLEDGMENTS

Any first book carries more debts than can ever possibly be repaid or acknowledged, but some material and personal obligations must be recorded, with due respect to those whom I do not have space to mention. I must begin by thanking Alexis Karacostas, who made the research for this book possible by allowing me access to the archives at the Institut National des Jeunes Sourds, which he has rescued from the cellars and found for them a temporary home in the laundry. I can only hope that this book contributes in some way to the creation of better facilities at the Institut. More material support came from the Center for Seventeenth and Eighteenth Century Studies at UCLA, who awarded me a Postdoctoral Fellowship and enabled this project to take shape. With a J. Paul Getty Center for the History of Art and the Humanities Postdoctoral Fellowship, I was able to complete the research and undertake much of the writing of the manuscript. The Graduate School at the University of Wisconsin-Madison provided summer support that enabled me to finish the manuscript ahead of schedule. My thanks also to the Yale Center for British Art and the Huntington Library for short-term Fellowships that greatly assisted the writing of specific sections. The librarians at the Bibliothèque Douet, Bibliothèque Nationale, British Library, Edward Minor Gallaudet Collection, and the New York Public Library helped me overcome the bibliographical difficulties of interdisciplinary work. Thanks to the History Department at SUNY Stony Brook, who tolerated an interloper on leave with good grace, especially Barbara Weinstein, who graciously lent me her office.

I have benefited from very generous intellectual and personal support over the years. Thanks to all the members of the New Deal, who enabled me to survive Oxford, especially Dr. Christian Jackson, John de Pury, P-J Wilkinson, and Joel Ziff. Special thanks to Andy Morgan for letting me read his M.A. thesis on the origins of anthropology in Britain. My advisors at Warwick, Anthea Callen and Gwynne Lewis, displayed remarkable patience and kindness in dealing with my importunate demands on their time and energies, as well as being models of engaged intellectuals. Irit Rogoff guided my foray into the world of American academia and has continued to be a generous mentor. At UCLA, I was fortunate in encoun-

tering a remarkable group of intellectuals who sustained the initial impetus of this project—thanks to Ann Bermingham, John Brewer, Lawrence Klein, and Jay Tribby. I have learnt much from the wit and wisdom of: Leonard Davis, Henry Drewal, Joseph Grigely, Jim Herbert, Amelia Jones, Harton Lane, Ira Livingston, Elizabeth MacCauley, Iona Man-Cheong, Felicity Nussbaum, Ann Reynolds, Richard Shiff, Sally Stein, and Jennifer Terry. Mary D. Sheriff and Sander L. Gilman gave excellent advice as readers for Princeton University Press. Elizabeth Powers has been an exemplary editor and Elizabeth Johnson and Tim Wardell made the production process as painless as possible. Thanks to my research assistant Lisa Nicoletti for doing many dreary tasks with good humor and efficiency.

One debt remains to be acknowledged, which is hard to do in words, let alone in a public forum such as this. The imprint of Kathleen Wilson's mind is on every page of this book, improving its intellectual content and writing style. In less definable but very precious ways, I came to understand in this enterprise just what is meant by partnership and the meeting of minds. This book is for her in a small gesture of recompense. It only remains to say that all howlers that remain are my own.

LIST OF ILLUSTRATIONS

LIST OF ABBREVIATIONS

AN	Archives Nationales, Paris
CE	Charles Baudelaire, *Curiosités Esthétiques* ed. Henri Lemaitre (Paris: Garnier, 1990).
EMGC	Edward Minor Gallaudet Collection, Archives of Gallaudet University, Washington, DC
INJS	Institut National des Jeunes Sourds, Paris
JSM	*Journal des Sourds Muets*
LCP	Laurent Clerc Papers, Sterling Memorial Library, Yale University
RG	*Revue Générale de l'Enseignement des Sourds-Muets*
RI	*Revue Internationale de l'Enseignement des Sourds-Muets*

SILENT
POETRY

INTRODUCTION

In its simplest form, art is a means of visual communication between people. So too is the sign language of the deaf. This book explores the interaction between these two systems of visual signs in France from the accession of Louis XIV to the release of *The Jazz Singer* in 1927, focusing on the nineteenth-century school of deaf artists, which emerged from the studios of the Institute for the Deaf in Paris established during the French Revolution. I have identified over one hundred deaf artists who made their living from art or exhibited their work in public in this period in France alone. These artists were not a footnote to the art of their day, but competed for the Rome Prize at the elite Ecole des Beaux-Arts, exhibited at the Salon, and even won the Légion d'Honneur. However, their work was anything but art for art's sake. Deaf artists played a central role in the deaf community, which formulated a cultural politics around both sign language and art. The deaf used the cachet of high art to resist being categorized as "primitive," and as a means of demonstrating their intellectual capacities to a skeptical hearing majority. This book is not simply concerned with the recovery of forgotten art, or the claims of a minority, but with the process and history of marginalization, the constitution of a "center" from which those designated as "abnormal" could be excluded, and the role played by visual representation within this discourse. This history presents a challengingly different view of the traditional wisdoms of art history, of the inheritance of the Enlightenment, and of the very functions of visual culture. Both sign language and the art practice of the deaf are means of visual communication that operate in between the standard poles of discourse. They disrupt such polarities as hearing/ deafness, aesthetic/ political, communication/silence, signifier/ signified, high culture/ low culture, colonizer/colonized, and so on. This history is a specific and precise means of examining the development of some of the most significant arenas in modern cultural history, precisely because the deaf have claimed centrality but have been constructed as marginal.

It is at once necessary to define what is meant by sign language in particular and the visual sign in general. The visual sign is an artificial

construct made for the purpose of representation, whether it be a gestural sign, a work of art, or even a written word. It is composed of a signifier, that which is seen, and a signified, the concept that is depicted or indicated. Visual signs do not have an unchanging essence, as the transformations in the history of art amply demonstrate, but seek to communicate and mediate representation in ways that are often unpredictable. In exploring this topic, I ground the arbitrary nature of the sign by drawing connections between art made and inspired by the deaf and the broader artistic, intellectual, and social milieux in which it was disseminated. Signs signify only in context, which necessitates historical investigation of the ways in which they were deployed and theorized in the period under discussion.

If any demonstration of the changing nature of the sign were needed, it can be provided by the remarkable changes in (hearing) attitudes to the sign language of the deaf in the last two hundred years, which caution against any statement of the "truth" of sign language. It is important to set aside some common misapprehensions. Sign language is not pantomime and the great majority of its signs bear no physical resemblance to their signified, that is, the object, person, or idea referred to by the signifier, that is, the gestural handshape.[1] Nor is finger-spelling, which spells out spoken language in manual form, sign language. Sign language is an inflected language, with its own grammar and syntax, which are distinct from those of the native spoken language. It is the misfortune of the deaf that their languages are closer in structure to Thai, Finnish, and some African languages than English, whose hegemony is such that it has taken the role of language itself. However, all sign languages are not mutually intelligible. For example, British and American Sign Language are very different, whereas the American and French Sign Languages have important similarities. In short, sign language is a language, but that fact forces us to reconsider what it is that we mean by language. As it is also a visual language, it further entails a rethinking of this commonplace phrase, more often used than defined. Sign language, a system of visual signs that convey precise and communicable meaning, has obvious interest and appeal to artists and art historians alike.

This book has been written against the grain of archives, libraries, and disciplinary pressures in almost Borgesian fashion. I was late for the Bicentennial celebrations of the French Revolution in 1989. Mitterand's regal parade seemed more appropriate for a commemoration of the ancien régime than as a reminder of the spirit of '89, let alone '93. But being as afraid of missing something as of being seen to take part, I finally made

the cross-channel trip at the very end of December. Skimming through *Pariscope,* I was delighted to see that an exhibition was about to open, celebrating two hundred years of state involvement with the deaf. For in reading the pictorial theory produced by the Academy of Painting and Sculpture during the ancien régime, I had been surprised to learn that the Academy taught its pupils that the best means of representing gesture in art was to imitate sign language.[2] Furthermore, I had just read Harlan Lane's ground-breaking history of the deaf, *When the Mind Hears,* in which he makes a brief reference to a painting of the abbé de l'Epée by a student of Jacques-Louis David, named Ponce-Camus.[3] I had wondered if there was a connection to be made, and if there were any other examples of such cross-fertilization between the visual language of the deaf and the visual language of painting and sculpture. The exhibition at the Sorbonne, curated by Alexis Karacostas, displayed not just the Ponce-Camus, but an array of works by deaf artists from the nineteenth century. Paintings by pupils of Ingres, Cabanel, and Girodet were on display, and the descriptions provided suggested that deaf sculptors and photographers had been prominent in the period. Immediately, it was clear that the answer to my questions was far more complex and intriguing than I could have suspected.

I later discovered the rediscovery of this exhibition ought never to have been necessary. At the end of the Second World War, the Institute for the Deaf in Paris had a museum devoted to deaf history and achievement, whose catalogue ran to over seventy pages and included over six hundred works by deaf artists.[4] Soon afterwards, the museum was abolished to make way for extra classrooms and the works it contained were dispersed, destroyed, or given away. Only a small cluster of these paintings, sculptures, engravings, and drawings, often donated by the artists themselves, now survive at the Institute. Even these are not on display to either the pupils of the Institute or the public, as they sit in an attic awaiting restoration, for which there never quite seems to be enough money. If it had not been for the diligence of deaf photographers and engravers, whose identity is now uncertain, and the tireless work of archivist Alexis Karacostas in making these works available for researchers, this book would have remained a footnote to my dissertation. This story is, then, one of achievement but also one of conflict. Deafness, sign language, and art are, to say the least, not cross-referenced and the materials on each subject are usually not even kept in the same buildings. If there are references to deaf art, it is under the heading of therapy. If deaf artists became famous, like Goya and Joshua Reynolds, their hearing loss is rarely discussed, but if

not, it is presumed that the work of these artists cannot be of importance. Art history's definition of the canon has thus excluded the very possibility of the deaf artist. This problem of categorization leads me to describe this work as belonging to the history of visual culture, rather than art history in its traditional sense. However, a note of caution should be sounded. While the dogged persistence of the canon bedevils the expansion of art history, the tools developed by art historians for visual analysis remain indispensable. Many cultural critics trained in history or literature find the visual arts a central point of reference, but often ignore the complexity of visual representation. If written texts are always "problematized," visual material is often used as a self-evident example of an argument, without paying sufficient attention to the specificities and complexities of the visual. While the formal tools of art history are far from perfect, they offer a point of departure for the specific analysis of the visual that adapted literary theory cannot provide. In short, visual signs are not simply words-in-pictures, but a distinct branch of semiotics.[5]

SIGN WARS

There was a generalized hostility to the deaf and to sign language in particular throughout the nineteenth, and much of the twentieth century. Prior to the eighteenth century, deaf people did not constitute a category for social intervention by the state, and it may be said that, although people were born deaf, no-one was born with deafness. The constitution of deafness as a medicalized category of the body politic, and hence a social question, was the direct outcome of Enlightenment sensualist philosophy in general and the politics of the French Revolution in particular. An initial fascination in the writings of Condillac, Rousseau, and Diderot with sign language as the original language of action soon gave way to the categorizations entailed by a new distinction between the normal and the pathological states of the body. Consequently, deaf people were now perceived as suffering from a disease called deafness, which affected the normal condition of hearing. During the French Revolution, the state undertook the regeneration of these "unfortunates," along with other such diseased sections of the body politic. At first, such regeneration was conceived as being enabled by the methodical sign language devised by the abbé Charles-Michel de l' Epée in the 1770s, but when it became clear that not only was deafness not disappearing, but that its extent had been greatly underestimated, governments turned their hopes to medicine and to speech training.

For there have been two main schools of thought amongst the hearing concerning the education and socialization of the deaf since the Enlightenment. On the one hand, beginning with the abbé de l'Epée, sign language educators have argued that sign language is the natural language of the deaf and that their education should be primarily in their own language. However, many have objected that whatever the capacities of sign language, the deaf must learn to speak in order that they can communicate with the hearing, a position known as oralism. Both sides have accused the other of every imaginable error, immorality, and incompetence, but the debate has hardly been between equals. The proponents of sign language, usually the deaf or those connected to the deaf, have faced an overwhelming majority of hearing people, who have successfully imposed their means of communication on others. Nonetheless, a remarkable body of deaf writers and artists established a flourishing sign language culture in Paris during the nineteenth century, which succeeded in allaying governmental hostility by winning over public opinion. Art was a key resource in this contest, and the Salon achievements of painters such as Frédéric Peyson, Léopold Loustau, and René Princeteau, and sculptors like Félix Martin, Paul Choppin, and Ferdinand Hamar, offered visible evidence of deaf culture and its possibilities. Under the sway of the new sciences of anthropology and medico-psychology, the French and Italian governments dismissed their work and prohibited sign language in deaf education at the Milan Congress in 1880.

Only in the last thirty years has there been a revival of official sign language education and recognition of deaf culture in the West. The old argument has revived between oralists, signers, and a newer position known as Total Communication, which argues for the use of all methods, but relies on the structures of English. Recently, deaf sign language users have come to see their language use as constituting a unique and distinct culture, open only to those who are both profoundly deaf and sign language users. The sign for VERY HARD-OF-HEARING can thus be used to indicate someone whose hearing is only slightly impaired, for, from the Deaf perspective, hearing is unusual, not deafness.[6] The proponents of this culture mark their difference by writing Deaf with a capital D. This Deaf culture is distinguished from the deaf community, which comprises all those with hearing difficulties and their families, friends, and supporters. It should be said that, despite being deaf in one ear, on neither count can I call myself Deaf and have therefore decided to retain the conventional orthography. This book, however, is neither a manifesto for the deaf, nor an advocacy program for the way in which Deaf culture should be organized. It is an examination of the uses of art by the deaf as a

means of artistic practice, visual communication, and social intervention between the deaf community and the hearing majority.

Unlike many of the pioneering works in deaf studies to which it is indebted, this book is not primarily concerned with the question of methods, or of education. But, in such a contested field, no one can claim neutrality. I find nothing exceptional in William Stokoe's comment: "Because American Sign Language is the medium of communication used by a community of people . . . anything expressible in another language can be expressed in it."[7] The deaf have as much right to an education in sign language as the hearing have to one in a spoken language. Stokoe and others in the Deaf community have been above all concerned to refute the nineteenth-century belief that sign language was not properly a language at all. This refutation was essential, but I have respected the complexity of nineteenth-century linguistic discourse, and have taken the oralist movement seriously, even though the aims and methods of "pure" oralism were both abhorrent and ultimately violent. Nonetheless, oralism was not simply evil or ignorant, but was able to command both governmental and intellectual support. By 1900, oralism was transformed from one of several schools of deaf education in the eighteenth century into the only acceptable method, as far as the great majority of hearing people and a small minority of deaf were concerned. Oralism gained its authority from its alliance with anthropology and racial science, which classified the deaf as abnormal and their sign language as an atavistic relic of the primitive stage in Western evolution, still to be observed amongst "primitive" colonized peoples. The different ways in which hearing people have constructed sign language since the French Revolution thus constitute one variety of the history of modernism.

THE ART OF SIGNING

> The ordinary teacher can, up to a certain point, pass over philosophy, but it is not at all the same for the teacher of the deaf. For him, philosophy is as necessary as medicine is to the doctor.
>
> Piroux, *L'Ami des Sourds-Muets*

How is the relationship between the visual sign, deaf art, and the sign language of the deaf to be understood? It is true, of course, that there is

no *necessary* relationship between these different practices. But historically there was such a relationship and it was well-understood by artists, critics, and philosophers, varying in ability from the unquestioned genius to the hack. I want to propose a framework in which this question can be posed and answered. To pursue the metaphor, if one side of my frame is devoted to art history and visual culture, another is taken up by the history of the deaf, a history that is closely linked to the work of deaf artists. These related histories cannot be treated in isolation. The reception of the deaf, sign language, and deaf art were critically determined by philosophy and by anthropology. These two fields thus constitute the remaining two sides of the framework within which this book operates.

From the first recorded statement by the hearing about the deaf that survives in Western history, in Plato's *Cratylus*, the deaf have been categorized within philosophy in between spoken language and art. Plato's work debated whether language was natural or conventional, that is, whether words naturally belong to that which they name, or whether they are assigned in an essentially arbitrary process. The history of hearing attitudes to the deaf can be written in terms of a series of oscillations between the two poles of natural and conventional language, with sign language and the visual arts also in movement between the two extremes. Language, history, and visual signs have a complex relationship which is neither reflective, causal, nor determined. As Deleuze and Guattari have recently argued: "The first principle of philosophy is that Universals explain nothing, but must themselves be explained."[8] Rather than supply a universal cause for the interaction between these three fundamental elements of Western culture, this book devotes considerable space and energy to the attempt to understand the forces that prompt shifts in their relations, which are never natural or preordained but reveal the ways in which language, far from simply reflecting social reality, conditions and shapes that reality. For Deleuze and Guattari: "Otherness is first of all the existence of a possible world." In other words, if a mode of existence is possible, then not only is it possible for all existence to exist, but it is possible for things to be other than they are: "Otherness is always perceived as an other, but in its conception it is the condition of all perception, for the others as for us."[9] There are no universal subjects, for everyone is an other for someone else. Perception is only a given of the human individual in a dialogue with others.

However, no philosophy can act without support. In the case of deafness, the crucial defining factor and institutional presence was that of

anthropology. In defining "Enlightening," Kant also described a new field he called anthropology, which was simply the "knowledge of the world through knowledge of man." Anthropology was, then, another more precise name for the Enlightenment itself, which Kant saw as the process by which Man came to self-awareness. Inevitably such knowledge was only accessible through language, raising the question of what constituted a language. For Kant, the answer was simple: "Words are the means best adapted to signifying concepts. So a man who, because he was deaf from birth, must also remain dumb (without speech) can never achieve more than an *analogue* of reason."[10] Kant's definition of anthropology thus excluded the deaf, not only from reason, but from the family of man, and from achieving Enlightenment. In the period considered in this book, the deaf and their sign language were the objects not simply of philosophy, but of philosophical anthropology. Kant's dismissive view of the deaf became conventional wisdom in anthropology as it became a discipline in its own right from the 1850s onwards, with serious and dramatic consequences for the deaf. Kant's *Anthropology* was contemporaneous with the work of the abbé de l'Epée, which had a very different view of the possibilities of sign language, making it clear that even for the philosophes, the Enlightenment was a process and a dialogue, not a once-and-for-all moment in history, philosophy, and ethics, as is so often argued today. In this alternative sense of Enlightenment, the self only perceives its existence in a continually renewed dialogue with otherness, explored in this book through deafness. Deafness, in this view, is as much a category by which the hearing define themselves as those without deafness as it is a definition of the condition of the deaf. Attitudes to deafness and the art of the deaf therefore become a means of interpreting the culture in general.

Deafness can never be stable or essential, but is always a cultural construction in need of renewal, and an image in need of focus and definition. The medicalization of deafness entailed a search for a visible cause of the new disease, enhanced by its all too visible symptom, sign language. Although deafness affects the perception of sound, this invisible deficiency was addressed visually throughout the modern period. In order to visualize deafness, a screen must be created and defined, which in turn requires that it be framed: that is, have defined borders and parameters. Neither the hearing nor the deaf live in self-contained worlds, but are interdependent on each other. For as the hearing look at the deaf, the deaf look back and disrupt or confirm the image produced. The result is what I shall call the "silent screen" of deafness, which depicts neither the deaf themselves nor the view of the deaf seen by the hearing, but rather the product of the

interaction of the two looking at each other. It takes two people for deafness to be seen, one with hearing and one without. The screen is the product of the intersection of two gazes which forms a certain space for perception, making it possible (in this case) to see the deaf within a category known as deafness. This notion of the screen is derived from that proposed by Jacques Lacan: "the screen here is the locus of mediation" between the gaze and the subject of representation.[11] Thus, as I look at the subject of representation, a third element comes into being on the screen.[12] Deafness cannot be seen only by the hearing or only by the deaf: both see each other and themselves in "seeing" deafness.

These views are by no means equivalent, for the dominant authority has always been with the hearing majority. The production of deafness as a visual category by the hearing requires that this blurred picture be clarified and that the images coalesce in a legible fashion. Central to this process is the framing of the visual image. Lacan's notion of the screen has most often been used by film theorists and historians in considering the nature of spectatorship in the cinema but, as such theorists have recognized, the cinema is a highly controlled environment in which the means of image production is given and the screen is already in place. Just as the visualization of deafness is a historically constructed process, the frame is not "natural" to the picture. In this connection, Jacques Derrida has insistently asked: "Now where does this frame come from? Who supplies it? Who constructs it? Where is it imported from?"[13] Derrida's questions indicate that the creation of deafness as a handicap cannot be fully explained by over-arching oppositions, such as that between natural and conventional language. The more precise question is why deafness was imported into that frame and by what means? Frames are of little use with no picture inside, but every picture needs a frame. Such framing was essential if the physiological invisibility of deafness was to become visible.[14]

The cultural politics of the deaf in the nineteenth century were informed by an awareness of the framework described above. Rather than refuse the perception of the deaf created by Enlightenment philosophy and Revolutionary politics, deaf artists and activists sought to use the construction of deafness for their own ends. Writers such as Roch-Ambroise Bébian, Laurent Clerc, and Ferdinand Berthier theorized sign language and spoken language in a symbiotic relationship in which neither was wholly complete without the other. Rather than settle for the Rights of Man due to the marginalized, deaf artists and activists claimed a position at the center of society, as gesture and expression were as indis-

pensable to the hearing as to the deaf. It is important to note that deaf artists, from sculptor Claude-André Deseine who made a bust of Robespierre, to the photographer of the Paris Commune Bruno Braquehais, saw art and activism as two facets of their expression of a deaf identity. By evoking the supplementary nature of Otherness, deaf activists claimed a difference that was more similar than it was different. Consequently, the work of deaf artists was not, with important exceptions, formally innovative, but explored and developed the possibilities available within the traditional Classical formulae. If this art did not transform the technical repertoire, often the benchmark for inclusion in the canon, it did transform the lives of the artists concerned and many others in the deaf community and beyond.

This questioning of the relationship between center and margin in the work of deaf artists is at the heart of its resonance and importance, and, more generally, expands our understanding of the uses and functions of the visual sign in a logocentric society. At a time when the ends of art, no less than the status of sign language, are in doubt as never before, these concerns are coming in from the margins to which they were once consigned to attain a renewed significance.

1 ANCIENT GESTURES, MODERN SIGNS

The history of art and that of sign language have long been intertwined. This chapter examines how French art of the ancien régime reinterpreted Renaissance theories of gesture and came to have a particularly dynamic interaction with sign language. Gestural signs offered both a literal service as a means of giving gesture in art specific meaning that could be understood by the spectator and also a metaphorical sense of how a purely visual language could function as a means of communication. A remarkable interaction took place between deaf sign language, artists, critics, and philosophers, whose legacy included not only the Institute for the Deaf but the proliferation of deaf artists in the nineteenth century. This complex interaction between the languages of sign, print, and art sheds light not simply on the history of the deaf, or of gesture in art, but on the uses of art in the ancien régime.[1]

None other than Leonardo da Vinci was the first artist to suggest the imitation of deaf sign language as the best factual source for the imitation of gesture:

> The forms of men must have attitudes appropriate to the activities that they engage in, so that when you see them you will understand what they think or say. This can be done by copying the motions of the dumb, who speak with movements of their hands and eyes and eyebrows and their whole person, in their desire to express that which is in their minds. Do not laugh at me because I propose a teacher without speech to you, who is to teach you an art which he does not know himself, for he will teach you better through facts than will all the other masters through words.[2]

One of Leonardo's students, Ambrosio de Predis, was the son of Christoforo de Predis, a deaf artist from Milan who was the likely source for Leonardo's observation of deaf sign language.[3] Leonardo made many detailed studies of hands, and in works such as his *Annunciation,* the gestures of both Mary and the angel are prominent. In 1500 Leonardo had

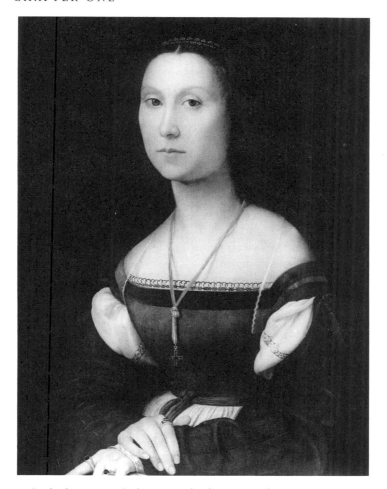

1. Raphael, *La Muta* (Urbino, Ducal Palace, c. 1507)

returned to Florence, where Raphael was then working, and his influence on Raphael at this time has long been accepted. Raphael's portrait of a deaf woman, *La Muta* (fig. 1), can be read as an attempt to put his ideas into practice. Although other works by Raphael may use more dramatic gesture, it is only in *La Muta* that we can be certain he was studying the deaf. Compared with *La Gravida* (Florence, Pitti Palace), another Raphael portrait of an anonymous woman from this period, *La Muta* has sharper, more distinctive features and seems to have a slight squint. Her hands are strikingly long and fine, with sharp, elegant fingers, in contrast to other portraits, such as the *Maddalena Doni* (Florence, Pitti Palace), in which the sitter's hands have round, short fingers. As if to call attention to this

innovation, *La Muta* rests her index finger against the frame of the picture itself, disrupting the division between the pictorial space and the space of the viewer. As Jones and Penny have remarked: "In this implication of the beholder, as in the form of his portraiture, Raphael follows the lead of Leonardo."[4] Everything in the portrait *La Muta,* from the title, the close observation of the hands and physiognomy, to the overall construction of the composition, suggests that Raphael knew of Leonardo's ideas on the imitation of the deaf and was engaged in a study to guide his application of them. Furthermore, Raphael had known a deaf artist, Bernardino di Betto di Biagio (1454–1513), known as Pinturicchio, when they were both students of Perugino.

Pinturicchio had considerable success, working on the Sistine Chapel and the Borgia apartments in the Vatican, among many other commissions for the Roman curia. He was one of three distinguished deaf artists in early modern Europe together with Hendrick von Avercamp (1585–1634), a Dutch artist in the school of Pieter Brueghel, and, perhaps most famous of all, Juan Fernandez Navarette (1526–1579), known as *El Mudo,* the court painter of Philip II of Spain.[5] An eighteenth-century biographical notice of Navarette recorded two of what were to become the standard clichés about deaf artists: "It is said that he was born mute, but I say that he was born totally deaf, as that is the reason for dumbness. . . . But this muteness was accompanied by great liveliness and talent (as is often the case), because Nature is provident, so what is lacking in one of the senses she distributes among the other senses or faculties."[6] The deaf are not, of course, necessarily mute but Aristotle believed that the same nerve controlled both speech and hearing, which is the origin of the misleading (and now offensive) term "deaf-mute." Nature's obliging sense of compensation in strengthening the surviving senses at the expense of the lost faculty is a more enduring myth. The early modern thesis was built upon the then scientific notion of the "spirits" which animated the material body. If a person did not use the spirits assigned to hearing, then obviously they had more at their disposal for the other senses. Long after spirits had been rejected, the notion of sensory compensation remained active.

FRENCH ANCIENTS & MODERNS

Leonardo's ideas on the imitation of sign language achieved greater currency in France after Roland Fréart de Chambray, a friend of Poussin and

Descartes held that only man has a soul, capable of expressing ideas and communicating with others. The sign language of the deaf made apparent this essential difference between rational man and the unthinking animal. Montaigne, by contrast, had interpreted sign language in exactly the opposite sense, namely that all species had language and were more alike than not. Although both authors acknowledged that gesture and sign language were classified in relation to voice, they then made diametrically opposed uses of that position.[16] The history of the reception of sign language reveals radical disparities at the heart of the Western tradition, which cannot be contained in one overarching intellectual framework. It disrupts the neat oppositions drawn by later scholars with which to explain the past, but restores the complexity, ambiguity, and fluidity of human experience. This political and cultural edge to the interpretation of gesture was to keep such arguments central to debates on language and culture throughout the Enlightenment.

In his *Vacationes Autumnales* (1633), the Jesuit Louis de Cressolles defined what was to become the Ancients' position. He upheld the virtues of Classical rhetorical gesture, as described by Cicero and Quintilian, disdaining "the widely held opinion amongst the ignorant who assert that natural gestures are sufficient in themselves." He was confident that "those persons of knowledge and cultural refinement" would no more approve of such vulgarity than they would bad pronunciation.[17] He did not describe exactly which gestures should or should not be used but rather the limits within which gestures could be deployed. Thus the speaker should neither extend the neck too far, which might suggest arrogance, nor crouch it too low, indicating humiliation but should instead strive for an appropriately restrained medium. De Cressolles saw human voice and speech as indisputably superior to any gestural or animal language, with the consequence that the words of the speaker were infinitely more important than any accompanying gestures. The spirituality of the voice could not be precisely defined, nor could the gestures it might inspire. The Ancients relied on breeding and class to ensure that gestures remained decorous, within the limits of the civilized, and shunned such indiscretions as the imitation of an actor's gesture. Correct use of gesture ultimately could not be taught or trained, but was an inherent attribute of the aristocrat, creating an elite discourse on gesture, which was given form not by its specifics but in its erudite horror of the popular and the modern. Just as the Moderns claimed universal properties for gesture, so did the Ancients insist on the superiority of the human voice over both gesture and writing.

This argument resonated with the Ancients and Moderns debate in the visual arts, for, as Louis Marin has argued, "in such a model there is an implicit valorization of sounds and voice compared to writing and an explicit but reverse valorization of design as compared to colors, for the very reason that both sounds and design are almost immaterial."[18] The logicians of Port-Royal made such distinctions explicit, remarking that color was "only the lowest and most material part" of painting.[19] Sign language was thus associated with color and the vernacular, while rhetorical gesture was linked to the Classical languages, voice, and design. In short, sign was material and voice spiritual. As the abbé Deschamps, an eighteenth-century deaf educator, put it: "Speech is like a picture in which the sign is the color which gives it *éclat,* but often these things are an illusion for the spirit."[20] For the oralist Deschamps, like his philosophical predecessors in the seventeenth century, a choice had to be made between the precision of speech and the brilliant, but illusory, sign.

Gesture was a part of the Modern refutation of the Ancients. Linked to the vernacular and color, it was an essential mediator of Modern thought. As such, the gesture was not the observed "fact" it was for Leonardo but a *sign.* A sign, as Port-Royal had defined it, was of two parts: "[T]he sign encloses two ideas, one of the thing representing, the other of the thing represented."[21] The gestural sign of the deaf is a striking visual example of this process, for the shape of the gesture is not the intended meaning of the user. For the Moderns, the cliché of Academic theory that painting was *la poésie muette* (dumb/silent poetry) could thus have metaphorical, as well as literal sense. The deaf sign was no longer simply "in-the-world" as a fact but was seen as an artificial, constructed, and, above all, visual system of communication, which could be taken as a metaphor for painting itself. The term silent poetry describes the interaction and interpellation between the two visual signifying systems of sign language and the visual arts, which are the focus of this book.[22]

In his Latin poem, *On the Art of Painting* (1668, translated into French by Roger de Piles), du Fresnoy emphasized both the imitation of sign language and the affinity between the visual language of the deaf and the silent artwork: "Mutes have no other way of speaking (or expressing their thoughts) but only by their gesture and their actions, 'tis certain that they do it in a manner more expressive than those who have the use of Speech, for which reason the Picture, which is mute ought to imitate them, so as to make itself understood."[23] After the triumph of the Moderns in the Academy, and the installation of de Piles as their theoretician in 1699, Academic art and theory began to explore fully the possibilities of deaf

sign language for artists. For the next forty years, the Coypel family, old friends of de Piles, dominated the Academy and used his ideas both in their teaching practice and in their own work.[24] Antoine Coypel, First Painter and Director of the Academy, said in 1718 that "the Rules of Declamation are needed for Painting, to reconcile the gesture with the expression on the face. The painter, who unfortunately is unable to give speech to his figures, should replace it by the lively expression of the gestures and actions that mutes ordinarily use to make themselves understood."[25] Although art historians have often had recourse to manuals on gesture for orators in attempting to explain the painted gesture, oratory may not be the best means with which to explain the silent image. In reading the semiotics of the body in the ancien régime, art historians have recently concentrated on Charles Le Brun's famous treatise on the passions. But Le Brun's scheme sought only to represent the expressions of the physical body in art, as described and explained by Descartes in his *Treatise on the Passions.* It can only be used to analyze one level of meaning in the painted body, that of the animal passions. The linguistic communication invested in the corporal sign cannot be deciphered or explained using this text. Even when Coypel explicitly referred to the rules of oratory, he advised painters to draw from the deaf rather than the established text books on oratorical gesture. The orator's gesture was a supplement to the spoken word, whereas both painting and sign attempted to imitate the essence of nature itself. In a later address to the Academy, Coypel defined painting in the following terms: "It is a language which could be common to all peoples, which the deaf understand and through which the mute can make themselves understood."[26] For Antoine Coypel, deafness was thus a metaphor that might explain the very function of art, taking its importance for art history far beyond the all-but-impossible task of identifying deaf signs in painting. This interaction between the widespread Enlightenment desire for a universal language, painting, and deaf sign language was to be of considerable importance throughout the ancien régime.[27]

In analyzing representations of gesture, it is therefore indispensable to situate them within these taxonomic debates if we are to understand their significance in the period. For in our impatience to decide whether a gesture is rhetorical, theatrical, or even from the vocabulary of deaf sign language, we act as if the boundaries between such signs are clearly distinct. But how artists actually made use of such sources cannot be determined, as sign language did not develop a transcribable format before the invention of film and, especially, video. Indeed, although hearing and deaf

people have no doubt always conversed, it awaited the pioneering efforts of the abbé de l'Epée in the late eighteenth century for the gestural signs of the deaf to be permanently recorded or classified by the hearing. Just as English and French are very different today to what they were in the sixteenth century, so too sign language has changed and evolved. As we simply do not know what deaf sign looked like, gesture in early modern art may or may not be a direct imitation of deaf sign language—the case can neither be proven nor dismissed. Furthermore, such efforts ignore an earlier semiotic equivalency. For example, in the introduction to his *Essay on Human Knowledge,* Condillac notes that language is one of the two subjects of his work: "I have begun with the language of action: here the reader will see how it has produced every art proper to express our thoughts; such as gesture, dancing, speech, declamation, arbitrary marks for words or things, pantomimes, music, poetry, eloquence, writing, and the different characters of language."[28] In Condillac's materialist semiotics, every sign was but a secondary production of the original language of action. One purpose of his philosophical investigation was thus to uncover this originary process of translation. Signs, whether gestural, painted, or written, were all fragmentary productions of this original language, which were equivalent to each other for epistemological purposes. Gesture attained signification not simply in itself but within a classificatory system of representation. In such a system, as Foucault has noted, "the ordering of things by means of signs constitutes all empirical forms of knowledge as knowledge based upon identity and difference."[29] To impose modern hierarchical structures of meaning on this diverse and fluid semiotic field is to render it illegible.[30] Signs interact in a manner that reveals both their contingency and common, deferred origin.[31] Deaf sign language was a key resource in this signifying system. In depicting the body as sign, artists, critics, and theoreticians of the ancien régime used the gestural sign language of the deaf as a technology of signification peculiarly well suited to the silent artwork, in keeping with the polysemicity and diversity of the body and the sign.

It was Charles-Antoine Coypel who fully developed this gestural language of painting. The younger Coypel was a remarkable figure, a playwright, critic, and theorist, as well as a painter. In a speech to the Academy and its pupils, he once again attempted to define painting as if it were oratory. He found pictorial equivalents for a wide range of rhetorical terms and devices, such as disposition, narration, and invention. However, when Coypel considered the depiction of contradictory emotion in art, no vocal parallel existed, leading him to the mediatory possibilities of sign language:

"I believe I can forcefully say that the use of this figure is more difficult for the Painter than the Great Writer. The Actors whom we place on the scene have no other language than gesture and the movements of the face: in speaking there is no man who can easily make it understood at which point he is torn by two contradictory emotions, but this would be the chef d'œuvre of a deaf-mute who, in a similar case, could inform us of the opposing movements that agitated him."[32] Neither Le Brun's system of expressions nor rhetorical gesture could assist Coypel in this central task of History painting, which sought to depict the supreme emotional moment of a narrative.[33]

A further source exploited by Modern artists in their study of gesture, in keeping with their endorsement of the vernacular, was the long-standing tradition of deaf characters in French popular theater. This interaction of theater with painting provides a striking example of the contingency and fluidity of gesture and the sign. As early as the sixteenth century, *Le Sourd* [*The Deaf Man*] appeared as a character in short comedies, and the role continued and developed as time went on.[34] By the seventeenth century, the romantic lead in a comedy often adopted a "deaf" character, but spoke normally when out of character. They pretended to be deaf in order to deceive others in the pursuit of a love affair, and this theme continued in popular theater until the nineteenth-century vaudevilles. One of the most successful early plays of this type was *The Mute* by Jean de Bigot Palaprat (1650–1721) and David-Augustin de Brueys. The Chevalier, the hero, impersonates a deaf-mute in order to gain access to the house of the Comtesse, where his love Zaide lives. The Comtesse has been searching for a mute to entertain her and the Chevalier, deftly substituted by the valet Frontin, fits the bill: "Everyone made signs to him to which he responded with a grace by which everyone was charmed." What these signs were and how the audience might have understood them is undecidable. In popular comedy, signs were one of a range of theatrical devices introduced to add spice to the action, which were necessary because, as Palaprat indignantly pointed out in his "Introduction," theater audiences were noisy, disruptive, and anything but homogeneous. In a busy theater, the author needed all his ingenuity to get a hearing, competing with the spectators of the *parterre,* who did not come solely to watch the play but to meet friends and have fun.

Coypel brought this understanding of the theatrical sign and public to his artistic work and criticism. In his review of the Salon of 1747, Coypel looked to see if "the characters in the scene expressed that which they could not say."[35] Similarly, William Hogarth noted that "my picture was

my stage and men and women my actors who were by means of certain Actions and express[ions] to Exhibit a dumb shew."[36] Hogarth was no more referring to classical rhetoricians than Coypel, for eighteenth-century London was captivated by popular pantomimes. In 1728, John Weaver, who was attempting to win support for his Classical mimes based on rhetoric, deplored "the Spectators now squandering away their Applause on Pseudo-Players, Merry-Andrews, and Tumblers; and but rarely touched with or encourage a *natural player* or *just pantomime*." Weaver himself was forced to adopt their "Grotesque Dancing, [by which] I mean only such Characters as are quite out of Nature . . . in lieu of regulated Gestures, you meet with distorted and ridiculous Action."[37] On both sides of the Channel, gesture in painting was Modern, theatrical, and conventional.

For both Hogarth and Coypel, the problem in the theater and in the exhibition was attracting and keeping the attention of the viewer in order to create an audience. The specific problem for painting and the dumb show, or mime, was that no voice could be used in this already difficult task. The public, rather than being a clearly defined agent which the artist or writer could respond to, appears here as the creation of a successful work. If a piece had merit, it would find and construct a public; if not, there were ample alternative distractions for the pleasure-seeker. Within this framework, gestural sign was both a spectacle in itself and a means of making the silent action comprehensible. Coypel used gesture, among other devices, as a means of catching the audience's attention in both his theatrical and artistic work.[38] Coypel blended his emphasis on gesture with Poussin's technique of separating the hero from the other characters by use of lighting. In his *Joseph accused by Potiphar's wife* (Priv. Coll., 1737) this device was further refined so that the light picks out not just the hero, Joseph, but the hands of all the actors. Potiphar's wife points out Joseph with an open palm as her seducer, while he avoids her gaze and blocks her accusatory gesture with the back of his right hand. His downturned left hand indicates his dismay at the situation, as Potiphar's outstretched palm and clenched fist show his fury and disbelief. This painting exemplifies Coypel's theory that gesture could allow the painter to express more than one emotion at once and hence depict pivotal moments in History with clarity. For the Salon of 1741, Coypel's *Joseph Recognized by his Brothers* (Minneapolis, Walker Art Center, 1740), again showed Joseph standing in the principal light while his brothers recognize and embrace him. In the words of one contemporary critic: "their embrace, handled with spirit in the theatrical style, allows all the action to be understood."[39]

The French ancien régime public understood and appreciated Coypel's interaction of gesture, painting, and theater.

THE DEAF IN THE HAREM

The deaf became best known as attendants in the Turkish sultan's harems, where travelers and historians reported that numerous deaf men were employed. In both factual and fictional accounts of the Orient, the distinction between the seraglio, or palace, and the harem itself became blurred beyond recognition, so that the entire Ottoman court was envisaged as the harem and a place of danger. Such confusions and misunderstandings make these texts almost irrelevant as historical sources, in the traditional sense of accurate records of past events. However, their importance cannot be underestimated in the formation of the hearing perception of the deaf.[40] It was the Englishman Paul Rycaut who first published a detailed description of the deaf in the harem in 1668:

> There is a sort of Attendant to make up the *Ottoman* Court, called *Bizebani* or *Mutes;* men naturally born deaf, and so consequently for want of receiving the sound of words are dumb: These are in number about 40 who by night are lodged amongst the Pages in the two Chambers [of the Seraglio], but in the daytime have their stations before the *Mosque* belonging to the Pages, where they learn and perfect themselves in the language of the *Mutes,* which is made up of several signs in which they can discourse and fully express themselves; not only to signify their sense in familiar questions, but to recount stories, understand the Fables of their own Religion, the laws and Precepts of the *Alchoran,* the name of *Mahomet* and what else may be capable of being expressed by the Tongue. . . . This language of the *Mutes* is so much in fashion at the Ottoman Court that none almost but can deliver his sense in it, and is of much use to those who attend the Presence of the Grand Signior, before whom it is not reverent or seemly so much as to whisper.[41]

Rycaut also informed his readers that sign language was widely used by members of court involved in what he termed "the doctrine of Platonick love," a homoerotics in which he believed men from the rank of student to the Grand Sultan himself were busily engaged. Within this imaginary harem, sign language thus served to render men equal—even the sultan and his courtiers—in the homosocial space of the harem.

Furthermore, the deaf servants in the harem were reputed to serve as

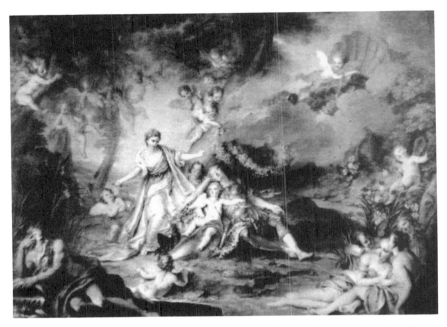

2. Charles-Antoine Coypel, *Armide and Renaud* (Neufchâtel, Musée de Neufchâtel)

the sultan's executioners, silently disposing of their victims by strangulation with silken cords. This titillating mixture of Eros and Thanatos in the most exotic of settings made the deaf intriguing, and also provided a space in which sign language could be imagined in action. This Orientalist fantasy, connecting murder and eroticism, lay behind the appearance in Coypel's painting of the murderess, often armed with a knife, whose aggressive gesture was counterposed with relaxed male figures. For in the phantasmic space of the harem in the Western imagination, all the servants of the sultan were equal in their subordination to him. The deaf executioner, feminized by his gestures and connections with the eunuchs, could thus be collapsed into the figure of the harem woman to produce the hybrid fantasy figure of the Orientalized murderess. She first appeared in an early work as Medea whose contradictory role as woman, lover, and killer fully achieved the contrasting effect sought by Academic artists for their history paintings, namely *Medea and Jason* (Berlin, 1715). She appeared again in his *Armide and Renaud* (fig. 2), a scene from Quinault's opera, in which she makes a striking contrast with the abundance of nymphs, cupids, and assorted *putti* surrounding the sleeping Renaud.[42] Armide's expansive gesture, ferocious expression, and centrality to the composition

make her a remarkable figure. Coypel later drew a cartoon of the work for the Gobelins tapestry manufactures, giving the image a wider audience. If, as Mary Sheriff has pointed out, the male artist could make use of the *négligence* of his brush stroke to generate erotic enjoyment, then he seems here to have found a counterpart in the hard, direct gesture of the murderess.[43] Armide's steely advance contrasts noticeably with the languid repose of Renaud, vainly protected by Cupid's arrows against this altogether more concrete assault. This relaxed state seems to suggest that the very unnaturalness of the threat posed renders it insubstantial and unlikely to be achieved. Renaud has the quiet confidence and self-satisfaction of a sultan in his harem, as imagined by the West. It is not surprising that this aggressive intent was soon turned with greater success against the female protagonist in an explicitly Orientalist setting. In his *Cleopatra Swallowing the Poison* (Paris, Musée du Louvre, 1749), Coypel depicted the denouement of Corneille's *Rodogune* in which his by-now-familiar figure of the aggressive woman suffers the effects of the poison she had intended for Antiochus and Rodogune. The saved couple stand apart, concerned but aware that such unnatural intent could not have succeeded, as Antiochus' diminishing gesture indicates. In the most ambiguous of these works, *Athalie and Joas* (fig. 3), derived from Racine's *Athalie,* the queen looks with terror at the child, who she has seen stabbing her to death in a dream but, in the words of the Salon catalogue, "she could not prevent herself from admiring his grace and nobility." Death by the knife has now visited the sleeping female lead but the sublime repose of the male character remains constant throughout, as the child looks to heaven as an assurance of his safety. Joas uses a classical gesture, with his fingers spread wide and only the middle and little fingers touching. This gesture had been used in art since the early Renaissance—see Andrea Mantegna's *Madonna and Child* (New York, Metropolitan Museum of Art, c.1460) in which the Virgin uses the same gesture—and was often used in representations of Louis XIV, to indicate his high moral status. Meanwhile the queen's physiognomy struggles with her contradictory impulses of affectionate respect for the prince and her fear of his murderous intent. In other words, the *Athalie and Joas* is an embodiment of Coypel's doctrine that rhetorical gesture should be used for simple emotions, but the contradictory impulses at the heart of history painting should be imitated from the deaf. Gesture now set a complex semiotic multiplicity in play in French painting. On the one hand, the *public éclairé* appreciated the gestural skill of the male artist, as evidenced in his use of *le faire,* and quietly appreciated the erotic overtones thereby implied.[44] The sexualized

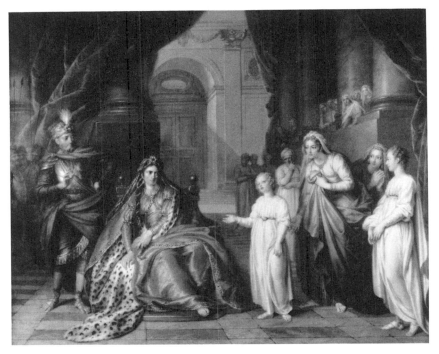

3. Charles-Antoine Coypel, *Athalie and Joas* (Brest, Musée de Brest, 1741)

looseness of technique contrasted with the dangerous feminine gesture, in which the woman is metaphorically read as her gesture, all too ready to transform herself into a fatal blow. The use of gestural language, literally and metaphorically related to the signs of the deaf, appealed to a wider audience and gave the work clarity. At the same time, the deaf recalled the Orientalist fantasy of the harem where they served as executioners. Finally, the depiction of dramatic, even murderous, gestures acted as a device to catch everyone's attention and generate a public response to the work. The dynamic interaction of these gestures and signs borrowing and learning from each other, was the basis of their semiotic power.

THE DEAFNESS OF THE ANCIENTS

Gestural sign language was so connected to the Modern aesthetic that committed partisans of the Ancient cause condemned it in all circumstances. One example stands out: the deaf artist Sir Joshua Reynolds (1723–1792). Joshua Reynolds, portrait painter, defender of Neo-

Classicism, founder of the Royal Academy in England, and author of the influential *Discourses,* was widely known to be very hard of hearing. This condition was attributed to a severe cold he caught at the age of twenty-nine while studying Raphael's paintings in Rome. Thereafter, he used an ear-trumpet, but according to Oliver Goldsmith's epitaph, it was unclear if it helped:

> Here Reynolds is laid and, to tell you my mind,
> He has not left a better or wiser behind:
> His pencil was striking, resistless and grand,
> His manners were gentle, complying and bland;
> Still born to improve us in every part,
> His pencil our faces, his manners our heart;
> To coxcombs averse, yet most civilly steering,
> When they judged without skill, he was still hard of hearing;
> When they talked of their Raphaels, Corregios and stuff,
> He shifted his trumpet and took only snuff.[45]

The extent of Reynolds' deafness is unclear from this passage. In his *Self-Portrait as a Deaf Man* (London, Tate Gallery) he depicts himself straining to hear, cupping a hand behind his ear, but not therefore actually deaf. Nathaniel Dance captured him in a similar pose in his drawing of *Sir Joshua Reynolds with Angelica Kauffmann*.[46] Reynolds holds his snuff box in one hand, as he leans closer to Kauffmann to catch her words, which she accompanies with a striking gesture of the right hand across the heart.

Despite his own condition, Reynolds had no sympathy with the French tradition of imitating sign language, for as the most prominent defender of Classicism, he could scarcely be seen using the Moderns' arguments. Reynolds wrote a series of notes for an English translation of Du Fresnoy's *De Arte Graphica* and took exception to the section now translated as: "Learn action from the dumb, the dumb shall teach, / How happiest to supply the want of speech." Reynolds did not accept this argument:

> Gesture is a language we are born with, and is the most natural way of expressing ourselves. Painting may be said therefore in this respect to have the superiority over Poetry. Fresnoy, however, certainly means here persons either born dumb, or are become so from accident or violence . . . [b]ut persons who are born dumb are commonly deaf also, and their gestures are usually extravagant and forced; and of those who have become dumb by accident or violence examples are too rare to furnish the Painter with sufficient observation. I would therefore wish

to understand the rule, as dictating to the Artist, to observe how persons, with naturally good expressive features, are affected in their looks and actions by any spectacle which they see or hear, and to copy the gestures which they silently make use of: but he should ever take these lessons from nature only, and not imitate her at second-hand, as many French painters do, who appear to take their ideas, not only of grace and dignity, but of emotion and passion, from their theatrical heroes; which is imitating an imitation, and often a false or exaggerated imitation.[47]

Two arguments are interwoven here. Firstly, Reynolds dismissed the gestures of the deaf as "extravagant and forced," arguing rather tortuously from a distinction between mutism and deafness that there were no "dumb" gestures that the artist could learn from. Reynolds symptomatically discounted the possibility of his own condition, accidental deafness, in an otherwise comprehensive survey. Reynolds' hostility to sign language may have its origin in anger with his own acquired deafness, which he tried so hard to overcome. For as recently as 1754, a commentary on this passage from de Piles, which was otherwise critical of Dryden's earlier translation, simply noted: "A very useful precept, for such unhappy persons are very expressive, and by action supply the want of voice."[48] But, secondly, Reynolds evinced an aversion to the techniques of French painters in general, of which the use of gesture was but an example. His distaste was consistent with eighteenth-century England's sense of its nationhood as masculine in opposition to a feminized France.[49] The natural and unaffected gestures of English art were thus opposed by Reynolds to the "false and exaggerated imitation" common to the French, still a popular theme in twentieth-century English xenophobia. The effeminate connotations of gesture for an English artist were reinforced by English Neo-Classicism's belief that, in John Barrel's words, "painting, in its highest manifestations, is by comparison with poetry a masculine art . . . outside and above the feminised realms of feeling and sentiment."[50] In eighteenth-century England, popular belief held that any Englishwoman had more masculine virtues than any Frenchman. In a typical 1766 print, a buxom Englishwoman at a Billingsgate tavern is seen giving a bloody nose to an effete Frenchman.[51] Reynolds was thus unlikely to accept French theory's notion of silent poetry: for it not only involved the sign language of the deaf but linked (masculine) painting to (feminine) poetry. In fact, he claimed that the naturalness of gesture set painting above poetry, rather than associating the two arts. In England, the simple fact that

deaf gesture had been accepted and used by the French Moderns was enough to exclude it from a place in the new artistic establishment. The association created between sign, modernity, and the French vernacular added up to an inevitable effeminacy in eyes of the English Academy, a view the French Ancients might ironically have endorsed. As a result, British artists never engaged with the deaf in the manner of their French colleagues, and there were fewer British deaf artists. The Enlightenment may have been a European phenomenon, but its unfolding was very different in different national contexts. The French engagement with the deaf was not an accident, but the result of a century of debate over natural and vernacular language, which was not replicated elsewhere.

PHILOSOPHY AND THE SIGN

To return to France, Carle Van Loo no doubt felt that his rendering of *A Subject of Medea and Jason* at the Salon of 1759 (Berlin, Schloss Charlottenburg), featuring a portrait of Mlle Clairon, a recent star in the Oriental role, would be an assured success. But, although much anticipated, it disappointed the critics. Diderot despaired: "Oh, my good friend, what a disaster! It is a theatrical decoration with all its falseness, a riot of color that one cannot believe."[52] The interventions of Diderot and Condillac had by now transformed the status of gesture from popular entertainment into a philosophical and linguistic sign. Furthermore, while Diderot remained close to the theater, he wanted to distinguish between the serious, moral theater, of which he approved, and lower classes of theatricals, such as the comedies and pantomimes, which made great use of gesture. He divorced the popular, comic gesture from the serious, philosophical sign. Van Loo's attempt to tap into the earlier popular genre of gesture was only successful when the figure of Medea was engraved—the resulting print sold heavily. It took the peculiar genius of the abbé de l'Epée to reunite the popular and philosophical conceptions of gesture in a way that would again be of importance to artists.

In his *Letter on the Deaf* (1755), Diderot commented widely on linguistic theory, poetry, painting, and, almost incidentally, the deaf. Six years previously, Diderot had engaged in a similar commentary on the blind, which led him to argue that our intellectual faculties are directly related to our sensory capacities: "All our virtues depend on our manner of sensing, and the degree to which things affect us! . . . Ah! Madame, how the morality of the blind is different from our own. How that of the

deaf would differ again from that of the blind and how a being which had one sense more than us would find our morality imperfect, not to say anything worse."[53] In pursuit of this relative morality, Diderot now conversed with a prelingually deaf friend to test his theories on the origins of language and also asked hearing people to translate their ideas into signs. He believed that there were various stages in the evolution of language and that the gestural sign was a "natural language." Describing his experiment, Diderot wrote: "One could almost substitute the gestures with their equivalents in words; I say almost. because there are sublime gestures which all the eloquence of oratory will never capture."[54] Like Coypel, Diderot identified qualities in deaf sign language that could not be matched by the orators and, in his Salons, he highlighted Greuze's use of gesture as an example of this sublimity. Following Locke's notion that the idea preceded the sign, he found this language so convincingly natural that, when looking at paintings, he would pretend to be deaf watching other deaf people conversing about a subject known to them. If the scene was convincing looked at in this manner, he judged it to be successful.[55] This naturalness of the sign was of inestimable use to the artist who was trying to show the thing itself, unlike the poet and the musician who created "hieroglyphs."[56] Similarly, when visiting the theater, Diderot would ascend to the gallery, and stop up his ears "in order to understand [*entendre*] better." By playing with the double meaning of the word *entendre,* which could mean both to hear and to understand, Diderot detached intelligent comprehension from the sense of hearing.[57] His notion of the sublimity of gesture certainly matched Academic practice. In the formulaic textbook by Dandré-Bardon, who taught Vincent and David at the Academy, the previous lengthy discussions on gesture were part of the standard Academic repertoire: "One gesture alone . . . can be sublime. Such is the gesture that Poussin gave to Eudamias' doctor in that painting where this Philosopher left his testament."[58] Like Diderot's philosophy, this pedagogy was prepared to use one system of visual language, deaf signs, to reinforce its artistic practice without feeling the need to distinguish or hierarchize among them.

Just as artists, critics, and pedagogues used deafness to conceptualize painting, so too did the abbé de l'Epée think of art as a means of instructing the deaf (fig. 4). Charles-Michel de l'Epée had a rather unsuccessful career, first as a Jansenist priest and later as a barrister, until, in his fifties, he had a much mythologized encounter with two deaf sisters in a poor district of Paris. Epée observed the women signing and realized that they were in fact conversing, providing him with an unsuspected opportunity

4. L. Boutelou, *Portrait of the Abbé de l'Epée* (Paris, INJS)

to save their souls for the Church. For the Catholic Church, no Cartesian institution, continued to think of the deaf as automata, that is, living machines which by definition did not have souls. Epée's virtually mythical status as the founder of deaf education has obscured the peculiarity of his moment of recognition. As we have seen, learned scholars and artists had been aware of sign language since Antiquity, and yet Epée seems to have been the first to consider using that sign language as a means of instructing the deaf, rather than writing a manual alphabet for them, or attempting to teach them to speak. He may have been helped by the skeptical tenor of his Jansenism, a theology that held that God's will was unknowable. He himself considered this to be a moment in which the deaf were suddenly made visible, describing them as "men similar to us, but reduced in some ways to the condition of beasts, as long as no-one worked to free them from the gloomy shadows in which they were enslaved."[59] The decline of oral culture that accompanied the print revolution in early modern Europe was an important factor in making deaf sign

"visible" as a communicative system. The eighteenth century saw a considerable expansion in silent reading, that is to say, reading in which the reader does not speak the text out loud or move their lips as if speaking.[60] It was now possible to conceive of intelligence and literacy being silent rather than outspoken. Epée used writing to educate the deaf in a fashion that could only have been conceived in the print era, for he used metal plates to teach spelling, each bearing one letter.[51] Thus, by using the same metal plates in the construction of different words, he instilled the notion of the alphabet to students for whom sound had no meaning. The legacy of his procedure was the long-term involvement of the deaf with printing. By 1791, the deaf were sufficiently skilled compositors and proof readers that they were printing the scholarly *Journal des Savants* at the deaf school. Deaf presses continued to publish throughout the nineteenth and early twentieth centuries, and without the newspapers, pamphlets, and books they published on the deaf and deaf history, the present work would have been impossible.[52] The deaf were thus among the first citizens to be enfranchised by the age of mechanical reproduction.

Epée believed that he had found the universal language which so many had sought, albeit in a rude state requiring certain additions. But, once refined, this language "could become a meeting place for all men."[63] The universal language had been something of a philosophical obsession in the seventeenth century. Descartes mused on its possibility,[64] but Leibniz is often considered to have originated the idea of a universal language, which he described as "a rational philosophy as clear and unshakable as arithmetic."[65] He further speculated, along with the Englishman John Bulwer, that the sign language of the deaf might provide such a universal language. Oralists quickly poured scorn on this notion. Amman rhetorically asked "how tame and defective is that Speach [sic] which is performed by signs and gestures?"[66] As the philosophical debate continued, the empirical evidence of the voyages of exploration suggested that sign language might indeed have some claim to being universal.[67] The French explorer Bougainville was the first Westerner to visit Tahiti and he persuaded a local dignitary named Aotourou to travel back to France with him. On 25 April 1769, Bougainville described how Jacob-Rodrigues Péreire, an oralist educator of the deaf, "examined Aotourou attentively on several occasions and discovered that he could not pronounce most of our consonants or any or our nasal vowels."[68] On Captain Cook's first voyage to Tahiti in 1768, he noted in his *Journal* that: "We observed that when they [the native Tahitians] were conversing with each other, they joined signs to their words, which were so expressive that a stranger might easily

5. The manual alphabet devised by Bonet and adapted by Epée. From J.P. Bonet, *Reducción de las Lettras y Arte para Enseñar à Ablar los Mudos* (Madrid, 1620)

apprehend their meanings."[69] It seemed as if exploration was vindicating the partisans of sign language, for although the Tahitians signs were clear, their speech seemed limited to Western observers.

Epée himself had at last found a vocation.[70] Working with the deaf sisters, he taught himself the rudiments of their language and proceeded to attempt to teach them written French. Epée's linguistic achievement was as an educator who realized that the deaf could be taught the written language of the hearing majority. Furthermore, even though he himself acknowledged his Spanish predecessors, he was the first to teach the impoverished deaf and as such has been remembered as the originator of deaf education (fig. 5).[71] It was no coincidence that in turning from educating deaf aristocrats, who had often been taught orally, to the deaf poor, Epée used sign language as proper to the "natural" mass of the poor.

Furthermore, Epée made the tradition of deaf characters and sign language in the theater the very subject of his performance, blended with salon culture and scientific display. Epée opened his house on Tuesday

and Friday mornings for demonstrations of his method, which were attended at various times by Marie-Antoinette and the Emperor Joseph II, and were so popular that those attending were asked to stay for no more than two hours. Epée's purpose was to demonstrate to the hearing that his pupils were capable of understanding the principles of grammar and metaphysics, which both Enlightenment philosophy and public opinion put far beyond their reach.[72] Students had to identify parts of speech from lists provided and respond in written French to Epée's questions concerning, for example, the nature of the Eucharist and other religious teachings. These proceedings were inevitably slow as Epée's signs were so cumbersome. Presumably, for the hearing audience, this provided an opportunity to discuss the event and its implications. Epée won such renown from these displays that the king awarded him a salary, which enabled him to increase the size of his school and place it on a more permanent footing. However, a royal edict donating the confiscated buildings of the Célestins in Paris to Epée on 21 November 1778 was never carried out.[73] It was the National Assembly that finally provided a state funded home for the deaf in 1791.

Epée's leap of comprehension took him beyond his philosophical mentor, Condillac, whose *Essay on Human Knowledge* investigated the origins of language. Condillac held that the first form of language was the gesture. Soon the gesture was accompanied by a sound which, in turn, came to replace the gesture altogether. Sounds were then combined to form phrases and sentences. It was thus impossible for a gestural language to have grammar, as it preceded the grammatical stage in the evolution of language.[74] Philosophically, therefore, sign language was understood as the common origin of language, albeit a primitive one.[75] Condillac used the case of a deaf man from Chartres, who regained his hearing at the age of twenty-three, as a material proof of his ideas. But, as he admitted, those who had observed this event did not ask the young man questions about his former life, "which we can only supplement with conjectures." This immediate reintroduction of theoretical speculation into the supposed empirical proof of his theory is typical of the supplementary logic that dominated linguistic discussion in the Enlightenment. Condillac held that as the deaf man would have been

> incapable of exactly fixing and determining the ideas which he received through his senses, he would not have been able, either by piecing them together or by breaking them down, to form notions for himself at will. Not having signs sufficiently commodious to compare his most trivial ideas, it would have been rare that he formed any judgments. It is

indeed possible that, during the first twenty-three years of his life, he did not carry out one single act of reasoning.[76]

For Condillac, gestural signs sufficed only to serve the most basic needs of the deaf but they could not educate the mind, an assertion for which he had no proof other than his conjecture. He noted: "You will ask me, are natural signs nothing? I answer that, until commerce, natural signs are not at all properly signs."[77] Deprived of "commerce" with other men, the deaf could not acquire the faculty of memory and thus could not develop the most basic function of language in Condillac's theory, the use of names to refer to absent objects. Without memory, there was no imagination and little, if any, possibility of reflection.

In announcing his work, Epée claimed that it served to "supplement the mistake of nature and to develop successively the intelligence of these Beings, who have been regarded up to now as types of semi-automatons."[78] But, just as Condillac's thesis depended on the supplementarity of his conjectures, Epée supplemented his own conjecture to his reading of Condillac. Drawing on the notion that all knowledge comes from the senses, he wondered if one might attempt "to insinuate into the spirit of the deaf by the canal of their eyes that which one cannot introduce through the opening of their ears."[79] Epée rejected any notion of a unitary body and instead believed that, like Condillac's famous statue in his *Treatise on Sensation* (1754), it could be worked on piece by piece. His evidence was artistic practice, and Epée may have derived his inspiration from one of his own students, Claude-André Deseine (1740–1823), the first significant deaf artist in France. He came from a family of artists, for his brother Louis-Pierre Deseine (d. 1822) entered the Academy as a sculptor in 1792 and another brother, Louis-Etienne, was equally successful as an architect, winning the Rome Prize in 1777. It was this latter who recommended Claude-André to Epée in 1773, while he was a student of Pajou's at the Academy.[80] Three years later, Epée observed:

> Painting is a mute art, which only speaks to the eyes, and the skill of the artist consists in knowing how to attract the gazes of spectators, fixing their attention on his work and deserving their praise. . . . Like painting, the art of methodical Signs is a silent language which only speaks to the eyes. . . . However, after this explanation, where have we got to? We are no more advanced than a Painter, who might have in his studio eyes, noses, ears, mouths, hands and feet represented on the canvas with all the force and the delicacy of his art. I went to an artist's place looking for a picture in this style made up of several figures; and I could not find even one whole figure there.[81]

Both painting and sign language were conceived as silent languages that "speak to the eyes," composed of fragments with individual meaning which nonetheless required some overall principle—beauty or grammar —in order to constitute a larger whole. Linguistic supplementary logic found its counterpart in the representation of the body. Neither the corporal nor linguistic sign could speak on its own without some unifying rational principle to generate meaning. The fragments became a whole by use of the principle of analogy, following Condillac: "Nature, which starts everything, starts the language of articulated sounds, just as it has begun the language of action; and analogy, which completes languages, forms them correctly, if it continues as nature has begun."[82] In a curious reversal, the artist who had sought to understand his work by analogy with deaf sign language was now used by Epée as an analogy for the completion of natural sign language. Condillac knew that on the transition between the natural and the arbitrary sign "my work is not at all clear"[83] and Epée attempted to conceive of this transition in terms of artistic practice, just as Condillac had envisaged original man as a deaf, blind artwork—the statue. Through this analogy, Epée could theorize a language, constructed from gestural signs, being capable of educating the deaf. So he perceived the sisters' gestures as signs with semantic content rather than as a purely physical manifestation of need. Thus, ancien régime semiotics, which might appear to be trapped in an unworkable chain of similitudes, was in fact remarkably productive, particularly in the analogous consideration of the origins of painting and writing.

This notion of the supplement in eighteenth-century linguistics has been incisively analyzed by Jacques Derrida who argues that the supplement completes something, but in so doing it reveals that it was not previously whole. The logic of the supplement thus cuts both ways: "The supplement supplements. It adds only to replace. It intervenes or insinuates itself *in-the place-of;* if it fills, it is as if one fills a void. If it represents and makes an image, it is by the anterior default of a presence. Compensatory and vicarious, the supplement is an adjunct, a subaltern instance which *takes-(the)-place.*"[84] Thus a supplement, which is exterior to the sign, reveals the lack of plenitude in the sign by the necessity of its addition. If the sign is truly complete, it would not have any need of the supplement. Christopher Norris has made a useful comparison of this idea with the Oxford English Dictionary and its regular Supplements. The Dictionary, which one presumes complete when issued, is in fact completed by the publication of the supplement. These volumes then call into question not only the status of the original dictionary but their own importance as additions. This complicated relationship between

what is proper to a thing and what is not is, Derrida suggests, ultimately irresolvable.

Both sign language and painting in the eighteenth century were systems of signification that operated by the combination of fragmentary signs into a whole by the supplementary addition of an exterior logic, whether that be grammar in the case of sign language or beauty in the case of art. Epée thus constructed a series of supplementary signs to complete the imperfect state of what he took to be natural sign language. Epée's teaching concentrated on the unifying principles of grammar, which he assumed to be naturally assimilated through speech alone.[85] These methodical signs as he called them stood for grammatical constructions which, in accompaniment with the natural French sign language vocabulary, were held to replicate the processes of speech. Epée's course moved rapidly from an introduction, to general principles of naming, to complex grammatical formulae. This was the seventh lesson given after students had grasped the idea of several nouns: "To dictate the word 'greatness,' for instance, we first make the sign for 'great,' an adjective, and then add the sign for noun, which signals that the adjective is a substantive and so modifiable by other adjectives."[86] This process became still more complicated once the verb was introduced with all its attendant questions of number, tense, and voice. In his taxonomy of deaf sign, Epée described how the same sign—a cupping of the right hand at the hairline—stood for hairstyle, the feminine gender and woman.[87] The sign itself was thus always contingent: metaphorical or metonymic, depending on context, but always polysemic—and gendered.

Epée's method was cumbersome and difficult, combining seventeenth-century technical handbooks with the philosophy of Condillac, but nonetheless it seemed to work. From the moment his school opened in 1755— by rather more than coincidence, the same year as Diderot's *Letter*—he enjoyed remarkable success, teaching his pupils how to read and write, and attracting widespread public acclaim. However, oral educators of the deaf immediately opposed his methods. In his *Elementary Course of Education for the Deaf,* the abbé Deschamps argued that "no-one will disagree that signs are natural to man; but equally no-one will regard them as more natural than speech; otherwise why would God have given it to us in preference to signs?"[88] Any argument to the contrary became in effect a condemnation of God himself, according to the traditional belief in the spirituality of the voice. Deschamps' method was not itself original, but derived from the work of the Dutch writer Amman which he translated into French. Amman himself owed much to his predecessors in England, such as Bulwer and Wallis, and they in turn to the Spanish monks Pedro

Ponce and Bonet.[89] Epée also faced competition in France from Péreire whose reputation stemmed from the speaking skills of his pupil Saboureux de Fontenay.

In fact the deaf Epée taught already knew the structures of language through sign. In his *Observations of a Deaf-Mute,* the first published work by a deaf author in France, Pierre Desloges noted that deaf people who had never been to Epée's lessons were nonetheless active and informed: "We express ourselves on all subjects with as much order, precision, and rapidity as if we enjoyed the faculty of speech and hearing. It would therefore be a gross error to regard us as types of automata destined to vegetate in the world."[90] Desloges compared sign language to a foreign language from the point of view of a French speaker. Epée's tuition thus introduced native signers to French in their own language, just as any other language teacher would, using what he termed the "natural language of signs" to overcome difficulties in the system. Desloges claimed that he was moved to publish in response to hostile oralist criticism of Epée's method, which elicited further essays by Deschamps and Saboureux. Both were skeptical of Desloges' claim to belong to a deaf community that was independent of Epee's teaching. Saboureux, reclaiming the honor of being the first published deaf author, noted acidly: "I recognize here the imprint of the genius of the Abbé de l'Epée," while Deschamps seemed to suggest that Desloges was actually Epée in disguise.[91] Indeed, there are three authorial "voices" present in Desloges' text. One is indeed that of Epée, for long passages are highly derivative from his work. Another is that of the anonymous editor who produced the edition and claimed to have met Desloges at Epée's house, but insisted that Desloges was not a pupil of the abbé. Thirdly, however, there is the voice of Desloges himself, whose experience is distinct from the other two, and belongs to the Parisian deaf community. He describes how deaf artisans named a person unknown to them: "Firstly, we designate the sex of the person, this sign must always go first; then we make the sign relative to the general class in which birth and fortune have placed this person: then we designate them individually by signs taken from their job, their profession, their residence, etc. This operation calls for no more time than it must take, I suppose, to pronounce M. de Lorme, cloth merchant, rue St Denis."[92] In this passage, the everyday experience of the Parisian deaf community can be perceived, despite its being rendered in the language of the philosophes. Indeed, the text thereupon reverts to Epée's "voice" and describes three kinds of sign—ordinary, reflexive, and analytic—referring to the work of Court de Gebellin and Condillac.

For it is clear that a functioning deaf community did exist in France

prior to Epee's work, as the comments of Montaigne, de Piles, and the Coypels would suggest. Seventeenth-century court records indicate that one Tillet de Saint-Leon was both deaf and literate.[93] Etienne de Fay (d. c. 1750) not only organized a school for the deaf in Amiens but was also a sculptor and a sufficiently skilled architect that, when the abbey in which he lived was destroyed by fire, he was entrusted with its redesign.[94] During his twenty-five years as bursar for this Couvent des Prémontrés, de Fay's school for deaf children acquired sufficient fame that it was visited by the duc de Chaulnes. De Fay and his sister were examined in 1733 by Lamarck from the Academy of Sciences. Among his pupils was one Azy d'Etavigny who later acquired fame as the pupil of the oralist Péreire. In his report to the Academy of Belles-Lettres in Caen on Péreire and his pupil, Père Cazeaux remarked that d'Etavigny's father had placed him in the school "so that he might be taught with the four or five other deaf pupils there who were in the care of an old deaf man, very skilled at explaining himself by signs."[95] De Fay's teaching provides at least one alternative source for the formation of the deaf community in France as well as evidence of its existence, for someone must have educated de Fay and Saint-Leon. This community evidently centered on Paris, described by Desloges as the most appropriate place to learn sign language, because "[i]n such a theater, our ideas develop and extend, through those ceaseless occasions that we have to see and observe new and interesting objects."[96]

SIGN AT THE SALON

Epée's interaction of sign language, the deaf, and the visual arts found an immediate audience at the Salon. The Salon exhibitions held by the Academy of Painting were the subject of an increasingly diverse and critical pamphlet literature.[97] One anonymous critique of the Salon of 1779, entitled *The Miracle of Our Times,* purported to be written by a deaf pupil of Epée's. The narrator told how he had been living wild in the woods until his capture brought him to the attention of Lenoir, chief of Parisian police, who had entrusted the wild boy to Epée. The story seems to anticipate the Wild Boy of Aveyron's capture in 1799 but was probably based on the highly publicized discovery of an abandoned deaf child in Picardy in 1773. Epée claimed that the boy had told him in sign language that he was in fact a dispossessed nobleman. The courts had upheld his claim, reinstating him as the Comte de Solar from Toulouse in 1776 in a blaze of publicity (see Chapter Two). However, in this (presumably) fictional case,

the deaf child becomes not a noble but an art critic as soon as he learns sign language:

> Soon, from the hands of this most useful mentor,
> For whom it is easy to make a prodigy out of any of my equals,
> I began to see the shining plan of my unknown being;
> I learnt to distinguish vice and virtue . . .
> I no longer regret the happy gift of speech:
> I have surveyed the important and frivolous arts.[98]

In a footnote, the "editor" of this text remarked that such developments were certainly possible, thanks to the "new and singular instruction" of the abbé de l'Epée, thereby both justifying the existence of his "text" and claiming the latest device for his pamphlet. At first, the deaf narrator reports the dialogue of the Marquis de Saint-Cyr and Cléophile, a beautiful woman, which he lip-reads in the entrance to the Salon. Tiring of this work, he enters the Salon himself and describes the exhibition from the point of view of a partisan of History painting. He praises the government for "the noble ambition . . . of reviving the grand genre, which has been neglected for several years," but is not above adverse criticism, admonishing Vien for example: "One regrets that he has allowed his hand to get ahead of his thoughts." The French school in general was criticized for its lack of knowledge of poetry, philosophy, and history. Such comments were typical of the Salon criticism of the period but they were remarkable when presented as the written observations of a deaf critic, who was unafraid to engage with the most elevated cultural issues of the day. No doubt the author was deploying a variant of the noble savage theme, in which the natural wisdom of the "primitive" mocked the vanity of decadent Parisian society. But the "deaf" critic made no special pleading for his point of view, and used such devices as describing sculpture in prose and painting in verse, recalling the traditional connection between poetry and painting.

Such analogies between art, gesture or sign language, and philosophy became increasingly common in the eighteenth century. Epée described sign language as writing in the air, making apparent the contingency of both spoken and written signs.[99] For Condillac, by extension, "it was most likely by the necessity of thus tracing our thoughts to which painting owes its origin, and that necessity has without doubt contributed to the preservation of the language of action, as that which can be painted most easily."[100] In his *Essay on the Origins of Language*, Jean-Jacques Rousseau reflected on the myth of Dibutade, whose tracing of her lover on the eve

of his departure was held to have been the origin of painting and was often depicted at the Salon: "Love, it is said, was the inventor of drawing. It might also have invented speech, although less happily. Not being well pleased with it, it disdains it; it has livelier ways of expressing itself. How could she say things to her beloved, who traced his shadow with such pleasure! What sounds might she use to work such magic? . . . This leads me to think that if the only needs we ever experienced were physical, we should most likely never have been able to speak; we would fully express our meanings by the language of gesture alone."[101] The mythical female gesture has changed from the knife thrust of Medea to the pencil tracing of Dibutade, and in the process becomes a creative, though limited, activity. We might note that the male object of her affections remains as reposed as Coypel's heros had been. Dibutade stands between physical language and the language of the passions, between gesture and speech, between nature and culture. She is on the point of inscribing that small difference that will become known as the origin of painting but, in the terms of the legend, she is unaware of this in her state of nature. It took her father, or his descendant the artist, to supplement her trace and fix her movement into culture. "Conventional language is characteristic of man alone," noted Rousseau.[102]

The Dibutade theme was also connected to the deaf. In 1781, the artist Lesuire published a Salon critique, *The Deaf Woman Speaks at the Salon,* in the carnivalesque style favored by many popular critics, which he presented as a dialogue with an imaginary deaf woman, named Mutine.[103] Her name connotes silence, slyness, and insubordination: Otherness. Lesuire described how: "she was condemned by nature to a perpetual silence, which, however she sometimes interrupted for a moment. As soon as something struck her she spoke at once; she expressed the sentiments which affected her, and returned to silence once her emotion had passed."[104] The male critic used the doubly "natural" figure of the deaf woman as his mediator to the realm of culture: "her face seemed in some way more transparent than the others and allowed one to see almost openly her *ingénue* soul." She speaks as a symptomatic response to culture but is unable to sustain what is, for her, the hysterical condition of speech—whereas the speaking woman became mute in a hysterical attack. For the sign-as-symptom indicates both repression and the process of transition from one system in the psychical apparatus to another, that is, from the natural as feminine to the cultural as masculine.[105]

Lesuire presented her comments as the spontaneous inspiration for his more learned critique. Mutine says of David: "One could say of him as of

Caesar, veni, vidi, vici; I came, I saw, I succeeded—because *I conquered* would be too strong." Lesuire then presented more reflective comments in his own voice. For the symptom-bearer cannot diagnose herself. The female body is both a sign and the site of the sign, conceived as an alien presence, comparable to a virus or hysteria. Her naiveté is further used to expose the pretensions of the Academy. Looking at Houdon's statue of Gerbier, "Mutine asked me for what crime he was so rigorously nude." As she leaves the exhibition Mutine finally speaks at length. She declares: "I want to imitate the brilliant efforts of the arts. A new Dibutade, I will force the stone to show the traits of those people who are dear to me; I will make them breathe on the canvas. . . . Flowers will be born under my brush to crown the mortal darling who will possess my heart. Let's hurry to fulfill such a delicious project." Mutine was inspired by Dibutade, but, once away from the paintings, she relapses into silence and signs to her male companion that he should write down her ideas. In this way, she was similar to Dibutade herself, whose original drawing was made in a state of anxiety, but which was only later preserved by her father. Creativity, genius, and art were held to be beyond the grasp of the deaf woman in 1781. Intriguingly, one Mlle Guéret did in fact exhibit a painting under the title *A Modern Dibutade* at the Salon of 1793.[106] Mutine's problematizing of imitation and creativity were to be central to the dilemmas of deaf artists in the nineteenth century. Furthermore, we should notice that Mutine can sign when she cannot paint or speak, significantly equating painting with speech in keeping with the Ancient tradition revived by the Neo-Classicists. Epee's "discovery" of sign language was perhaps the living example of these mythological origins. His assimilation of the deaf sisters' sign language brought him fame and access to the highest levels of society but we do not even know the women's names.

SIGNS OF REVOLUTION

When the Academy of Painting and Sculpture opened its annual exhibition in the Louvre in 1789, the Bastille had already fallen. Art historians have often looked to this Salon for visual parallels with the social upheaval spreading across France outside, focusing most attention on Jacques-Louis David's entry, the quickly canonized *Brutus*.[107] This mighty canvas, depicting the virtue of the Roman consul Brutus in sacrificing his children to the common good of the Republic, has been interpreted in the light of prevailing intellectual fashion ever since 1789, for even as intrepid Pari-

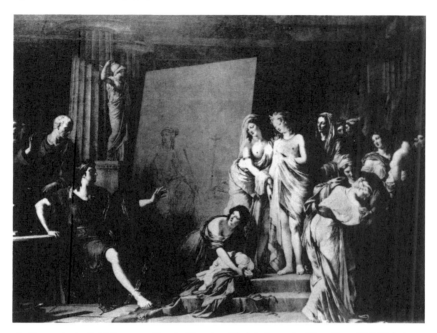

6. François-André Vincent, *Zeuxis Choosing Models from the Most Beautiful Girls in the Town of Crotona* (Paris, Musée du Louvre, 1789)

sians sold fragments of the Bastille to souvenir hunters, the myth of the Revolution was being constructed. However, the Salon of 1789 was more representative of ancien régime culture than a signpost to the future. If we detach our gaze from the fetishized *Brutus,* this culture in crisis was best exemplified in François-André Vincent's painting *Zeuxis Choosing Models from the Most Beautiful Girls in the Town of Crotona* (fig. 6), also exhibited at the Salon of 1789. Since the Salon of 1783, Vincent, one of the founders of Neo-Classicism, had been regarded as one of the outstanding artists of the day.[108] He depicted the fabled Greek artist according to Pliny's account of his painting of Helen of Troy. Zeuxis composed his figure from the most beautiful fragments of women's bodies that he could discover in the town of Crotona, being unable to find one woman beautiful enough to be the model. Vincent had selected a traditional Academic theme in making his bid for ascendancy of the French school. As early as 1671, Félibien, an early Academic theorist, had compared Zeuxis' necessary labors to achieve "the perfect model of Beauty," with the good fortune of the seventeenth-century artist, who could find perfection in the sole person of Louis XIV.[109] In returning to this mythic archetype of the

artist, Vincent sought to emphasize that the new school of French painting was decisively marked by its inheritance from the golden age of the seventeenth century, and was the logical conclusion of the return to the Classical principles of Poussin. Vincent had already invoked the spirit of the seventeenth century in his *President Molé and the Insurgents* of 1779 (Paris, Chamber of Deputies). Similar historical parallels were often drawn by the reform movement in the Academy, until its abolition in 1793.[110] One woman at the front of the composition wears a red Phrygian bonnet, above white and blue garments, forming a noticeable tricolore in the middle of the painting. His *Zeuxis* therefore seems an appropriate means to examine the visual system of the ancien régime in this moment of crisis.

Among mixed reviews, Vincent's composition was praised for its brilliance by the *Mercure*, which deserves further consideration. The sole male figure of the artist is balanced by, and contrasted with, the group of women. The point of their interaction is across the scene of painting itself, the blank canvas on which Zeuxis has been drawing. Vincent highlights gender difference as a state of being different. The drawing of the body is here presented, not as a straightforward opposition of male and female, but as the interaction between one male artist and many women. The body was an assembly of fragments, drawn from many different sources, in the absence of a perfect model, such as Louis XIV.[111] Such multiple constructions of the body had impeccable Antique credentials. In the *Symposium*, Plato mused on the origin of the sexual drives and theorized that "in the first place the sexes were originally three in number, not as they are now; there was man, woman and the union of the two." These doubled beings were divided in half by Zeus. Ever since then, "the two parts of man, each desiring his other half, came together, threw their arms about one another, eager to grow into one."[112] The fragmented parts of Vincent's composition were thus driven together by an urge for unity and were linked by the spectator's gaze, called and held by Zeuxis' outward look. On the canvas, only the outline of Helen's figure has been drawn in. Zeuxis has taken the stylus from Dibutade and, with it, the right to control the sign, even at its origin. The seemingly empty space between Zeuxis and his models is the point where the sign exchanges its natural physical status for the artificial or composed, making it possible for critics to praise the composition of this apparently disjointed work. But now the sign has become gendered so that it requires a male prototype to create the composed, civilized, intellectual sign from the natural, simple female. One woman was not enough to construct the plenitude of Rousseau's

"conventional language," for the figure of woman is equivalent to the simple sign. Like the natural signs of the deaf, women had to be combined and composed in order to signify.

This myth of Zeuxis creating beauty from fragments represented corporal reason at the outbreak of the Revolution. Neo-Classicism announced a movement in the late eighteenth century towards reading cultural products as masculine reifications of the intuitive feminine leap across the divide between nature and culture, incarnated in the fleeting gesture or moment of speech. The single, masculine realm of culture was formed from the broad, natural mass of the feminine. Vincent depicts the body not as an immaculate whole, but as an assembly of fragmentary signs constructed by the artist. Just as it was for Epée, the body was at once a sign, an assembly of fragmentary signs and a place of signification.[113] In an awareness that signs can never be natural but must always and already be reproductions, the masculine drive of Neo-Classicism reclaimed the scene of representation, resulting in a curious overlapping of the discourse of Ancients and Moderns.[114] Neo-Classicism was, by its nature, a return to Ancient principles and subject matter. Its major concerns were the depiction of scenes from Antiquity which taught clear and ascetic moral lessons and this revival of the *grand genre* that had been hailed in the Salon criticism, including those pamphlets using signing deaf characters. Yet in so doing, it retained many of the theoretical principles and compositional practices of the Moderns who had dominated the Academy for so long. Vincent's assemblage of fragmentary signs into a composed whole was consistent with Enlightenment thought on the sign, as exemplified by Condillac and Epée. Neo-Classicism did not seek to innovate but to reproduce, which is not to say copy. Such a process of reconstitution is inevitably supplementary. Like the sign with which it was so often linked, the painting depends on the double-edged supplement: "The supplement, which seems to be added as a plenitude to a plenitude, is equally that which compensates for a lack."[115] These terms insistently recall the construction of gender, Vincent's explicit theme in the *Zeuxis*. His composition retained the passivity of the male figure initiated by the Coypels, in the seated Zeuxis whose receptivity of the sign is proposed as a natural attribute of his masculinity. This supplementary masculinity is thus also uncertain, calling to mind either the fullness of masculinity—as Vincent perhaps intended—or its incompleteness. The Neo-Classicists discovered that implementing a fusion of Modern theory with Ancient subject matter was less than straightforward. In taking over the transmission and reception of the sign, both revolutionaries and artists would soon come to look for help, which was provided by the paternalist republic.

In July 1791 the Jacobin Prieur de la Marne proposed to the National Assembly that Epée's school for the deaf should now be administered by the government. In a speech which neatly encapsulated the results of over a hundred years thought on the sign, Prieur declared:

> What is more, the deaf have a language of signs which can be considered as one of the most fortunate discoveries of the human spirit. It perfectly replaces, and with the greatest rapidity, the organ of speech. . . . It does not consist solely of cold signs and those of pure convention; it paints the most secret affections of the soul which, by the play of the organs, and particularly that of the eyes, are much mixed into its elements.
>
> If one were ever to realize the much desired project of a universal language, this would perhaps be that which would merit preference; at the least, it is the most ancient of all.[116]

Prieur appreciated that gestural sign was, as Condillac had said, the first language, but that, as Epee maintained, its natural signs had required the addition of conventional ones to make it a fully operative language. Sign language was not the original language, whose pursuit had been abandoned, but was the most ancient of all. He appreciated that its uniquely visual quality made it a variety of painting, which helped give it the possibility of becoming a universal language. It was therefore appropriate that, in appointing a professor of painting for the new institution, he should choose none other than Vincent. One month later, clearly believing that his *Zeuxis* had considerable, even revolutionary, significance, Vincent exhibited it again at the Salon of 1791.

2 SIGNS AND CITIZENS

The creation of the Institute for the Deaf in Paris transformed the deaf community and the possibilities open to its members. A new social category came into being in France—deafness. As with any culturally constructed mode of difference, deafness proved difficult to define and to control. The interaction of race, gender, and pathology involved in the definition of deafness was only intelligible visually. Thus while doctors sought a visible symptom of deafness, anthropologists considered sign language to be a useful resource in making contact with the native peoples of Africa and Australia, and artists saw communication between the deaf and the hearing as a powerful image for the dilemmas of the new French society created by the Revolution and Empire. The relationship between sign language and the visual arts had been primarily metaphorical under the ancien régime. Now it came to have a specific meaning, as hearing artists studied the education of the deaf, and deaf students undertook the study of art. It was above all in the elite corps of David's studio that Neo-Classical artists explored the possibilities of this seemingly universal, visual sign language in attempting to communicate with the new Republican and Imperial citizen. Much attention has been paid to Géricault's portraits of the mad in Bicêtre, but the works of Langlois, Ponce-Camus, and Cochereau concerning the deaf anticipate his work by as much as twenty years. The transformation wrought by the Institute for the Deaf seemed to offer a way past the new division between the normal citizen and the pathological Other.

This achievement was a specific creation of the Revolution. The abbé de l'Epée was by no means the first educator of the deaf, even if he was the first hearing instructor to make systematic use of sign language. Without the intervention of the National Assembly and later the Convention, his achievements might have had little or no long-term consequences for the wider deaf community, as had been the case for Bonet in Spain, Wallis in England, or Amman in Holland.[1] The revolutionary governments incorporated the deaf in a wide-ranging program of social regeneration which

had both utilitarian and philanthropic goals. In the ensuing period of experimentation and adaptation, the deaf themselves were able to create a space for the development of their language and culture that was not possible within more established disciplinary institutions, such as the school and the prison. That culture is the focus of the next chapter. In what follows, I explore in some detail the particular and specific set of artistic, discursive, and political currents in the revolution, which made that culture both possible and necessary, before turning to a consideration of the visual representations of the deaf created in David's studio.

REGENERATION AND THE DEAF

Revolutionary discourse envisaged so complete a transformation of society that it entailed a biological evolution in the French people. In Mona Ozouf's analysis: "It was a new race that was about to be born, energetic and frugal." Regeneration quickly became a watchword for revolutionary practice.[2] The history of the deaf in the period can be seen as a case study of this discursive practice, which was figured as a corporal transformation. In the later years of the ancien régime, the physical degeneracy of the aristocracy, exemplified in their sexual deviations, had been a staple of the underground press.[3] By contrast to such immorality, radical pamphlets declared as early as February 1789 that: "The least moral revolution entails a physical transformation." Both the popular press and political elite ushered in by the Revolution saw a direct parallel between the reform of the body politic and the health of the physical body of the French citizen. Mirabeau told the Assembly that: "You breathed on remains that seemed inanimate. Suddenly a constitution was organized, and already it is giving off an active force. The cadaver that has been touched by liberty has risen and received a new life."[4] This resurrected body politic required care and attention. In a pamphlet exhorting donations to the government, Cerruti described such patriotic gifts as "being for the body politic that which the veins of the human body are for the circulation of the blood; without this necessary circulation all moving faculties are without resource, everything languishes, everything dies."[5] In a doubled interaction, political action could not only heal the body, it was indispensable for the body's health. Thus, in 1791 one Dr. Faust demanded the transformation of clothing by the National Assembly in the interests of the nation's health. He condemned the restrictions placed upon the male sexual organs by *culottes* as liable to engender their precocious development and incomplete maturity,

which held the traumatic prospect of increased onanism and depopulation. For Faust, however, echoing Juvenal's precept, "a true and natural equality" would ensure "a healthy soul in a healthy body."[6] This focus on the body was seen as one of the specificities of the French Revolution, for, as Condorcet put it, "unlike the American Revolution, the French Revolution must be a refounding of the body politic and of the social body."[7] In undertaking this universal commitment, no group was to be excluded. The initial Revolutionary commitment to the deaf was, then, entirely consistent with the broader goal of the regeneration of France. By healing the deaf and restoring them to society, the revolutionaries sought to complete their wider agenda in which individual physical regeneration would lead to the social regeneration of the body politic. Laurent Clerc, the deaf intellectual who introduced Sicard's method to the United States, placed Sicard and Epée's work within this context: "The unfortunate creatures entrusted to their *regenerating* care are passing from the class of brutes into that of man."[8]

At the deathbed of the abbé de l'Epée a delegation from the National Assembly, led by Archbishop Champion de Cicé of Bordeaux, had declared: "Die in peace: the fatherland (*patrie*) will adopt your children." This was a truly radical proposal. The king had previously promised a building, but the National Assembly placed itself in the role of father to the deaf, intending to regenerate their prospects and conditions. Although many similarities can be drawn with other medical, educational, and emancipatory reforms, one crucial difference is of greater importance. Whereas Pinel sought to end the "Great Confinement" of the insane, and Bichat revolutionized medicine, entailing the birth of the clinic, and even Valentin Haüy had the example of the Quinze-Vingts hospital for his Institute for the Blind, there was no precedent to be followed or transformed in creating a state institution for the deaf.[9] Epée had lodged his pupils in boarding houses and assembled them for twice-weekly classes, but a full-time residential institution was a totally different proposition. Both legislators and educators were thus forced to innovate.

The politics of regeneration depended upon a new interpretation of the sensualist philosophy of the Enlightenment, which had inspired Epée. Sensualism, as Ozouf notes, "tends to consider men as above all sensitive and impressionable beings."[10] If the sensory input was changed, in this view, the resulting person would also change. But Epée had believed that the deaf were irredeemably stuck at a lower, more primitive level of humanity. Roch-Ambroise Sicard (1742–1822), the successor to Epée at the

deaf school, drew his own more radical conclusions, seeing the deaf person as:

> a sort of walking machine, whose organization is inferior to that of animals. . . . What kind of sentences could a man write in a foreign language who knew only the meaning of each word without knowing its syntax, above all if he had as a native language only the language of nature, the language of the peoples of Africa, the language of the deaf and dumb. We know the sentences of the Negroes; we can judge those of the deaf and dumb, who are even closer to nature.[11]

Sicard's view of the deaf—which he later repudiated—was very much in tune with Enlightenment tropes of the natural. The natural was not a simple given but a hierarchical construct, operating between the parameters of *la belle nature* and *la nature empirique*.[12] Existing nature was found insufficient and in need of correction by reason. As Goethe argued in his work on anatomy: "The mere idea of an archetype in general implies that no particular animal can be used as our point of comparison; the particular can never serve as a pattern for the whole."[13] So too had Zeuxis, in the myth consecrated by Vincent, assembled a more beautiful nature from the constituent parts offered to him by his models. Deafness was among the accidents of nature and not part of the ideal nature, which the Enlightenment was striving to define and create. In applying Condillac's theory of supplementarity, it had been possible for the deaf to climb the linguistic ladder, as it were, away from the state of nature and to attain a degree of parity with the hearing. The Revolution now attempted to accelerate that change in its Zeuxian search for the regenerated citizen, who could play a full part in the revitalized social body. The belief in the Rights of Man engendered a practical, social program to render all citizens worthy of participation in the civic process.

Mona Ozouf has demonstrated that two notions of regeneration existed during the Revolution. One held that the Revolution had, in and of itself, inspired regeneration, leading to a sudden and dramatic change in the body. Boissy d'Anglas announced: "To rule the destinies of the world, you have only to wish for it. You are the creators of a new world—say let it be light and it will be light." In this view, regeneration was an event, more or less miraculous depending on the temper of the writer, but essentially immediate and complete. Alternatively, regeneration could be described as a process, with much still to be achieved despite initial progress. A full regeneration might require strenuous activity and even violence. In the

Year VI, Heurtaut-Lamerville recognised that the Revolution had to cross: "a space of time between what was and what exists, between servitude and liberty, the old habits expiring and the new usages and between the old superstitions and the simple morality of the republic."[14] Strikingly, Ozouf found no equivalence between such beliefs and any other political allegiance or activity. The "fit" that might be expected between a Girondin view of regeneration as completed, and a Jacobin realization of the work still to be done, was not borne out in practice.[15] Instead, confusion reigned. Radical thinkers might have believed regeneration to be an accomplished fact, while moderates called for drastic action. Although many may have felt the chances for radical transformation diminished after Thermidor, in this case at least, the field belonged not to the Terror and its opponents, but to that movement that led one Directory official to wish "to place the air that we breathe under surveillance."[16] The discourse of regeneration was not transformed by political events but by the reconfiguration of its terms within the institutionalized framework of the normal and the pathological.

The revolutionaries themselves were aware of these contradictions and from 1791 to 1799, they attempted to institutionalize the distinction out of existence. Regeneration was not just a discourse of revolutionary literature but a practical program, centering on the creation of new institutions. However, it proved easier to make such undertakings than carry them out. For the body politic and the individual body were mediated by what was called the social body, constructed by and organized from a series of key institutions. Le Trosne insisted on the need for "a living body" of government: "It is essential that all the Nation, which seems today to be deprived of life and action, having only a passive kind of existence, should become animated and organized in all its sections in order to form a real social body."[17] Michel Foucault has notably analysed how the formation of the prison and other disciplinary institutions in the period shaped the social body: "What was then being formed was a policy of coercions that act upon the body, a calculated manipulation of its elements, its gestures, its behavior."[18] Within this broader framework, the Institute for the Deaf can be seen as a specific apparatus for the production of the deaf as a new category in French society, which had a legitimate claim upon the government. The medium through which the social body would act upon the individual bodies of the deaf was Epée's methodical language of signs.

Those responsible for establishing the disciplinary institutions often saw them as strictly temporary corrective measures, necessary only to deal

with the excesses inherited from the ancien régime, which would disappear before long. As Barère said in the Year II: "If we are agreed that no portion of humanity should suffer . . . let us put inscriptions above the gates of our asylums which declare that they will soon disappear. For if, when the Revolution has ended, we still have some unfortunates among us, our revolutionary labours will have been in vain."[19] In this utopian view, the Revolution was seen as a transitional process, after which all of its mechanisms would be abolished as a condition of its success.[20] A need for a temporary, reforming education was widely acknowledged, such as that offered by the Institute for the Deaf. Condorcet even envisaged the end of schools in general: "[A] time will come when every man will find in his own knowledge and in the rectitude of his own spirit sufficient weapons to dispel all the weapons of charlatanry."[21] There was another more pragmatic side to this attempt to eradicate difference through institutionalization. Prieur de la Marne did not envisage the deaf Institute as a permanent feature of the revolutionary landscape, but nor did he imagine the deaf themselves would disappear. He simply believed that, once the school was established, "the pupils themselves will be able to provide free places by means of their labor; and, consequently, the establishment can maintain itself."[22] The inevitable failure of this utopian project led to a change of direction in the early years of the nineteenth century, sometimes embittered, sometimes hostile, sometimes merely dismissive.[23]

As a case in point, the creation of the Institute for the Deaf transformed the career of the deaf sculptor Claude-André Deseine, one of Epée's earliest pupils.[24] Several other of Epée's pupils were artists, including the painter Paul Grégoire and the engraver Boutelou. In June 1782, Deseine had shown a number of works at the Hôtel de Villayer in an exhibition entitled *Correspondance générale et gratuite pour les sciences et les arts,* a minor competitor to the Academy's Salon, where he exhibited again in May 1789.[25] In 1783, he made a bust of Mme Saint-Huberty, the singer, which he sold from his house in the rue Faubourg Montmartre, together with busts of Voltaire and Rousseau.[26] It was the Revolution that gave Deseine his opportunity. Following Mirabeau's elevation to the Pantheon, he presented a bust of the orator to the National Assembly, which immediately gained him the attention he had not been able to achieve under the ancien régime (fig. 7). The *Journal de Paris* offered a sympathetic account of his presentation on 14 May 1791:

We do not live in times when the deaf might hear and the mutes might speak, but marvels of art, of the spirit, are taking the place of miracles.

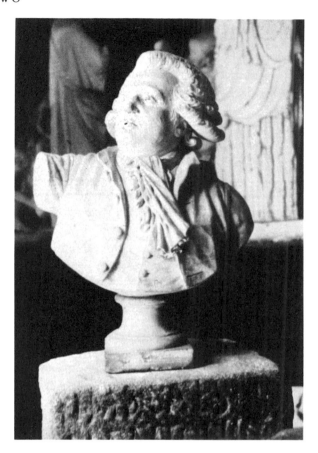

7. Claude-André Deseine, *Bust of Mirabeau* (lost)

The deaf, for whom intelligence has been created in creating for them a language, have a commerce of ideas with those who speak and hear. One of these men—whom we must not call unfortunate since in the place of a sense and an organ which they lack, they have better made and more exact ideas than the vast majority of men, for whom it is so common to understand neither anything which is said to them nor which they say themselves—a deaf mute has paid hommage to the National Assembly in the shape of a bust of M. Mirabeau.[27]

In this account, Deseine's work represented both an indication of the progress of the revolution and of its limits. The regeneration of France was not complete, and miracles had not been achieved—the deaf remained deaf, but marvels such as this sculpture were possible. In fact, the Revolution had not made Deseine's work possible but made it visible, marking a clear distinction with ancien régime practice. Epée had made sign lan-

guage "visible" to the hearing majority, and the Revolution similarly made "visible" the work of the deaf, in particular deaf artists.[28]

However, as any artist knows, it is not enough to be seen, one must also be commercially active. Again, the Assembly, and later the radical wing of the Revolution, provided Deseine not just with visibility but with work. Immediately after Prieur's bill was passed, Deseine successfully petitioned the Assembly for the right to make a full-size statue of Epée for the new institution, modelled on the bust he had made from life. According to the *Journal de Paris:* "The Assembly was touched both to see a distinguished talent in a man, who formerly would have been condemned to not even having an intelligence, and this talent being dedicated to perpetuating the image of his real creator."[29] It is as if the deaf made a bargain with the Revolution that they would consent to being described as the creation of revolutionary principles, in exchange for the rights of man. Deseine's work certainly took a more political direction. At the Salon of 1791 he showed an "Allegory of Liberty," demonstrating his affiliation to revolutionary principles. For the Salon of 1793, he showed no less than ten busts, nearly all of which had revolutionary connotations, including the busts of Voltaire and Rousseau as well as heroes of the Revolution such as Le Pelletier and, of course, the abbé de l'Epée. Although he did not attempt the *grand genre,* his "charming pieces" attracted the attention of at least one critic amongst the Salon throng.[30] One of his most remarkable works was a portrait of Madame Danton, which was modelled from her body seven days after her death (fig. 8). Danton had her body exhumed so that Deseine could make this bust, indicating that the sculptor had arrived at a measure of intimacy with the revolutionary leader.[31] Shortly afterwards, Deseine produced a striking bust of Robespierre, a testament to both his artistic and political skills (fig. 9).

Deseine never completed his projected statue of Epée, as the political transformation of the body politic and the social body continued apace, and priests of all descriptions became suspect by definition. After his bust of Mirabeau had been accepted by the Assembly, he was commissioned to make another by the Jacobin Club in December 1791. However, following Robespierre's denunciation of Mirabeau as an "intriguer" on 5 December 1792, the plaster bust was destroyed. Deseine attended a meeting of the Jacobins on 13 February 1793 to propose that he instead make a bust of Le Pelletier. Despite some opposition, this idea was adopted, both because the commission had already been made, and in order to allow Deseine the chance to reform himself: "Deseine, who has used his chisel to reproduce the traits of the most immoral of men, will purify that chisel in making the bust of Michel Pelletier," declared one speaker.[32] Deseine

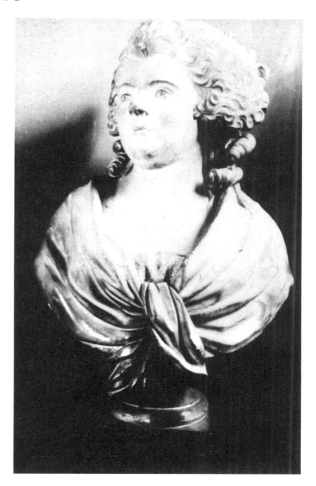

8. Claude-André
Deseine, *Bust of Mme
Danton* (lost)

quickly took advantage of the acceptability of his new work to present a
copy to the Convention on 11 April 1793. But one deputy, Comète,
objected because Le Pelletier was shown in the uniform of the *Parlements,*
which had now been abolished. Although the bust was accepted, the inci-
dent shows the difficulties for artists during periods of intense revolution-
ary change, especially in a time-consuming medium such as sculpture.

THE POLITICS OF DEAFNESS

After Epée's death in December 1789, he was succeeded by the abbé
Roch-Ambroise Sicard. Sicard was an ambitious priest and grammarian,

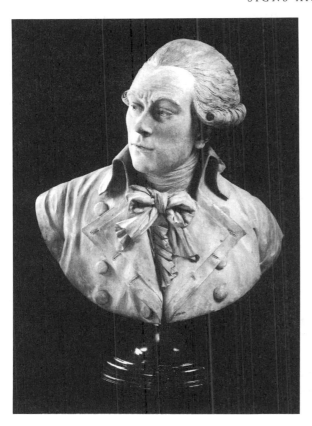

9. Claude-André Deseine, *Bust of Robespierre* (Vézelay, Musée de la Revolution Française, 1792)

who had been working with the deaf in Bordeaux, at the behest of the same Archbishop Cicé who declared the Assembly's support for the deaf. Perhaps mindful of the opportunity that awaited, Sicard had engineered a contest for the post with Epée's designated successor Sylvan. The evidence of Sicard's merit as a grammarian and a teacher was the skill of his deaf pupil Jean Massieu, whose abilities not only won Sicard his job, but ensured that the deaf remained in the public eye. Sicard's star pupils, Gaillac, Col, and Massieu himself, had all been trained by a local priest named Saint-Sernin rather than by Sicard, who nonetheless took all the credit.[33] Massieu was not Sicard's only pupil at Bordeaux, but was part of a class of thirteen other boys and three girls, including his own sisters Jeanne and Blanche.[34] Although Sicard fleetingly mentions their presence in his *Course of Instruction for a Deaf-Mute from Birth*, Jeanne and Blanche Massieu found the "mute and inglorious" fate, which Virginia Woolf predicted for Shakespeare's sister, while Jean Massieu is (rightly) still remembered.[35] Sicard nonetheless recognized that he had learned sign language

from Massieu (and his invisible sisters): "It is important to say that it was neither myself nor my illustrious master [Epée] who invented the language of the deaf. . . . [A] speaking man should not involve himself in inventing signs or in giving them abstract values."[36] Nor, it seems should deaf women.

For all Sicard's lack of trust in the capacities of the deaf, it was Jean Massieu who re-opened the question of an Institute for the Deaf by writing to the *Comité de l'Extinction de la Mendicité* of the National Assembly on 24 August 1790 that, as "the deaf are the first children of the fatherland," the long-deferred promise to entrust the former Célestins to the deaf should now be enacted. However, the political landscape had changed. The Célestins was located in the Section of the Arsenal, whose radical Committee took a keen interest in the question. On 11 October 1790, one Vernet presented the results of their investigations to the Assembly. The Section was suspicious of Sicard's succession, believing it to have been unfair. Vernet further accused him of carrying out "a plan of personal speculation" in spending 2000 livres on restoring the Célestins when 1000 would have sufficed. He called for precise estimates of the Institute's budget and number of pupils. At the Section meeting, further discontent over the budget led to more serious political debate. Speakers questioned the benefits to the Revolution of aiding the deaf Institute under Sicard, who was held to have demanded much and done little. Sicard's public demonstrations were dismissed as "a type of charlatanism," interestingly anticipating deaf critiques of Sicard in the nineteenth century. The Arsenal instead supported the Institute for the Blind, administered by the known patriot Valentin Haüy, over Sicard's proposed establishment, suggesting that the Célestins would be better used as a barracks.[37] In a spirit of compromise, Bailly proposed on 15 October 1790 that the *Comité* uphold the decision to turn the Célestins into the deaf Institute, but also give space there to the blind.

Although Sicard was a die-hard royalist, he found no difficulty in cutting his cloth to the temper of the new times. In the face of opposition from the Sections, the Institute could only succeed with radical support. By June 1791, when no progress had been made, and the butcher and baker were no longer extending credit to Sicard, he had no hesitation in approaching the radical deputy Prieur de la Marne to propose the necessary legislation in the National Assembly. Writing to the abbé Sylvan who, in a remarkable display of stoicism had become Sicard's deputy, he observed: "It is M. Prieur, my dear abbé, who must make the report on our institution to the National Assembly."[38] Three days later, on 29 June

1791, Sicard supplied a plan of classes and a budget to Prieur, as the Sections had demanded. From the outset, Prieur conceived the Institute within the regenerative framework of a network of relief agencies, seen not as permanent features of the social environment, but as temporary corrections to the deviations produced within the body politic by the ancien régime. These new institutions were thus theorized as containing the seeds of their own eventual transformation and abolition. In Prieur de la Marne's initial *General Plan for a School of the Deaf and Dumb*, he described how: "this establishment ought to be at once a hospice, a college and a school."[39] On 21 July 1791, Prieur proposed to the National Assembly that Epée's school for the deaf should now be administered by the government. Prieur indicated that he believed the government should make use of "the utility which one can extract from these men deprived of their two most precious organs."[40] Initially, the school would mostly cater to the offspring of "well to do families," but the "paternal nation" must ensure that it did not become part of "the patrimony of the rich" by providing a number of free places in the short term, before the school generated its own income. To this end, an exceptional budget of 22,000 livres was proposed, reverting to 12,000 after the first year.[41] Numerous workshops were created at the school so that the pupils could pay their way, in printing, painting, drawing, sculpture, and engraving. As well as Vincent's painting class, Pajou offered sculpture, Bervick engraving, and Madame Labille-Guiard directed the women students in embroidery and tapestry.[42] But, like Prieur, their notion of both the visual and gestural sign was still that of the Enlightenment. As one writer declared in the revolutionary press: "All the liberal arts are properly speaking no more than languages, more perfected, more pure, less subject to the propagation of errors than these languages of convention we make use of in society."[43] This was language as conceived by Locke, Condillac, and Rousseau. State involvement had institutionalized the deaf as a category of the social body, rather than initiating any significant transformation in the reception of the sign.

On 3 July 1793, the Section of the Arsenal presented an extensive dossier to the Convention (established in place of the National Assembly after the fall of the monarchy in August 1792) detailing the merits of the blind over the deaf, and, in particular, demanding equal pay for the educators of the blind with those of the deaf.[44] Since the creation of the Institute for the Blind on 28 September 1791, the two groups had been in an uneasy co-habitation at the Célestins. The Section led a group of blind pupils into the Convention, where they sang the Marseillaise and the *Ça*

ira as a demonstration of their patriotism.[45] When this petition met with no response, the youth of the Section demonstrated at the Convention in favor of the blind teachers on 9 Frimaire Year II (29 November 1793). A few days later, Sicard found himself under arrest and investigation by the Committee of Public Safety itself. His deaf pupils organized a petition to the Convention, dated 14 Frimaire, lamenting their fate: "Condemned by nature to the saddest vegetation, ranked by her among the class of the brutes, one of those geniuses with whom she is so miserly has come to cheat her and transform us into men; he has recently been taken from us under the pretence that he is a counter-revolutionary but it is he who has taught us to cherish liberty, it is he who has made us realize all that we owe to the Republican government." The first signatory to the letter was a woman named Le Sueur and, in fact, twelve deaf women signed and only five men.[46] The role of these women has been consistently underplayed in deaf history in favor of such men as Massieu, Laurent Clerc, and Ferdinand Berthier. Yet it was a deaf woman who felt able to challenge the power of the Committee of Public Safety at the height of the Terror, an act that could have had dangerous consequences (fig. 10). On 19 ventôse an II (5 March 1794), the *Comité des Secours Publiques* transformed Sicard's prospects of surviving the Terror by transferring the Institute for the Deaf to the former convent of Saint-Magloire on the rue Saint-Jacques, still its location today, specifically because it was out of the jurisdiction of the Arsenal section. Sicard only survived the radical phase of the Revolution thanks to the politics and credibility of his students, whom he regarded as savages.[47]

In 1793, the *Comité des Secours Publiques* realized that, in establishing the Institute for the Deaf, the government had undertaken the care of a group about which very little was known and decided to rectify the situation. On 30 July 1793, they sent a letter signed by Saint-Martin, Roger Ducos, Plaichard, and Enjubault to each department:

> The Committee . . . wishes to know the number and age of deaf-mutes from birth of each sex who are actually present in your *arrondissement:* this information is all the more necessary since the success of the abbé Delepée [sic] in this area might engage the Committee in opening throughout the Republic a number of suitable institutions to receive and instruct those of these unfortunates . . . who would be susceptible to instruction, by which means they will be returned to society and can become useful and happy citizens.[48]

The production of "useful and happy citizens" can be taken to be the goal, not just of deaf education, but of the politics of regeneration itself. This

10. Léopold Loustau,
*The Devotion of
Mademoiselle Cazottes,
2 Septembre 1792 at
the Abbey of Saint
Germain* (Paris, INJS)

inquiry marked a significant change in approach to the deaf. Prieur had estimated that there were about four thousand deaf people in France, an underestimate of at least five hundred percent.[49] The Jacobin committee may have been more aware of the scale of the problem, but they had significantly changed the government's commitment from a paternalist embrace of all deaf people to a meritocratic selection of those most likely to profit. Abandoning Prieur's belief that rich deaf children would finance the majority of the school's operations, they were concerned with identifying deaf children between the ages of nine and sixteen without financial support.[50]

Before the results of the inquiry were known, the Directory passed new legislation concerning the deaf, which sparked a final challenge to the Institute's existence after Thermidor. In the *Comité des Secours Publique*, Nicolas Raffron (1723–1801) argued that the deaf had no need of such a

school, in terms similar to those used by Desloges: "They have a language of their own. . . . Those whom I knew already understood their grammar of signs very well, even though the abbé de l'Epée had not yet even opened his school." Raffron was a former Montagnard and regicide, who had changed sides after Thermidor, and led the interrogation of the painter David. In what was one of his final political acts before his retirement in 1797, Raffron had revived the radical position on the deaf, which combined an unworried acceptance of sign language with a skepticism about clerical, hearing instructors of the deaf. He demanded nothing less than the abolition of the Institutes for the Deaf in Bordeaux and Paris.[51] Perier, one of Sicard's deputies, met this attack directly with a twenty page printed pamphlet defending the Institute. He adamantly insisted on the need for an Institute: "The Deaf-Mute is a savage, always close to ferocity and always on the point of becoming a monster."[52] Perier situated the deaf, not in the ideal state of nature sought by the Enlightenment, but in existing "savage" nature, as found in Africa. He stressed analogies with the recent decree abolishing slavery and argued that, if the Institute continued to be funded, "the deaf will be restored to civilization, just as the men of color are about to be restored to their rights."[53] This distinction between the deaf as savage nature, and the hearing as refined culture, was to dominate nineteenth-century thinking on the subject. There is a certain irony that a doctrine that would cause so much harm to the deaf was first coined to save the jobs of hearing professors.

Perier's arguments were successful and the Convention passed a law ensuring the continued survival and funding of the Institute for the Deaf on 16 Nivôse an III (5 January 1795). It provided for sixty free places at the Paris establishment for deaf children without means of financial support between the ages of nine and sixteen. Another 60 deaf children were to be educated at the state's expense in Bordeaux.[54] The report for the joint Committees of Public Instruction, Finances and Public Assistance was scathing about the 24 places established by the Constituent Assembly in 1791: "as if the number of these unfortunates was equal to the number of places established." They believed that the 120 places now on offer would adequately cater for "just about all the deaf poor, who are capable of receiving instruction." The report made it clear that no special privileges were being offered to the deaf, but simply their right to "reading, writing, the rights of man and a trade."[55] As Roger-Ducos of the *Comité de l'Instruction Publique* argued: "All children belong to the fatherland, which must make use of them to generate a profit for itself."[56] This law remained the basis for deaf education in France for nearly a century, and

enshrined the administration of the deaf by the newly re-established Interior Ministry, rather than that of Public Instruction, giving financial and administrative problems priority over educational needs.

The results of the survey of the deaf came in piecemeal and a full report was not presented until 4 Thermidor Year III (23 July 1795), after the new legislation was in place. The reports vary in quality and depth from a simple indication of numbers to a detailed taxonomy with charts and figures supplied, but all the local officials seem to have been aware of the central government's political intent. For example, Hilaire, the government agent in Grenoble, reported: "The majority [of the deaf] belong to poor parents and only subsist as the result of their labor; they could be susceptible to education and justify some hope that they might thus serve society, the arts and the Republic at once. Let us make useful this interesting class which Nature seemed permanently to have excluded."[57] This awareness of the ideological tenor of the inquiry mandates caution in handling the returns as if they presented a fully accurate picture of the state of the deaf in France. For example, in nearly all the reports, far fewer deaf women are listed than men. Given the numbers of deaf women at the Institute itself and the dictates of probability, these figures are highly unlikely to be reliable.

Nonetheless, something of the deaf way of life in France can be glimpsed from these fragments. By way of example, I shall describe the report from the Doubs, which was one of the most detailed. This region was the subject of a proto-ethnographic survey by Joseph-Marie Lequinio de Kerblay in the Year VI. He was delighted to find "a good republican spirit, a plan for the common good, formed from the reunion of individual possessions." But at a local festival he was shocked to observe "the unadulterated, vulgar habits of a savage people."[58] This apparent dilemma confronted enlightened republicans throughout the Revolution, and the statistical survey of the deaf was one means devised in response. The local authorities reported eighty-one people in their department to the *Comité*, composed of 62 who were described as deaf-mutes, eight deaf, six mutes, three blind, one imbecile, and one deaf and blind. In addition to statistics of age, sex, date of birth, and residence, some reports provided laconic notes on the deaf in their area. For the most part, they were isolated in villages without contact with other deaf people, just as Jean Massieu was later to describe his childhood. Clearly, it was these deaf people who had most to gain from the artificial deaf communities that were formed by the deaf Institutes. In Besançon, however, there were seven deaf people, one blind man and one unfortunate described as deaf,

blind, and an imbecile. The village of Charmauvilliers had a small community of six, mostly elderly, deaf people. One intriguing entry records that there were thirteen deaf people in Ornans, including one Etienne Courbet, aged 12, presumably a relative of the realist painter Gustave Courbet, born in Ornans in 1819, the son of Régis Courbet, a native of the town. In the village of Cendrey, two brothers from the Grave family were deaf and the commissioners noted that their father, Pierre Grave, had served in the Revolutionary Army. Under the Directory and the Empire, such service records became one method of securing a place for deaf offspring in the Institutes for the Deaf. This initial report did in fact attempt to select candidates from the Doubs for government aid. The commissioners highlighted the twelve-year-old Pierre François Breton who "has only been deaf for several years. Is without support and merits compassion," as well as Jean and Louise Tournaux of Chainesol: "both of whom are in the greatest possible need." For the most part, the deaf recorded in this survey worked as laborers, domestics, and agricultural workers but many were simply described as miserable or poor. We also hear of people such as Nicolle Chevanne from Lyonne, a deaf woman from birth who "maintains herself here by her intelligence." The overall picture the survey presented showed small, active deaf communities in the towns and some villages, but many individuals who were both impoverished and isolated. The survey literally named those whom the government had undertaken to care for and gave an identifiable form to that commitment. It was these rural deaf people who gained most from the Republican commitment to the deaf and who were to remain loyal to government policy even in the oral period. The report fulfilled and exceeded its remit. The numbers of deaf were listed, but the numbers of blind and mentally handicapped were also supplied unasked. The commissioners understood central government policy, echoed its ideological agenda, and anticipated it in supplying candidates for the Institute. They may have also underestimated the numbers of the deaf poor in order to maintain the myth that this was a small problem that could easily be dealt with by the politics of regeneration. Indeed, on 18 October 1795 only thirty-four places were filled at the Paris Institute.[59]

The Institute became subject to an official bureaucracy, which both ensured its survival and created a profession of caring for the deaf. On 16 Floréal an III (6 May 1795), the Interior Ministry issued a set of guidelines as to how each department should present its candidates to the Institute. This process quickly became highly bureaucratized and a circular of 28 Thermidor an IV repeated the Jacobin survey of the deaf by arron-

dissement to facilitate such admissions. In order for an individual pupil to gain funds from the Treasury, a birth certificate and *certificat d'indigence* were mandatory, accompanied by letters from local and departmental officials, a statement from the parents, and a doctor's certificate attesting to the child's deafness. This meritocratic process aimed to ensure that only those deaf children most likely to benefit from education received it, marking an initial retreat from the Jacobin policy that all the deaf should be "useful and happy." Now only a select few were to have that opportunity. However, this restrictive and bureaucratized admissions policy led to the formation of a highly skilled deaf community centered on the Institute, including artists, poets, sculptors, and writers.

THE NORMAL AND THE PATHOLOGICAL

It was during the Consulate and Empire that a radical and unprecedented shift in the understanding of the deaf and their sign language by the hearing took place, the consequences of which echoed down the nineteenth century and have only very recently been challenged. This change was part of a wider and longer evolution, described by Georges Canguilhem as "normalization": "Between 1759, the date of the first appearance of the word *normal,* and 1834, the date of the first appearance of the word *normalized,* a normative class conquered the power to identify the function of social norms with its own uses and its own determination of content."[60] This new taxonomy categorized hearing as normal and deafness as pathological, dating from the Consulate and Empire. Perhaps the most striking consequence of this recategorization was not so much the renewed antipathy to the deaf, which has been recorded since Aristotle, but the visual construction of deafness. Visible causes were sought for the new disease, and sign language was less of a philosophical problem than a symptom. Anthropologists, artists, and physicans were all involved in creating this visual taxonomy.

Under the Directory, it became evident that the rapid, regenerative transformation Prieur had hoped for was not taking place, and the Jacobin imperative that the deaf should be both "useful and happy" was limited to making them simply useful. The law of 16 Nivôse had stipulated: "Each pupil will learn a suitable trade to supply him with the means to provide for his subsistance when he is returned to his family." However, on 7 Fructidor an VI (24 August 1798), Letourneux, minister of the Interior, closed the workshops that trained students in the "arts of luxury,"

which presumably included painting.[61] While Sicard was in hiding following the proscription of priests in 1797, the minister made the first official call for an oralist education of the deaf: "It has been shown that all mutes can speak . . . they can all articulate words in a manner sufficient to make them understood by all the world."[62] As soon as the category "deafness" (as opposed to deaf people) came into being in the state and civil society, the politics of regeneration demanded that it be transformed into the "normal" condition of speech. Regeneration was as coercive as it was liberatory.

In concord with this shift in priorities, deafness came to be treated not as an irreversable condition, whose primary consequences were in the realm of perception and cognition, but as a physical disease affecting the health of the entire body. Although quacks and charlatans had no doubt been offering "cures" for deafness for generations, the chimera of a cure for deafness now entered the realm of official practice and discourse. The Consulate reformed all areas of medical training and accreditation, creating a sharp divide between legal, state-approved practitioners and the rest.[63] On 20 Messidor an VIII (9 July 1800), a doctor named Le Bouvier-Des Mortiers published a *Memoir on the Deaf,* which attacked Condillac's handling of the deaf man from Chartres. It would have been far better, in Des Mortiers' view, for Condillac to have inspected the young man's ears rather than his metaphysical ideas: "For there are many deafnesses from birth that result from obstructions or puffiness in the organ of hearing, and which would not be incurable."[64] In a particularly visual approach to the body, the new medicalization of deafness assumed that there must be a physical obstruction within the ear causing deafness, as hearing was a "given" of the human body. Des Mortiers believed the obstructions could be overcome by electricity, injections into the ear, and steam baths. When Jean-Marc-Gaspard Itard (1774–1838) became the doctor at the Institute for the Deaf that same year, he put these theories into practice upon the deaf pupils at Saint-Jacques, although his attention was distracted between 1801 and 1806 by Victor, better known as the Wild Boy of Aveyron.[65] Nonetheless, a new era of medicalization had begun, symbolized for many by the liberation of the mad by Philippe Pinel and his creation of the "moral" treatment. However, as Michel Foucault has famously observed: "The absence of constraint in the nineteenth century asylum is not unreason liberated, but madness long since mastered."[66] The asylum and the Institute sought to contain and control the margins of rationality, not to set them loose.

For the hierarchy of nature, which had previously been seen as a malleable field and hence capable of being regenerated, became the very state of

nature. Under the influence of the *idéologues*, the new discourses of social reform removed mobility for those classified as pre-civilized. The deaf were an early instance of what Alan Sekula has called "that privileged figure of social reform discourse: the figure of the child rescued by a paternalistic medico-social science."[67] The infantilized status of the deaf was reinforced and given new meaning by the application of anthropological and racial theory. As we have seen, race, "disability" and class became inextricably interlinked in this period. The deaf had been categorized as "savage" for a mixture of political, ideological, and (seemingly) empirical grounds during the Enlightenment. The transformation was not so much in the racial dimension of *Idéologue* thought, as in its use of these ideas within a visualized disciplinary and normative framework. The insertion of such disciplinary theories into the hierarchical framework of supplementarity legislated difference as natural and irrevocable. For Destutt de Tracy, "to think is to sense and nothing but to sense," leaving no possibility of compensating for deficiencies in perception.[68] Inequality was inevitable. Education and society should be organized in recognition of that fact. Thus the *classe savante* was naturally worthy of education, whereas the *classe laborieuse* would not benefit from it at all.

This moment of transformation can be observed in the proceedings of the Société des Observateurs de l'Homme, founded in 1799 to advise the colonialist expeditions of Nicolas Baudin to Australia and Levaillant to Africa.[69] Its membership was a cross-section of those intellectuals who benefited from 18 Brumaire, that *coup d'état* of the Institut. Destutt de Tracy and the other leading *idéologues* were members along with physicians such as Philippe Pinel and Itard, colonial explorers, scientists like George Cuvier, as well as Sicard and Massieu. The closeness of this circle can be seen in the fact that Sicard employed Jean-Baptiste Jauffret, brother of L.-F. Jauffret, secretary of the Society, at the Institute for the Deaf and later sent him to Russia as an educator of the deaf.[70] For the Society, the fascination of studying the "savage" was not in itself but for the clues such study would bring to the understanding of civilized man. Joseph-Marie de Gérando, a rising star of the Institut, and future administrator of the Institute for the Deaf, argued that: "Here we can find the necessary materials to compose an exact scale of the different degrees of civilization and to assign to each one the properties which characterise it."[71] De Gérando believed that the hierarchy of nature theorized by the *idéologues* could be empirically researched in the New World. The colonized Other was thus, as so often, a means for the colonizing self to validate itself through comparison and contrast.

Jauffret, the secretary of the Society, declared that language was at the

heart of their investigations, since "speech is, after reason, the most beautiful prerogative of man . . . it is above all [speech] that distinguishes man from the crowd of animals which surrounds him." This emphasis on speech was no longer simply a question of its utility, but was couched in heavily moralistic terms. Jauffret emphasized that "the observation of physical man is intimately linked to that of moral man and it is virtually impossible to study either the body or the spirit in isolation. . . . Each illness is almost always the product of a vice."[72] Jauffret's addition of a moralizing dimension to the traditional distinction of humans from the animals by reason of their speech made it reprehensible not to be able to speak. He saw the deaf as "these disgraced beings of nature," whose silence clearly indicated a moral fault. In this sense, Jauffret fulfilled Kant's categorical imperative which, as Gayatri Spivak has argued, "can justify the imperialist project by producing the following formula: *make* the heathen into a human so that he can be treated as an end in himself."[73] Condillac and Diderot's relativist conception of morality gave way to the human as an absolute end in itself, which both refuted the theory of the arbitrary sign, and left an ignorance of the means by which words had come into existence, that could be rectified by the study of "primitive" deaf sign.

De Gérando thus advised anthropologists to learn sign language in order to communicate with the native peoples they encountered: "For travelers, to whom these reflections are directed, one cannot recommend too highly the detailed study of the methodical signs, which citizen Sicard has used with such success to establish his first communications with the deaf-mute. For the deaf-mute is also a savage, and nature is the only interpreter which can translate for him the first lessons of his masters."[74] De Gérando wrote as if Sicard was a linguistic Columbus, the first hearing person ever to communicate with a new form of "savage," the deaf. The inclusion of the deaf as a subject for anthropology completed the process of defining the pathology of deafness. In the view of these early anthropologists, civilized man was everywhere surrounded by savages and animals, an important resource for his narcissistic study of himself. But the self could only be fully realized by defining the Other in ways that would ensure no possible confusion. The French citizen was hearing and thus anyone who could not hear was not truly French. Later governmental efforts to make the deaf hear and speak stem from this moment of definition. The Society placed the Chinese Tchom A.-Sam in Sicard's care precisely because he was "the national interpreter of the human race."[75] Jauffret carefully noted that the savage revealed to date by exploration was not the noble savage, or man of nature, whose existence was now

doubted.[76] In this polygenetic view, difference was inevitable and insurmountable because the human race was not one, but several, clearly separated races.[77] The deaf were now seen as one class among the ranks of the "primitive," subject to disciplinary control and observation. The new social body of France was constituted only by "whole" citizens, whose eligibility for membership depended upon fulfilling the corporal and disciplinary norm.

For these anthropologists, the deaf could provide no clues to the cognition of the "civilized," refusing a philosophical tradition which stretched back to Plato. Philosophy itself merged into speech, conceiving itself as a dispassionate voice, which de Gérando saw as the means to move beyond the "egoism" of the revolutionary period: "True philosophy, always in accord with morality, offers us another language. . . . But what is the best means of studying Man? Here the history of philosophy, the voice of the *monde savante,* answers us. The time for systems is past. Far from agitating itself for centuries in vain theorizing, the genius of knowledge is finally set on the route of observation." The voice of Philosophy no longer theorized, it simply spoke of its observations. In an attempt to circumvent the logic of supplementarity, speech became philosophical, disconnected from the material language of gesture. Destutt de Tracy argued that "sounds have the two properties of being the most natural and most commodious of all signs." He considered the alphabet as a direct representation of sounds, and thus not a sign system, but an authentic transmission of thought.[78] The moralized and philosophical voice had no connection with gesture, being of an altogether different and higher order.

The Society was clear that a new political moment had dawned and brought with it the need for a new knowledge: "The Society, in searching to raise human dignity, that beautiful prerogative which was so cruelly ignored, so insolently outraged, during the awful regime which recently ruled France, will have the advantage of completing, by the sole influence of its observations, the extinction of a crowd of abuses to which this odious regime gave birth, and which the existing government has not yet succeeded in destroying." In the wake of Bonaparte's expedition to Egypt, power was colonial and disciplinary, relying on its all-seeing observations, both at home and abroad. The scale of supplementarity, which had made sign language epistemologically intelligible, was now subsumed within what Foucault has described as "the *medical bipolarity of the normal and the pathological.* Consciousness lives because it can be altered, maimed, diverted from its course, paralyzed; societies live because there are sick, declining societies and healthy, expanding ones; the race is a living being

that one can see degenerating; and civilizations, whose deaths have so often been remarked on, are also, therefore, living beings."[79] Thus the success of the colonizing race depended on its health at home as well as its dominance abroad. The deaf were subject to this colonizing power, not as the subjects of economic imperialism, but as members of the new grouping to be rescued by the *mission civilisatrice* of nineteenth-century France. A new science of man and an accompanying political economy of the body had emerged out of the revolutionary crisis, in which the deaf found themselves newly categorized as savage and immoral.[80]

DAVID'S STUDIO AND THE DEAF

The new visibility of deafness, as opposed to deaf people, was represented in a series of paintings by David's students concerning the deaf. Ancien régime artists had previously looked at the deaf for a fully expressive visual language, which might assist their own efforts in similar directions. As such, they did not "see" sign language, but misread it as a universal language of pantomime. This vision was thus direct, in that it did not see sign language as pathological, but was mistaken in its assumption that sign was the universal language. In the era of pathology, deafness was called into being and what I have termed the "silent screen" of deafness came fully into being. The hearing artist who looked at the deaf now saw sign language as a symptom of deafness, framed by notions of pathology and anthropology, but also as a visual language. This double character of sign language gave it compelling force for hearing artists. If visual representation offered one key tool for understanding the complex interactions between the normal and the pathological, the civilized and the savage, the whole and the incomplete, these interactions could all now be depicted in representations of the redefined deaf. These works mark a moment during the Consulate and Empire, in which the cultural meaning of deafness acquired a new urgency for Neo-Classical artists. As the optimistic allegories of regeneration gave way to the hierarchical symbols of Empire, the definition of the normal citizen was not simply textual but was also visual. Due to the prominence of Sicard's demonstrations at the Institute for the Deaf, the deaf provided not just a source for the depiction of gesture, but an entire moral and philosophical subject, worthy of depiction in History painting. Their education encapsulated the Imperial dilemma entailed by the need to create unity among a people presumed to be not merely divided by class or political allegiance but by biological and cultural barriers

of race and development. The spectacle of deaf education provided, in the post-Revolutionary context, a metaphor for the possibilities, achievements, and obligations of the French state and citizen.

In strictly artistic terms, the superimposition of "Ancient" morality and subject matter over "Modern" technique, which had constituted the achievement of early Neo-Classicism was coming unstuck. Within David's studio, the hegemony of the master's Neo-Classical style came to be challenged and even rejected. When David unveiled his *Sabine Women* in 1799, an important faction in the studio was unimpressed, seeing the picture as insufficiently "Greek" by comparison with the as-yet-unrealised Greek aspirations of the sect known as the Barbus.[81] Alternatively, other students were initiating moves towards a more emotionally invested style with subjects derived from medieval French history, rather than the Classics. The hegemony of traditional Classical subject matter in French art, which government and artists had struggled to achieve since 1776, was over. In charting a new way forward, the Institute for the Deaf was an important subject for David's students.

Among these was Marie-Pierre Nicolas Ponce-Camus (1778–1839), one of David's five hundred students now forgotten by art history, although David rated him as one of his best.[82] He joined the studio in 1791, but then enlisted in the Revolutionary armies, and so did not exhibit in the Salon until 1801. He later won medals of honor at the Salons of 1804 and 1812 and painted a series of military portraits of Napoleon, later hung at Versailles.[83] He remained loyal to David throughout his career and signed the letter written in 1816 by a group of former pupils, requesting the Minister of the Interior to allow David to return from exile.[84] In 1819, his *Alexander and Apelles,* a subject derived from the permanently unfinished canvas by David, was refused by the Salon for demonstrating unacceptable Napoleonic sympathies, and he spent the remainder of his career as a successful portrait painter. Ponce-Camus also understood Epée's methodical sign language and made explicit use of it in his *Painting representing an anecdote of the life of the famous abbé de l'Epée, taken from the causes célèbres,* exhibited at the Salon of 1802 (fig. 11).[85] Two figures dominate the scene, edged in by the frame, who seem close to the space of the viewer because of the proximity of the rear wall. The elderly priest is the abbé de l'Epée, seen returning one of his abandoned deaf pupils to his rightful home in Toulouse and his noble inheritance. In a lengthy description of the scene, the Salon catalogue presented the *Abbé de l'Epée* as an *exemplum virtutis* for the moral edification of the viewer, marking a transformation in the signification of sign language and the

11. Marie-Nicolas
Ponce-Camus, *Painting
Representing an
Anecdote of the Life of
the Famous Abbé de
L'Epée, Taken from the
Causes Célèbres,* 1802
(Paris, INJS)

deaf. Whereas ancien régime artists had turned to sign language as a means of resolving artistic dilemmas, Ponce-Camus made it the very subject of his work, and won the endorsement of the Salon for this new direction in History painting. For he had unusually used Epée's methodical signs for the deaf to form the upward gesture of the abbé, whose hand correctly forms the sign for Heaven.[86] It is the counterpoint to the natural gesture of the child, who holds Epée's hand to his heart in gratitude. The thanks, Epée signs, are due to God. Ponce-Camus has used gesture exactly as formerly prescribed by the Academy, in imitation of deaf sign language.[87] Following the establishment of the Institute for the Deaf, Ponce-Camus' use of sign language could be identified as such, and was located within the context of deaf history, rather than as a device to render a scene from the historical canon legible. In comparing this version of the scene to others in popular prints, it is immediately noticeable that the abbé's sign is the innovation of the painting.[88] Ponce-Camus used his knowledge of sign language as a resource in History painting, acknowledged by contem-

poraries as the most complex genre of painting. In Stephen Bann's useful phrase, the sign was Ponce-Camus' "technical surprise," which confirmed the painting as a History painting and established its claim to the viewer's attention.[89] The stillness of the artwork allows one gestural sign to be isolated and emphasized in a way that was impossible in deaf conversation. It is truly silent poetry. For if poetry can be defined as a language that resists intentional dissolution into other forms, the visual sign is certainly poetic.[90]

As a History painting, Ponce-Camus' scene told an unusual story, the scandalous case of the Comte de Solar. In June 1775, Epée discovered a deaf boy in the hospital of Bicêtre. He used sign language to discover that the boy claimed to be the abandoned heir of a noble family. A visitor to one of his sign language demonstrations identified the child as the Comte de Solar. Investigation suggested that here indeed was Joseph, the deaf eldest son of the now-deceased Comte de Solar. In Toulouse, where the family lived, it was discovered that Joseph had last been seen traveling with his tutor, a young law student named Cazeaux. Cazeaux had reported that the child died from smallpox on the journey, and no more was thought of him, for he had been something of an embarrassment to his family. It appeared that Cazeaux had in fact abandoned the child in order to facilitate his affair with Joseph's widowed mother, and he was arrested, taken to Paris, and thrown into an *oubliette*. The identification of Joseph seemed secure, for the unusual extra tooth in his upper jaw matched that which the Comte had been known to have. Yet Cazeaux protested his innocence and, before his trial, the famous lawyer Eli de Beaumont produced a sensational defense. Cazeaux could prove that he left Toulouse on 4 September 1773, by which date "Joseph" had already been committed to Bicêtre, having been discovered in Picardy a month before that! Cazeaux's lawyers bitterly protested that his arrest was based on no evidence other than Epée's interpretation of sign language: "It is thus, in all history, that deception and fanaticism, aided by certain singular circumstances, have caused the multitude to adopt the reveries of the imagination, and the fictions of illusion."[91]

The judges ordered Cazeaux released and an investigation was set up in Toulouse with Joseph present, Joseph's only return to Toulouse, as depicted by Ponce-Camus, although Epée did not in fact accompany him. Initial evidence proved inconclusive, so the judges ordered the tomb of the boy Cazeaux had buried to be opened. Inside was the skeleton of an eight- to ten-year-old child and, sensationally, the child's skull showed an extra tooth in the same place as that of the Comte. The judges arrived at

an extraordinary verdict. Cazeaux was found innocent of abandoning the Comte and the young deaf man was confirmed to be the Comte de Solar. The court itself remarked in its judgment: "The curiosity of the public in the adventures of the young Solar will not be satisfied: no more is our own."[92] The defense lawyers' claims that Cazeaux was the victim of aristocratic privilege seem amply confirmed in this verdict, for, if the child in Paris was Solar, Cazeaux had committed an offence in fraudulently registering the corpse in Charlas as that of the Comte. Alternatively, if he was fully innocent, then "Joseph" had no connection with the family whatsoever.[93]

Cazeaux was not satisfied and neither was Caroline, Joseph's sister, who lost half her inheritance to her "brother." In 1791, they appealed the decision together, and not only won the case but were restored to the family property with compensation. Once the patronage network of the ancien régime had crumbled, so too did Joseph's defense. The lawyer Eude, who undertook the later investigation on behalf of the court, remarked: "There was a time when the name of *Solar* in itself would suffice to aspire to the favors which the hazard of birth could procure. No longer: the progress of human reason has put paid to these prejudices."[94] For Eude, the Revolution symbolised an overturning of ancien régime superstition in which Epée's sign language was thoroughly implicated: "So what is to become of the system of the abbé de l'Epée, and what do we make of the pretentions which he has inspired in his pupil, when they are forced to agree that on the first of August Joseph was in the hands of the Le Roux's in Cuvilly, Picardy and also that on the second of September he was in the hospital of Bicêtre in Paris?"[95] Eude's hostility to Epée and sign language, among a host of other contradictory details, leaves the question over Joseph's true identity open.[96]

Ponce-Camus had thus painted an event that in 1802 was believed to be fictitious, and was legally part of a criminal conspiracy, in which the status of sign language was a central question. Rather than a depiction of actual events, or scenes from the Bible or Antiquity, as traditionally prescribed by History painting, the work can only be understood as a depiction of a scene from Jean-Nicolas Bouilly's play, *Abbé de l'Epée,* which opened in December 1799 at the Comédie Française. Both the play and the painting were remarkable popular successes, despite unfavorable reviews from the literary journals and newspapers. The play was second in performances only to the *Marriage of Figaro* in the period. Bouilly was a lawyer and writer, who successfully reactivated the earlier theatrical tradition of using deaf characters, with the addition of Epée's methodical signs.

The character of "Theodore," as the young Count was called by Bouilly, was played by Mme Talma and it is noticeable that the character of the signing deaf boy was considered an appropriate role for a woman. She went to study sign with Massieu in preparation for her role and, in her autobiography, Mme Talma recalled that: "I established a daily society of the deaf; they were enchanted to see me profit from their lessons."[97] Her absorption into the role was such that when a piece of stage machinery accidentally fell over during a performance, creating a huge crash, she remained immobile, while her fellow actors rushed backstage to investigate. This skill in sustaining illusion won her four curtain calls that night. Eude published his legal account of the case at this time so as to discredit the argument of Bouilly's play, noting that in the revolutionary ferment of 1791 the posters announcing the verdict "were taken down the minute they were put up."[98]

The traditional hostility of the Neo-Classicists to theatrical subjects and to sign language were thus doubly refuted by Ponce-Camus. Critics were not slow to respond. The painting was dismissed as a "bizarrerie of composition" which placed emphasis on achieving "marvellous" effects over the true responsibilities of History painting: "In the end, it is nothing but the stamp of ignorance."[99] In the satirical Salon pamphlets, his picture fared even worse: "M. Camus, what devil asked you for a history painting? We know perfectly well that it's impossible for you to achieve one and it can only be that you are willing to incite the laughter of the always over malicious public. Between ourselves, let it be said that your abbé de l'Epée is ignoble, his pupil not much better and this dog looks like a cardboard cutout. Your perspective is completely off; your pavement climbs to the sky; your principal beggar looks more like he's threatening Epée than calling down the blessings of heaven upon him. Apart from this, your picture is not without merit."[100] Ponce-Camus' combination of theater, sign language, and deaf history was indeed a new departure for History painting, and was rebuked as such.

But Camus was not alone in being so reproached. For the public invoked by Camus' critic: "there is practically nothing at the Salon; and, as you must know, it is not done [*pas du bon ton*] to exhibit one's pictures on the first days of the show."[101] For such critics, the more the crowd enjoyed the exhibition, the less the public could find anything of merit. This public was constituted as a reading public, those who consumed the pamphlets and newspaper reviews. Reviewers often commented that their remarks would be self-evident, if only the reader could see the pictures themselves. Evidently, whether the reader was supposed to have seen the

pictures or not, the review was expected to be read elsewhere in private. Ironically, it was precisely those private, silent readers for whom art critics had long called for a revival of History painting, who were being let down by the Salon and stayed away as a result. In 1806, Eugène Dandrée commented: "The Salon is open and the crowd presents itself there. . . . The Public? But for that, it would be necessary that the public was generally in a state to judge, to direct, to lead in a good direction."[102] As such remarks made clear, many critics believed that the public, and by extension History painting, were in a feeble condition. As the Neo-Classical agenda dissolved, uncertainty reigned. The lament that the *grand genre* of History painting was dead, while artists pandered to the tastes of the plebeians, was to be heard throughout the nineteenth century. In 1802, facing such hostility, the Academy was forced to bring out some old favorites from previous years by Girodet and Gérard.

For the crowd, or conversational audience, the evocation of sign language remained as popular as it always had been, attracting attention to Camus' picture and its subject. The print culture critics felt obliged to refute the accuracy of the scene, for at the same time *Abbé de l'Epée* was having a rerun at the Comédie Française, generating renewed hostility. The critics noted that "chamberwomen and servants"[103]—that is, the audience of the *parterre,* the popular theatre and Salon audience— enjoyed the marvelous and the adventures in the story. But they denounced the play as being historically inaccurate—which it was—and for being the ally of superstition and the magic of signs—which it wasn't.[104] Such criticism tacitly acknowledged the popular acceptance of sign language, which the newly medicalized human sciences had rejected. Bouilly himself dismissed all such debate: "I know that power, intrigue and, above all, the hate which the Archbishop of Paris bore towards the abbé de l'Epée, had prevented this latter from obtaining all the rewards of his long and precious researches. . . . No matter! It was no less true that the great man whom I celebrate was able to make an interesting man out of this young deaf mute."[105] This defence was supported by the 1790 investigations of the Arsenal section—no friends to the Institute for the Deaf— who found that the archbishop was responsible for delaying the transfer of the Célestins to the deaf.[106] Despite all the critiques, Bouilly's work remained "the play of the people, always the friend of marvels and adventures."[107]

The tension between the professional and popular attitudes to the deaf mirrors the difficulties encountered by the Directory in its effort to forge a national culture from above, using the confused heritage of monarchical

and Republican France. One typical report of a government commissioner in the Basses-Pyrénées describing a popular festival could easily have been a review of Bouilly's play from the literary magazines: "There fanaticism had erected its stage; there the most ridiculous farces were played out. In the end all the phantasmagoric tricks had so disturbed the minds of the spectators that many poor unfortunates thought they had witnessed miracles."[108] As Mona Ozouf has emphasized: "One could not be content simply to allow public opinion to emerge: it had to be formed."[109] The Directory was unable to impose their rational, ordered schemes on the population at large, who remained stubbornly attached to their patois—including sign language—their superstitions, and their religion.[110] The Directory could not escape the dilemma posed by Robespierre: "*Le peuple* must believe in its own virtue."[111] In other words, a people must already be virtuous in order to create a virtuous society. However, as Sièyes had remarked in the early days of the Revolution, popular ideas were made up "of the aggregations of men subjugated by superstition."[112] After a decade of regenerative politics, such superstitious fancy still seemed to have a hold. Why, one critic complained, did a revival of *Brutus* close immediately whereas *Abbé de l'Epée* played to packed houses?[113] The Directory's control over discourse, given concrete form as the Institut, did not always entail political control in the widest sense, particularly in the cultural sphere. Since Thermidor, the popular forces had been separated from political power and continued to adhere to their own sense of sentiment, the marvelous and the power of signs, which contradicted official thought.

It was part of the genius of Bonaparte that he was able to harness and control that popular sentiment, which gave him the authority the other post-Thermidorean governments had lacked. For Bonaparte, it was enough that he himself was virtuous, and seen to be so, thereby escaping the Republican dilemma. Bouilly's play was a striking early example of this Bonapartist style. It was first read to the inner circle of Josephine's salon, where Bouilly was a regular and David was often in attendance with various of his pupils. Both Bonaparte and Josephine came to the second night, leading to some prearranged theatricals in the audience.[114] At a particularly poignant moment of the play, the writer Collin d'Harleville, another regular at the salon, made a resounding appeal for clemency to Sicard, who had been sentenced to deportation by the Directory in 1797 for his pro-royalist journalism. The First Consul noted the lively, and no doubt pre-arranged, support for d'Harleville's appeal and granted it shortly afterwards. Bonaparte's gesture symbolized his fusion of a renas-

cent private, salon politics with tightly controlled public display. Sicard's liberty was no threat to the Consular regime, whose ideological politics aimed less at individual participation in Republican culture than at a generalized subservience to discipline. Foucault has well described the Napoleonic aura:

> At the moment of its full blossoming, the disciplinary society still assumes with the Emperor the old aspect of the power of spectacle. As a monarch who is at one and the same time a usurper of the ancient throne and the organizer of a new state, he combined into a single, symbolic, ultimate figure the whole of the long process by which the pomp of sovereignty, the necessarily spectacular manifestations of power, were extinguished one by one in the daily exercise of surveillance.[115]

Thus, although Ponce-Camus' picture showed a scene that only referred to a contemporary play, it was still possible to think of it as a History painting. The surveillance exemplified by the emperor extended its gaze into the symbolic panoply of the time, in which History painting played a full and important role. Michael Fried has commented on this passage: "The ubiquitous gaze at play in Napoleonic painting is ultimately that of the Emperor himself, or rather of the Imperial regime of systematic surveillance."[116] In Ponce-Camus' painting, the fusion of traditional spectacle with the new discipline can be strikingly observed. The virtue it exemplified was two-fold: on the one hand, it recalls the general virtue of the abbé de l'Epée as a teacher of the deaf, as set out in the Salon catalogue, but it also recalls the specific action of Bonaparte in showing clemency by releasing Sicard. More specifically still, Epée's gestural sign recalls Bonaparte's gesture of civic virtue in healing political divides for the common good, in anticipation of Gros' famous depiction of *Napoleon in the Plague House at Jaffa* (Paris, Musée du Louvre, 1804). The theatrical values of Neo-Classicism had now been deployed within an explicitly dramatic setting.[117] This strategy of representing representation—combining sign language, theatre, and politics—offered interesting new possibilities for History painting.

The interaction of philanthropy and governmental authority evoked by Ponce-Camus can be described as paternalism, for both the figure of the father and ideas of fatherhood are central to his work.[118] Ponce-Camus continued David's strategy for rescuing those whom Carol Duncan has called the "fallen fathers" in Greuze's painting.[119] David had painted Socrates and Belisarius with much younger dependents or disciples, but their relationship was paternalist, mediated by moral authority. He thus avoided the dilemmas of the family romance, so powerfully evoked by

Rousseau. In his depiction of Epée, Ponce-Camus echoed David's use of gesture in the *Death of Socrates* (1787), the father of the *Horatii* (1785), and especially *Bonaparte Crossing the Alps* (1799).[120] Epée's age contrasts strikingly with that of the child, but was not puzzling because of the institutionalized relationship between them. For behind these risen fathers was a new moral and legal paternal authority, which ran throughout the different levels of interpretation to the gestural sign. The picture shows the "Comte de Solar" finding his paternal home once more and being recognized as part of the family by the dog at the gates. Bouilly's play centered around the transformation of an evil father into a natural father. It was through the paternal authority of Epée, often referred to as "the father of the deaf," that Solar gained access to sign language, without which nothing would have happened. In the painting, Epée's methodical sign contrasts with the natural gesture made by the boy, demonstrating that it was only through Epée's paternal intercession that the child has escaped the state of nature. Finally, the painting invoked the joint power of God, who inspired Epée, and the State, which ordered police searches on his behalf and funded his school. Paternalism thus held sway in the state, society and the family, as the nineteenth century recast power around the model of the bourgeois family. It provided an over-arching metaphor for Ponce-Camus, keeping his polysemic representation from degenerating into meaninglessness.

This interaction between sign language and History painting in France can be appreciated by comparing the reception of Bouilly's play, and a painting derived from it, in England. When Thomas Holcroft's translation opened under the title *Deaf and Dumb* at London's Drury Lane Theater, it was an immediate popular success.[121] From the first night, 24 February 1801, the main business, as far as both audiences and critics were concerned, was the performance of Miss Maria de Camp, the future Mrs. Charles Kemble, as the deaf boy Julio, the putative Count of Solar.[122] In an epilogue added to the English version by Holcroft, s/he finally spoke:

Here's *Dumby* come to speak-'twas ten to one
That I had talked before the play was done.
Of all authors, he is far most cunning
Who can ensure a woman's tongue from running.
Speech is our nature—if I err convict me—
What bachelor so rude to contradict me?[123]

For newspaper reviewers and diarists, de Camp's cross-dressed mutism was a scandalously titillating episode that the *Morning Chronicle* returned to

time and again: "That a *Deaf and Dumb* character should afford so much scope to the powers of a female performer seems at first sight a little extraordinary; but though the *tongue* be one of the most *commanding* instruments of communication which a woman can employ, yet there are others which are fully as imperative."[124] Sign language was well-known in England and was used even within the oralist schools of Thomas Braidwood, visited by Dr. Johnson.[125] Its use was sufficiently widespread for Jane Austen to be able to communicate with a deaf acquaintance, probably via finger-spelling, as she wrote to her sister Cassandra: "[Mr Fitzhugh] poor man! is so totally deaf that they say he could not hear a cannon were it fired close to him; having no cannon at hand to make the experiment, I took it for granted, and talked to him a little with my fingers, which was funny enough. I recommended him to read Corinna."[126] But sign language carried none of the political, aesthetic, or philosophical connotations in England, which were so noticeable in France.

James Northcote, a pupil of Joshua Reynolds, painted a half-portrait of *Miss St. Clair Performing the Deaf Alphabet* (fig. 12), in which the young Miss St. Clair forms the letter "D" in a manual alphabet.[127] The exact identity of Miss St. Clair is a puzzle, but she was evidently an actress, rather than a deaf woman, making it likely that Northcote's painting was inspired by his friend Holcroft's play.[128] The portrait thus ignored not only Reynolds' strictures against the imitation of sign language, but Fuseli's admonition that very year in the Royal Academy against "commanding gesture . . . [which is] scarcely admissible in art or in the theatre."[129] Northcote himself distinguished between actors and painters in an 1807 article, noting that the painter controlled his entire scene: "But the Actor, not having these advantages, must supply the deficiency by violent and decided gestures, actions, and expressions of the countenance, such as may be seen and understood at all distances, and by all the various capacities that compose his audience . . . and this may be at times an excuse for his *out-stepping the modesty* of Nature. . . . But the Painter has no such motives to check his highest attempts at refinement."[130] Northcote broke his own rules precisely because he was not working as a History painter but in the more popular genre of portraiture, in which he insisted that the customer was always right. Although Northcote was at this time attempting to become a History painter, he saw no wider possibilities in deafness and never again depicted sign language. It was only in the context of the regenerative politics of the French Revolution that deaf sign had a broader signification and could serve as the subject for History painting.

12. James Northcote, *Miss St. Clair Performing the Deaf Alphabet* (Washington Missouri, 1802)

Two paintings representing the deaf and their education from the Napoleonic period by Jerôme-Martin Langlois (1779–1838) demonstrate the importance of the institutionalization of deafness in France. Langlois assisted David on his *Bonaparte Crossing the Alps* and was placed second in the Rome prize of 1805 which he won outright in 1809 with his *Priam at the Feet of Achilles,* a composition that owed much to David's *Belisarius.*[131] This contradictory, emotional subject was exactly that proposed by Antoine Coypel as being suitable for the use of gestural sign language, suggesting that Langlois' later interest in the deaf was no coincidence. Langlois had a triumph at the Salon of 1819 with his *Diana and Endymion,* was awarded the Légion d'Honneur, and became a member of the Institut in 1838.[132] He painted two canvases of Sicard educating the deaf, the first in 1806 and the second in 1814, depiciting classes in the Institute for the Deaf (figs. 13–15). These paintings are among the first visual

13. Jerôme-Martin Langlois, *The Abbé Sicard Instructing His Deaf Pupils*, 1806 (Paris, INJS)

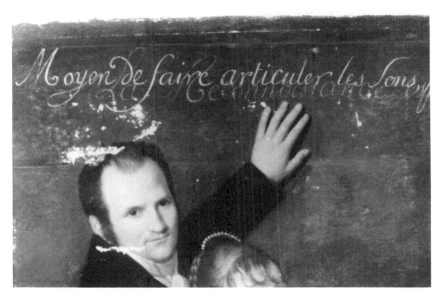

14. Detail of fig. 13 in restoration

representations of the disciplinary institution in France and, unlike Géricault's later portraits of the insane, concentrate on the workings of the Institute, rather than the simple depiction of the "abnormal." As such, their subjects are startlingly modern, especially for a student of David, and indicate that the Institute for the Deaf was an important point of reference for artists in the Napoleonic period. This relationship is not as surprising as it might at first appear. Just as the medicalized definition of deafness depended on identifying visual symptoms, the new disciplinary institutions were above all scopic regimes. The Panopticon and other such institutions controlled their denizens by the surveying gaze. In the disciplinary regime, Michel Foucault observed, "visibility is a trap." To be seen was in certain senses to be controlled, and, in the Panopticon, "one is totally seen, without ever seeing; in the central tower one sees everything without ever being seen."[133] Within the frame of that gaze, the various registers of difference called into play by the new category of deafness could be seen, recognized, and accomodated. The paternalism that controlled Ponce-Camus' work was now represented by the institution, in this case the Institute for the Deaf.

In his first painting Langlois resorted to writing in order to explain the scene, in contrast to Ponce-Camus' use of visual sign. His work was ex-

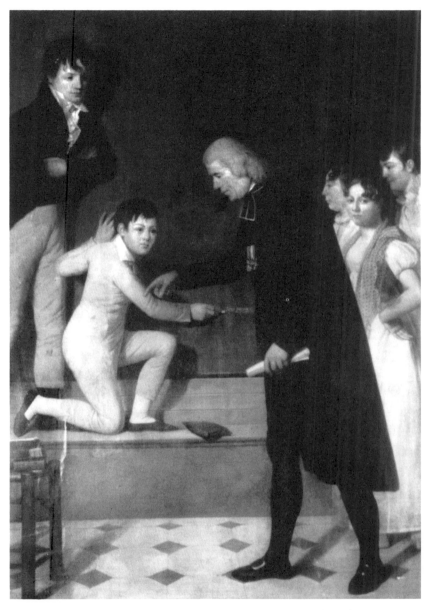

15. Jerôme-Martin Langlois, *The Abbé Sicard Instructing His Deaf Pupils* (Paris, INJS)

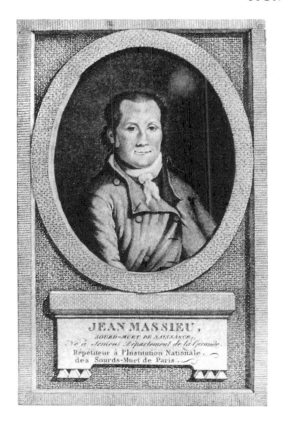

16. *Portrait of Jean Massieu*
(Paris, INJS)

plicitly concerned with the question of communication and education in Imperial society. Sicard is engaged in teaching a deaf woman to speak, in the presence of two other young deaf women and a woman teacher. The gloves worn by the taller woman indicate that she is Mme Laurine Duler, a speaking *répététrice* at the school, whose gloves made her signs more intelligible.[134] On the left stands Jean Massieu, the gifted deaf teacher (fig. 16). The blackboard on which Massieu has written is both the screen of our vision and the field of writing, reinforced by the double signification of the French word *tableau,* which means both picture and blackboard. The words hang in a typically gloomy Neo-Classical background, as if at an understated Belshazzar's Feast. Massieu gestures towards the text, which he has written with the chalk in his left hand: "Means of making sounds articulated by the feeling of pressure." But he, a signing deaf person, is not connected to the words, which are taken from Sicard's *Course of Instruction* for the deaf. Rather than being shown signing, his gesture is reduced to a mere pantomime of indication.

It is Sicard alone who possesses the gift of speech, conveyed by his hand that reaches across this divide, not in sign, but in the attempt to instruct the woman to speak. Sicard, like the anthropologist he was, is represented as possessing the ability to educate and communicate, among the mass of the primitive and unskilled. The woman endeavors to form the particular sounds, which she has been taught, in reponse to Sicard's cue of pressure on her arm, while measuring her own voice by feeling the vibrations of her throat. She is trying to imitate the vibrations of sound, which she has learnt from Sicard. Such methods were, and remain, primarily successful with those who become deaf after acquiring language, or who have some residual hearing. The composition partially obscures Massieu from our view and reinforces the hierarchical concepts of language embodied in the Institute. In the foreground, and in the light, are those who speak, or are trying to speak. In the background, in the shadows of deafness, is Massieu. Above them all, in an uncertain but powerful position hangs the writing. Writing had been the means by which the deaf had become educated but was also, in the philosophy of the time, a debased form of speech. It was writing that seduced the deaf away from the effort of learning to speak and was therefore suspect. Derrida has described how the eighteenth century "considers writing as a dangerous means, a menacing aid, the critical response to a situation of distress. When Nature, as self-proximity, comes to be forbidden or interrupted, when speech fails to protect presence, writing becomes necessary. It must *be added* to the word urgently."[135] It was thus to writing that the hearing artist had to turn in order to make his image comprehensible, having abandoned the gestural language of sign.

Recent restoration has indicated that the present text has in fact been changed from an earlier version, which read: "*La reconnaissance est la mémoire du coeur*" (Recognition is the memory of the heart). This aphorism was Jean Massieu's famous answer to a staple question at the signing demonstrations organized by Sicard, "What is memory?" For, according to Enlightenment philosophy, the deaf were incapable of memory, as they did not have the use of speech. Massieu's response was widely known as a riposte to that charge. It seems likely that, as so often, Sicard has obliterated the words of the deaf and let his own stand in their place to emphasize his importance. If Massieu's words had been retained, Langlois' image would have presented both sign and speech as media for deaf education, while still giving first place to speech. Nonetheless, the writing would have acted as a means of communication between the deaf as represented and the hearing viewer, rather than as a caption and technique of classifying the action.

In his 1814 painting, Langlois again emphasized the importance of written, rather than signed, communication between the deaf and the hearing. The scene shows Sicard testing the ability of a student to understand his action. He gestures towards the book lying on the chair, and the boy interprets this to mean that he will soon fetch the book. Hence the student writes "sera prenant" [will be taking] on the board. In contrast to the dominating words of Sicard in the first picture, the deaf boy's writing is small and hard to see. The composition appears disjointed and was widely criticized.[136] Sicard's isolated position is emblematic of the self-image of the Imperial educator, who believed himself to be the sole bearer of knowledge among the ignorant and inferior. Only Sicard's pointing hand and the boy's writing hand can be seen, as if to preclude even the possibility of a gestural sign. In the small group of deaf students looking on, one palm can be seen but the signing hands remain inactive. The source of Enlightenment is the Institute itself, not the language used by its pupils.

Behind, a figure stands with his arms folded. His frock coat distinguishes him from the other pupils and he stands in the place formerly occupied by Jean Massieu. It is in fact a portrait of Laurent Clerc (1785–1869), one of the most remarkable figures in deaf history (fig. 17). Deafened at the age of one, Clerc was an early student at Sicard's Institute and learned with an extraordinary facility. He was later to accompany Thomas Gallaudet to Hartford, Connecticut, and help establish deaf education in the United States. At the time of Langlois' painting, Clerc was an *instituteur* at the Institute, one of Sicard's assistants who in fact did the majority of sign language instruction. Clerc's abilities in written French, signing skills, and official position combined to make him unofficial leader of the deaf at the Institute. In that capacity, he wrote to Langlois and complained about his picture, after the Comte de Montalivet, Minister of the Interior, had decided to purchase it and donate the work to the Institute. Clerc's critique of Langlois' work is the earliest authenticated art criticism by a deaf person and it confirms the interpretations I have advanced in this chapter. Clerc wrote that the deaf students found that the picture, "although making the greatest honor to your talent, does not, however, conform perfectly to their desire and still leaves something to be desired. *The young Grivel is hearing-and-talking and has ignored the benefits which he has received at the Institute. By this double title, he is no longer part of the class of the deaf* [original emphases]. What would be said if he was seen there after this act of ingratitude? The deaf demand therefore that his portrait be effaced and that a deaf student from the school take his place."[137] Clerc's comments are remarkable. For the first time, the repre-

17. *Portrait of Laurent Clerc*
(Paris, INJS)

sentation of the deaf steps out of symbolic anonymity and into the history of a community. Grivel was a student with a record of bad behavior. On an earlier occasion, Sicard instructed Clerc to write out a reprimand to Grivel for all the students to read, after the boy had incited a group of pupils to get up at 4:30 am and would not go back to bed. Later that day, Grivel skipped Mass and left the Institute, without telling anyone where he was going. He spent the rest of the day on bread and water for his pains. Under the circumstances, it is hard to decide if his expulsion was really due to his being able to hear or to his conduct. But if he could hear, then Grivel's demonstration of writing skills was unremarkable, and Clerc's request would have given the painting greater force. As he pointed out, it was only a question of altering the face.

Clerc continued: "We hope . . . that *you will wish to make* these *changes; without them,* this picture will not be agreeable to us, and we will *not consent to confirm to the minister the object of our petition and to write to him a letter of thanks.*" He also demanded changes in his own portrait. He did not question the likeness, and as his British entry visa of one year later identified him as five feet four inches, with brown hair and

blue eyes, it seems likely to have been a good one. His objection was more general: "I have more of the air of a strange spectator, than that of a true deaf person. One would desire that I be represented writing something on the blackboard that would transmit to posterity the eternal gratitude of the deaf to those two friends of humanity, M. l'abbé de l'Epée and M. l'abbé Sicard." Clerc's clear sense of entitlement in demanding retouching from Langlois is noticeable. He spoke as any patron of a portrait might, not as the recipient of a charitable bequest. His letter testifies to the creation of a group of deaf students at the Institute, who believed themselves to be the true class of the deaf—educated, literate, and signing. These deaf people were not simply disciplined by the Institute but were also empowered by it. Clerc called for a work that, rather than using the deaf as examples of social and moral dilemmas, made their achievements the subject of History painting in itself. Indeed, by the fall of the Empire, Deseine was only the most senior of the deaf artists. The engraver Aubert had petitioned the government for a travel grant to study in Rome, while the Martin brothers worked as painters in Marseilles, and Claude Wallon was known as a mosaicist.

This tension between the deaf themselves and their representation is an appropriate figure for the situation of the Institute, the artistic use of sign, and the politics of regeneration in Napoleon's last days. All had roots within the ancien régime, yet all had been decisively changed by the Revolution. The unresolved, perhaps unresolvable, revolutionary dilemmas over language, sign, and art continued to set the terms of debate until the 1880s. The Empire had created new mechanisms of disciplinary surveillance and control, but it was far from clear how the Institute for the Deaf would fit in to these apparatuses. Its pedagogical practice and administration were a curious fusion of Enlightenment, Revolutionary, and *Idéologue* theory, which had yet to find a permanent shape. A new community was being formed within the institution, in ways that had not been anticipated by any of its founders, but were to have a decisive impact on deaf culture. From this point on, the deaf were not content to be the subject of representation, but used painting, sculpture, engraving, and photography as a means of representing themselves. Regeneration was an inevitably utopian project, but it had real and worthwhile consequences. But the future belonged, not to regeneration, but to its cousin pathologization.

3 THE MIMICRY OF MIMESIS

The nineteenth century marked a radical break in the history of the deaf and of deafness. Paradoxically, the pathologization of deafness was concomitant with the beginning of a deaf cultural politics. The metaphorical use of deafness and sign language in art gave way to a school of deaf artists. A deaf cultural elite sought to evade the disciplinary norm by camouflaging themselves as the *semblables* (fellows or likenesses) of the hearing, redefining sign language not as Other but as "mimicry." The mimicry referred to was not of speech, but of the ideas that precede speech, presenting sign as almost the same as spoken language—but not quite.[1] While mimicry also had an essential political dimension, art was one of the key weapons in this more nuanced cultural politics. By the end of the century, a school of French deaf artists had developed, numbering over ninety exhibiting artists in France alone, who used the inevitably silent media of the visual arts to demonstrate to the hearing majority that deafness was no hindrance to the intelligent perception and representation of exterior reality. Such an artistic style can be thought of as a mimicry of the mimesis of the official Salon style, raising interesting questions about both modes of representation. For the appropriation of the Salon style by deaf artists produced not just an imitation of official art, but brought deafness itself into view. Unlike the depiction of the deaf by David's students, this vision of deafness was proposed by the deaf themselves and was given a positive valency. Deaf artists produced a significant and, at the time, widely recognised body of work. Deaf artists exhibited at the Salon, competed in the Rome Prize of the Ecole des Beaux Arts, and were even awarded the Légion d'Honneur. This chapter examines the experience of deaf artists in working within this double session of mimicry in the early nineteenth century.[2]

The Salon of 1814 was a splendid affair, with the leading artists of the day, such as Gérard, Gros, and Guérin, mounting what were in effect small-scale retrospectives under the aegis of the restored monarchy which inevitably received the lion's share of reviews. However, the reviewer R. J.

Durdent found time to remark upon the Salon debut of the deaf painter Paul Grégoire, a pupil of the abbé de l'Epée, who submitted a treatment of *The Temptation of Saint Anthony,* a popular nineteenth-century theme. Durdent noticed the affinities of Grégoire's work with Teniers' treatment of the subject in the Louvre, but was full of praise: "But otherwise, let us note that the artist is a deaf mute. As a result, he can only excite more interest; and one would like to think that he has found in his talent a secure means of not finding his fate too burdensome. It seems to me that we can find here a good and true philosophy."[3] His comments established a precedent for the reception of deaf artists in the early nineteenth century. Their work was to be closely connected with the artistic canon and tradition, rather than avant-garde innovation, and was often well-received, in terms that make it clear that reviewers were aware of the artists' deafness. Furthermore, the art of the deaf was seen, like sign language itself, as holding an important philosophical message.

In the same year, the close connection between David's studio and the Institute for the Deaf can once again be observed. Mathieu Cochereau (1793–1817), usually known by his pseudonym Léon, had worked with David since 1810. He was also the nephew of Prévost, the creator of the panoramas upon which Cochereau worked daily. This background helped give him a sense for the popular and his famous *Interior of David's Studio* (Paris, Musée du Louvre, 1814) was immediately successful, despite the disdain of Neo-Classical critics such as Landon: "If M. Cochereau contents himself with the acclaim he is to receive from the public without seeking to enlarge the sphere of his talent, he can be assured of a complete success."[4] In 1815, the state purchased this work for the not inconsiderable sum of 3600 francs and Cochereau then turned to the deaf in an attempt to find a similarly successful follow-up. His next projected work was to have been a depiction of one of Sicard's public demonstrations of sign language, for which the sketch survives in Chartres' Musée des Beaux-Arts.[5] But the work was never finished, due to Cochereau's early death in 1817.

Remarkably, the deaf artist Augustin Massé produced what one might call a finished version of the sketch in his *A Public Demonstration of the Deaf* (fig. 18). In composition and organization, Massé's work is clearly derived from Cochereau's sketch, whereas neither resemble a contemporary print of the demonstrations from the *Tableaux de Paris* (fig. 19). In many respects, the images are remarkably similar. But Massé supplied more precise details than Cochereau, such as the busts of Epée and Sicard on either side of the blackboard, more deaf pupils on stage, and the depic-

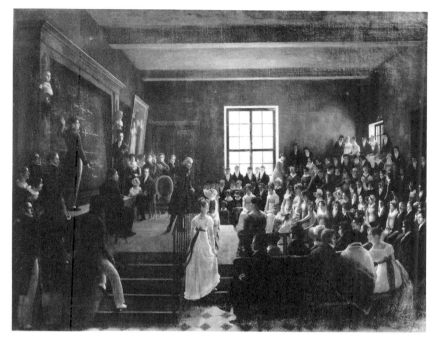

18. Augustin Massé, *A Public Demonstration of the Deaf* (Chartres, Musée des Beaux-Arts, 1814)

tion of an incident in the audience involving one man showing another the way out. The left wall is less acutely in perspective than Cochereau had sketched it, bringing the back wall "closer" to the spectator, with the consequence that the window in that wall seems to dominate Massé's scene to a greater extent. Langlois' 1806 portrait of Sicard hangs on the wall beyond the blackboard, a visual representation of the events actually taking place on the stage. It is directed towards the hearing audience and is almost invisible to the waiting deaf in the wings, indicating the lack of signification it held for the signing deaf. The presence of sign language is clearly indicated by the *répététrice* in front of Sicard and the two seated women who face Massieu to convey questions to him in sign language. Further, in the center of the painting a young girl seems to be trying to sign to a seated priest who nonetheless ignores her. The figure of Massieu stands center stage and, in contrast to the Langlois, his saying on memory remains inscribed on the blackboard, together with a definition of hope. As in Langlois' work, the double signification of *tableau* as blackboard and picture reinforces its importance and, in effect, constitutes the classic trope of the picture within the picture, but to different effect. Various

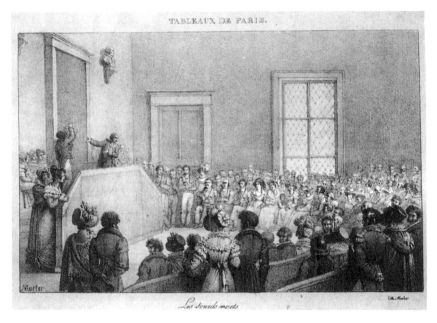

TABLEAUX DE PARIS.

Les Sourds muets

19. Marlet, *The Deaf* (Paris, INJS)

mathematical figures, such as squares and circles, can be seen as well as a
version of Sicard's construction of human nature:

"*Cœur* [Heart]—*Esprit* [Spirit]

|

Ame [Soul]

|

Homme [Man]"

This diagram is an excellent summary of Sicard's philosophy of the deaf.
He believed that, although the deaf knew the emotions of the heart, their
spirit was dormant without recourse to language, or, more exactly, speech.
By awakening this sensibility, Sicard considered that he enabled the deaf
to access their souls, as it were, and hence achieve full status in the human
race. For Roch-Ambroise-Auguste Bébian (1789–1839), the first hearing
educator of the deaf to learn deaf sign thoroughly, the task of the educator
of the deaf was similarly "to awaken the spirit so that it may best direct the
heart."[6] One of the prime objectives of deaf cultural politics was to expose
this reductive schema as philosophically and intellectually mistaken. Its
presence on the blackboard is symptomatic of that politics.

 The room is crowded with the Parisian bourgeoisie, fashionably dressed

as if for the theater. Many heads are turned in conversation with their neighbors, rather than attending the demonstration, for this is the audience of the *loges* and not that of the *parterre*. Each head is closely observed in a portrait fashion that seems to be derived from David's *Coronation of Napoleon I*. But the image is most remarkable for its depiction of the scene as a deaf student might have seen it. As a result of the changes in pictorial space from Cochereau's sketch instituted by Massé, there is a sense of width and space that is almost alarming, instead of the narrower perspectival box traditionally prescribed. The viewpoint feels distanced from the scene because of the very awareness of the artificial construction of pictorial space. Similarly, the lighting is not from the side, as was traditional, but from the window confronting the spectator, again given greater emphasis by Massé. Thus, for the hearing audience depicted, the scene was "correctly" lit, as it would have been for Langlois, but for the imagined deaf participant a different light is seen. The luminosity of the window suggests a point of escape from the confines of being an object on display. Massé's work conveys the anxiety of being seen, caught in the full glare of the light so as to best be observed, with only the writing of Massieu as a means of response to an inattentive audience. Massieu stands as the man in the middle, caught between hearing society and writing which was increasingly seen as inextricably linked to speech. Similarly, he is isolated between Langlois' History painting and the spectators in front. The anxiety of this painting came from the knowledge that the possible space between such binary poles was closing.

It might be asked what authorizes such an allegorical reading of the image: is there a sense in which such commentary falls into a kind of oralist practice in making the deaf "speak"? Though such a risk is inevitably present, several factors mitigate in favour of interpretation over simple description. As soon as the deaf gained access to print, they were extremely hostile to the public displays of Epée and Sicard. Ferdinand Berthier, the doyen of deaf intellectuals, described the displays as nothing more than "theatrical representations."[7] Bébian, his professor and friend, was equally scathing: "It is not difficult to teach a deaf-mute to write words in the order in which they are dictated; the public blindly admires; but the conscientious instructor cannot content himself with this deceitful appearance. He will wish that the pupil understands everything which he reads and writes."[8] Massé, a contemporary of Berthier and a pupil of Bébian's, appears to have shared these critical attitudes to the sign language displays. While Laurent Clerc had acted as the spokesperson for the deaf students in response to Langlois, Massé created an artistic response to

Cochereau, responding to Clerc's earlier call for a responsible image of the deaf and of Sicard. Massé presents the view from the "other" side of the silent screen of deafness, the deaf view of the deaf being observed.

This work partakes of, but is also different from, conventional attitudes to artistic representation in the nineteenth century. Artistic discourse in the period was much exercised over the question of distinguishing (poor) copies from (good) imitation. Good imitation was often referred to in philosophical terms as mimesis. Mimesis was used by Plato to refer to the process of duplication of an original model in which the mimetic operation is neutral. A mimetic work was praised for its skill in imitation, providing that it was not simply a copy. But, as Derrida remarks, "the diverse logical possibilities opened up by the concept of *mimesis* . . . are numerous, paradoxical, and disconcerting enough to have unleashed a rich system of combinations and permutations."[9] Massé's work demonstrates these possibilities, for it falls between mimesis and imitation. If it was not a copy of Cochereau's sketch, it was sufficiently derived from it to prevent one calling the picture a mimetic imitation of the real. I would like to suggest that in keeping with the term for sign language used by the deaf of the period, we envisage this artistic style as *mimicry,* and that those who practised mimicry will be referred to using the nineteenth-century term "mimicker."

MORALITY, SIGN, AND PATHOLOGY

In 1813, Paillot de Montabert, the author of a vast theory of painting, devoted an entire volume to gesture which dismissed the former tradition of drawing gesture either from modern society or the deaf as producing art in which: "all the divinities have had their little finger turned back for more than a century, recalling both the *boite à mouches* and the snuff box."[10] In taking their sources from the streets and from the common people, artists had made use of other such undignified gestures, including crossed legs, interlaced hands, folded arms, and so on. It was no coincidence that Paillot dated the decline of gesture in art to the moment of the Moderns' triumph in the Academy. He was shocked to see that: "Dufresnoy, de Piles, and Leonardo da Vinci went even further: they recommended the imitation of mutes in their pantomime, because, according to these writers, mutes being deprived of the significations of speech, know best how to make themselves understood by gestures; the views of the spirit are one thing but the affections of the soul are something else again;

by this means you will paint nothing other than the deaf who could never be the man of nature."[11] Paillot displayed an evident familiarity with these texts, indicating by the vigor of his rebuttal that they were far from antique curiosities in the nineteenth century, but an active part of artistic theory. For Paillot, gesture could only be derived from the imagination, using the antique as its sole resource. Deafness had lost its philosophical dimension and became just another disease. The gestural sign language of the deaf, far from being the privileged source for artists that it had been since Leonardo, now represented nothing more than a pathological symptom. The Empire had sought ever more transparent means of communicating with the mass of the people but rejected the Enlightenment hope of a universal gestural language. The gestural sign failed to achieve a place in the new sciences of man and no longer had anything to offer the Classical (hearing) artist. In the nineteenth century, culture was to be consumed verbally at all costs.

This emphasis on speech was in part given its power by the pathologization of deafness that had occured during the French Revolution. As medicine began to construct notions of disease as pathological in binary opposition to a normal, healthy body, deafness itself came to be seen as a disease to be cured, and hence pathological. Since the Bourbon restoration in 1814, the Baron de Gérando had sat on the administrative board of the Institute and became its director in 1822. He continued to medicalize the Institute, turning it from a school into a clinic. Two tasks awaited the would-be doctor of deafness: a medical definition of deafness and a cure. It was Itard, the Institute's doctor, who addressed these questions and discovered the difficulties involved. It was obvious that a person who was profoundly deaf and someone with perfect hearing formed medical opposites. But at what point does the person with some residual hearing become known as deaf? Nineteenth-century medicine came to theorize that there were degrees of deafness, such as half-deaf, a third deaf, and so on, which were more or less susceptible to treatment, but such terms did not help resolve problems of classification. On 26 September 1807, a deaf boy named Lefebvre was admitted to the Institute. Sicard soon found the boy's behaviour "intolerable" and a bad moral influence on the rest of the pupils and ordered a re-examination of his right of entry to the Institute.[12] The doctor's report from his native Le Havre claimed that, although he could not talk, Lefebvre could hear "completely." As his father Guillaume had been killed in naval action in 1803 and his mother was reduced to poverty, the boy was admitted. The Institute prided itself on its ability to render the mute speaking. Now that grounds were required to

expel him, Itard focused his investigation on the organ of hearing. If Lefebvre could hear sufficiently that his mutism was not a consequence of deafness, the administration would then feel justified in expelling him. But, as Itard reported on 30 January 1808, "it was extremely difficult to determine with regard to a being who still had no means of communicating his ideas or rather his sensations and who has anyway a small susceptibility for attention, to what point he could hear [*entendre*]." Itard determined that he looked like "a being disgraced by nature," a circumlocution for deaf, and placed him under "surveillance." He discovered that Lefebvre would repeat the word "*oui*" whenever it was spoken to him, even if it was in an inaudible manner but concluded from this that "his intellectual faculties are no more susceptible of improvement than his moral faculties." One might argue that Lefebvre was in fact learning to lipread and imitate speech in the manner approved by the Institute but Itard's surveillance was not designed to achieve this result.

From this point forward, deafness was cross-referenced with the new terminology of mental illness devised by Philippe Pinel. Lefebvre was excluded from the Institute because he was classified an "idiot," someone whose reasoning *esprit* could not be revived under any circumstances. By 1853, a report to the Academy of Medicine on the deaf noted that: "All those who have seen and observed people born deaf can, like us, verify that this infirmity is often found to be connected to a more or less marked state of debility in the organs of the brain."[13] Indeed, all but one of the fifteen expulsions recorded in the smaller Institute for the Deaf at Bordeaux between 1840 and 1849 used as grounds the tautologous rubric "incapacity, idiotism."[14] The double meaning of the French verb *entendre*, meaning both to hear and to understand, inevitably intertwined discussions of the ability to hear and to reason. Pinel described the idiot as suffering from dementia, leading to an incurable "automatic existence," although it was the most common of mental illnesses. His classification recalls Sicard's definition of the uneducated deaf as automata, and the two men had been colleagues at the Société des Observateurs de L'Homme.[15] Indeed, Pinel claimed that almost all "idiots" were deaf. Itard simply argued that idiocy was not accidental but inherent in many cases of deafness and thus arrived at a very convenient form of diagnosis. If the patient showed signs of improvement in understanding and intelligence, the disease was simply deafness and, if not, deafness compounded with idiocy. Diagnosis thus depended on the results of treatment not on the invisible and unmeasurable deficiency of hearing it was supposed to address.

A new term *surdi-mutité* was coined in order to register the medicaliza-

tion of deafness, which one might translate as deafy-mutism to retain the strange sound of the neo-logism.[16] Itard was diligent in seeking a cure for *surdi-mutité,* despite his difficulty in diagnosis. He attempted the use of injections, electricity, astringents, and even the use of hot irons in his efforts to overcome the "blockage" in the ears he believed to be impeding hearing.[17] Horrific as these "treatments" may seem today, it is only reasonable to note that they were no more or less barbaric than other nineteenth-century medical procedures in the era before anaesthetic. It is our knowledge that they could never have had a beneficial effect that makes them seem so disturbing. The deaf professor Pelissier later wrote angrily: "All those of my brothers in misfortune who were *operated* upon had their intellectual faculties deranged and they continue to feel the effects."[18] Itard came to realize the deleterious effects of his actions and later apologized for them: "One can regard a cure, properly speaking, for congenital deafness as impossible, so rare is it and so great is the number of deaf people who have been uselessly tormented to render them a sense which nature has pitilessly denied them. I accept the share of this reproach which adheres to me."[19] But Itard did not repent of his diagnostic procedure, arguing that the deaf were not susceptible to mania or delirium because of "the inactivity of this faculty of the intelligence [*entendement*]."[20] In Itard's view, a person without *entendement* was either deaf or an idiot, the difference being it was possible to do something for the former but not for the latter. In light of this diagnostic connection, it is less surprising that the deaf and the insane were dealt with by the same department of the Ministry of the Interior throughout the nineteenth century. The stigma of deafness was doubled by that of madness with which it had no necessary connection whatsoever.

Although the chances of curing deafness were known to be very low, Itard's medical successor at the Institute, Prosper Ménière, wrote in 1853: "The deaf believe that they are our equals in all respects. We should be generous and not destroy that illusion. But whatever they believe, deafness is an infirmity and we should repair it whether the person who has it is disturbed by it or not."[21] His comments came at a meeting of the Academy of Medicine, which discussed a Second Republic (1848–1852) initiative to cure deafness using the methods of one Dr. Blanchet. Blanchet had revived Itard's discredited belief that everyone has some hearing, even if very little, and that the faculty could be improved with practice, just as muscles can be improved by exercise. The Republican government had been keen to adopt his therapy, for it held the promise of eliminating deafness as a category and restoring the deaf to oral society. Despite Itard's

recantation of his own method, a section of the Academy also supported the proposal. One Dr. Bouvier reported—after one week's study—that it was "a sort of primitive language; its expressions resemble the first language of a child, that of peoples little advanced in civilization . . . [and] Chinese."[22] Sign language was taken to be a symptom of the deaf patient's immoral refusal to be cured and could have no place in the advanced civilization of the West. Even active supporters of the deaf gave credence to such ideas. In a sermon given in 1824, the American Thomas Gallaudet described the uneducated deaf as "heathen": "I only crave a cup of consolation, for the Deaf and Dumb, from the same fountain at which the Hindoo, the African and the Savage, is beginning to draw the waters of eternal life."[23] Although Gallaudet defended sign language and the deaf, his cultural presumption was still of their primitive status. It was this notion of primitivism that grounded the medicalization of deafness and sustained it in the face of practical failure.

MIMICRY, COPYING, AND ORIGINALITY

The pathologization of deafness presented deaf artists with an overriding imperative to demonstrate the "normality" of their perceptions and their re-presentation in art. By 1838, France had legislated the concept of the "normal man" into existence by establishing a nationwide asylum system for the insane whose intentions were widely recognised as being "simultaneously a law of philanthropy and general police."[24] The patient's sanity was to be judged by the professionals of the asylum system in comparison with a notion of what the normal person might do in any given situation. French deaf artists had to operate under this law of general normalization, placing them in a tortuous artistic dilemma. The deaf artist had to be both normal and original at the same time, an impossible conundrum. To be a deaf artist was, in nineteenth-century terms, virtually an oxymoron. This belief was strikingly expressed by the Baron de Gérando in his magisterial two volume work on deaf education: "One hears of several deaf people who have become distinguished painters; they still exist today; but although they are skilled in execution, in everything which relates to imitation, they fail in original composition and can never attain to the ideal of art."[25] This denial of artistic creativity depended upon and reinforced the perception of the deaf as "savages," for James Hunt, founder of the Anthropological Society in England, attributed the same failure to Africans: "The Negro had had the benefit of all the ancient civilizations, but

there was not a single instance of any pure Negro being eminent in science, literature or art. . . . What civilization they had was imitated, and they had never invented an alphabet nor reasoned out a theological system."[26] Needless to say, part of the construction of that civilization was the belief that no "savage" could ever master it and any evidence to the contrary was, as de Gérando showed, simply dismissed as an anomaly. The predicament of deaf artists was analogous to that in which women artists were deemed capable copyists but no more: "The female sex possesses a remarkable talent for translation, adaptation, interpretation. In the domain of imitation, she is inimitable. . . . Her natural inclinations lead her less toward invention than toward imitation. Where receptivity dominates, originality is weak."[27] For the deaf, for the African, and for women, originality was a category from which they were excluded by definition, reinforcing the long-lasting and complex analogies between these three groups, which had originated in the myth of the harem and were to be of such importance in the later nineteenth century. As a further indication of the fluidity of such designations of pathology, as the nineteenth century progressed the deaf were increasingly compared to the Jews, rather than to Africans, but in exactly similar terms. As the Jews came to represent the internal Other for France in general, they increasingly became the model for understanding what one might call other Others, such as the French deaf.

It was in fact the first and most important maneuver of mimicry that it sought to valorize gestural language on the same grounds as those who tried to dismiss it.[28] The intricate theories of mimicry have received little attention from historians of deaf culture, except insofar as they provide ammunition for one or other side of the language debate, with the consequence that neither the sophistication of the culture nor the value of its artistic production has been fully appreciated. In the first half of the nineteenth century, the deaf community formed by the Institute sought to have their language recognized in its own right. Pointing out that Epée's methodical signs required three signs to express an idea, compared to only one in what they called *la mimique* (mimicry), the native sign language of the deaf, the deaf writer Ferdinand Bérthier claimed that: "Mimicry, on the contrary, is the admirable language of nature, common to all men, because it does not reproduce words but ideas, created by need, imagination, genius and, thanks to its universal character, understood by all peoples."[29] Rather than claiming sign language to be a type of language different from spoken languages, Berthier rewrote them as being almost exactly the same. For, just as spoken language was held to represent the

idea itself, so Berthier claimed that mimicry represented the pure idea, in imitation not of speech, but of the signified itself.

Mimicry was understood as a supplement to spoken language in a manner that took account of the major changes in linguistic theory that followed the French Revolution. The philological revolution of the early nineteenth century argued that, as Foucault put it: "The whole being of language is now one of sound."[30] Rather than investigate the origins of language, the new science of linguistics sought to discover the roots of words through a history of sound, examined in its inflections and derivations. The sensualist philosophy espoused by Locke and Condillac was rejected as outdated, for, as Victor Cousin remarked in 1829, their work entailed: "the negation of all the great truths that escape the senses and which reason alone discovers."[31] Furthermore, racial theory in France held that humanity was polygenetic, or composed of several races, meaning that there was no one original creation of language.[32] The eminent linguist Charles Nodier consequently argued that, just as there were many races of man, so too were there many natural languages. Each was proper to its own community and determined by the new science of *milieu*, composed of the study of climate, geography, and race: "Each people has thus made its language like an individual man, according to his organization and the predominant influences of the locality in which he lives."[33] If linguistics removed sign language from its history, it also opened the door to mimicry. Rather than the indispensable step towards spoken language theorized in the Enlightenment, mimicry was now one language among many.

In his essay comparing sign language to the "natural" language, Bébian saw gesture as an original, natural language to which voice was an accessory: "The gesture, without any auxiliary, expresses both the idea and the relations [*rapports*] of ideas."[34] Mimicry was thus the answer to the contemporary scholarly quest, described by Foucault, for "the exact reflection, the perfect double, the unmisted mirror of a non-verbal knowledge."[35] For Berthier mimicry offered that doubled image in which: "thought is reflected whole as if in a mirror, complete with its most delicate contours. It materializes there, so to speak."[36] Mimicry refused to be pathologized as speech's Other, but used the arguments of phonocentrism to justify sign language. Mimicry was both a part of, and an accommodation with, linguistic theories that, although prioritizing speech, allowed for an original moment of meaning that had dispersed into numerous different languages, analogous to the polygenetic formation of the human races.

Mimicry was nonetheless not a perfect double. Deaf people were

often described as being "separated by a murky veil from their fellows [*semblables*]."[37] In Homi Bhabha's important analysis of the ambivalence of the colonial mentality, they were "almost the same but not quite."[38] Bhabha's formula to describe the colonial situation is clearly an apt one for the so-called "savage" deaf, one of the many human races then believed to exist. Mimicry was presented as the supplement to a language that has full presence in speech, but the logic of the supplement cut both ways. This destabilizing characteristic of the supplement gave it a subversive and dangerous force, undercutting Berthier's argument that mimicry could and should exist in a stable relationship to speech,[39] being "that primitive language of which the infant makes use instinctively before and after the appearance of its nascent reason." In this sense, it was something prior to speech, whose fullness was not disturbed by this addition. But he continued: "It slips, at a more advanced age, into daily conversation, unknown to the speakers and becomes, without their noticing it, the obligatory auxiliary for people who shine at the bar, at the political hustings, on the throne, as on the stage, whether tragic, comic or even comic opera. What is an exactly reproduced ballet, if it isn't above all an excellent lesson in mimicry?" Here, the supplementarity of mimicry reveals the lack in spoken language, that is, its inability to present the full and complete representation of the idea, pre-vocal and fully known. Speech in its most crucial, as well as its most everyday moments, lacked, in Berthier's view, the means to represent itself without being completed by the addition of gesture. Mimicry's relationship to speech was thus crucial for the production of meaning, and any attempt to pathologize or eliminate sign language would thus have profound consequences for speech itself.

In much of the recent recovery of "hidden" histories, like that of the deaf, it has been argued that the Other was marginalized within the social order. But one of the goals of nineteenth-century deaf culture was to resist marginalization. Jacques Lacan argued in a different context that: "the effect of mimicry is camouflage. . . . It is not a question of harmonizing with the background, but against a mottled background, of becoming mottled—exactly like the technique of camouflage practised in human warfare."[40] Mimicry claimed to be the equivalent of speech in order to permit such maneuvers in the open, for camouflage helps prevent detection but also permits an undetected attack. Deaf cultural politics proceeded in the open, under the camouflage of mimicry, with considerable success. Mimicry's strategy was not to argue from the margins but from the center, the absent center upon which discourse depended but which could not be fixed.[41] Marginalization requires a strong, defined center

capable of articulating difference, but in itself this center can only be a construct and is therefore capable of appropriation. The supplementary relationship of center and totality meant that mimicry, itself a supplement, could attempt to insert itself into the constant exchange between the center and totality, which constitutes the functioning of structure in society. For the totality can only be known in relation to its center and vice-versa. The very ambiguity of the idea of the center of society made it difficult to construct a secure margin of those to be excluded, even with the aid of the disciplinary institution. To be sure, this position is a "weak" one, yet it was successful in enabling the survival of a signing deaf community for eighty years in a hostile climate.

The connection between these apparently disparate systems of signification—speech and sign—was made by analogy. Although sign language had previously been reproached for its dependency on metaphor, mimicry claimed to be constructed on secure principles of analogy. In the *Rhetoric,* Aristotle observed that "of the four kinds of metaphor, the most taking is the metaphor by analogy."[42] As we have seen, Condillac argued that all signs operated by means of analogy, an argument redefined by Kant: "If we wish to make a division of the fine arts, we can choose for that purpose, tentatively at least, no more convenient principle than the analogy which art bears to the mode of expression of which men avail themselves in speech."[43] Whereas for Condillac, all signs were analogous to each other, Kant sought to limit and control analogy by linking it with speech. For Bébian, similarly, the sign "fixed" its meaning through analogy: "The analogy that exists between ideas is found again in the corresponding signs, leading from one to the other; and the accuracy of the sign guarantees the accuracy of the idea."[44] This principle caused de Gérando to relax his strictures and conclude that: "In effect, the deaf, united with one another, have instituted a language of signs, a true conventional language, although founded upon analogy."[45] Mimicry thus had a history, as well as having been a natural language. In effect, mimicry moved sign language from nature into culture. The theorists of mimicry argued that it was natural, not because it preserved a pure historical record of the lost original language, but because it maintained a natural connection between the sign and the idea: "Metaphorical language, in matters of style, can be called *natural,* because it is the first product of the play of our intellectual faculties; proper language is also *natural* in a sense, being more similar to the truth of things."[46] As long as the "thread of analogy" between the sign and the idea remained intact, mimicry could evolve, transform itself, and remain natural at the same time.[47]

In search of that thread, De Gérando's treatise abounds with metaphors for the deaf and their language, whether to coins, books, armies, or, most intriguingly for my purposes, the visual arts: "Drawing and the language of action, or mimicry . . . are founded on imitation and analogy."[48] The theory of analogy drew mimicry closer to principles of artistic creation and expression than to early nineteenth-century linguists who were seeking to reduce the doubled and arbitrary nature of the sign to a natural unit of sound. Mimicry operated instead on what de Gérando called a "double scene" for the provision of ideas to the soul: "If the deaf person does not have the same provision of ideas in common with us, at least he has the same materials to make that provision in common with us. These materials are in part exterior, in part interior. The first type takes in the scene of the sensible universe; the second that of the hidden world of which our soul is the theater."[49] For both the deaf and the hearing, ideas were the result of an operation in the theater of the soul by the interior spirit on artifical signs derived from exterior reality. The consequent "social commerce" was no different in principle for those with hearing and those without. Signs operated in the visual space of a theater within the mind, requiring a certain space for the operations of the judgment. The soul unraveled the distinction between the signifier and the signified to arrive at a natural perception, and even if this gap was small, its existence was central to this doubled notion of perception.

This distinction between signifier and signified remained active in the arts of the early nineteenth century, leading Bébian to argue that the natural language expressed in mimicry was "the principle of the fine arts; it is to this that sculpture and painting owe their most beautiful effects. It is through the knowledge of natural signs and their connections with sensations [*sentimens*] that the artist brings both canvas and stone to life."[50] By process of analogy within the double scene of perception, the user of mimicry was an artist, just as the artist used mimicry to capture the natural. De Gérando considered that: "Drawing, considered as a painting of ideas, and symbolic or ideographic writing are only two successive degrees of the same language of analogy, which beginning with the imitative description of sensible forms, lifts itself progressively to the metaphorical expression of abstract and intellectual notions. . . . [Thus] the language of action has a close affinity with drawing considered as a language."[51] Both drawing and mimicry proceeded from the primitive imitation to the complex intellectual metaphor. Throughout the nineteenth century, deaf artists created a direct analogy between art and the deaf sign, both at one remove from the idea itself, which both motivated and sustained their work. Within the terms of mimicry's own theory, there was an analogy

between the culture of mimicry—by which is meant sign language, deaf cultural politics, and the deaf community within and without the Institutes—and the artistic production of the deaf, even if no gestural sign was visible in the artwork. Such analogies were subject to the same limitations and problematics as the notion of mimicry itself, but they were the correlative product of such work not an interpretation with the advantage of hindsight. Deaf artists sought to use the double analogy of their work to sign language and to their own hearing loss as a statement of their cultural politics.

Let us consider the following passage by Laurent Clerc, who arrived in America with Gallaudet in 1816, and was soon involved in campaigning for funds from the state legislature in Connecticut.[52] His speeches, which he wrote out for others to read and had printed at the time, serve as a summary of deaf culture in the period:

> He knew that every language was a collection of *signs* as a series of drawings is a collection of *figures*, the representation of a multitude of objects and that the Deaf and Dumb can describe every thing by *gestures*, as you paint every thing with *colors*, or express every thing by *words*; he knew that every object had a *form*, that every form was capable of being *imitated*, that actions struck your sight, and that you were able to describe them by imitative gestures.[53]

Drawing, painting, and sign language were thus linked in a signifying system that claimed equal power to speech in terms derived not from linguistics but from artistic theory. Clerc defended the arbitrary nature of the sign upon which sign language theory depended by highlighting the distinction between color and line in art. The visual sign itself was a figure, composed of color and form, which the gestural sign could mimetically imitate. Such terminology invites a comparison with the famous line versus color debate that dominated French art in the first decades of the nineteenth century. Sign language itself was classified by de Gérando as "classic," in opposition to the "ordinary" education favored by the oralists: "[T]his study takes from the beginning the character of classical education . . . [in which] all the theory of language, the principles of a healthy metaphysics take on a high degree of importance."[54] Mimicry valorized itself as classical and of the Enlightenment, a position that led it into a later opposition with certain varieties of modernism. Finally, it is important to note that Clerc's address was a political appeal for funds from the Conneticut legislature. From the outset, mimicry was a political maneuver.

This complex interaction was strikingly expressed by perhaps the most

famous of deaf artists, Francisco Goya. Goya lost his hearing in 1792, meaning that the canonical Goya works are all the work of a deaf artist, a point not lost on his friend and critic Juan Antonio Ceán Bermúdez: "The deaf and dumb are usually notable painters and our own Goya, whom God preserve for the glory of Spanish painting, was not particularly outstanding until he lost his hearing."[55] Goya's deafness was often noted by his contemporaries but, outside Spain, subsequent critics have rarely used it as an interpretive category for his work, preferring to discuss his alleged schizophrenia, syphilis, or even anal-sadistic fantasies.[56] Once again, Goya's deafness has been "invisible" to those who have studied him, in contrast to recent analyses of Van Gogh's madness, Monet's shortsightedness, or Berthe Morisot's gender.[57] Clearly, in the age of the "death of the author," caution is required, but it is noticeable that some biographical details, such as deafness, have been far more easily discarded than those of, for example, race or gender. Goya's hearing loss was central to his life and, as befits an artist from the country of Navarette and Bonet, he evidently knew some kind of sign language. In a letter to his friend Zapater, Goya described a journey he took with Godoy, remarking that the latter had "learnt to speak with the hand, and neglected to eat in order to speak with me."[58]

In his famous *Saturn Devouring His Children* (fig. 20), Goya vividly portrayed the pathology of genius as represented by Saturn. Saturn is far from a sympathetic figure in this work, which depicts the destructive capacity of genius whose achievements are never without cost. The painting comes from Goya's home, known as the *House of the Deaf Man*. This overlap of concerns is no coincidence and Goya's work can be read allegorically, as expressing the anger of an artist who has become aware of the tension between his construction of himself as an artist and his existence as a deaf man. Indeed, it faces a work sometimes known as the *Old Deaf Man*. Saturn was a well-known allegorical figure in the late eighteenth and early nineteenth century. The linguist Antoine Court de Gébelin argued that the mythology of Saturn was so barbaric that it could only be considered in terms of allegory: "If in the history of Saturn, there is one aspect that must make us suspect that the whole thing is nothing but a tissue of allegory, it would be his barbaric conduct towards his Brother, his Father, and his Children."[59] Goya depicted Saturn at exactly one of those moments, the cannibalism of his children, making an allegorical reading not just possible but inevitable. Given the mythological connection of Saturn to the invention of speech, and mimicry's own status as a language of analogy, one dimension to a reading of this painting must

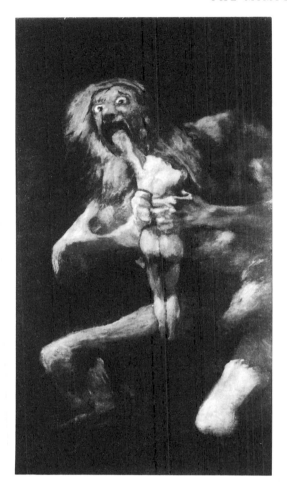

2C. Francisco Goya, *Saturn Devouring His Children* (Madrid, Prado, n.d.)

turn on the artist's deafness. Ceán Bermúdez certainly thought so, and in his analysis of Goya's late work *St. Justa and St. Rufina,* he commented on the boldness of the figures' outline:

> Goya overcame these difficulties and others too by giving the matter too much thought, and by working out the problems alone with his deafness, as the deaf-and-dumb artist Navarette did, in similar isolation when painting his pairs of apostles for the Escorial. . . . Coloring is central to painting. . . . It is not a question of the brightness and beauty of the colors in themselves, since if this were the case the Chinese would certainly be superior to us. And who better to create this accord than one who is unable to hear the sound of a voice or a bell,

and so seeks harmony in everything he sees with no voice to distract him. . . . Total and absolute deafness gave Goya in his misfortune a wonderful gift that cannot normally be acquired without a great sacrifice of this kind.[60]

Ceán Bermúdez drew precise parallels with Navarette and interestingly suggested that, far from lacking originality, the work of this deaf artist suffered from an excess of thought. He found Goya's deafness the key to certain technical aspects of his work, such as the boldness of his figures and the overall harmonization of color, rather than resorting to a generalized statement of the artist's presumed state of mind, as a result of his deafness. Goya's deafness should neither be reduced to bland generalizations nor simply overlooked, for it clearly contributed in very specific ways to his artistic formation.

Goya, however, was deafened after having received an artistic training, whereas most of the French deaf artists had been deaf from birth or early childhood. In 1817, the artist Girodet took on two deaf students, the brother and sister Edouard and Fanny Robert. Girodet placed Edouard in his main studio: "I believe that he's going to bring about a revolution in the studio and from now on they will only talk in signs, and I will end up as the disciple of my students." His students developed the relationship with the deaf that had been begun within David's studio. Girodet continued to regard the deaf as the best subjects from whom to learn the depiction of gesture, but also trained deaf artists. The Institute for the Deaf formerly possessed drawings of three pupils named Montheilh, Mulle and Dubray by a pupil of Girodet's named Momanteuil, who may have been copying their gestures, teaching them to draw, or both.[61] Fanny Robert was taught separately, as part of Girodet's intention to create a studio solely for women.[62] In this practice, he followed his own master, David, and showed that more professional restrictions were placed on the aspiring woman artist because of her gender than for her hearing loss, at a time when the Institute for the Deaf was co-educational. While in the studio, Fanny Robert found herself unable to attempt or complete a major work, despite showing considerable success in her studies. Her hesitation was not due to nervousness for as a ten-year-old child she had correctly answered questions in sign language put to her by Pope Pius VII at a ceremony at the Institute where she was a student (fig. 21).[63] A few years later she met Napoleon at a ball before the Iena campaign and later exhibited at the Salon between 1831 and 1835 (fig. 22).[64] Perhaps, like the fictional Mutine, she was hesitant to approach the zone of History painting from which she was doubly excluded as a woman and as a signing deaf person.

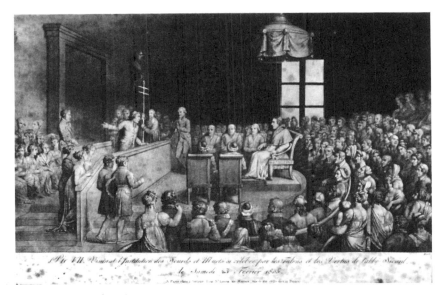

21. Marlet, *Deaf Students Demonstrating Sign Language to Pope Pius V*, 1805 (Paris, INJS)

REVOLT AND ORGANIZATION

This seeming impasse between creativity and the deaf was to be resolved by a new direction in the community formed by the Institute for the Deaf, a significant concentration of deaf people, who both received and created an education. Sign developed into a language beyond the grasp of their teachers, as de Gérando recognized: "In our Institute, they converse in signs without their teachers being able to penetrate the subject of their discussion. . . . It is certain that there exists in our building a tradition of signs, which is the invention of the deaf."[65] The formation of a coherent linguistic tradition generated a sense of community with rights and aspirations from within the disciplinary institution. This community developed a politics that was formed by the regenerative ideals of the Revolution, stalled by the Empire, and rejected by the Restoration. There had long been an undercurrent of discontent in the Institute. At first, those who could not tolerate the new conditions of the Institute simply tried to escape. But the penalty for such actions was severe. In 1805, when a student named Henry was recaptured by the police of the fourth arrondissement after his escape, Sicard had him consigned to the lunatic asylum of Bicêtre, consistent with Itard's diagnostic razor between deafness and madness.[66] Just prior to his departure for America, Laurent Clerc wrote to

22. Fanny Robert, *Portrait of Her Mother,* n.d. (Paris, INJS)

the administration, complaining of the quality of the food: "the vegetables are so insipid that few of us can eat them."[67] His move deprived the deaf students of leadership, and four of his pupils were soon removed from the Institute on the grounds that they had exceeded the maximum stay. By 1822, the successful escape of a pupil named Roger prompted a review of security procedures which concluded that the building was "too open for an Institution," detailing six places where a child might be able to flee, especially the low garden wall. However, in 1820 one Gilles had dug his way *under* the wall, showing an impressive determination to escape. Such bids for freedom were not uncommon throughout the period until the garden wall was finally raised in 1846.[68] In the chaotic conditions following the death of Sicard in 1822, it is not hard to find reasons for such actions. When the Duchesse de Berry came to visit the Institute, Bébian showed her some of the pupils' work and the Duchesse expressed a desire to meet some of them. Bébian replied: "If the deaf do not appear in front of your Royal Highness, it is because they are not clothed. For four

months they have not been able to go for a walk for lack of clothing and shoes."[69] Bébian was forced to resign for this impertinence and the students covered the walls of the Institute with his name in protest.[70]

The students' discontent culminated in what was later called a "mutiny," caused by an attempt to introduce the oral methods of the Englishman Watson.[71] In February 1830, a group of students advised by Berthier banded together to write a letter to the Minister of the Interior, complaining about the excessive severity of the abbé Borel, then director of the Institute. The students demanded his replacement with Ferdinand Berthier, the deaf professor, who was at that time paid only half the salary of his hearing colleagues with similar experience.[72] Clerc had cited in his complaint of 1816 that he had received no pay increase in his nine years as an instructor. The revolt prefigured the famous student revolt at Gallaudet University, Washington, DC, with its similar demands for a deaf president, by one hundred and fifty years. Unlike Gallaudet's successful movement in favour of I. King Jordan, the French students were rebuffed and eight students were expelled, including the first signatory to the letter, fifteen-year-old Jules Imbert.[73] When the Orléanist monarchy collapsed in the July Revolution of 1830, the deaf community at Saint-Jacques saw a renewed opportunity for reform and sent a deputation to Louis-Philippe on 1 November 1830. Led by Berthier, their request was simply for the reinstatement of Bébian and the expansion of educational opportunities for the deaf. Noting that there were 13,000 deaf people in France in 1830, their Address continued: "Of this number, the Paris Institute only caters to 160. The others know nothing of morality, of rights, of duties. They know nothing of the law, which, in the heat of passion, they violate every day. Sire, as people, as French citizens, as the unfortunate, they have a right to your sollicitude."[74] Louis-Philippe offered a cordial reception and some financial recompense for Bébian but did not address their substantive concerns. On 14 November 1831, he appointed an oralist to be director of the Institute for the first time, one Désiré Ordinaire, who believed in: "the sterility of the mimic language for all that which concerns the exterior world."[75] The interpretation of the Revolutionary heritage was at stake. For Berthier, the primary concern was the rights of the deaf as citizens. He echoed Sicard's belief that the uneducated deaf were unable to exercise those rights. For Ordinaire, the central objective was rather the post-Thermidorian emphasis on placing the deaf in contact with the hearing, something that mimicry could not do as it had developed into an evidently autonomous language.

Ordinaire thus radically altered the curriculum at Saint-Jacques to ac-

23. Anon., *Caricatures of the Hearing Teachers at the Institute for the Deaf, c. 1830* (Paris, INJS)

commodate oral education, making the students get up an hour earlier at five and undertake an hour of preparation and lessons in "articulation of speech" before breakfast at seven. The number of classes was increased, with greatest emphasis on speech tuition. To prevent the deaf from signing, they were bound hand and foot in the effort to teach them to speak.[76] Closer surveillance of the students was ordered. The supervisors (a post distinct from that of professor) were instructed to follow pupils who left dormitories at night to answer the calls of nature in order to check that these were genuine. Clearly, Ordinaire was concerned that the pupils would not take kindly to his new regime. He quickly found such fears to be justified (fig. 23). In December 1832, two pupils named Gérold and Gueille were expelled after having escaped by breaking down a barrier and forcing a locked door. However, they were also accused of giving rise to other "sources of discontent" and Ordinaire posted a notice to the pupils concerning their actions: "Your friends [Gérold and Gueille] have been declared unworthy to return. But those who are really to blame are those who, abusing the influence which they think they have over you, have not feared to deceive your good faith in leading you to acts of insubordination against your superiors and in making you envisage as arbitrary and unjust all the measures taken in the interests of order and discipline, which are consequently in your true interest. . . . It is to lead you to insubordination and revolt that they make up complaints for you." Ordinaire urged the

pupils to resist these "vile intrigues," claiming that any former pupil would recognize recent improvements in food, clothing, and the structure of the building.

The Ministry of Commerce and Public Works (which briefly assumed responsibility for the Institute following the July Revolution) accepted the expulsion of the pupils but also reprimanded Ordinaire in the light of a letter received from Mme Gueille. The minister could "scarcely believe that a workshop supervisor would be allowed to strike the pupils who tried to escape," and ordered tighter control of Ordinaire's subordinates. Ordinaire's claim of improvements missed or avoided the point. The students had been prepared to put up with neglect, lack of clothing and even the medical experiments of Itard, but they would not tolerate this attempt to obliterate their newly established sign language culture. Gueille and Gérold's revolt was evidently part of the broader hostility to Ordinaire's program. His reponse was strikingly similar to the protests of colonial administrators, unable to understand the local language but also unable to perceive why the "natives" are so ungrateful for the evident benefits being brought to them by the colonisers. Edward Said has argued that Orientalism "makes the [mute] Orient speak." Here the deaf, characterized as "savages" throughout hearing society, resisted the imposition of such policies with some success, as later recorded in the deaf press: "Despite administrative measures, the students continued to resist from 1830 to 1832. However, the administration and Désiré Ordinaire, director, tired of continual rebellions, partially suppressed the teaching of speech."[77] This account was published in 1904, suggesting that the memory of these events had endured within the deaf community for over seventy years. Ordinaire tried to present the events as a dispute over such details as the witholding of sweets from the students. But given the cause, prolonged duration, and remembrance of these events, what took place was not simply a disturbance but "an insurrection of subjugated knowledges,"[78] an insurrection of the culture of mimicry.

The frustrated institution-based politics of the deaf community, like that of many other colonized peoples, took a cultural turn. The senior members of the deaf community created an alternative to the Institute as a forum for their concerns, both as a vehicle of influence and as an uncontested space for sign language culture. The point was, as it were, to create a space in which the subaltern did *not* have to speak but could sign.[79] In November 1832, the deaf poet Forrestier and his friend Gire were discussing the oralist initiative when they realized that it was in fact the birthday of the abbé de l'Epée. Over a celebratory drink, they decided to hold a

commemorative event the next year. So on 24 November 1833, they were joined by Berthier and another colleague Boclet who all decided to establish a Comité des Sourds-Muets, which would hold an annual birthday banquet in remembrance of Epée using only sign language. In 1834, fifty-four deaf guests attended the inaugural banquet held in a restaurant in the place du Châtelet.[80] These banquets were in themselves a mimicry of the political banquets that were such an important feature of French opposition politics in the 1830s. Indeed, it was the monarchy's attempt to suppress one such banquet that later sparked off the February Revolution of 1848. In between the annual banquets, the Comité held monthly meetings to discuss issues affecting the deaf community. This extra-institutional forum constituted a permanent revolt against the Institute, often referred to as "the mother school," in favour of Epée, "the father of the deaf." In keeping with this oppositional stance, the Comité used Republican formats and allied with Republican figures in order to promote their cause, judging that support was most likely from that political quarter. In 1836, the radical Ledru-Rollin was a guest and in 1837, when the aging Bouilly was guest of honor, Berthier was hailed in sign: "*Voilà Camille Desmoulins!*"[81] Desmoulins had been a radical journalist and member of Danton's party in the French Revolution, suggesting that the deaf audience at the banquets were thoroughly aware of the radical nature of their actions and revelled in them. When the Comité established itself as a legal society in 1837 under the title of the Société Centrale des Sourds-Muets, marking a genuine coming of age, Berthier demonstrated his continuing attachment to revolutionary discourse in envisaging the Society as "the fecund seed of of the total regeneration of this exceptional class."

CULTURAL POLITICS

A central feature of this deaf movement was its literary and artistic achievement.[82] Seventeen deaf artists were celebrated at the opening banquet in 1834, while the audience included Louis Daguerre, inventor of the daguerreotype.[83] While the door to formal artistic training for the deaf had been opened by David and his students, it was the *juste milieu* artist Léon Cogniet (1794–1880) who firmly established the deaf presence in nineteenth-century art by accepting several deaf artists as his students. Cogniet was himself trained by Guérin, a student of David, so there may be a direct connection. It also seems likely that Cogniet was himself hear-

ing impaired. A contemporary account recalled how "his eye was fixed upon and his ear turned toward the person who spoke. . . . When he was on a jury, there was great difficulty in making him give an opinion." His friends referred (in a non-medical sense) to his "mutism," and the account is certainly consistent with considerable hearing loss.[84] A painting by his daughter Marie-Amélie Cogniet, *Interior of Léon Cogniet's Studio* (Orléans, Musée des Beaux-Arts), indicates that his large working studio was a busy and perhaps progressive place. Two women can be seen at work, for unlike David and Girodet, Cogniet was prepared to allow men and women to work alongside one another in his studio. One of his most famous students was Rosa Bonheur.[85] It must have made a congenial environment for the deaf artists after the rigors of Saint-Jacques.

Cogniet himself was remarkably successful, crossing the artistic divides of the period and winning praise from the public and critics alike. His major canvas at the Salon of 1836, *The Parisian National Guard Leaves for the Front in September 1792* (Versailles, Musée Nationale du Château), an official commission, won widespread acclaim: "The crowd has not stopped coming to see his picture. . . . One finds there characteristics that are easily appreciated by the public; namely, a perfect clarity in elaborating the subject, a variety of episodes which are full of interest and well-distributed, and lots of exactitude in painting the enthusiasm that animated the nation at the time."[86] In Michael Marrinan's analysis, Cogniet's work was well-suited to the official art program of the day "precisely because [it] masked its historical fiction with a seeming sincerity and everyday directness. . . . [He] renounced much of the enobling artifice of traditional high art in favor of a direct, accessible representation utililizing devices rooted in the theater, popular imagery and strategies of genre painting."[87] This combined approach had much to offer the mimic artists who had a political agenda that did not wish to characterize itself as such and who were seeking to utilize long-standing alliances with popular culture and theater. For example, at this time Berthier was assisting the actress Lhérie in her vaudeville performance of *Le Sauveur*. Later he would assist the famous mime Debureau, just as Massieu had worked with Mme Talma.[88] It was Frédéric Peyson (1807–1877), a deaf painter from Montpellier who carried such initiatives into the Salon (fig. 24).

Peyson was deafened by a fever at age two and came to Saint-Jacques in 1817. After his graduation, he lived with Auguste Bébian and was active in deaf politics throughout his life, becoming joint president of the Comité in 1834.[89] He studied at the Ecole des Beaux-Arts from 1826 and entered for the Rome Prize on three occasions, achieving a creditable third

24. Anon., *Portrait of Frédéric Peyson*, n.d. (Paris, INJS)

place in 1834. He studied with Ingres, Gros, and Hersent, as well as with Cogniet, but it was in Cogniet's studio, where he was introduced by another deaf pupil, Léopold Loustau, that he gained most attention.[90] Cogniet repaid the favor by attending the 1837 banquet, along with M. Dupin, the president of the Chamber of Deputies. This indication of the double-edged nature of deaf cultural politics was noticeably reaffirmed in 1838.[91] In that year's Salon, Peyson exhibited his *Saint Margaret Bringing Down the Dragon* (fig. 25). Upon seeing the canvas, Cogniet declared: "He can walk alone." The painting depicts Saint Margaret standing over a recumbent dragon, holding a quill in one hand and pacifying the monster with the other in a highly finished and traditional style, especially in the finely observed shadows and drapery. Certain anomalies in the painting

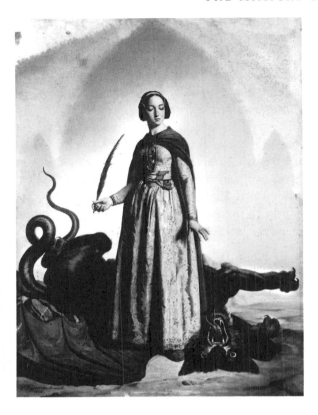

25. Frédéric Peyson,
*Saint Margaret Bringing
Down the Dragon*
(Montpellier, Musée
Fabre, 1838)

disrupted the finished Classical style and render Peyson's mimicry apparent. Her gesture seems to be the traditional rhetorical gesture of authority—fingers spread with middle and third finger touching—but she is using the "wrong" hand, her left. The saint is drawn after Ingres' redefinition of the Madonna with the same characteristic hair style and downward gaze. But the subject is a reversal of Ingres' famous composition *Roger and Angelica,* which he reworked on several occasions, in which a heavily armed Roger rescues a naked Angelica from the dragon. Peyson described his work in a manner more reminiscent of the Romantics than his Classical master: "To create a virgin, the ideal virgin, as I conceive her, as all thinkers must conceive her, it would be necessary to live as detached as possible from the world, to feel one's soul in the purest atmosphere. It is impossible."[92] The painting shows an intellectual's triumph, nonetheless, as Roger's lance is replaced by Margaret's pen and her seeming weakness becomes a source of strength over the dragon. The quill in her hand points to the signature of the artist, written in script at bottom left: "Fré-

déric Peyson, *sourd-muet* 1838." The artist seems to have intended his audience to notice the reversals in his image as a means of drawing attention to the reversal inherent in his own status as a deaf artist, a category held to be an impossibility by his contemporaries. Saint Margaret's triumph—that of culture over nature—is identical to that claimed by the Society for the deaf in nineteenth-century France.

For Peyson's deaf contemporaries, the analogy of this picture to his condition as a deaf artist was unmistakeable: "O all of you to whom fortune has confided the happy mission of encouraging the arts, cast your eyes on this canvas, and you will feel at once what secret instinct has led an unfortunate to the subject of a martyr, himself being a martyr to the rigors of fate; he knows how to make the saint speak, and he is himself deprived of speech!"[93] Forestier hailed Peyson as "our young David! The success of each is common to all of us who are brothers!"[94] Peyson's work brought the deaf concept of deafness into view on the silent screen of representation. For the Société Centrale des Sourds-Muets, art was therefore one of the central facets of deaf cultural politics, and they sought to encourage its development in the deaf community. Beyond the artist's probable intention, it is also possible to discern a sequence of analogy at work in this image from the deaf artist to the female martyr, both of whom are analogous to writing. Analogy is a difficult figure to control for, once it is established, further analogies are always possible that may detract from the meaning of the original comparison. Mimicry wanted to be compared to speech not writing, yet the figure of writing seems to return over and over again in the images used by deaf artists and writers.[95] Bébian's attempts to create a written format for sign language which he called *mimographie* were unsuccessful not because of the inherent difficulty of the project—Champollion deciphered and transcribed Egyptian hieroglyphs during this same period—but because the deaf community did not wish to make its difference so visible. Significantly, deaf writers made no effort at *mimographie,* even in the *Journal des Sourds-Muets* founded by Bébian himself in 1827.[96] Without support from the language-using community, no form of transcription can succeed, as the recent fate of such diverse media as Esperanto, the eight-track cartridge cassette, and 3-D movies can attest.

In that same year, 1838, the Society was able to intervene decisively in the affairs of the Institute. In October, Ordinaire resigned as director, having become disillusioned with his constant struggles both with the deaf students and professors and with de Gérando's Administrative Council, claiming that "the tribulations of all kinds which I have suffered for

the strength of my convictions, the patience with which I have endured them, and which have been the object of scandal for so many, say better and more clearly than any words of mine, that I have fulfilled not only the duties of my position, but those of conviction and conscience."[97] M. de Montalivet, Minister of the Interior, named his successor, a politician named de Lanneau, without consulting the Council and succeeded in provoking a political scandal. What had been a minor item for the press became a front page story after the refusal of the Council to attend de Lanneau's inauguration or to let him use his office. The opposition paper *Le Commerce* disparaged the appointment as motivated solely by "political favoritism," calling de Lanneau "a man who is altogether too young and lacking in titles. . . . [H]e is completely ignorant of sign language." The affair was seen as part of a larger crisis for the Minister: "He is at war with almost all the bodies who direct the benevolent foundations. . . . The politics of corruption must have its hand everywhere, even in the workings of social charity."[98] The official press dismissed the affair: "In truth, one has to read the newspapers of the opposition to understand how such a simple administrative operation can contain so many grounds for complaint."[99] In the midst of all this upheaval, Berthier, Lenoir, and Allibert, the deaf professors at Saint-Jacques, invited de Lanneau to the banquet of the Society, the first such invitation to be extended to a hearing administrator of the Institute.[100] It was an important moment for de Lanneau, giving him an authority as director that he had otherwise lacked. He recognized this in his speech to the banquet: "What you have done is give me freedom of the city among you."[101] The Society had established itself as a legitimate body with a say in the naming of the Institute's director and as an alternative source of authority. The price paid for these significant gains was co-operation with the Orléanist government in contradiction to the traditionally republican stance of deaf politics. For the time being, however, all were conscious of the remarkable transformation in the deaf community's political and cultural possibilities. It was a long way from digging under the Institute's walls.

Berthier was inspired by the Society's success to arrive at a new conception of the deaf community as a nation in its own right. As early as 1836, the banquets had been hailed as containing "the germ of the future emancipation" of the deaf.[102] In a manuscript completed in 1840, although not published until 1852, Berthier conceived that emancipation in the form of "the deaf-mute nation" with 23,000 fellow citizens.[103] He celebrated deaf achievements and their language in a bolder vein than hitherto: "The richness, flexibility, clarity, and energy of our language of

mimicry gives it an incontestable pre-eminence over all spoken languages."[104] Although Sicard had believed that sign language could only achieve maturity in a country where everyone was deaf,[105] and Itard had wondered about establishing a colony of the deaf, Berthier now presented the deaf nation as an already existing fact. Nations are notoriously hard to define and this one was no exception. Evidently it could not be defined geographically, politically, or even medically, but only as a community of language users, a community that had developed into a nation from the long-standing French deaf community by means of the Institutes and the Society. Benedict Anderson's well-known definition of a nation as an "imagined community" can be applied here, for Anderson indicates that one form of such communities, which have no real existence except in the imagination of those who consider themselves to belong to that communion, was centered around "the non-arbitrariness of the sign."[106] Anderson's example of China as one such community suggests both the validity and difficulty of the attempt to imagine a deaf nation. Like the Chinese, the deaf used different languages for conversation and writing. While all had access to the vernacular sign, only an elite knew the written French or Mandarin in which the nation was to conduct its affairs. There was a linguistic hierarchy even within the deaf community. For the deaf nation existed within a print culture to which only the literate minority of the deaf community at this time had access. The origins of the deaf newspapers and journals which were to flourish under the Third Republic can be traced to this moment of national inauguration. However, as the comparison with China shows, there was a glaring weakness inherent in such a strategy, for the Chinese Empire exercised extensive power, while the Society held tenous authority over a minority community within a major imperial power. That community was held together by a language which was itself evolving and changing, creating a clear need for the invention of a deaf tradition to unite the new nation. A history had to be constructed, with important figures and moments isolated, so that deaf individuals could find a means of identifying themselves as part of a deaf nation that had no existence except in the cultural sphere. Berthier's career was devoted to these goals as he consistently celebrated current deaf achievements while hailing past glories in his numerous publications. His problems, and those of the Society, were to come partly from the majority of his own community, for whom this print culture was as inaccessible as the Parisian banquets.

Conflict appeared almost at once. After several years of dissent, the first rival banquet was held in 1843, organized by Jules Imbert and Benjamin

Dubois, on the anniversary of the passing of the Revolutionary laws in favor of the deaf in July 1791.[107] Imbert held that Republican politics, rather than Berthier's nationalism, were the means to deaf emancipation. The two sides met on Epée's birthday in November 1845. Imbert set out a very different program for deaf political activity to that pursued by the Society, focusing on the creation of a friendly society and co-operative groups that would provide health care and employment for the deaf.[108] These commendable goals were addressed to the mass of the deaf population rather than the Parisian elite, but were as yet difficult to realize in practical form. The rival banquets continued until 1848. Imbert's banquet of that year held a collection for the wounded of June 1848, while Berthier had to counsel his guests not to lose heart at the decline in numbers, but it would be premature to exaggerate the split in the deaf community.[109] After the February Revolution, the *Courrier Français* reported that: "Several deaf-mutes took an active part in the defense of the barricades and they fought with an intrepidness that cannot be praised too highly. One of them was killed in the attack on the post of the Château d'Eau."[110] On 13 March 1848, Berthier led a parade of the Parisian deaf to the Hôtel de Ville to claim the rights of the deaf from the Provisional Government. The march was received by Lamartine himself and included "practically all the deaf of Paris," according to one newspaper account.[111] Berthier himself ran unsuccessfully for the Republican Constituent Assembly, declaring that: "All the classes of society ought to be represented in the new Chamber . . . I believe that I have acquired the right to intervene in the affairs of the country, as much as a frankly Republican citizen as the organ of the 22,000 deaf French."[112] Yet this moment marked the highpoint of republican deaf politics for nearly twenty years, perhaps due to the failure of the Second Republic in both the limited arena of deaf affairs and, of course, more generally. In 1849, Berthier accepted the Légion d'Honneur from President Louis-Napoleon, soon to be Emperor, at a ceremony in the Institute.[113] There were no more Republican banquets until 1862.

Central to the creation of a tradition for the deaf nation was the cult of the abbé de l'Epée, which the Society's banquets had inaugurated, connecting the deaf to Enlightenment philosophy rather than to the achievements of the French Revolution, in keeping with the political climate of the day. As those who had known Epée personally died, it became increasingly important to fix a visual image of the "emancipator of the deaf," a task accomplished by Frédéric Peyson's *Last Moments of the Abbé de l'Epée* (fig. 26), which was shown at the Salon of 1839 and presented to the

26. Frédéric Peyson, *Last Moments of the Abbé de l'Epée*, 1839 (Paris, INJS)

Institute in 1845. The first painting by a French deaf artist to gain wide-spread acclaim, it was both inspired by, and a contribution to, the culture of mimicry. It depicts Epée on his deathbed, surrounded by his grieving pupils. A young deaf woman at the right of the picture, who was taught by Epée, has rushed to his bedside in despair. Peyson also included the resolution of her anguish in the picture. At the left side of Epée's deathbed can be seen the delegation from the National Assembly, led by the archbishop of Bordeaux, Monseigneur de Cicé, who declared: "Die in peace, the nation will adopt your children."[114] By depicting this party in his work, Peyson reminded the Salon audience of the nation's undertaking to provide deaf education in sign. As a good pupil of Cogniet's, Peyson included a political content without it being excessively manifest. Peyson presented his work as being the same as that of the official Salon artists, and so it was—but not quite. One might think of Peyson's artistic style as a mimicry of the official mimetic style for art, exploiting its ambivalences in

order to permit the deaf to represent themselves as deaf but not patholog-
ical. Within the mimesis of the salon style, it was thus possible for deaf
artists to comment, silently as it were, on what constituted representation
in both cultural and political terms. Although any Salon-style work might
be termed a mimicry of mimesis, that which makes the work of the deaf
artists not quite the same is located in their evocation of deafness on the
silent screen of painting. Deafness was not depicted as a deformity or
disease, but was nonetheless present in the image as the motivation of the
entire scene, for Epée could not be understood outside the framework of
deafness. Peyson made it impossible for the hearing to gaze at the deaf
without being aware of the deaf looking back. In so doing, he created a
vision of deafness that implicated both the deaf and the hearing but
avoided envisaging it within pathology.

The painting was a part of the Society's campaign to commemorate
Epée and remember his achievement. For Epée was so widely held to be a
great Frenchman that no one could object to such memorials. At the same
time, Epée's work was clearly associated with sign language, despite fre-
quent attempts by oralists to remind the public that Epée had believed in
signs only as a step on the road to speech. The oralists had a case, but it is
a measure of the success of deaf politics in the nineteenth century that
Epée came to be associated solely with sign language. As befitted the
tactics of the Society, Peyson's work was hailed on both sides of the politi-
cal divide. Remarkably, both the *Moniteur* and the *Commerce* published
favorable reviews of his work even though they had been on opposite sides
in the de Lanneau dispute only months before. In the pro-government
Moniteur, the reviewer noted that: "the author is a young deaf-mute and
this composition, full of sentiment, is his first important work; I think
that the most severe connoisseurs will be pleasantly surprised by such a
debut. As for me, I find that this painter has already discovered the art of
ordering his subject, the manner of bringing all his details into the unity
of interest; his color is not tormented and lacks neither freshness nor
harmony—in a word, M. Frédéric Peyson merits, up to the present mo-
ment, the greatest encouragements."[115] The opposition newspaper, the
Commerce, had similar kind words:

> The author is a deaf-mute. It is the first time since the discovery of the
> art of instructing the deaf that such an important result has been of-
> fered to the appreciation of the public. We are talking here of a picture
> in all the accepted sense of the word, of a canvas in large dimensions,
> filled by twenty-odd characters. There is something touching here, a
> noble sentiment in this first use of talent which returns to its source,

and consecrates itself first of all to gratitude. Each passing day adds to the benefits which the children of this unhappy family owe to the love of humanity and to the abbé de l'Epée. He completed these mutilated natures: he created after God. We avow that we cannot look at this picture without emotion, without imagining to what kind of torture this unfortunate man would have been condemned, if such faculties had remained in the state of vague thoughts that could not express themselves; because there is a real talent in M. Peyson's picture. The background is perhaps a little severe. But the expression of the figures is well rendered and the woman on her knees in front of the bed and seen from the back leaves nothing to be desired in terms of drawing and execution.[116]

These commentaries demonstrate the success of the deaf cultural politics that are the focus of this chapter. The critics recognized that Peyson's work was so clearly within the artistic mainstream of the period in genre, style, and composition, as to make it a statement of the essential "normality" of deaf perception and its representation. Otherwise their comments are un-remarkable examples of Salon criticism—and therein lay their impor-tance for the deaf artists, who had won a measure of acceptance as "normal" artists. Peyson's suitably restrained use of color, depiction of *sentiment,* composition, and other technical devices demonstrated how sign language could liberate artistic potential from the "savage" deaf. This achievement was attributed to the abbé de l'Epée and was thus inescapa-bly linked to sign language, despite the absence of any visual depiction of sign language. Peyson's figures use their hands in ways that could not be mistaken for gestural signs. The abbé de l'Epée himself is shown with both hands extended, palms facing down. Other visible gestures are those of prayer and grief. But sign language is elsewhere. For the political inten-tion of the Société was to make the continuance of mimicry possible by presenting it as essentially the same semiotic process as speech, albeit in a different format. Within the painted image, there was no need to insist on even this marginal difference. The traditional rhetorical device by which painting had been described as silent poetry emphasized both the meta-phorical and silent qualities of art. For deaf artists, silent poetry now seemed to offer a space in which there was no difference between them-selves and their fellows (*semblables*). In the painted image, everyone is a deaf-mute. Since it was precisely the intent of deaf cultural politics to emphasize the convergence by analogy between the deaf and the hearing, Peyson's omission of gestural signs was not only understandable but delib-erate. He was certainly successful in recalling the importance of sign lan-

guage to the deaf, being himself a testament to what could be achieved by the educated, signing deaf.

The deaf artists of the period worked with the Society to gain further explicit recognition of their work from the Academy of Painting, which organized the Salon, and from the government. They hoped that the government would give its seal of approval both to Peyson and the Society by purchasing his work for the state, but although the Minister of the Interior supported the idea, the Ecole des Beaux Arts found the price too high. Peyson presented the picture to the Institute at the 1844 Banquet.[117] The Society also argued that the deafness of an artist should be indicated in the official Salon catalogue, alongside the traditional information supplied, such as the artist's address, the studio in which he or she trained, prizes awarded at the Salon, and national honors. As Allibert remarked at the June 1843 meeting of the Society: "One is allowed to say if a painter is a baron or a marquis, that Ducornet was born without arms! Don't you wish that it [the catalogue] would silently repeat that we, poor deaf-mutes, we have had one hundred times more obstacles to overcome than these other artists to pierce the crowd which encumbers the sanctuary of the arts. . . . It is barbarous of the speaking, so rich in masterpieces, to strip our modest political crown of its least ornaments."[118] His argument confirms that the deaf artists' work was interpreted by the deaf elite as being inherently political in demonstrating deaf abilities. The Academy did not relent, so the artists resorted to signing their title directly onto their work. "Signing" here takes on a double reference to the signature and the gestures of a deaf artist. Peyson either wrote out the words *sourd-muet* or added the initials "S.M." to his signature. Many other deaf artists, such as Fanny Robert, followed suit. It is a curiously ambivalent title, a mark of the difference between this work and the official style it imitated. On the one hand, for the deaf community, it recalled the professional or honorific initials that people place after their name to register achievement, such as B.A. or O.B.E. In this sense, S.M. might be understood as a declaration of pride. But it might also register the difference of the artist from the viewer in such a way as to claim a special indulgence for the work. Thus, a potential critic of the painting might be appeased by the realization that the artist was deaf and any level of artistic achievement was highly praiseworthy. Regardless of the signatory's intent, neither possibility can be excluded. Mimicry was never quite the same as its model.

The deaf artists continued to enjoy success at the Salon throughout the July Monarchy and Second Empire. Their work continued to present itself in ways that readily lent itself to analogies with the situation of the deaf community in general. For example, Loustau's Salon debut in 1839

27. Frédéric Peyson, *Bohemians in the South of France* (Montpellier, Musée Fabre, 1844)

was *Saint Peter Healing a Cripple,* followed in 1840 by his *Jesus Christ's Sermon on the Mount,* which succeeded where Peyson had failed, for it was bought by the state. In 1842, Loustau won further recognition with his *The Infant Jesus Among the Doctors of Law,* winning a third class medal for History painting and overthrowing de Gérando's assertions regarding the poor quality of deaf artists. The picture was hung in the chapel of the Strasbourg lycée.[119] The next year, Loustau sent his *Jesus Christ and the Little Children* with the famous verse "suffer the little children to come unto me" reprinted in the Salon catalogue. The constant theme of his early work was religious charity and generosity to the less fortunate, among whose number the deaf were of course included. Peyson's work took a more unusual direction, treating subjects such as *The Blind Beggar* (1841) and *Bohemians in the South of France* (fig. 27). The latter work was a remarkable foreshadowing of the themes soon to be found in the work of Gustave Courbet and other Realist painters. In a broken-down build- ing an aging father searches his daughter's hair, presumably for lice. His

hands are gnarled and muscular from manual labor, while his wife, tanned and exhausted from her outside life, sits indifferently in front of a cooking pot. Only the daughter still seems to have spirit, and she looks out inquiringly at the viewer. The dirt on her hands and feet contrasts strongly with the whiteness of her shoulder, suggesting that in different circumstances, she might have posed for an elegant portrait in an off-the-shoulder dress. The social commentary implied in this work was echoed in a pamphlet published by the Society in 1846, detailing the achievements of the deaf in the nineteenth century. It was sold at the gate of the Institute for the benefit of the deaf poor, and in his article, Berthier posed a rhetorical question that might stand as a gloss on all these works: "Which country has not had its persecuting caste and its persecuted caste? The Jew, the pariah, the hypocrite [cagot], the bohemian—who has not had to suffer the usurping tyranny of some men over other men? What atrocities has the unfortunate child deprived of speech not had to suffer over the centuries of ignorance?"[120] Berthier's assemblage of Others indicated that exclusion was possible on grounds of race, caste, class, or honor as well as physical difference. Peyson's *Bohemians* made a direct analogy with one of the categories later invoked by Berthier, whereas Loustau concentrated on more generalized religious allegories.

By the unusual inclusion of the hypocrite, Berthier further suggested that the reader might at any time find him or herself excluded and, indeed, they may already be excluded. The passage recalls Baudelaire's famous invocation in *Les Fleurs du Mal* of his "Hypocrite lecteur—mon semblable—mon frère" [Hypocrite reader—my fellow—my brother]. Furthermore, the deaf were often referred to as the *semblables* of the hearing, with only a small, invisible difference to separate these two classes of humanity. Baudelaire and Berthier combine to suggest that deafness is not a world apart but a *rapport* in which we are all involved, even if against our will, by the inevitable operations and extensions of analogy. There is nevertheless a gap in Berthier's chain of analogy. In the polygenetic scheme of race, which underpinned the mimickers' arguments, races were not analogous to each other but separate. Analogies were often made between sub-groups of the various races, for example between black men and white women, but the deaf, insofar as they constituted a race, could not claim analogous connections to other races.[121] This failure of analogy may explain why the mimickers never elaborated upon their notion of analogy. Instead, the deaf artists constantly emphasized the analogy between the Christian duty of charity and the fluctuating state of social exclusion in their Salon paintings of the 1840s.

The ambivalence of the gestural sign in art was revealed in 1834, when Marie-Nicolas Ponce-Camus attempted to give his painting *Abbé de l'Epée* to the Institute. Ponce-Camus' painting showed the scene from the play in which Epée has successfully led the young "Solar" home. As the boy signs his thanks to Epée, the abbé responds by signing that they are due to Heaven. The picture was a threefold embarrassment. It reminded the Institute of Epée's most serious mistake at exactly the moment the deaf community was seeking to venerate his memory. Secondly, as the defense had acidly noted, it cast doubt upon the accuracy of sign language itself, for Epée's case rested upon the interpretation of the "Comte's" signs. Finally, the picture was out of date in its direct use of gestural sign. Bébian explicitly denied that painting could be helpful in "writing" sign: "Ordinary painting would be nothing more than a weak assistance, even if it were as rapid and easy, as it is in fact slow and difficult: painting is immobile, and the gesture is a movement."[122] But, as Berthier himself had noted, one sign can contain a significant meaning and painting's very immobility could serve to arrest and highlight that gesture in a manner impossible in ordinary deaf conversation. Ponce-Camus had sought to do exactly that, but his insistence on the difference of sign language was now contrary to the mimickers' strategy of camouflage.

At first the Institute would not accept the painting on the grounds that they could not afford to pay for it. When he offered to give it to them, the administration was profoundly embarrassed that "Ponce Camus had consecrated an erroneous deed," believing that Epée had been the victim of an intrigue which they did not wish their students to see.[123] It was then agreed that the picture would be accepted on condition that a written inscription detailing the mistake be attached. The administration then indulged in an exercise in close reading which demonstrated an extraordinary belief in the potential ambiguity of the written word. The phrase "Given to the Institute" was found difficult: "Who or what was given? Was it the abbé de l'Epée? or the erroneous deed itself? There was a doubt because the proposition had two subjects." The second attempt described the scene as "purely imaginary" which was also found displeasing and was substituted by "an error of zeal." As Epée's interpretation of the boy's signs had created the entire controversy, his entire method was implicated in the scandal, as the courts had earlier perceived. The gestural sign when isolated and highlighted, away from its mimetic camouflage, revealed only too clearly that the sign does not exist in a natural relation to the idea, but instead signifies by virtue of its context, contingency, and difference. That was not the message either the deaf artist or the Institute for the Deaf wished to display in the nineteenth century.

Far closer to the culture of mimicry was the contribution of deaf artists to the picture galleries at Versailles, the major artistic project of the period. The leading patron of the deaf artists, Léon Cogniet, was much involved in official work for Louis-Philippe and so too were older associates such as Langlois who was elevated to the Institut and commissioned to paint a major canvas, *The Return to Paris of the Parliament Called by Louis XVI* in 1838, which unfortunately turned out to be the year of his death.[124] As the Versailles museum was dedicated to "all the glories of France," it was obviously an important site for the deaf community to be recognized. As we might by now expect, sign language was only present by analogy. Following a request by Berthier, M. de Montalivet commissioned Frédéric Peyson to paint a *Portrait of the Abbé Sicard* (Versailles, Musée du Château, 1841), whom he had known when a child.[125] Sicard is shown in a half-length portrait against a conventionally sombre background in clerical dress relieved only by his collection of medals. He has a somewhat worried and thoughtful look and the portrait frankly depicts the lines on his face and thinning grey hair. The portrait was only connected to the deaf by the signature, two-thirds of the way down on the left-hand side, which reads "Peyson s-m 1841." Loustau's *Portrait of Bertrand-Pierre, Vicomte de Castex* (Versailles, Musée du Château, n.d.) is a similar official portrait, decorated with the Vicomte's coat of arms, showing him in uniform, wearing the cross of the Légion d'Honneur. Deaf artists had by this time assumed an unobtrusive position within the classic, official art world and were not seeking to innovate from or transform that situation.

Indeed, Peyson, a man of independent financial means, did not exhibit after 1850. His last picture was a *Self-Portrait*, dated 1842 but not shown until 1850, that remains firmly within the mainstream (fig. 28). He depicted himself seated, shown three-quarter length and face, against the prescribed dark background. He is dressed as a respectable member of the bourgeoisie in frock coat, waistcoat, and dress shirt with a boldly tied cravate to indicate his status as an artist. The highly polished chest of drawers with several books scattered on its top focuses our attention on the artist's material wealth, literacy, and artistic skill. As well as the books, the portrait is filled with allusions to literacy and artistic talent. In the bottom right corner, a bulging portfolio of work carries the familiar signature "F Peyson sourd muet" again written in script. The artist holds a sketching book open to a blank page over two-thirds of the way through the volume, indicating the frequency of his drawing. He holds a pencil in the right hand and looks out of the picture space towards the presumed subject of his sketch. The blank page leaves open the possibility that he is about to write rather than draw and his large, prominent hands captured

28. Frédéric Peyson,
Self-Portrait
(Montpellier, Musée
Fabre, 1842)

by the light remind us of the connections between sign language, drawing, and writing. The tabula rasa in front of the artist was a familiar figure for the deaf child prior to education and the portrait may thus be read as containing an allegory of the artist's life from the blank prelinguistic state to the accomplished figure of middle age. This self-portrait was a fitting last public statement from Peyson, who continued to be involved in the deaf community and trained a young deaf artist, Nachor Ginouvier, in Montpellier.

Peyson's retreat from public life may have been due to certain confidence about the deaf culture he had been so instrumental in creating. As well as his own contributions, Loustau, Joseph de Widerkehr, a marine artist, Octave Bézu, a pupil of Institut member Drolling, and others were exhibiting regularly at the Salon. Mimicry attempted to install itself at the (absent) center of society and the Salon was the perfect example of that strategy. As Allibert had observed, the Salon was the "sanctuary of the arts," a metaphor that conveyed both its centrality and guarded state. For the Salon was located both at the heart of artistic life and at one remove

from it, as it became the site of increasing controversy in the early nineteenth century. Innovative artists such as Eugène Delacroix and Théodore Rousseau were regularly refused the right to exhibit and, after the critical failure of his *Saint Symphorian* in 1834, Ingres, the leader of the French School, refused to submit his work there. Ingres subsequently refused even to sit on the jury, in company with a number of other distinguished artists of the period, such as Paul Delaroche and Horace Vernet.[126] Any informed observer therefore knew that artistic life in Paris was taking place both within and without the Salon. Many nineteenth-century critics were obsessed with the idea that the Salon was in decline, along with the informed reading public who constituted its ostensibly proper audience. Now, they argued, the Salon was overwhelmed by the crowd. There was no doubting the crowds—in 1846, there were 1,200,000 visitors to the Salon by one estimate.[127] Across the critical spectrum, a consensus emerged in the 1830s and 1840s as to the future direction of the arts which held that, although the Salon was indeed turning into a popular event, it was in that popularity that its redemption might lie. A review of the 1837 Salon was typical: "In a word, the passions, fashioned on the model of the giants, are the only thing that can lead to art; when they take hold of a people and absorb it, art can lead them to greatness. Then the people and art are sublime."[128] Charles Blanc, the future director of the Ecole des Beaux-Arts, agreed: "The multitude is the best judge of the productions of art: the learned man criticizes, the simple man enjoys, there's the only difference."[129] For the writer of one popular critique, the time had come to revise the accepted view of the degeneration of the Salon: "In fact, we never yet had this public, we who nonetheless believe ourselves to have progressed beyond the past. Such a public never existed—it will exist. The annual exhibitions will create it."[130] The sanctuary of the Salon was thus in a curious state of transition between a disappeared, perhaps fictional, past and a future that was yet to come.

It was surely no coincidence that the deaf artists entered the Salon at precisely this transitional moment, for it constituted the perfect refuge for the cultural politics of mimicry. The Salon was an unequivocally central institution in French culture evolving from being the domain of the imagined reading public to the creature of the age of mechanical reproduction.[131] Its future was uncertain but interest in it continued to grow, for, as Edouard Manet put it in the 1860s, "the Salon is the true field of battle—it is there that one must measure oneself."[132] The Salon constituted a space in which the deaf artists could be seen, from which they could register certain claims, and which was central, while being suffi-

ciently in flux to provide a suitably mottled background against which to operate in the camouflage of mimicry. The deaf artist at the Salon was a *flâneur* in reverse, who wished to be seen and at the same time blend into the crowd.

A CULTURE OF GESTURES

The mimickers' success at the Salon was matched and enabled by a similar acceptance of their principles in the liberal arts, which is not to say that everybody agreed with them, but that they were sufficiently similar to the intellectual mainstream of the day as to win acceptance—their ideas were not so much central as of the center. In 1832, Fanny Robert painted the portrait of Mme Charles Nodier. Her husband, the linguist, wrote admiringly of her work: "Speech is such a little thing, such an imperfect expression of thought that those unfortunates who, like myself, are obliged to make use of it, do so only with disgust."[133] Nodier's remark should not be dismissed as a social pleasantry, for it was consistent with his own work on language, in which he argued that the original exactitude of vocal imitation had been corrupted by the invention of the alphabet: "There is no good alphabet; I will go further: . . . there is no alphabet at all. One cannot in practice give this name to the fortuitous mixture of vague, equivocal, insufficient signs of which all alphabets are composed."[134] Language after Babel was nonetheless unimaginable without alphabets, leaving the "insufficient" languages they composed in need of a supplement to complete them, just as mimicry's theorists had argued. Writing in the *Moniteur,* Edouard Thierry agreed: "Through the language of mimicry, a second emancipation has come for the deaf: they are improvisers, orators, poets. . . . Those who speak will be astonished at the insufficiency of speech, compared to mimicry."[135]

An example of the new valency of gesture in nineteenth-century France can be seen in Eugène Delacroix's reworking of two themes closely associated with deaf gesture in the eighteenth century, namely Medea and the murder in the harem. *The Death of Sardanapalus* (fig. 29), his *succès de scandale* at the Salon of 1827, depicts Sardanapalus as an Oriental sultan using his "eunuchs and officers of the palace," to quote Delacroix's description in the Salon catalogue, to execute his other servants.[136] Prominent in the foreground is a bearded man—hence not a eunuch—putting a woman to death by the sword, which may be read as a return to the famous deaf executioners of the harem that travelers had reported since

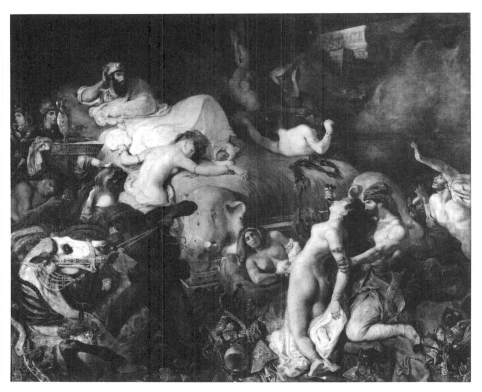

29. Eugène Delacroix, *The Death of Sardanapalus* (Paris, Musée du Louvre, 1827)

the sixteenth century. It would certainly have been possible for a viewer of
the *Sardanapalus* to have made the connection with the deaf harem guards
and their gestures of conversation and execution. In 1820, the recollec-
tions of M. d'Ohsson, the Swedish ambassador to the Court of Constant-
inople, had been published in France, emphasizing the importance of the
Ottomans' deaf servants: "The mutes wear a hat with gilt embroidery,
different in form to the other pages. They express themselves by rapid
gestures and this language is known to the courtiers, women of the
Harem, and the Sultan himself, who often only uses a sign of his hand to
give orders to those who surround him." Twelve years later, Delacroix
turned to the theme of *Medée Furieuse* (Lille, Musée des Beaux Arts, 1836)
which was prominently displayed at the Salon of 1838, perhaps in recog-
nition of its traditional subject.[137] Strikingly, Delacroix's work was the
first nineteenth-century version of the theme and it captures the central
yet ambivalent dramatic moment so beloved of Neo-Classical art theory.
Medea clutches her children in an embrace that is both maternal and

murderous, as their struggles seem to indicate. The hand holding the dagger is very prominent, as its haft catches the light and, ominously, the shadow of the blade falls across one child's flesh, literally foreshadowing Medea's gruesome revenge against Jason. Yet her face, which would be the site of her moral dilemma according to strictly physiognomic principles, is in the shade, leaving her hands to hold both the children and the dagger and thereby express her contradictory emotions.[138]

Baudelaire's *Salon of 1846* contained his first extended discussion of Delacroix. He found gesture, not color, to be at the heart of the Romantic artist's talent: "Each of the old masters had his kingdom, his attribute—which he was often forced to share with his illustrious rivals. Raphael had form, Rubens and Veronese color, Rubens and Michelangelo the imagination of drawing. One part of the empire remains into which only Rembrandt has made some excursions—drama—natural and living drama, terrible and melancholic drama, expressed often by color but always by gesture. In the matter of sublime gestures, Delacroix only has rivals outside his art. I can only think of [the actors] Frédérick Lemaître and Macready."[139] Baudelaire argued that Delacroix's mastery of the sublime gesture was his true claim to a place in the canon, for no other artist could match him in this field. In insisting upon the centrality of gesture in the visual arts, Baudelaire unwittingly agreed with the mimickers' notion of gesture as an indispensable supplement to speech, especially in painting and the theater. Both received unexpected support from the Academy of Painting, in whose long-awaited Dictionary gesture was accorded an important place: "Gesture accompanies, underlines, and prolongs speech; one might say that it designs [*dessine*] speech. . . . The important signification of gesture will already be apparent and to what an extent it is possible with gesture alone to show the spirit of a race or a school." Noting that David had used cold Roman gestures, the entry continues: "Romanticism overthrew this doubtful archeology and substituted research into life and truth. But gesture was proclaimed truer according to its degree of excess and it was only declared sound on condition of being exaggerated. Ingres, classic by education, romantic by temperament, remains in the appropriate moderation [*juste mesure*] where his pure taste and fine understanding of the old masters keeps him."[140] The Academy accepted gesture as a prime measure of artistic quality, but inevitably replaced Delacroix with Ingres as its master. Just as in the ancien régime, gesture was here a central point of dispute between the Ancients, who argued for moderation, and the Moderns, who argued for the mimicry of real life.

Mimicry thus gained its greatest support in the arts from the famous

quarrel between the Romantics and the Neo-Classics. For the dispute between the supporters of color and those of line rested upon an assumption that the visual sign was both artificial and constructed: "The two traditions [of Romanticism and Neo-Classicism] are in effect supporting and reinforcing each other at the very moment when they seem to be at the height of their antagonism."[141] If signs were simply natural, then it would be impossible to argue that color should have precedence over line or vice-versa. The nature of the *querelle* over the constitution of the visual sign maintained a way of thinking about the sign that was highly congenial to the advocates of mimicry. For example, Charles Blanc saw the Salon of 1839 as marking a decline from the days of David: "Today, it's the opposite: the laws of propriety have yielded place to marvels of execution. It seems that a talent for painting armchairs allows us to dispense with common sense. . . . We have execution, now we only need ideas [*la pensée*]. Our painting has a body, now we must endow it with a soul."[142] Blanc explicitly accepted the multiple, constructed, and hence artificial, nature of the sign which linguistics was now attempting to reject. Further, in using this corporal metaphor to describe the divided state of the arts, Blanc arrived at a formula similar to those being used by advocates of mimicry, who believed that the deaf person's soul was awakened by education.

Blanc's acceptance of the conventional nature of the sign was widely shared across the cultural divides. Baudelaire argued that caricature was structured from "the drawing and the idea, the violent drawing, the biting and veiled idea,"[143] which by analogy might lead to the conclusion that: "one can be both a colorist and a drawer but in a certain sense," relying on the insight that, even for the Romantic partisan, color "exists only relatively."[144] Neither drawing (Blanc's *pensée*) nor color could exist on their own. Both were an essential part of the visual sign that was a product of their combination. Critics might favour one component over the other, but were uneasily aware that their favorite required the supplement of the other, leading to the search for a synthesis in styles that was indicatively named eclecticism or the *juste milieu*.[145] But, as Alex Potts has cogently argued, the distinction between, on the one hand, the high and beautiful styles of the Antique and, on the other, the sublime, formulated by Winckelmann and expanded by Hegel, created "a structural disparity between the image conceived as the representation of an idea, and the image conceived in its literal reality as body, texture or thing."[146] This disparity in the very concept of the visual sign in the early nineteenth century created the possibility of the line/color debate, while also ensuring that it was

irresolvable. It was in the gap between the two sides that mimicry found a space in which to operate.

Perhaps the most important victory for mimicry was its adoption by the Institute for the Deaf and other learned societies. In 1827, the Institute began to publish a circular which was distributed to all the educational establishments for the deaf in Europe and North America. As an indication of the demand, the print run in 1829 of three hundred was soon exhausted and, after repeated requests, the Interior Ministry authorized a reprint of another two hundred and fifty in November 1839.[147] Through such initiatives, the imagined print community of the deaf which constituted Berthier's deaf nation was given form and substance, even if the circulars, which ran to four editions, often contained medical and disciplinary items hostile to sign language. One striking example of this new relationship between some sections of the deaf educational establishment and the deaf community can be found in the proselytizing work on behalf of mimicry by Jacques Rambusson. Rambusson, the hearing director of the Institute for the Deaf at Chambéry, described himself as an associate of the Société Centrale des Sourds-Muets. He won prizes at learned societies for his papers promoting mimicry as the universal language,[148] in which he fully endorsed the mimickers' theoretical agenda: "The mimic language is the expression of thought by gestures, just as spoken language is the expression of thought by speech."[149] This separation of signifier and signified in the constructed sign was, as we have seen, the widely shared basis of mimicry's cultural intervention. More importantly still, Berthier's critique of Itard was upheld in 1852 by the Academy of Medicine: "When all's said and done, I agree with the learned professor of the deaf that the latter have neither more faults nor less qualities than other men."[150] This simple proposition, upon which mimicry depended, had now won scientific acceptance.

MIMICRY AND MIMESIS

For Balzac mimicry was the very motor of nineteenth-century bourgeois society. In his description of Parisian physiognomies which opens *La Fille aux yeux d'or,* Balzac described the small shopkeeper who

> takes his patriotism ready-made from the newspaper. . . . He is always expert in miming mirth, grief, pity, astonishment, at producing conventional cries or remaining mute, as he stands by to take on any role at the Opera every other evening. . . . His children are recruited into the

class immediately above. . . . Often the younger son of a small retailer aspires to a position in the civil service. . . . That kind of ambition brings our attention to the second spheres of Paris. There you will see the same result. Wholesale merchants and their staff, small bankers of great integrity, bailiffs, solicitors, notaries, clerks; in short, the bustling, scheming, speculating members of that lower middle class.[151]

The petit bourgeoisie of Paris learnt their social skills from print culture and proceeded to mimic their social betters in order that, in a kind of cultural osmosis, the next generation should rise a social rank, according to nineteenth-century beliefs in progress. In fact, the history of the cultural politics of the period could be written as a history of mimicry.

Despite these successes, mimicry was always dependent on the stability of its presumed origin, mimesis. Within a mimetic style, the artist strives for the closest imitation of reality possible.[152] Stemming from Plato's notion of the painter in the soul, mimesis was one of the determining principles of Western art, as defined here by Court de Gébelin: "That which is painted cannot be arbitrary, it is always determined by the nature of the object to be painted."[153] Mimicry depended on this rule as a condition of its legibility which it could not help but undermine by its very existence. Plato had long since recognized the dangers inherent in mimesis which lay behind his opposition to the visual arts. As a central principle of Western culture, mimesis depends upon the Other being natural, rather than cultural, and thus being an uninscribed ground for representation.[154] Mimesis in Western culture was held to have its origins in a moment of self-recognition and distinction from the natural, epitomized in the myth of Dibutade inventing drawing in Greece. Educationalists and philosophers argued that the deaf were a prime example of uncorrupted nature, presenting a tabula rasa awaiting the mark of civilization. Mimicry accepted the deaf as natural but argued that in the state of nature, the deaf nonetheless had a language that, although primitive in the natural state, had been refined and developed in the Institutes for the Deaf until it was analogous to speech itself. It developed a cultural politics that both provided a forum for the deaf community and a means of interaction with the hearing. The entry of deaf artists into the Salon was a central moment in that politics, which was nonetheless fraught with contradiction. For the mimicry of mimesis, as I have called this imitation of Salon style, was nonetheless still a supplement to that style, just as mimicry was a supplement to speech. Here, however, the painter emphasizes the plenitude of mimesis, rather than calling attention to its deficiencies. But the very silence of the image and the metaphorical nature of this description (*la poésie muette*) cannot

help but also indicate the impossibility of an absolutely perfect imitation. Unlike Pygmalion, the artist could not so completely imitate the real as to overcome its inevitable silence. Even more critically, the very notion of mimicry destabilizes the relationship of mimesis to its object. Mimicry is always close to mockery, as this golden age of caricature was inevitably aware.[155] Derrida has described how the mime may in fact not imitate at all but create a copy for which there is no original: "There is no imitation. The Mime imitates nothing. And to begin with, he doesn't imitate. There is nothing prior to the writing of his gestures. Nothing is prescribed for him. No present has preceded or supervised the tracing of his writing. His movements form a figure that no speech anticipates or accompanies."[156] What the mime puts at risk in this moment of unveiling is not the time-worn culture of mimesis, which was in fact to be revitalized by photography and science, but mimicry itself. For just as the Greeks first theorized mimesis, so did they initiate the practice of executing the messenger who brings bad news.

4 VISUALIZING ANTHROPOLOGY

The deaf cultural politics of the July Monarchy and Second Empire became impossible under the Third Republic as the intellectual consensus the mimickers had exploited disappeared. In the era of evolutionism, human culture became monolithic, and Republican governments sought social peace by marginalizing and excluding the "abnormal." This repression was authorized by the Milan Congress of 1880, which outlawed sign language in deaf education, a decision that was legitimised and mandated by the new science of race, especially the revived discipline of anthropology. The pre-eminence of polygenetic race theory consigned anthropology to a marginal role until the 1850s and thereafter, when this renewed anthropology had a remarkably broad scope. In 1868, Paul Broca, the founder of the Parisian Anthropological Society defined it as: "The history of the arts, no more than that of languages, religions, literature, or political societies, no more than that of biology, zoology, palaeontology, and geology forms part of the program of anthropology . . . [A]nthropology can exclude no branch of human knowledge which can furnish any data on the history of man and human society."[1] The eighteenth-century anthropological classification of the deaf was now renewed, but with far greater significance. Anthropologists defined sign language as an atavistic survival from the era of primitive man, enabling the Milan Congress resolutions to appear both reasonable and progressive.

Milan was not, as it is sometimes presented, the end of deaf culture. A second generation of deaf artists emerged and found new responses to the changed situation in both their artistic work and their political activism. A group of professional deaf sculptors not only sent work to the Salon, but produced public sculpture, which both accommodated the aesthetic demands of the Republic and opened a new space for deaf artists to engage with it. Paradoxically, deaf artists were to know their greatest successes at precisely the moment when the elimination of their institutional sign language culture became official government policy. In order to unravel this complicated story, I shall begin with the history of the hand itself,

which is exemplary of the change from the culture of mimicry to that of visual anthropology. Next, I consider the interpretive transformation of the visual sign in the age of evolutionism, both in the visual arts and in the study of the deaf. The latter half of the chapter details the response of the second generation of deaf artists to this very changed situation.

TOUCH, THE HAND, AND GESTURE

Touch had been a central concern of French philosophy, as a key part of sensory perception, since Condillac's *Treatise on Sensations* (1754). Nineteenth-century writers continued this speculative tradition, in investigating the sense of touch. The explosion of professional literature on deviance and its correlative, sexuality, found the hand itself to be the object of suspicion, investigation, and discipline. In these works, concerning the care of the deaf, blind, and insane, or the regulation of sexuality, a distinction emerged between the transforming, material hand and the invisible, spiritual sense of touch. Condillac's single category of touch was now understood as comprising two distinct processes. On the one hand, touch was a process of judgment, which had no effect on the touched object, nor any visible presence when not in use. This kind of touch included the distinction between hot and cold, sharp and blunt, wet and dry, etc. In this sense, touch was was not suspect or subject to moral condemnation. On the other hand, touch was an activity, which left a mark on the object touched. In order to preserve this distinction, the active touch was often described simply as the hand. It was, however, no easy matter to separate touch and the hand. Under Absolutism, the distinction emanated downwards from the body of the King, who was alone able to combine the material hand and the spiritual touch by virtue of his anointment as God's secular representative on earth. This gesture was the royal touch for the scrofula, in which French monarchs healed those afflicted with this skin disease.[2] In the early nineteenth century this practice was recalled in Gros' famous depiction of *Napoleon in the Plague House at Jaffa* (Paris: Musée du Louvre, 1804), showing the Emperor healing the plague-stricken with his touch. Without such Absolute authority, incarnated in the person of Louis XIV or Napoleon, the confusion between touch and the hand became a central dilemma for artists, anthropologists, and criminologists.

The distinction between touch and the hand emerges clearly in comparing the history of the deaf to that of the blind, who were initially

housed together by the state during the French Revolution. The language used to describe the deaf was also applied to the blind, as here by one administrator of the blind school in 1817: "The moral world does not exist for this child of nature; most of our ideas are without reality for him: he lives as if he was alone; he relates everything to himself."[3] The initial breakthrough in the education of the blind was the invention of a raised typeface by Valentin Haüy, condensed by Louis Braille (1809–52) into the code of dots with which we are familiar. Although both systems depended on touch, they were not criticized for it. Instead, educators of the blind worried that, as Braille was not based on the shapes of the phonetic alphabet "this writing has the inconvenience of being arbitrary."[4] As discussions of the old chestnut regarding the preferability of blindness or deafness continued, they were decisively resolved (by those who could see and hear) in favor of blindness. For the loss of hearing was held to entail the loss of voice and hence of thought. When the blind read Braille, they converted the dots into the "pure" medium of sound, which more than compensated for its non-alphabetic character, whereas the deaf used sign, and thought without sound. By late century, official French government manuals on the care of the "abnormal" advised that Braille was "an intermediary system between the manuscript and the printed text," but in sign language, "all spiritual ideas will be unhappily materialized."[5] Thomas Arnold, who founded a small oralist school in Northampton in 1868, believed that the blind: "mentally, morally and spiritually [are] in a more advantageous condition than the deaf." If the blind could create "a mental language of vibrations and motions" from touch, the deaf were restricted to "a language of mimic gestures, . . . which is destitute of all that phonetic language provides of antecedent progress in thought and knowledge."[6] Indeed, as Arnold reminded his readers, the oralist method of deaf education used touch as its primary method: the deaf child was taught to feel the vibrations of the speaking person's voicebox, and attempted to imitate them. Despite the curious vampiric embrace of throats entailed by this method, it was supported by moralists over sign language throughout the century, for oralism upheld the moral supremacy of touch over the hand. This distinction was not lost on deaf activists, who defied the oralists to "invent a method permitting the blind to read without touching."[7]

This distinction was rationalized by describing the sense of hearing itself as a form of touch: "In people endowed with all their senses, the membrane of the tympan is touched by the aerial vibration which results from vocal movements: that is normal hearing."[8] In Condillac's theory of the senses, it was touch that educated the other senses into sensibility; in

this view, revived by Hippolyte Taine and his followers, every sense was a form of touch. Artificial "hearing" thus imitated the natural sense by replacing the touch of the air waves with the touch of the hand. In 1840, Braille was considered arbitrary and mimicry had won a certain acceptance, but by 1890 it was Braille that had become acceptable and the deaf were once again considered pre-civilized. Nothing essential had changed in the nature of sign language and Braille in the intervening fifty years. In Arnold's widely accepted viewpoint, the decisive factor in this change of opinion was the blind's ability to hear. Sight was "much inferior in providing us with available mental images and an organ of expression," indicating that hearing alone was now considered a "pure" sense. Arnold's privileged point of reference was the alienist Charcot, as the "abnormal" became the province of what was termed medico-psychology. Bicêtre was now the dominant partner in the relationship with the Institute for the Deaf established by Sicard and Itard.

If touch was not the culprit in this medical and moral revision, gesture, on the contrary, left behind it the hand. Once a sentence in Braille has been read, no trace of the reading touch remains. But when a deaf person has completed a sign, the hand which formed it remains as a palpable, material entity, visible evidence of the arbitrary nature of the sign. Braille thus partook of the ideal purity of thought, while sign language was a material process. In a philosophical division of labor that has strong parallels with the equivalent process in emerging industrial capitalism, manual work, in all its senses, had to be disconnected from the higher faculties of thought. The hand, capable of all manner of activities, was very much at the centre of moral and cultural debate in the nineteenth century, evoking discourses of sexuality, crime, and class. The much discussed sin of female masturbation was euphemistically referred to as "manualization," making it clear that in a curious way, the hands themselves were held responsible for this irrational, corporal sin.[9] For the science of phrenology, founded by Franz-Joseph Gall, considered that the forms and shapes of the body were symptoms that revealed important inner truths. The hand was the focus of one popular offshoot of these ideas, known as chiromancy, from which palmistry is derived. The key to understanding that Lavater found in the face was relocated by chiromancers, such as Adrien Desbarrolles, to the hand and his study of the particularities of the hand and of gesture ran through many editions.[10] Phrenology was rejected as a science by the 1850s, but the belief it inspired in the legibility of the body was retained.

Early French criminologists were acting on this tradition when they

identified the existence of criminal types of hands and gestures. For Cesare Lombroso and his followers, whose theory of the atavistic criminal ascribed deviance to biological deformity and racial descent from "Negroes" and "Mongloids," thieves were "frequently remarkable for the mobility of their features and their hands."[11] The similarity of this description to that of a signing deaf person was reinforced by the "finding" that "the hearing of criminals is relatively obtuse and they are prone to disease of the ear." One Dr Gradeningo, whose findings were popularized by Havelock Ellis, reported that 72.5 percent of "instinctive criminals" had defective hearing.[12] The opposing side in the criminology debate, who stressed free will and social conditions as the causes of crime, nonetheless continued to investigate the hand in support of their very different conclusions. At the Third International Congress of Criminal Anthropology, held in Brussels in 1892, Lombroso's theories were decisively rejected. Nonetheless, delegates still approved a paper which held that: "The human organism forms a very complicated ensemble whose different parts influence one another. A change in one of its organs sometimes entails alterations in very distant parts."[13] The Congress thus denied that the criminal could be identified by atavistic deformities, but proposed that the pathology of criminal activity nonetheless entailed observable physical mutations.

The observation of the hand had thus quickly become an established part of police practice. In 1879, Alphonse Bertillon began to create his anthropometric system of photographing and measuring the criminal, in which the hand had a prominent place, for it was held to be one of those body parts that no criminal could disguise.[14] As this practice spread, prisoners in England were photographed in 1880, holding their hands palm down in sight of the camera (fig. 30),[15] a marked change from earlier practice which produced simple portrait photographs of convicts.[16] This means of identifying individuals by tell-tale details, rather than the whole, was endorsed by the art critic Edmond Duranty in his 1876 essay on "The New Painting," which we now call Impressionism: "What we need is the particular note of the modern individual, in his clothing, in the midst of his social habits, at home or in the street. . . . By means of a back, we want a temperament, an age, a social condition to be revealed; through a pair of hands, we should be able to express a magistrate or a tradesman; by a gesture, a whole series of feelings."[17] For the painter Degas, it was a matter of creating "a more relativistic Lavater, so to speak, with symbols of today rather than the past."[18] The artist, critic, and detective made their identifications in the same fashion, isolating a detail and concentrating upon its salient features, which could not be disguised. Deviance had to

Book C.C. [For instructions respecting the Photographing of Prisoners, see Standing Order Nº 41]

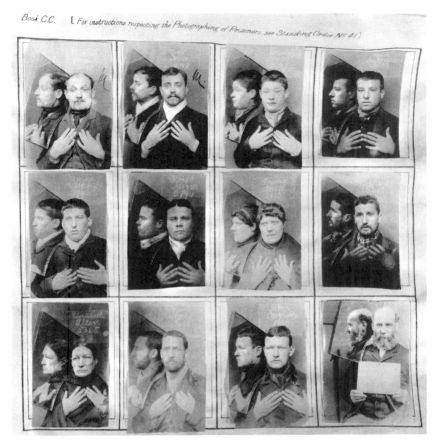

30. Anon., *Portraits of Prisoners* c. 1880 (London, Science Museum)

be made visible, whether it was found in the prison, the deaf institute, or the art gallery. This penetrative scientific gaze was felt by all concerned to be the height of progressive modernism.[19]

The manual identification of criminals was refined by Francis Galton into the use of fingerprints as a means of distinguishing the massed ranks of the colonized. For Galton, fingerprints were "the most important of all anthropological data," even though he was unaware of the traces left by the fingers which we now call by that name. Instead, he saw the patterns on the hand as fulfilling "the need [which] . . . is shown to be greatly felt in many of our dependencies; where the features of the natives are distinguished with difficulty; where there is but little variety of surnames; where there are strong motives for prevarication . . . and a proverbial prevalence of unveracity."[20] Territories at home or abroad could not be controlled by

the police alone. The micro-techniques of discipline now sought to colonize the body and even the hand. In concord with the longstanding classification of the deaf as "savages," deaf administrators in France quickly came to argue, in the words of one Inspector Arnold, that: "the language of signs is *the language of thieves,* because swindlers have the habit of talking amongst themselves in low voices often with the use of both hands and physiognomy."[21] In this pronouncement, Gall's physiognomy rubs shoulders with Lombroso's criminology, and the anthropological focus on language and human activity. Although the name of the science had changed from phrenonology to anthropology, the same physical characteristics remained under suspicion. The casual connection between race, crime, sexuality, and sign language, which had been conveyed in the myth of the harem, now had causal, scientific force.

The criminalization of the (overly active) hand had important implications for artists, whose personal style is often described as their "touch." The distinction between the hand and touch was inevitably hard to sustain in the case of the visual arts. The artist undeniably marks the canvas or stone in making a work. The question for aestheticians and critics was to determine whether a spectator of the finished work could perceive the influence of the hand, and what consequences should be drawn from this judgment. This seemingly grey area was a crucial arena of debate in nineteenth-century art.[22] Ingres, the leader of the revived Neo-Classical school, opined that: "The brush stroke, as accomplished as it may be, should not be visible . . . *instead of the thought, it betrays the hand.*"[23] Ingres' reformulation of the Classical aesthetic held that it was precisely the hand of the artist that should be invisible to the viewer, in an attempt to deny the manumission of the painterly mark. If the "hand" were invisible, then the painter's work could remain within the domain of touch. Indeed, the aura that Ingres was seeking was no less than that of the Royal healing touch. For ancien régime Academicians, who enjoyed the title "Painter for the King," such a syllogism of royal and painterly touch was easily made by association. The contractual monarchies, empires, and republics of the nineteenth century could not offer artists such divine reinforcement. In addition, they had to compete with new methods of image making, such as lithography, photography, and film. Walter Benjamin summarized this dilemma for artists in the age of mechanical reproduction:

> How does the cameraman compare with the painter? To answer this we take recourse to an a analogy with a surgical operation. The surgeon represents the polar opposite of the magician. The magician heals a sick

person by the laying on of hands; the surgeon cuts into the patient's body. The magician maintains the natural distance between the patient and himself; though he reduces it very slightly by the laying on of hands, he greatly increases it by virtue of his authority. The surgeon does exactly the reverse; he greatly diminishes the distance between himself and the patient by penetrating into the patient's body, and increases it but little by the caution with which his hand moves among the organs. . . . Magician and surgeon compare to painter and cameraman.[24]

Benjamin's insight also has a literal application in this context. For the painter, the laying on of hands implied in the creation of a work had been obliterated by the reflected authority gained from the aura of the king, whose healing touch greatly increased the distance between the Royal body and that of his citizens. When that aura was stripped away, artists found that their "touch," far from being automatically distinct from the hand, was in the domain of the medical gaze.[25] The subject of that gaze was first and foremost the human body, just as all artistic training began with the depiction of the body. In the age of pathology, the surgeon displaced the artist as the primary arbiter of the body.

Such questions of technique and technology were especially pertinent for deaf artists, who had to escape the cut of the surgeon in order to attain the magician's status as an artist. Deaf artists in France, whether painters and sculptors, had no interest in destroying the aura of the artwork, and worked in resolutely traditional styles throughout the Second Empire. In the preceding chapter, I discussed the work of two deaf artists, Frédéric Peyson and Francisco Goya, and highlighted the convergences between their work. However, they used very different painterly styles. In his late works, such as the *Saturn*, Goya used a very free brushstroke and loose finish, in order to declare both his artistic independence and the genius, which, according to medicalized thought, his deafness should have made impossible. Peyson, on the other hand, followed the dictate of his master Ingres. His works have the smooth, finished sheen prescribed by the Classical tradition. Goya's work was private, literally executed in and on his own home. But Peyson sought and received the approbation of the artistic establishment through public exhibition, which could not be achieved with a "loose" style in the 1830s. Even Delacroix had to wait until the 1850s before he became a member of the Institut. These contrasting styles demonstrate that artistic style and facture were, as ever, not simply neutral techniques but discursive systems.

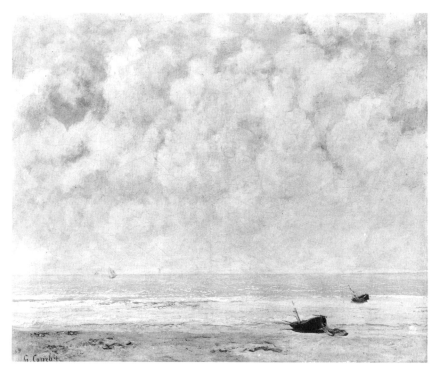

31. Gustave Courbet, *Calm Sea* (New York, Metropolitan Museum of Art, 1869)

As the century progressed, the gesture could no longer serve as a media-tor between the hand and touch. Avant-garde artists responded to the criminalization of the hand by asserting that their "touch" was indeed pathological, but that it was the pathology of genius. Avant-garde artists increasingly used a visible facture as an indication, not just of their rejec-tion of academic doctrine, but of their belief in an artistic genius, which simply existed and could not be trained. For very different (hearing) art-ists, from Courbet to Monet and Van Gogh, the defiant assertion of the hand was central to avant-garde practice in the nineteenth century (figs. 31–32). Their paint was visibly manipulated by palette knife, brush, or even fingers, leaving the viewer no possibility of ignoring the artist's hand. Critics were well aware of this move, as indicated by this comment on Courbet by Maxime du Camp, who was later to play an important role in deaf history: "His skillfulness is notorious, as we have just said; his draw-ing often leaves much to be desired; he has at his service a hand which can achieve much, but the brain is absolutely absent; he sees and he does not look. He does not know how to search, to compose or to interpret; he

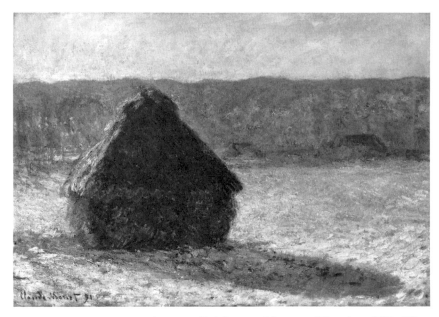

32. Claude Monet, *Grainstack (Snow Effect)* (Boston, Museum of Fine Arts, 1890–91)

paints pictures as one polishes boots; this is a worker [*ouvrier*] of talent, not an artist."[26] Du Camp understood that Courbet refused the traditional connection between gaze and touch, in favour of an unmediated, unthinking hand. In this way, artists sought to escape being relegated to the status of junior house doctors. The surgeon was a product of his or her training, but artists now claimed that their work was independent of all tuition. Their hands acted independently, beyond the control of a disciplinary, professionalized gaze.

Deaf artists had always sought to evade du Camp's characterization of the artist as mindless copyists. The deaf found themselves caught between the anthropological reading of sign language as deviance and the pathology of the avant-garde genius. For artists seeking to use the arts to resist being defined as pathological and to defend sign language culture, the painterly avant-garde offered no resources. It was thus more than coincidence that deaf artists in the later nineteenth century increasingly became sculptors and photographers rather than painters. Seventeen professional French deaf sculptors emerged in this period and by 1899 a writer in a deaf journal announced that "[o]f all the arts, sculpture is without contradiction that in which many deaf people have become famous."[27] Unlike painters, sculptors like Jean-Baptiste Carpeaux often came from the work-

ing classes, for this was unequivocally a manual trade. The famed Romantic sculptor David d'Angers described young sculpture students at the Ecole des Beaux Arts in 1848: "These children of the people descend from their poorly furnished attics—often they barely have enough to live on, yet they rejoice in a future which in their eyes seems wafted on golden clouds. . . . This is the way a child forms the letters which will serve him to change men's lives. . . . Sublime workers [*ouvriers*]!"[28] The transformation of the sculptor was thus analagous to his or her transformation of the raw material of clay or stone into what was still prized as one of the highest forms of art. The agent of that transformation was the hand, as Johann-Gottfried Herder argued in his 1778 essay on sculpture: "The eye is only the guide, only the hand is reason itself. The hand alone yields up forms, the concept of them, what they mean, what lives within them."[29] The sculptor's hand escaped the widespread condemnation of manual activity. Henri Jouin, an establishment art figure who devoted much of his critical career in the 1870s and 80s to the promotion of sculpture, was unequivocal: "The sculptor's tool is his hand." For Jouin, "the spiritualist marble, grandiose and sovereign whose ideal whiteness is similar to some apparition from a higher world," was both manual and ideal.[30] Sculpture offered the deaf student a means of self-transformation in which the primacy of the hand, far from causing disquiet, was indispensable.

In 1859, the Institute for the Deaf reorganized its professional training workshops, creating two new studios in sculpture and lithography.[31] Sculpture extended from the wooden sculpture of cornices and other domestic decorations to the marble and bronze edifices created for the Salon. The administration's intent was primarily practical rather than artistic, for sculpture was widely perceived as one of the few possible careers for deaf people. An anonymous photograph shows the workshop in action, with eleven students at work on a variety of projects, guided by a bearded professor (fig. 33). The abundance of tools and finished pieces on the walls attest to both the seriousness and artistic intent of the workshop. Although the young sculptors are engaged with such practical projects as mouldings and decorative panels, their finished work demonstrates more ambition. Low relief heads and copies of classical reliefs can be seen on the walls, with free-standing busts and figures on the back shelves. The lithography workshop was the subject of an anonymous lithograph by a deaf student, showing the distinctive uniforms worn by the pupils in the late nineteenth century, and a workshop crowded with tools, books, and prints. The skill of the print attests in itself to the abilities of the students (fig. 34).

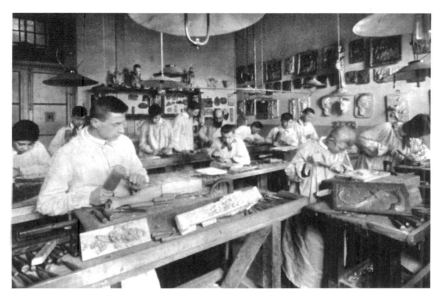

33. [Anon.] *Sculpture Workshop at the Institute for the Deaf, c. 1886* (Paris, INJS)

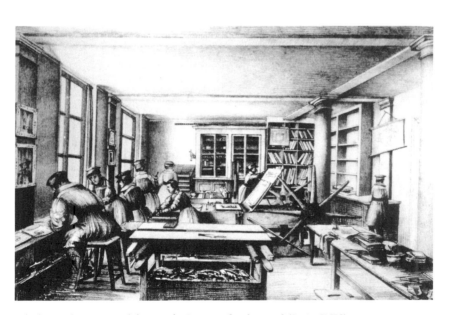

34. [Anon.] *Print Workshop at the Institute for the Deaf* (Paris, INJS)

35. *Félix Martin* (Paris, INJS)

It was from these workshops that the next generation of deaf artists would emerge, led by sculptors such as Félix Martin and Paul Choppin, and lithographers such as Auguste Colas and René Hirsch. In the tradition of Peyson and Loustau, these men would play significant roles in deaf politics as well as in the art world. If one may venture a judgment from their photographs, these were men of very different temperament and class. Félix Martin wore the correct, bourgeois frock coat, complete with a cane (fig. 35). The only indication of his profession comes from the plinth on which he rests his right arm. Paul Choppin, on the other hand, appears as something of a bohemian and an intellectual (fig. 36). Sharply dressed, with an extravagant cravat, he leans upon a workbench littered with clay models. A cigarette is firmly clasped in the corner of his mouth. Crowded bookshelves above attest to an inquiring mind, with a drawing easel at rest

36. *Paul Choppin in His Studio* (Paris, INJS)

behind him. Léon Morice was very much the working sculptor (fig. 37). He sits on a sofa in his studio, with his work clothes on and a tool in his hand. The wall is covered with bas-relief portrait busts, Morice's stock-in-trade. Below the easel, a display of bronze casts can be seen. A screen in the corner may have been for the use of models. Despite this diversity, there were only men in this second generation of artists, for the 1859 reorganizations also made the Institute in Paris all male, and the Bordeaux school for women only. Deaf women learnt to draw as before, but a professional career was almost impossible without access to the Parisian art world.

The leader of the new generation of deaf artists was Félix Martin (1844–1916). Born deaf in Neuilly-sur-Seine, he arrived at the Institute in 1855 aged eleven. Martin came from a privileged background, for his grandfather Louis Martin had been a deputy and his uncle Alexandre Martin was twice elected to the Chamber in the Second Republic.[32] He studied in the sculpture workshop at Saint-Jacques, working with M. Rigal. The routine class work consisted of daily one hour drawing classes, together with two years training for six hours a day in the workshop itself.[33] Martin gained admission to the Ecole des Beaux-Arts, where he worked with sculptors such as Loison, Guillaume, and Cavalier, as well as with the leading teacher of the day Francisque-Joseph Duret (1804–

37. *Léon Morice in His Studio* (Paris, INJS)

1865). In the eleven years preceding his death in 1865, Duret's students, including Jean-Baptiste Carpeaux, had been honored in the Rome Prize competitions six times.[34] In 1865, Martin won the prize for the *tête d'expression* at the Ecole and gained his first acceptance at the Salon. The subject, *St. François de Sales Instructing a Deaf-Mute,* followed the lead of the earlier deaf artists in calling attention to the artist's deafness but was overlooked in the midst of the uproar over Manet's *Olympia.* His success stands in contrast, nonetheless, to the deaf painters of the period. For, despite a switch to genre scenes in 1857, Léopold Loustau had yet to build upon his earlier success and, indeed, he was relegated to the Salon des Refusés in 1863. Martin continued to progress and won the second Prix de Rome in 1869 with a bas relief study of *Alexander the Great and his Doctor Philip.* His entry attracted the attention of Théophile Gautier: "M. Martin, pupil of M. Cavelier (2nd prize), turned his Alexander to the right. He was the only one of the contestants who had this idea; all the other Alexanders look to the left. Apart from the obligatory group, we find in M. Martin's composition a woman on her knees, an ephebe seen from the back resting on a lance, a servant arranging the pillow, a trophy of arms and both assorted warriors and nonentities of the scene."[35] These auspicious beginnings would lead in less than ten years to a Légion d'Honneur for Martin and a central role in deaf culture. His achievements came after the possibilities for a deaf cultural politics had been trans-

formed by the redefinition of mimicry and the sign. It is to these developments I shall now turn before discussing the revival of deaf artists in the Third Republic.

EVOLUTIONISM, ART AND THE SIGN

Following the 1858 discovery of early human remains at Brixham Cave, which provided clear evidence that the antiquity of "Man" was far greater than the Biblical span of six thousand years,[36] Charles Darwin published *The Origin of Species* in 1859 to an immediate storm of controversy. For Darwin used the anomalies prevalent in polygenetic theories of human origin to insist, not just that all humans were descended from the same origin, but that all forms of life were interconnected.[37] The debate soon shifted from nature to culture, when the Duke of Argyll defied Darwin to explain the fact that humans could speak, whereas apes could not, which he saw as a purely human attribute.[38] George Stocking has described how: "Classical evolutionism may best be interpreted not as a 'paradigm' but as a synthesis from various pre-existing intellectual orientations. . . . Darwinians used the ladder of cultural evolution to get from the presumed ground level of human antiquity to a point higher up the trunk that led to human evolution."[39] This ladder was itself a cultural construct that depended on notions of race and sexuality. Philosophy and anthropology had returned to the debate over the origins and nature of language initiated by Locke, Condillac, and Rousseau, which had seemed redundant within a polygenetic model of the human race, a move that was far from advantagous for the deaf. Darwin's theory of the unity of the human race invalidated the analogy made by the mimickers between mimicry and speech, which was based on the separateness of the different varieties of the human race.

As early as 1864, Alfred Russell Wallace, who had arrived at the theory of natural selection at the same time as Darwin, attempted to end the language debate by placing the division of the human species into the various races prior to the acquisition of speech.[40] In his popular discussion of the questions raised by evolutionism, *Researches into the Early History of Mankind* (1865), Edward Burnet Taylor argued that, on the contrary: "the deaf-and-dumb man is the living refutation of the proposition, that man cannot think without speech."[41] The acquisition of culture could not simply be reduced to speech. Tylor denied that "the gesture language," as he called it, had been an intermediate stage between primi-

tivism and speech, for it lacked both grammar and the abstract capabilities of speech. The concrete nature of sign language meant that "the relation between the idea and the sign not only always exists, but is scarcely lost sight of for a moment."[42] If Tylor thus accepted the argument of Berthier and Bébian regarding the precision of the gestural sign, he was far from believing it to be the equivalent of speech. Like the earlier Société des Observateurs de l'Homme, Tylor saw the gesture language as irredemably primitive, but hence of use to anthropological inquirers: "Savages and half-civilized races accompany their talk with expressive pantomime much more than nations of higher culture. The continual gesticulations of Hindoos, Arabs, and Neapolitans, as contrasted with the more Northern nations of Europe, strikes every traveler who sees them. . . . The best evidence of the unity of the gesture language is the ease and certainty with which any savage from any country can understand and be understood in a deaf and dumb school."[43] For Tylor, the cultural ladder was clearly defined by the standards of civilization he saw around him. The Northern Europeans were at the top of a scale which descended, via the Italians, to Hindus, Arabs, Chinese, and, lowest of all, Africans. There was a caesura on this scale marking the divide between the civilized and the primitive, and, as a consequence of their gesture language, the deaf were firmly placed below the line.

Tylor's thesis was both theoretically and practically productive for the evolutionists. For example, James Sibree carried out thirty years of field work in Madagascar, including his classification of "relics of the gestures and signs accompanying oral speech amongst the Hovas of Central Madagascar."[44] It was Darwin himself who completed the anthropological transformation of the deaf and of mimicry. In 1871, he published the *Descent of Man,* which argued that: "with mankind the intellectual faculties have been mainly and gradually perfected through natural selection,"[45] and language was no exception.[46] Darwin accepted that a gestural language was possible, but believed that it had been rejected by natural selection: "Why the organs now used for speech should have been originally perfected for this purpose, rather than any other organs is not hard to see. . . . We might have used our fingers as efficient instruments, for a person with practice can report to a deaf man every word of a speech rapidly delivered at a public meeting; but the loss of our hands, whilst thus employed would have been a serious inconvenience."[47] For the hands had been evolved to fashion and use the tools and weapons that ensured the success of the species: "Man could not have attained his present dominion in the world without the use of his hands, which are so

admirably adapted to act in obedience to his will."[48] The hands were evolved for manipulation by the rational, speaking human, and thus any manual langauge could only be an atavistic, primitive survival.

The following year Darwin published an intended section of the *Descent of Man* as a book in its own right, entitled *Expressions of the Emotions in Man and Animals*. Darwin divided the expressions into three types, of which the second was the principle of antithesis. The deaf were among the innocents regarded by Darwin in forming this category, a considerable fall from the philosophical importance accorded to the deaf by Plato, Descartes, and Kant. Acting on information from the English oralist Dr. William Scott, and the thesis advanced by Tylor, Darwin concluded that: "With conventional signs which are not innate such as those used by the deaf and dumb and by savages, the principle of opposition or antithesis has been particularly brought into play." He expressed disappointment that these signs were less frequent than he would have hoped because of "the practice of the deaf and dumb and of savages to contrast their signs as much as possible for the sake of rapidity."[49] The majority of gestures used by civilized, hearing people were, on the contrary, innate and "quite beyond our control." Darwin accepted that "certain other gestures, which seem to us so natural that we might easily imagine they were innate, apparently have been learnt like the words of a language," but the difference was imperceptible to the untrained eye.[50] Deaf sign language was explicitly excluded from this redefined mimicry. Darwin's work left the deaf unequivocally associated with "savages," and gestural sign language as nothing more than one of those atavistic survivals, "which may fancifully be called living fossils [and] will aid us in forming a picture of the ancient forms of life."[51] The deaf had been claimed by visual anthropology, and relocated to a linguistic version of Jurassic Park.

The French reception of evolutionism was affected both by a revival of Lamarck's earlier theory of evolution and a survival of many forms of polygenetic scientific practice. The rise of evolutionism did not so much transform French anthropological debate as redirect it. Just as evolutionism did not mark a paradigm shift in England, polygenetic racial theories continued to have a marked influence in France after Darwin. In the natural sciences, there was a nationalist revival of Lamarck's evolutionary theory, which stressed "the inheritance of acquired characteristics," meaning that the changes induced by exterior environmental or cultural factors in one generation could be passed on to the next.[52] Lamarck's theory offered the possibility of social regeneration, which had been so cherished by the French Revolution. On the other hand, readers of B. A. Morel's

Treatise on Degeneration (1857) could mesh his theory with Darwin's to envisage organisms adapting to pathological environments by developing physical and nervous deformations in later generations.[53] In other words, both an optimistic and a pessimistic view of evolution were possible in France and the deaf were caught up in this debate.

Evolutionism made race one of the primary interpretive categories in late nineteenth-century France, as can be seen from the significant example of Hippolyte Taine, both because of his unquestioned preeminence as a philosopher in his own time, and because of his acknowledged influence on Impressionism.[54] In 1866, Emile Zola hailed Taine's work: "To me he embodies the last twenty years of criticism. . . . The new science made up of physiology and psychology, history and philosophy blossomed with him . . . I consider him, in literary and artistic criticism the contemporary of the telegraph and the railroads."[55] In the Introduction to his *History of English Literature,* Taine advanced a theory of historical causality dependent on the intermingled factors of race, environment (*milieu*), and climate, with race being the predominant factor.[56] Although he referred to Darwin's *Origin of Species,* Taine believed in "a natural variety of men, as of oxen or horses"—in other words, the polygenetic view of human origins that Darwin had set out to refute. Taine made great use of other features of Darwin's work, especially in his description of "a graduated scale of ideas" in the mutually incompatible varieties of the human race. Here language was the most important example. Taine began his scale of sociocultural evolution with the Chinese language, which was disparaged as "a sort of algebra," ascending via the Semitic languages to those of the Aryan races, in which "language becomes a sort of cloudy and colored word-stage in which every word is a person. . . . [I]n this interval between the particular representation and the universal conception are found the germs of the greatest human differences," which were by nature unchangeable and hereditary.[57] Evolution did not imply a single human race, but a single human scale of intellectual capacity.

In Taine's system, the ability to use, perceive, and interpret signs was determined above all by race. He discerned "a particular inner system of impressions and operations which makes an artist, a believer, a musician, a painter, a wanderer, a man of society." As part of the "innate and hereditary dispositions" of each race, the inner impressions varied in quality according to the rank of the race. In *On Intelligence,* his highly influential analysis of the functioning of these impressions, Taine again emphasized the importance of race in distinguishing signs: "the genius of the great races . . . consists in noticing the most delicate or new resemblances."[58]

Clearly, those limited to the algebra of Chinese—or the similarly concrete representations of sign language—could not perceive the abstract purity of Aryan languages (to use Taine's categories). However, for those sufficiently able to feel such delicacies, there was "a resistance in the word itself" that would prevent misinterpretation.[59] In short, words are in theory abstract but usage gives them a direct relationship to the thing described. Language embodied the transition between the material object and the abstract concept. As Richard Shiff has emphasized, Impressionist and Symbolist artists thus derived from Taine their similar belief that "[t]echnique would facilitate the passage from the personal to the universal."[60] The universal was, paradoxically, not open to everyone, but only to the users of Aryan languages. Mimicry, condemned both for its abstract relation to the object and its materiality, could no longer claim to be analogous to such speech. Accordingly, Taine regarded gesture as "the figurative pantomime of the savage,"[61] no substitute for the sense of hearing.

The avant-garde critics who supported Impressionism were certainly aware of and influenced by Taine's ideas. For example, the poet and art critic Jules Laforgue attended Taine's lectures at the Ecole des Beaux-Arts in 1880–81 and blended them with his understanding of Darwin in his famous 1883 essay on Impressionism:

> The Impressionist eye is, in short, the most advanced eye in human evolution, the one which until now has grasped and rendered the most complicated combinations of nuances known. . . . [E]verything is obtained by a thousand little dancing strokes in every direction like straws of color—each struggling for survival in the overall impression. No longer an isolated melody, the whole thing is a symphony, which is living and changing, like the "forest voices" of Wagner, all struggling for existence in the great voice of the forest—like the Unconscious, the law of the world, which is the great melodic voice resulting from the symphony of consciousnesses of races and individuals. Such is the principle of the *plein air* Impressionist school. And the eye of the master will be the one capable of distinguishing and recording the most sensitive gradations and decompositions, and that on a simple flat canvas.[62]

Laforgue's endorsement of the Modernist aesthetic of flatness has ensured his place in the critical canon, but his belief that Impressionism was the product of a Darwinian struggle for cultural existence dominates the essay. He endorsed Taine's polygenism, seeing the various races as having separate voices that blend together, and his references to the Teutonic forest

identified the Impressionists as Northern, or Aryan. For he was less concerned with the means of representation than the internal effect caused by the painting, which was above all perceptible to the "eye of the master," the exclusive prerogative of Taine's "great races." Finally, painting was directly linked to the voice as color in painting became equated with the choral symphony. In short, the racial, cultural, and artistic principles of Impressionism were such as to exclude deaf artists from participating in the new movement.[63]

The new racial categories had a striking and immediate effect in art education. Guillaume Duchenne de Boulogne (1806–75) decisively connected evolutionism and artistic training via photography. Duchenne was convinced of the therapeutic and experimental powers of electricity, and claimed to have cured numerous deaf people by electric shocks.[64] In 1862, he set out to find and record "an experimental living picture of the passions" by applying electric shocks to the various muscles of the face. With photographer Adrian Tournachon, the brother of the famous Nadar, Duchenne experimented on two of his patients at the Salpêtrière (fig. 38). His models were a man who had anesthesia of the face, and a blind woman who hoped for a cure from the procedure. Today, the photographs appear anything but natural. In one picture, entitled *Scene of Coquetry*, Duchenne can be seen applying electricity to a young woman's forehead. The resulting coquetry comes not from the expressionless face, but from her disordered clothing, and the gesture of her left hand, which supports her breast. One doubts if this hackneyed scene was induced solely by electricity. Nonetheless, the *Journal des Débats* made the desired connection to the arts: "This atlas of natural expressions artificially provoked, which will be of equal profit to physiologists and artists, will remain as one of the most curious monuments of our times."[65] This prediction was remarkably accurate. Darwin used Duchenne's photographs in his treatise on expression and emotion, as proof of the independence of the facial muscles, indicating that many expressions are "from the earliest days and throughout life quite beyond our control."[66] In order to pursue this line of research, Darwin commissioned a series of photographs of the emotions and gestures in children from Oscar Rejlander, some of which were then published in his book.

Both Rejlander and Duchenne were eager to demonstrate the usefulness of their work to artists. Rejlander posed a model in imitation of Titian's Venus from the *Venus and Adonis* and thereby highlighted the anatomical defects in the master's work: "Venus has her head turned in a manner no female could turn it and at the same time show so much of her

38. Duchenne de Boulogne,
from *Mechanism of Human
Physiology* (1862)

back. Her right leg is also too long. I have proved the correctness of this
opinion by photographs with variously shaped female models."[67] Like-
wise, Duchenne "corrected" the Classical statue of Laocoon by "harmo-
nizing the movement of the eyebrows and the modelling of the forehead"
on a plaster bust, which he then photographed. Such strategies were con-
sistent with traditional academic training, especially Charles Le Brun's
theory of the passions (1697), which envisaged the eyebrows as the most
expressive of the features.[68] In 1874, Professor Mathias-Duval began
using large scale enlargements of Duchenne's photographs in his anatomy
lessons at the Ecole.[69] Eugène Guillaume, the new director of the Ecole,
saw an opportunity to revive the often-derided teaching program and
revive the "classical education" in the arts by giving it a "scientific charac-
ter." He supported the instigation of "the study of the human races in
such a manner as to establish references for the course in History."[70] A
detailed course of nearly forty lessons resulted, including a study of the
"forms of the skull, according to ages, sex and race," inspired by Paul
Broca's anthropology. Expression was taught by use of Duchenne's photo-
graphs and the students studied both his written work and that of Darwin
on the expressions. The course concluded with an examination of "the

human races [and] their anthropological characteristics."[71] Photography now worked alongside the traditional arts to promote a "scientific" depiction of the body. Visual anthropology was now the official teaching program of the Ecole des Beaux Arts.

The new course was described as mimicry: "It is immediately evident that the representations of the human figure, by sculpture and painting, are only possible through mimicry and it is impossible to separate them from this latter."[72] Bébian's defence of mimicry as the sign language of the deaf was now unwittingly deployed by the Academy to mean the "scientific" study of anthropology, race, and craniometry. Edouard Cuyer, who popularized Mathias-Duval's course in a number of publications in the late nineteenth and early twentieth centuries, explictly rejected the Academy's earlier definition of mimicry in its Dictionary, and instead defined mimicry as "gestures executed under the influence of emotions felt by the subject, without the will of the subject intervering in the productions of movements, gestures and facial expressions corresponding to these emotions."[73] Mimicry taught using the theory of Darwin and the practice of Duchenne was held to be truly scientific. For unlike sign language, science claimed to catch the natural, involuntary, and unmediated gesture. Mimicry was reduced to an anatomical, rather than linguistic, process. Mathias-Duval, Guillaume, and Cuyer firmly believed they were being progressive in instituting these and other reforms, for the atavistic sign language of the deaf could not be allowed to impede the advance of progress.[74]

The rise of anthropology thus removed much of the intellectual ground from beneath the mimickers' feet. After 1880, one rarely reads of sign language as "mimicry," with terms such as "the language of signs" or "the gesture language" being preferred. For artists, the chain of analogy between sign language and the visual arts appeared to have been broken. From the Academy to the avant-garde, there was now an acceptance of what Paul Broca called in 1876: "the notion that race is not only constituted by physical characteristics, but by a combination of intellectual and moral characteristics capable of exercising strong influence on the social and political destinies of peoples."[75] Thus in 1875, one Theobald, a professor at the Institute for the Deaf, reiterated de Gérando's theory of the lack of originality in deaf artists: "Our pupils imitate well, very well, I should say even admirably; but in the end, he who servilely imitates piece by piece will never be anything but a copyist; the true artist imitates, but in such a fashion as to produce a new and foreseen effect."[76] Theobald subscribed to the doctrine that "savage" races, including the deaf, were excellent imitators but poor innovators. As "servile" peoples, they were by

definition under the control of a superior and had no place to create, but only to obey. Theobald's use of the term "effect," which was at the heart of debates over Impressionism, demonstrates that he was not simply ignorant of the arts, but was in fact right up to date. In the eyes of the hearing, the revival of anthropology returned the deaf to the pre-civilized condition to which they had been consigned by the Ideologues at the start of the nineteenth century. This new interaction between race, reform, republicanism, and progress was to prove a far more tenacious discursive practice, intolerant of opposition or contradiction.

THE SILENT MONUMENT

A new generation of deaf artists had now emerged. Ten deaf artists submitted their work for the Salon of 1875, and seven were accepted, causing the Institute for the Deaf to take notice: "A very remarkable artistic movement has become manifest for some time among the deaf."[77] Just as deaf artists had earlier used the discourses of linguistics against itself, so the second generation now made play with visual anthropology central in their painting and, especially, sculpture. Sculpture had always played an important role in Republican politics, beginning with the demolition of Royal statues in 1792.[78] In the February Revolution of 1848, the statue of Spartacus in front of the Tuileries was decorated with a red liberty cap, made from fabric removed from the throne of Louis-Philippe. Meanwhile, an equestrian statue of the duc d'Orléans was overturned and the bas-reliefs on the plinth were replaced with inscriptions dedicated to the dead of 23 and 24 February.[79] In 1871, one of the most controversial acts of the Paris Commune was the destruction of the Vendôme Column and its statue of Napoleon III. If Republican uprisings destroyed statues, the established Third Republic succumbed to a "statuo-mania." As the politician Jules Simon reflected around 1900, "erecting statues has been our latest mania."[80] Critics who had traditionally focused on painting were forced by the increased popularity of sculpture to take another look. At the Salon of 1877, Charles Timbal remarked: "For several years, the public has enlarged the circuit of its promenades at the Salon. Today it is almost as interested in the works of our sculptors, as in those of our painters."[81] The public's interest was matched by that of those critics inclined to support the "official" view of the arts: "Sculpture in France today is making excellent progress, and one can say that, in proportion to the number of works exposed, its level is superior to that of painting."[82]

The public spaces of France became decorated with innumerable statues of its great citizens, which increasingly supplanted allegorical representations of the Republic and Nation.[83] The status of such public sculpture allowed deaf artists to adopt a new role. To modern eyes, these works are almost invisible. Robert Musil's thoughts in this vein on public sculpture have been used as a motif by Marina Warner and others: "The most striking feature of monuments is that you do not notice them. There is nothing in the world as invisible as monuments. . . . They virtually drive off what they would attract. We cannot say that we do not notice them. We should say that they de-notice us, they withdraw from our senses."[84] Yet this invisibility did not apply in the pre-First World War Third Republic. With its repeated political crises—the monarchist threat in the 1870s, the Boulanger crisis (1888–89), and especially the Dreyfus Affair from 1894 onwards—there was little time for the public to grow quietly used to their sculptural history. As we shall see, when sculptures were installed, the public could and did engage with the medium in quite different ways to those offered by painting. By the time Musil wrote his essay in 1936, not only had the issues of the nineteenth century died, but many of the more controversial statues had been destroyed or removed. Certainly, all but one of the Parisian public sculptures by the deaf were gone by this time. On the other hand, the artist responsible for these works could find an almost instantaneous anonymity. Like the *flâneur,* the deaf sculptor was unseen and unheard on the street, behind the mask of the silent monument. In distinction to Warner's desire to "see the caryatids speak," deaf sculptors wanted their work to signify silently.[85]

Just as the First Republic had aided the career of Claude-André Deseine, so did the Third assist Félix Martin. Unlike Deseine, Martin's work was much noticed by the critics and he was especially promoted by the art historian, cultural activist, and critic Henri Jouin. From 1873 onwards, Jouin published an annual article on sculpture at the Salon, prefaced with a theoretical essay on various aspects of the art, which were later published as books. Jouin developed a rationale and aesthetic for sculpture in modern times, based on race, nation, and republic, which he called "an analysis in depth, reasoned, realist, I might almost say materialist." He argued that "modern peoples are enlightened by precepts the Greeks never knew," and believed that a new sculpture, based on "the intimate union between matter and thought" was both possible and necessary.[86] Sculpture could thus take up the banner of the Ideal in art, which he felt painting had abandoned. Jouin understood sculpture as the perfect example of the conventional, arbitrary sign, in which certain forms came to be the vehicle for

the expression of the Absolute, following the argument of Charles Töpffer, whose *Nouvelles génevoises* had famously theorized the conventional sign.[87] Jouin dismissed the new painting, arguing that "the realists are only photographers of the visible. They do not seek the idea but the object."[88] Art was rather a composite, motivated by the idea and thus similar to language as conceived by Condillac, Töpffer, and the mimickers: "Speech is only a piece of clothing, deriving a share of its revitalising force from the idea. Words reappear on the surface of a written or spoken language with transparency and integrity; one might describe them as a piece of cork, which my hand can hold for an instant at the bottom of a vase, but which its own weight cannot keep submerged. . . . Gesture and attitude have completed the Verb."[89] This somewhat opaque theory refused both the realist intent to depict only "perceptible nature," and traditional Academic formulae. He called for a fusion of realism, idealism, and mysticism to create what he called "the liberating school."[90] This sculptural program offered new possibilities for deaf artists within the regime of visual anthropology.

Jouin proposed that, rather than being the subjects of paintings they never saw, the Parisian crowds should become the spectators of a new generation of sculpture: "That which properly belongs to the people is the forum, the public square, the street. . . . The factory gives out onto the street, and it is therefore this terrain that must be decorated. Here we must people the place with statues, just as it is peopled with workers. The eloquence of a work of sculpture is increased one hundred times by being in full sunlight."[91] This curious mixture of the conservative, liberal, and even socialist was characteristic of official culture in the Third Republic, ever fearful of the Commune to its left and the forces of reaction to its right. These contradictions within republicanism become evident in Jouin's racial conception of sculpture. Jouin admired the "primitive whiteness" of marble sculpture and asked where beauty might be found: "Doesn't the artist's eye come to rest on the whiteness of our race? Plato proclaimed young men whom nature had given a white skin the children of the gods."[92] He thus managed to reconcile nineteenth-century race science with Classical philosophy and art practice. However, art was not simply the imitation of the ideal, white type: "Despite their primitive unity, don't the men of one race appear distinct by their physiognomy and their aptitudes?"[93] This formula of variety within fixed racial boundaries defined the republican juste milieu in cultural, scientific, and political terms.

Ann Wagner's description of the dynamic between sculpture and criti-

cism is applicable to the relationship between Jouin and Martin: "In an age when anatomical knowledge was a secure and solid branch of science, the artist knew more than ever about how a body *ought* to look. So the business of sculpting and of looking at sculpture became more and more the matter of relating the requirements of a 'correct' figure to a concept of 'appropriateness' defined, not *in* the sculpture but external to it, by the title or subject the work was asked to express."[94] By the 1870s, anatomy was not an independent science, but was intertwined with race science, art, and anthropology, whose intellectual domain expanded as fast as the French Empire itself. The kind of corrections called for by critics like Jouin were not only related to the appropriateness of the figure to the subject, but to its precision in regard to racial type. Given that such criticism sought to modify and improve the body in relation to a racial norm, it can be called *eugenic* criticism.[95] In such a program, any reference to deafness, even by analogy, could be perceived as a defect to be eliminated from the ideal body type. It might seem obvious that sculpture was a mute medium, but critics of the period did not think so. For Jouin, "the sculptor would like to speak his thoughts out loud, and, form being the verb of the sculptor, he will search out a powerful form in the clay, distinguished, ideal, impregnated with the divine."[96] The sexualized metaphor recalls that the myth of Pygmalion, who was helped by the gods to bring the sculpted figure of Galatea to life, became a popular subject for artists in the late nineteenth century and was treated by such figures as Gérôme and Rodin. But it was not only a myth of sexual desire, for Pygmalion also made his sculpture talk and hear. One of the most awkward problems for Martin and his contemporaries, who were very much involved in deaf politics, would be finding ways to refer to their deafness in their art.

The first sculpture by Félix Martin to be reviewed by Jouin was exemplary of this racial consensus. Martin exhibited his *Hunting the Negro* at the Salon of 1873 (fig. 39). It depicted a black man brought down by a hunting dog, which is on the point of attacking his throat. It would be a mistake to conclude that Martin was in any way a supporter of slavery, which had finally been abolished in the French colonies in 1848. Indeed, as Albert Boime has pointed out, abolitionist works of art "tend to indict the cruelty and inhumanity of the institution of slavery."[97] Nonetheless, the figure gives little sign of resistance almost seeming to embrace his attacker, a point highlighted in Jouin's review: "M. Martin's *Hunting the Negro* is a group which has merit. It contains some very beautiful parts. The blood-hound [in English in the original], which has thrown the man to the ground and strangles him, has great energy of movement. The

39. Félix Martin, *Hunting the Negro* (lost)

negro is no less studied, but one could reproach him for laying himself open a little too much to the embrace of the animal. The sentiment of preservation should have given the head of the slave a backward movement, which it does not have; the features of the face would also demand a greater expression of suffering. Despite these lacunae, M. Martin's group is nonetheless one of the best works of the Salon."[98] These comments were typical of Jouin's criticism, combining very specific criticisms of faults with rather generalized words of praise. Jouin's sentiment that this was "one of the best works of the Salon," was shared at higher levels, for his piece was purchased by the state for 12,000 francs and sent to the Museum at Evreux.[99] There seems to be a paradox in Jouin's call for sculpture to reflect the beauty of the white race and Martin's subject, an escaped African slave. There was indeed a certain tension in Martin's attempt to anthropologize the visual, caught between critical demands to remain true to his sculptural subject and to make visible the gendered dimension of the racial divide. But Martin had in fact carefully followed the racial categories of the period, and the male figure was unmistakably typecast as a "negro." His skull slopes at an appropriately low angle and bulges at the back, a craniometric sign of the lower development of the African race, according to Paul Broca's classification of humanity into three classes according to skull shape, with the *races occipitales*—blacks

with most brain development in the rear—occupying the lowest rung.[100] Martin's figure clearly displays this feature. The artist's desire to make this difference visible explains the raised posture of the head. His *Hunting the Negro* indicates that the anthropological courses being introduced that year to the Ecole des Beaux-Arts were as much a response to current artistic and critical practice as a pedagogical innovation.

The figure of the slave also has very prominent wide hips that seem to be derived from Ingres' *Grande Odalisque* (Paris, Musée du Louvre, 1814) or Auguste Clésinger's famous 1847 statue, *Woman Bitten by a Snake* (Paris, Musée du Louvre) rather than from a male model. Both Ingres and Clésinger were depicting Oriental women, although many believed that a snake was added to the latter's statue as a thinly veiled excuse to depict a writhing female nude. The parallel with Clésinger is enhanced by Martin's 1875 Salon entry, the *Death of Cleopatra*,[101] the same title as Clésinger's 1861 version of his piece.[102] Once again, Martin was adhering to the principles of anthropology in depicting a black man as being closer to a woman's physique than that of a white man. In his 1864 *Lectures on Man,* Carl Vogt, the foreign correspondent of the anthropological society of Paris, concluded that "the grown-up Negro partakes, as regards his intellectual faculties, of the nature of the child, the female, and the senile white."[103] These were the groups later observed by Darwin in his study of the expressions. Martin had made this anthropological difference visible by "feminizing" the hips of his figure, a point he was not called to correct by his critic. By contrast, the blood-hound is, as Jouin observed, finely muscled and his wagging tail seems to indicate his pleasure in his work. As the dog evidently stands in for the absent white slave owner, his taut musculature can be taken to represent (masculine) whiteness in opposition to the weak, feminized slave. The slave could not resist the blood-hound, if this gendered racial difference was to be fully apparent, emphasized further by the phallic tail of the dog rising from above his prominent genitalia. Martin has adhered to his mentor's precept in depicting "primitive whiteness" after all. Indeed, there is a possibility that Martin undertook this work precisely in order to delineate the distinction between the deaf and the African. For whereas race science had clearly distinguished "African" characteristics, it was still only possible to identify a deaf person by his or her sign language. Furthermore, the very creation of such a sculpture, the most advanced form of art, indicated how far the deaf were beyond the "primitive" culture of the African.

Certainly, there was a conscious attempt by deaf artists in the early 1870s to represent what Jouin called the "national idea."[104] After the

humiliation of defeat in the Franco-Prussian war, such themes had a topical urgency, were impeccably republican and served to rebut the latest allegation against the deaf, that they lacked patriotism. During the war of 1870, the deaf artist Frédéric Peyson was arrested as a German spy because of his looking around in the manner of a *flâneur,* in the description of the period. His sign language gestures only increased suspicion, until a hearing friend was able to vouch for his status.[105] Peyson had conceived the deaf artist as a *flâneur* in reverse, mixing in with the crowd and being seen to do so, an option that no longer seemed to be open.

The patriotic theme therefore became newly important in deaf politics. For after the loss of Alsace-Lorraine, the very speaking of the French language was associated with patriotism, in such a way as to exclude the deaf from the fatherland itself. Adolphe Franck, the writer, member of the Institut and advisor to the Institute for the Deaf went so far as to say in 1875 that "the deaf-mute has never heard the voice of his mother and he will never hear that of his child, nor that of his friend, nor that of his fatherland [*patrie*]; for the fatherland has a voice whose silence is a cruel torture for us, it is that which we so justly call the maternal language."[106] Even the affluent René Princeteau (1844–1914), a deaf artist who usually worked on landscapes and animal pictures, responded to this challenge (fig. 40). Princeteau had won medals at the Ecole des Beaux-Arts, and later worked both as a painter and a sculptor. At the Salon of 1874, he exhibited his equestrian portrait of the President of the Republic, General MacMahon (Versailles, Musée du Chateau). The carefully rendered portrait showed the lacklustre president wearing full military uniform and in dignified pose. The surrounding officers were depicted in less-finished style and the light fell full on the president's face. He literally stands out from the crowd. No one could doubt the patriotism of this work. Another national subject, Martin's *Louis XI at Peronne,* was praised in 1875 as "M. Martin's best work and one of the most remarkable works of the Salon."[107] In 1876, Princeteau, Félix Martin, his brother Ernst Martin, and Georges Ferry, a pupil of Cabanel, sent work to the Philadelphia International Exhibition. They were thus able to represent themselves both as French and as deaf artists in defiance of Franck's edict.[108]

In July 1875, Martin Etcheverry (1814–1895), director of the Institute for the Deaf, visited Félix Martin's studio with a proposal, which would mark the highpoint of the deaf artistic movement and, ironically, signal the imminent oralist challenge to deaf culture. Etcheverry proposed that Martin execute a statue of the abbé de l'Epée, as a companion piece to the painting of Epée with Louis XVI and Marie-Antoinette by the hearing

A. Courrègea
Place de la Gare
LIBOURNE

40. *René Princeteau*

artist Gonzague Privat (Paris, Institution Nationale des Jeunes Sourds, 1875) (fig. 41). Maxime du Camp called for a statue of Epée in 1873, in his articles on the deaf in the influential *Revue des Deux Mondes:* "One looks in vain for a statue of the abbé de l'Epée" at Saint-Jacques.[109] Du Camp was a writer and an Orientalist, who published an account of his visit to the harem in Istanbul, and later accompanied Flaubert to Egypt and North Africa. He took a series of photographs of the ancient monuments of Egypt—and of Flaubert in Arab dress—that have won him a place in the canon of photographic pioneers. In short, he personified the modern man of the nineteenth century. In his assessment of the deaf, du Camp realized that everything depended on the term *entendement,* which could mean either hearing or understanding. Itard and his successors had used this ambiguity to connect the deaf with the mad. Du Camp thus argued that the essential question was whether hearing was "indispensable to the development of the intellect," which, according to one's view of evolution, could be answered in either pessimistic or optimistic fashion.

41. *The Hall of the Institute for the Deaf Showing Gonzague Privat's Painting of the Abbé de l'Epée* (Paris, INJS)

The optimistic view held that the achievements of deaf writers and artists demonstrated that "the evil which affects [the deaf] is local and does not at all affect the faculties of the brain. . . . [S]everal have been able to reach a remarkable degree of culture; among the latter are named authors, sculptors, painters and skilled artisans." The development of such a cultured elite had been the strategy of the Société Centrale des Sourds-Muets to rebut the charge of primitivism. But du Camp clearly adhered to the pessimistic view, which categorized the deaf person as "mentally an invalid . . . whom we can never entirely cure. . . . He remains fixed in an inferior rank, which makes him only a sort of intermediate creature; interesting, is is true, and capable of receiving a limited education, but shut up by a pathological accident in comparative darkness. . . . [They are] betrayed by the ill-shaped head, the tapering forehead and chin, the prominent ears, and the nervous twitchings of the face which many cannot restrain; these are a sort of indication that the animal nature predominates."[110] He saw resemblances in their physiognomies to "hares, apes, and bulls." Du Camp wove one hundred years of (mis)representations of the deaf into a complicated pattern, mingling notions of pathology, phrases from Sicard and Epée, and phrenology. He argued that the overriding goal should be the creation of a new "model institution . . . [which] would attract wealthy deaf-mutes," and thus reduce the cost to

42. Félix Martin, *L'Abbé de l'Epée*

the state. Du Camp's critique attracted considerable attention among deaf educators and was soon translated into English for the *American Annals of the Deaf.* Etcheverry's idea for a statue was thus inspired from the outset by a desire to transform what du Camp called an "establishment which, after having enjoyed for many years a universal reputation, is now little regarded."[111]

For Martin, the chance to commemorate Epée in this fashion was both an important development in his career, and the opportunity to make a public statement of the value of sign language (fig. 42). The statue of Epée by Auguste Michaut (1789–1879) at Versailles, which had been installed on 21 August 1844, was Martin's point of departure (fig. 43).[112] He followed Michaut in showing Epée holding a scroll with the word DIEU (God) written upon it, but, instead of having Epée point to Heaven as Michaut did, he showed him finger spelling the first letter, "D," and he added the figure of a deaf boy signing "D" in response. The first version of the piece was exhibited at the Salon of 1876, where Jouin was ready with his critique: "If the age of the child was nearer to adolescence, if the attentive pupil was grouped with the principal figure instead of simply being placed on his right, the monument which M. Martin proposes to elevate to the abbé de l'Epée would be sheltered from all criticism. The simplicity of the action unites with the science of the modelling in this

43. Michaut, *The Abbé de l'Épée* (Paris, INJS)

work, which the artist has not taken on through caprice but by a just sentiment of gratitude, which does him honor. The work of M. Martin has its place reserved at the Institute for the Deaf, where he himself grew up."[113] This discrete reference makes it clear that Jouin was familiar with Martin's biography and he was certainly informed as to the intended destination of the work.

Although Martin had observed many of the conventions for a statue of this type, his departures were more significant. It was common to imitate biography by representing the figure in a typical moment from his or her life, with additional bas-reliefs on the plinth detailing the "works." Statues such as David d'Angers' *Gutenberg Monument* (1840) require an ability to "read" their message, rather than simply be admired. David, a life-long Republican who was a deputy and Mayor of his arrondissement in Paris during the Second Republic, considered the invention of printing a moment of liberation and emancipation.[114] The figure of Johann Gutenberg stands next to a model of his press, holding the title page of his legendary Bible, on which only the phrase "And there was light" has been carved by David. Print spread the word, which in turn spread freedom to the four continents, as was made clear by the reliefs on the base. Each scene was devoted to one continent, and centered around a printing press. In the scene devoted to Africa, an Emancipation proclamation has been printed

out, and enthusiastic Africans thank William Wilberforce, Thomas Clarkson, Condorcet, and the abbé Grégoire, whose figures were labelled to aid identification. At the rear, books are handed out to grasping hands, while the chains of slavery are removed at the right. The white men were carefully distinguished from the Africans. The whites are physically larger, clothed, and have dignified "Greek" profiles, but the Africans are semi-naked, small, and have the exaggerated lips and jaws, and low cranial angle, prescribed by polygenetic race science. The press was envisaged as universally liberatory, but it was clear that David d'Angers did not believe the human races to be equal.

The final version of Martin's sculpture was exhibited at the Salon of 1877, and shows similar faith in the powers of reading and print culture, which were at the heart of Epée's "emancipation" of the deaf. One of the plinth reliefs showed the primal scene of recognition, in which Epée visited the deaf sisters and saw sign language for the first time (fig. 44). Epée's virtue was commemorated in another relief depiciting his reluctance to spend money on firewood for himself, even though he was ill in winter (fig. 45). In the main group, the boy was depicted at only half the size of Epée, a convention described by Albert Boime as "the iconographical embodiment . . . of what I call the *abased slave* and the *exalted liberator*."[115] Epée was clearly the liberator, and the deaf child the freed victim. But neither the deaf figures in the reliefs, nor the deaf pupil in the free-standing group, have any visible stigma to indicate their deafness, for their skulls are classically shaped and they are of European descent. Whereas David d'Angers had made the distinction between the European liberator and the Other strikingly apparent, Martin refused to accommodate the desires of visual anthropology by making deafness a visible deformity, or the deaf a race apart.

Jouin again reviewed it at length, finding new faults: "The attitude and gesture speak of the character of this priest who drew from his heart the syntax of a new language, fated to give intelligent life to thousands of the disinherited. The young deaf boy standing at the right of the abbé de l'Epée repeats, with a charming naivety, the sign that his master is about to teach him, and which will permit him to name 'God.' There is a poem more delicately thought than rendered in this primitive [*rude*] bronze; but even if we observe in the finished work qualities that the model of the statue did not contain, we would hope that M. Martin, who has already mastered the idea, that great driving force of the artist, will not delay in acquiring a light touch, finesse in modelling and touch of the chisel, without which the most serious works cannot seduce the gaze."[116] Jouin's

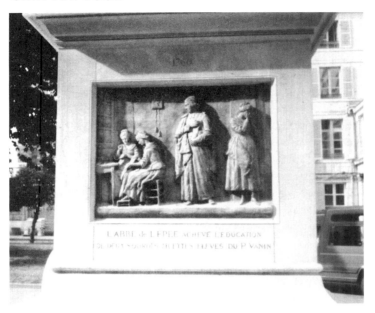

44. Félix Martin, *L'Abbé de l'Epée*—plinth panel

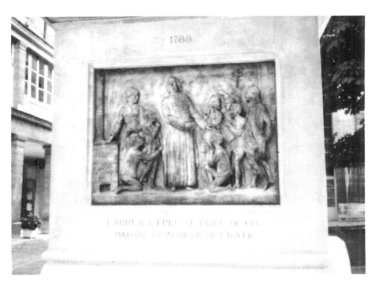

45. Félix Martin, *L'Abbé de l'Epée*—plinth panel

use of the term "seduce" is curious. It had long been a staple of painting theory that, in the words of the eighteenth-century writer Roger de Piles, "[t]he essence and definition of Painting . . . to seduce our eyes."[117] For de Piles, the seduced spectator then approaches the work and enters into a silent or spoken conversation with it. Sculpture criticism typically used a more direct sexual metaphor to refer to the union of the artist and his model, not the artists and his spectator.[118] A signed or silent conversation would not do for Jouin, proponent of the eloquence of sculpture. Public sculpture needed to seduce the populace into speech, or its educative mission would come to nothing.

Jouin's eugenic criticism was also disturbed by the apparent acceptance of the "degenerative" symptom of deafness implied in Martin's work, which proposed no cure for the disease, but even celebrated its symptom, sign language. Jouin misread Epée's finger-spelling as a gesture indicative of his good character. The body, especially the hand, could not be read as an active signifier, but only as passively reflecting inner thought. Hence he returned over and over again to the failures of the hand he perceived in Martin's work, in modelling, chiseling, and overall "touch." The hand was a symptom both of Martin's deafness and his shortcomings as an artist. Jouin's departure from his usually favorable comments on Martin's work is all the more conspicuous in the light of other positive reviews. Eugène Loudun concluded his review of the Salon with a description of Martin's work: "The young child, a pretty and intelligent figure, repeats the sign with his little fingers; and the first word that he learns to read on the open book in front of him is the name of God, that God who has given thought to him along with life, and the spirit of compassion for the weak and the young to the Christian priest."[119] To the critic not bound by eugenic critical standards in sculpture, the sign was not only visible, but was indispensable to the reading of the work. The intelligence and good looks of the deaf boy were subject for praise. The *Journal Officiel* read Martin's intentions well, in commenting that the statue was "at once evidence of gratitude, and an incentive for the pupils to emulate, in showing them that which work and perseverance can do for the development of the faculties which they have received equally to other men."[120] This interpretation made sign language the means of intellectual development for the deaf students in the Institute. An engraving by the deaf artist Auguste Colas shows that the statue, far from being "de-noticed," became the center of celebrations at the Institute on Epée's annniversary (figs. 46–47). The statue was decked with flags and illuminated by Japanese lanterns, with fireworks completing the festivities. For the deaf students,

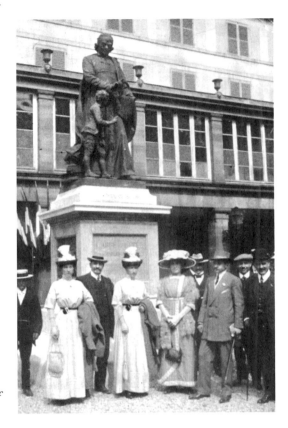

46. *Members of the Salon Silencieux Posing in front of Epée's Statue* (Paris, INJS)

Martin's work was indeed seductive. His achievement was comparable to that of Frédéric Peyson, in reaffirming the potentialities of the deaf, especially the deaf artist, made possible by sign language, but unlike Peyson, he made signed language itself the centerpiece of his work.

Martin succeeded in gaining official state support for his work. After the bronze was exhibited at the Universal Exhibition of 1878, the government accepted Martin's gift of the statue and it was inaugurated in a ceremony on 14 May 1879 at the Institute for the Deaf. Not only did the Minister of the Interior Charles Le Père attend, but he awarded Martin the Légion d'Honneur in public. In his speech, however, Le Père emphasized that "the role of the state is limited, and, in works of public charity, the principal task belongs to the departments and the communes." This disengagement led the Minister to see the age of Epée as firmly in the past. He noted that the house in which Epée had first encountered the deaf women had recently been demolished to make way for the avenue de

imprimé à l'Institution

La fête de l'abbé de l'Épée à l'Institution Nationale
Embrasement de la statue

Dessin d'Auguste Colas, ancien élève de l'École

47. August Colas,
*The Anniversary of
l'Abbe de l'Epée at the
Institution Nationale*

l'Opéra: "How far it is from that poor room where they had come to-gether to the grand establishment where we meet today!"[121] The implica-tion was that Epée's modest beginnings had now been left far behind, and that deaf education could no longer rely solely on Epée's sign language method. Despite his efforts to the contrary, Martin's statue could thus be read in more than one way, either as a monument to a now superceded past achievement, or as a symbol of the origins of the modern, signing deaf community.

The government made its own intentions clear by calling on Adolphe Franck, who had recently become a convinced advocate of oralism, to speak. He was ill on the day of the inauguration, but his speech was published in the commemorative pamphlet. Franck attempted to rewrite the accepted picture of Epée as an indisputably great man. He correctly noted that Epée had not been the first educator of the deaf, and that many

of his ideas had been anticipated by others. He further recalled that Epée was "a priest, violently suspected of Jansenism," which took on a different connotation in light of the Third Republic's broad commitment to lay education. Why, then, should the government provide a Catholic-inspired education for the deaf? For Franck, it was time for a change to oralism, known as the German method: "I desire that it should be introduced in France, beginning with the National Institution [i.e., the Paris Institute], because speech is, after all, the most universal means of communication."[122] Franck used the occasion to revoke his support for the 1861 commission of the Institute, which had overwhelmingly endorsed sign language. In the wake of the humiliation of 1870–71, the German method could not be so cavalierly rejected by those seeking to regenerate the Republic. Ironically, then, Martin's statue provided the opportunity for the newly secure Republican government to declare its committment to oralism.

MILAN AND AFTER

As the reception of Martin's statue of Epée had shown, sign language had an equivocal position at this time, even for those who are remembered as its supporters. Edward Gallaudet, son of Thomas Gallaudet, and founder of the National College for the Deaf in Washington, which now bears their name, declared in 1870: "I would bear in mind every hour of the day and every moment in the hour, that the sign language, in a school for the deaf and dumb, is a dangerous thing."[123] For Gallaudet, its danger lay in the "laziness" it engendered in the deaf student, preventing the acquisition of spoken English. The supplement of mimicry had come to be recognized as dangerous. But this view was far from universally accepted among deaf educators, and Gallaudet's remarks caused a storm of protest. In the respected journal *XIXème Siècle,* Professor Houdin, from the school for the deaf at Passy, rejected oralism in 1874: "That is a phantasmagoria and, not to mince words, charlatanism."[124] Even Maxime du Camp dismissed oralism's potential: "[T]hey succeeded in making a few human parrots."[125] The government was not dismayed and, in October 1879, the Interior Ministry ordered the Institute for Deaf Women in Bordeaux to commence "pure" oral instruction, on the advice of a commission composed of Charles Le Père, Minister of the Interior, Octave Claveau, the inspector general of charitable institutions, and Théophile Denis, the administrator in charge of deaf education.[126] All were committed oralists, so their verdict was no surprise.

In 1880, an international conference for deaf educators was held in Milan to resolve the question of methods. As nearly all the delegates were French and Italian oralists, the result was never in doubt from the interminable opening address of the chair, Giulio Tarra: "Gesture is not the true language of man. . . . Gesture, instead of addressing the mind, addresses the imagination and the senses. Thus, for us, it is an absolute necessity to prohibit that language and to replace it with living speech, the only instrument of human thought."[127] The proceedings consisted of endless repetitions of this theme, as if the failure to find a visible pathology of deafness had to be countered by a numbing torrent of words to make the mute, deaf body speak its deviance. Finally, in what can only be described as "Derrida's Nightmare," the Congress closed to shouts of "*Vive la parole!*" [Long Live Speech!] led by Adolphe Franck. The Milan Congress banned sign language from all areas of deaf education, a ruling that held good in France until 1976. *Vive la parole!* was thus a watchword throughout the High Modern period. It became so only by government enforcement, for sign language continued to be used by the deaf. The state education of the deaf in the nineteenth century was a case study of Derrida's term "phonocentrism," which has so often been dismissed as mere word play. For the deaf, it was very real and very specific.

By now, the Interior Ministry was in fact pursuing a wide-ranging anthropological agenda, of which the suppression of sign language was one striking example. In 1879, the Ministry accepted Alphonse Bertillon's proposal to photograph prisoners, which had been rejected sixteen years earlier.[128] The junior minister in charge of the Penitentiary Department, expressed the goal of the anthropometric photographs: "In one word, to fix the human personality, to give to each human being an identity, an individuality, that can be depended on with certainty, lasting, unchangeable and easily adduced."[129] His words can stand for the entire program of the Interior Ministry. As the adoption of oralism indicated, deviance was not simply to be identified but corrected. When Waldeck-Rousseau became Interior Minister in 1880, he launched a movement to regenerate the Republic. The term was identical to that used by the First Republic but it now had a very different connotation. For Waldeck-Rousseau and his contemporaries, the choice was not between regeneration as a process or regeneration as an event. Rather, republicans believed they faced a choice between regeneration or degeneration.[130] Robert Nye translates *régénérer* as "rehabilitate" and this judicial flavor is appropriate. Degeneration could only be avoided through social peace, which was in the interests of all, according to Waldeck-Rousseau: "The most important factor for the prosperity of labor is social peace, the respect of all interests."[131]

It was precisely to prevent degeneration and preseve social peace that the Ministry wished to fix the human personality forever. For Waldeck-Rousseau saw his penal reform as being essentially connected to educational reform, and both were couched in medical and anthropological terms. In his call for deportation of criminals, he condemned "the miserable creatures driven to evil by a moral or physical deformity," and he undertook "not only [to] suppress these monsters but also cure them."[132] His words could equally well have been applied to the care of the deaf in the Third Republic.

After Milan, Waldeck-Rousseau appointed Albert Regnard as Inspector of the Deaf Institutes to carry out these policies. Regnard had an impeccable Republican background, having served four months in a Second Empire prison for his articles in *La Libre Pensée,* and later being the Secretary-General at the Prefecture of Police under the Commune.[133] After the amnesty for the Communards, he returned to France and was able to apply his early training in medico-psychology during over twenty years in charge of deaf education. His abiding passion was anti-semitism. He would remark with approval that "Aryan antiquity did nothing for the deaf-mute," referring to the myth that the Ancient Greeks abandoned deaf infants to death by exposure to the elements. The criminal and the deaf were different types, according to Regnard, but degenerate status was itself observable and hereditary: "Of course, it is not a matter of establishing a parallel between criminals and the deaf, but simply of this fact that, in all cases of this type, hereditary degenerescence is the dominant fact."[134] The deaf type was particularly low, being "like *homo alalus,* like the pre-historic man without words, but even more backward because he does not hear, he passes among his fellow men, for him the equivalent of shadows, without hearing them and without understanding them: everything human is foreign to him."[135] These comments came in a prize-giving ceremony at the Institute for the Blind in July 1898 and thus represent the official, public face of Third Republic policy towards the deaf.

Indeed, the former parallels between the primitive "savage" and the deaf had become reduced to an evolutionary formula by this time. In 1900, an official congress of deaf educators met in order to coincide with the International Exhibition in Paris. In the preface to the published minutes, the oralist Giulio Ferreri made it clear that the deaf were now considered racially distinct:

> Deprived since earliest childhood of the formative organ of intelligence, that is to say the mother tongue, [the deaf] always remain

inferior in their psychic development, even when the most patient and intelligent art has rendered them speaking. What can we say of these same deaf-mutes [sic] when, in spite of an education offering them the clean and precise vision of the grandeur of the gift of speech, they persist in considering their violent and spasmodic mimicry as a natural language, which can at least serve as an argument to establish their consanguinuity with the famous Primates?[136]

In other words, the deaf are closer to the apes than the hearing in a direct evocation of the traditional racist slur against Africans. In this new blend of psychology and evolutionism, the deaf were an atavistic throwback. They did not constitute a race as such for there were no visible signs other than sign language to betray their origin. By the mid-nineteenth century, even such elusiveness of racial characteristics had a racialized connotation, which led the deaf to be increasingly compared to the Jews, another elusive racial group. Both the Jews and the deaf were seen as groups with no distinct national origins, who nonetheless had a wide demographic distribution. It was no coincidence that an anti-semitic race statistician named Dr. Boudin presented a memoir to the French Academy of Sciences in 1862, claiming a high rate of deafness among French Jews because of their inbreeding. The charge was indignantly denied by the chief rabbi of Paris, but does not seem to have been noticed by the deaf community.[137] By the 1880s, anthropologists drew still closer connections between the deaf and the Jews, as Jews came to be seen as having an excessive propensity to insanity. As deafness came to be defined as a mental disease, the deformation of the brain caused by lack of speech, to be Jewish became very similar to being deaf in the eyes of the Christian hearing. Not for nothing was sign language culture firmly in favor of secular government and lay education.

The signing deaf community did not, of course, disappear at the wave of this Franco-Italian wand, nor did oral education take hold easily. As early as September 1884, the Ministry was forced to create a two-tier education, offering either intensive oral education, or rather less for those of "normal aptitude."[138] By November 1885, a report to the Interior Ministry accepted the superiority of oral education, but argued that "as they [the deaf] almost all belong to indigent or badly-off families, it is incontestable that the search for the most fitting means to assure for their later existence must necessarily remain the principle object and preoccupation of those who bring them up."[139] So much time was being devoted to speech that all other activity was being neglected, and the report called for improvements to the apprenticeship workshops. The possibility

for a camouflaged culture of mimicry had now disappeared. Rather than defend sign language as the equivalent of speech, it now had to be promoted as the modern solution for deaf education. The ambiguity of representation had been replaced by the certainties of classification. Deaf culture now had to stand or fall in its own right. Immediately after the Milan Congress, a Société des Sourds-Muets de Bourgogne was set up to defend the use of sign language.[140] Between 1883 and 1899, no less than fourteen newspapers and periodicals by and about the deaf commenced publication.[141] For example, in August 1885, a newspaper entitled *La Defense des Sourds-Muets* began publication and vigorously attacked the "Jesuitical" oralists, denouncing "the reactionary Franck" and "the bonapartist Claveau."[142] Such struggles were not without success, and oralists later argued that it was not until 1890 that the change in methods was fully accomplished, a victory that was not fully perceptible until 1900.

At this time deaf artists were increasingly taking the lead in French deaf politics. Berthier's Société Centrale des Sourds-Muets had been challenged, both by a revival of the Republican banquets in 1862 and by a banquet organized by the Institute for the Deaf itself in 1865, with the result that it all but ceased to function. However, the death in 1867 of Dr. Blanchet, the prime mover of the Republican banquets, led to the foundation of a united organization, which hence took the name of the Société Universelle des Sourds-Muets.[143] The painter Loustau was on the organizing committee of this new group, but, after an interruption caused by the war of 1870, there was very little activity in the early years of the Third Republic.[144] In frustration at this quietude, the deaf artists organized a banquet of their own in 1878, which was open to the wider deaf community. Unfortunately, a personality clash between two of the organizers meant that this highly successful event was not to be repeated.[145] In 1880, a group of deaf republicans founded the Appui fraternel des Sourds-Muets de France, which was the first deaf political organization to accept women members. These credentials persuaded the aging Victor Hugo to accept both an invitation to their first banquet on 23 November 1880, and the title of Patron of the society. One of the first presidents of the Appui fraternel was Léopold Loustau, a fitting culmination to a half-century of activism.[146] The new group won 280 deaf members, who paid a fee of one franc per month in anticipation of a pension after five years of membership.[147] The deaf community was now sufficiently established in Paris that it was able to put into action the co-operative schemes, which had been discussed for over thirty-five years.

Deaf artists also defended their sign language culture in their work.

48. Félix Martin, *The Death of Bara*

Loustau painted a scene of *The Watchmaker Monnot Saving the abbé Sicard* (1882), an apt reminder both of republican excesses during the September Massacres and the popular defence of sign language. At the Salon of 1881, Félix Martin attracted attention with his sculpture of *The Death of Bara* (fig. 48). The drummer boy Barra had died in defence of the revolutionary standard in 1791 and had been commemorated in an unfinished but well-known painting by David. In sculpting his *Bara,* Martin highlighted the sacrifices made by *le menu peuple* in defence of the Republic, implying that the deaf were now paying a similar price. The critic Emile Bergerat recognized a change in Martin's style: "M. Félix Martin shows us a little drummer boy Bara, no longer standing but recumbent: the dramatic character of the piece is remarkable, the execution is that of a hand accustomed to male studies, which has been softened and ordered for the circumstance."[148] Certainly, the dying figure of the boy

has his eyes shut and mouth open as he lies, grasping his drum and sup-
porting himself on one arm. But unlike David's painting, this Bara is
fully clothed and, apart from the youth of the subject, the departure from
masculinity perceived by Bergerat is not immediately obvious. It is as if,
after all those dying Cleopatra's, the moment of death in sculpture had
become so equated with female sexuality that the Stoic tradition of meet-
ing a virtuous, principled death had been forgotten. The "revolutionary"
import of the piece was therefore either lost on Bergerat, or no longer
attached to the subject.

More deaf people were now becoming artists than ever before. At the
Salon of 1886, a record thirteen deaf artists exhibited. Using the detailed
review by the oralist and partisan of deaf art Théophile Denis, I shall
briefly review all of these entries, as a means of indicating both the scope
of deaf artistic practice, and its continued capacity to confound the preva-
lent definitions of what it meant to be "deaf." The leading deaf artists
were all represented at the Salon of 1886. Léopold Loustau was now
exhibiting genre scenes, such as his picture of Napoleon on St. Helena, *Le
15 août 1816,* as well as a portrait of his daughter. René Princeteau com-
bined his society activities as a member of the Jockey Club with his artistic
career.[149] His *Return to the Farm in Time of Flooding* was typical of his
painting, showing a procession of ox-carts and their drivers moving across
a flooded field, with well-observed reflections in the water. His work
blended the skills of animal painters such as Constance Troyon with a
loose handling of paint and finish, reminiscent of the "official Impression-
ists," such as Bastien-Lepage. Félix Martin was represented by a bust of his
father and a patriotic statue, *Le Grand Ferret* (fig. 49). Ferret was a peasant
servant of Charles V, who was reputed to have single-handedly changed
the course of the battle against the English for the château de Longueil.
Wielding his massive ax, Ferret accounted for no less than forty-five En-
glishmen that day. Martin showed him with the ax poised to descend
upon another hapless victim, whom he crushes underfoot, causing Denis
to declare: "The subject is seductive. M. Félix Martin has rendered it with
the soul of a patriot."[150] This dramatic moment of execution, combined
with the uncontroversial patriotic subject, had the seductive quality that
Jouin had missed in the *Epée.* This year saw the emergence of another
important deaf sculptor, Paul Choppin, who not only succeeded in an
open competition for a statue of Broca, but won an Honorable Mention
from the Salon jury for his two entries, *Suzanna Surprised in the Bath* (fig.
50) and *The Genius of the Arts.* The former subject was long familiar to
painters as a means of depicting a moment of voyeurism within the His-

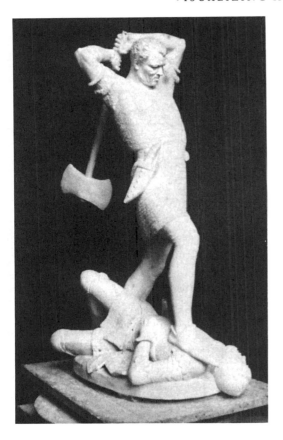

49. Félix Martin, *Le Grand Ferret* (lost)

tory painting tradition, but was more unusual in sculpture. In depicting only the figure of Suzanna, Choppin equated the space and activity of his audience with that of the lascivious Elders of the Biblical story. Such work was very much in the mainstream of contemporary sculpture.

In addition to these already successful figures, there was a group of young deaf artists at the Salon of 1886. Georges Ferry and Olivier Chéron exhibited landscapes. Ferry, a pupil of the leading Academic artist Cabanel, had been showing landscapes and genre scenes since 1875, whereas Chéron's landscapes were first seen at the Salon of 1880. Ernest Martin, brother of the sculptor, was an occasional painter of military scenes, and in this Salon he showed a scene of *Cavalrymen at the Camp of Châlons.* The final painter to note, René Badeuf, was making his Salon debut with a portrait drawing. Badeuf was a pupil of Boulanger and had been born at Blidah in French Algeria. Deaf sculptors were well represented, with sev-

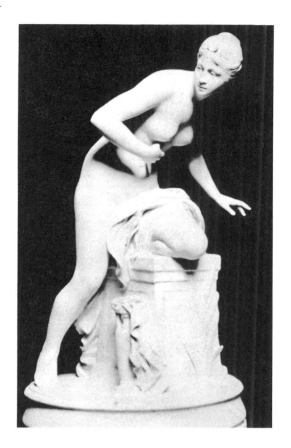

50. Paul Choppin, *Suzanna Surprised in the Bath* (lost)

eral newcomers making their first appearances. Gustave Hennequin achieved his fifteenth Salon entry, showing his respected portrait busts. On the other hand, it was only the second Salon for Albert d'Arragon with a portrait bust. René Desperriers and Gustave Lassy had their first accepted work shown this year, with busts and medallions respectively.

Amongst these younger artists, the rising star was Armand Berton (b.1845), also a pupil of Cabanel.[151] He had been deafened at the age of twenty-one, just as he joined Cabanel's studio. After a series of modest portraits and watercolors at the exhibitions of 1875–1882, Berton was now taking a more independent course and attracted patrons such as Alexander Dumas.[152] In 1882, he won a Third Class medal for his drawing *Eve* (fig. 51). The female nude marked a new direction both for Berton and deaf artists in general. Berton now returned to this theme with a *Venus,* inspired by Flaubert's novel *The Temptation of Saint Anthony.*

51. Armand Berton, *Eve*
(Paris, INJS)

Denis, usually eager to praise the deaf artists, was unusually hesitant: "In effect, the canvas has some strange quality at first sight; it attracts, I would say it intrigues. I do not add that it seduces. This woman, who has finely modelled parts, agreeable transparencies in her complexion and elegant inflexions, does not have a pleasing face at all; it is even without a frankly revealed expression. The right forearm is massive and flat."[153] Denis seems to have associated Berton's work with that of the realists or Impressionists. Despite the overt subject being sexual temptation, he denied that the painting was seductive, presumably in either the pictorial or corporal sense. The figure of Venus was both too precisely a modern woman and too imprecise for her divine status. In the corner lurked an Orientalized Saint Anthony, just as confused as Denis by this modern Venus. In 1887, Berton's pastel *Woman at the Mirror* was awarded a Second Class medal,

eliciting this shocked comment from Denis: "She gets out of her bath in the uninhibited manner of a realism very little mitigated by decency."[154] For Denis, Berton's choice of a realist style was as transgressive as the erotic overtones he perceived in the picture. The mode of representation was never a neutral practice, especially for deaf artists.

In 1887, two works of art indicated that the visual representation of deafness remained an ambivalent and contested question. At the 1887 Salon, P-L Bouchard (1853–1937), a now forgotten History painter, exhibited his major canvas *The Deaf in the Harem*.[155] The catalogue announced that: "In the harem, the mutes, subalterns to the eunuchs, were skilled at tightening the fatal bowstring, and when the Sultan had pronounced a sentence, they executed it immediately and without noise." The painting shows four "mutes" entering through a door at the right of the canvas, carrying the famous bowstrings as visible identification of their deafness. But they were also depicted as black, merging the categories of race and deafness into one multiply deviant body. The muscular black "mutes" are advancing on a group of scantily clad women at the left, who vainly clamber up onto a bed to escape the executioners. In a pictorial pun, one woman attempts to flee by drawing back a curtain placed in the exact center of the image, otherwise known as the vanishing point of the perspective, only to be blocked by a male figure, perhaps the Sultan himself or his head eunuch.

In the wake of the Milan Congress, this picture was not simply an idle fantasy. The intended victim of the executioners seems to be a barebreasted woman lying unconscious on the bed, giving the image an eroticism that is more than a little tinged with sadism. Evoking the sexuality of the deaf, the picture enjoyed a "spectacular success with the public," who no doubt appreciated the sexual connotations of this picture and other similar works. At the same Salon, the sculptor Emmanuel Frémiet (1824–1910) showed a new wax-colored version of his *Gorilla Carrying Off a Woman*, first shown in 1859. A massive gorilla carries off a white woman, who half resists and half embraces the animal. In 1859, Baudelaire was not deceived: "Here it is not a matter of eating but of rape. Only the ape, the giant ape who is both more or less than a man, sometimes shows a human craving for women. . . . He is dragging her off; will *she* know how to resist? Every woman is bound to wonder about this, with mixed feelings of terror and prurience."[156] In Baudelaire's view, the ape and his supposed close relative the African male had more sexuality and less humanity than his European counterpart. Frémiet depicted the gorilla with an absurdly extended lower jaw and sloping forehead, forcefully remind-

ing the viewer of the racial hierarchies created by cranial angle and skull shape. In the later version, Frémiet used colored wax to drive home his interplay of race and sexuality. Remarkably, Théophile Denis used very similar language in describing Bouchard's painting: "The dramatic subject, relieved by a somewhat gaudy virtuosity, chills women's skin with an irresistible shiver and provokes elsewhere intense fantasy and reflection."[157] The deaf had long been compared with African "savages," and du Camp thought they resembled apes. Both Baudelaire and Denis were fascinated by the possibility that the white woman would not be able to resist the advances of the black/deaf man, a fantasy well designed to provoke intense reflection on the part of the white, hearing male spectator. It was this chilling interaction between deafness, race, and sexuality evoked by Bouchard that motivated both eugenic art criticism and the oralist campaign of the 1880s. This fear of deaf sexuality was to play a central role in the reconfiguration of anthropology into eugenics.

In that same year, 1887, the deaf sculptor Paul Choppin unveiled his statue of Paul Broca, the anthropologist (fig. 52). Choppin defeated fifty other sculptors in an open competition to make the statue because the jury thought "the thinker, the scientist, the unpretentious and good-natured man whose memory was to be perpetuated ought to be shown the way we had so often seen him work in his laboratory, in his everyday clothes and unposed . . . his head bare . . . inclined . . . meditative."[158] Choppin had depicted Broca in exactly this fashion, dressed as a man of the nineteenth century, and contemplating a skull in the manner of Hamlet. A pair of measuring calipers in his right hand indicated that his thoughts were bent on establishing the race of the skull, rather than any metaphysical distraction. The calipers and skull distinguished Choppin's statue from other similar works depicting men in nineteenth-century clothing, such as Pradier's 1834 statue of Darcet,[159] but even so some Salon visitors mistook the figure for Claude Bernard. After his victory was announced, the journal Le Voltaire ran a praise-filled feature on Choppin and his statue: "The figure is serene and smiling, his lips gently skeptical; the movement is correct, without exaggeration, without false nobility of attitude. It is a work of beauty, which does great honor to the artist." Choppin had succeeded in creating a statue that met the exigencies of eugenic criticism, depicting the very founder of anthropology in one of the triumphs of the reconfigured deaf cultural politics after the Milan Congress. Choppin explained why he had refused to reveal his deafness to the judges, all of whom had been anthropologists: "If it had been learnt that I am deaf, there would have been an outcry. . . . No-one would be willing

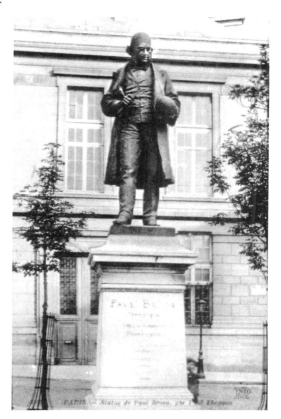

52. Paul Choppin, *Paul Broca* (lost)

to believe that I could have as much talent as those who hear and speak. Very likely, my rivals would have declared that it was not because of my merit but because of my pitiable misfortune that I had to be given the prize."[160] The journalist instead declared that Choppin had won on merit. Given the deleterious influence of anthropology upon the deaf, it might seem surprising that Choppin would have wished to sculpt Broca at all, but in his study of the physiology of speech, Broca had defined language so as to include sign language: "There are, in effect, several types of language. Any system of signs permitting the expression of ideas in a manner that is more or less intelligible, more or less complete, and more or less rapid, is a language in the most general sense of the word: thus speech, mimicry, dactylology, figurative writing, phonetic writing, etc., are all types of language."[161] Far from reinforcing the categorization of deafness as a variety of mental disorder, Broca had accepted mimicry as a language more or less equivalent to speech. The anonymity of this public

sculpture competition allowed Choppin to use the figure of anthropology's founding father against itself.

The statue, far from being invisible, attracted considerable controversy. *Le Figaro* anticipated trouble before the unveiling of the statue in the Place de l'Ecole de Médecine on the Boulevard Saint-Germain: "To the great regret of his family, the learned professor defended the most advanced materialist doctrines throughout his entire life, as well as the most accentuated theories of free thought. Several of his friends and disciples wish to profit by the official ceremony, in recalling together with the works of the deceased, his struggle against religious ideas, etc., etc."[162] The police barricaded off the site in order to prevent any disorder and the ceremony took place in "the silence demanded by the family," who found Broca's views embarrasing.[163] According to an incensed Gabriel de Mortillet, a left-wing anthropologist and colleague of Broca, not even those who had subscribed to the statue were invited. Furthermore, the event was scheduled at 9.30 a.m., an unheard of hour at the best of times, but during the summer holidays "the time and the date could not have been more advantageously chosen to create a void around the statue. And in fact, it was a void that was wanted. . . . One would have said that it was some shameful act that was being hidden, and that it was arranged as close as possible to the hour of executing criminals . . . to execute scientific truth, yes, to kill the free spirit of Paul Broca!!!"[164] Thus the deaf artist's statue was fittingly installed in silence, as a truly silent monument. Choppin displayed an adroit tactical sense, concealing his deafness in order to win the prize, but, once it was secured, quickly gaining publicity for himself and the statue. The subject, Paul Broca, revealed discordances both within the anthropological community, and between the believers in progress and in religion.[165] Or, to put it another way, between the oralists, whom Octave Claveau declared dedicated to "a scientifically co-ordinated ensemble of procedures,"[166] and the abbé de l'Epée, a Catholic priest. By 1887, these positions were being presented as diametrically opposed, but Choppin's work indicated that the distinction was not so clear. For the scientist Broca was closer to Epée's theories of language, inspired as they were by Condillac, than he was to the mix of Darwin, Lombroso, Gall, and missionary-style Christianity, which inspired the oralists. The very fact that the anonymous candidature of Choppin defeated numerous hearing sculptors refuted the charge that the signing deaf could never aspire to originality. Above all, his success, together with that of the other deaf artists, stood in marked contrast to the struggling oral education program in the Institute for the Deaf.

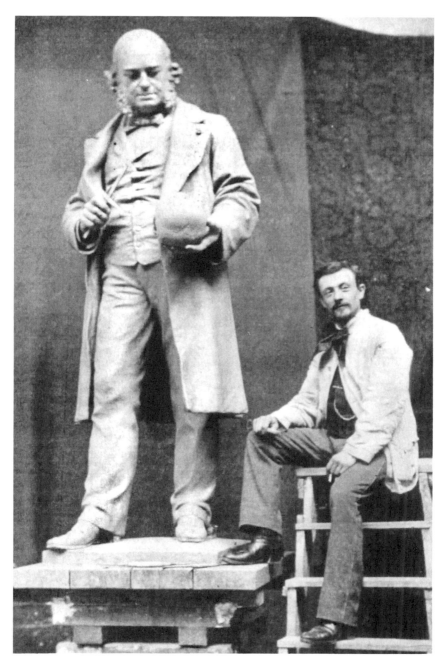

53. *Paul Choppin with His Statue of Broca* (Paris, INJS)

Martin and Choppin had made the monumental, public statue into a new point of purchase for deaf artists, which offered an ambiguous blend of invisibility, affirmation, and resistance. It was not a question of some simple application of deaf politics to art, or vice versa. The future artists spent their childhood and adolescence in the Institute for the Deaf, learning both the culture of mimicry and the practice of sculpture. Their work was thus a product of the interaction of the two modes of visual expression, which cannot be simply separated by art historical dissection. In 1784, the abbé de l'Epée described the beginnings of his sign language method: "I say to them [the deaf] that the interior painting which is the object of their amusement, is that which we call an idea, or the representation of an object in the spirit."[167] In a photograph showing Choppin sitting next to his statue of Broca in his studio, the sculptor smiles and his eyes crease with amusement (fig. 53). For what greater proof of sign language's capacity for visual representation could there be than a monumental statue? Choppin's smile hints at the ambivalence, skill, and wit that are inherent to the visual sign. In short, he smiled at the pleasure of the visual sign.

5 A DEAF VARIETY OF MODERNISM?

In the last decades of the nineteenth century, a medico-psychological consensus emerged that it was now possible to transform the *sourd-muet* [deaf-mute] into a new being, the *sourd-parlant* [deaf-talker], consecrated by a museum at the Institute of the Deaf to record the history and achievements of that now endangered species, the deaf-mute.[1] The continued success of the deaf cultural movement was dismissed by those in thrall to anthropological, biological, and pyschological indicators of deviance. As a consequence, deaf cultural politics finally split over aims and methods, catalyzed by the Dreyfus Affair. While most deaf activists continued to defend sign language culture, some now supported the oralists, who in turn were divided among themselves into Republicans, eugenicists, and technocrats. Each faction had a different strategy of visual representation, and although the oralist schools prevailed, they had neither an unopposed nor a total victory. All sides in this conflict believed that their method represented the modern method of deaf education and hence the means of producing a modern deaf community. In the nineteenth century, as today, modernism was a privileged discursive term whose ownership was contested in political and cultural terms. There was not one modernism but many modernisms, all of which competed for validity. The triumph of an aesthetic variety of modernism in visual culture leading to abstract painting was neither inevitable nor ordained, but rather the outcome of an interplay of social, intellectual, and political forces. The over-familiar story of the rise of modernism in art history can only be told at the expense of many other histories and, more importantly, at the expense of understanding that modernism was not a unique phenomenon, but was and remains a contested discursive practice. This chapter traces the history of this contest over modernity between the signing deaf community and the oralists. For although this period is often portrayed as one of the low points in deaf history, it in fact also saw the emergence of a hitherto unrecognized deaf modernism in the deaf press, in the graphic arts, and especially in photography. If the ultimately victo-

rious variant of modernism was incompatible with deafness, and even sought to eliminate it, that did not preclude deaf writers and artists from constructing a deaf variety of modernism.

REPUBLICAN MORALITY

The French Republican consensus viewed the "National Institution [for the deaf] as a moral body."[2] In 1896, two official reports were published from which we can perceive the meaning of that morality. In his Preface to the *Practical Manual for Special Teaching Methods for Abnormal Children*, Charcot's colleague Dr. Bourneville saw the goal of those educating the "abnormal" as enacting the 1882 law guaranteeing every child a primary education: "It is to bring the abnormal up to the dignity of men, to make them as close as possible to ordinary citizens, to render them capable of providing for their own subsistence, to be able to place them, to make use of them."[3] This program was distantly related to the First Republic's commitment to the regeneration of the body politic, but in so totally different a discursive framework as to make the comparison all but irrelevant. The deaf were now seen as irretrievably abnormal, so that the moral duty of the state was not education but "the special education necessitated by the abnormal state in which nature has placed them."[4] In short, the deaf should have low expectations of life, and be grateful for what they received.

Oralism sought to produce docile subjects, not educated citizens. For the adminstrators set out to produce what they called "disciplined" deaf. The first three words taught to a new pupil at the Institute for the Deaf were "sit, stand, [and] go away (fig. 54)." It was no coincidence that former prison directors were increasingly being placed in charge of schools for the deaf[5] and, as Michel Foucault has written of the technicans of discipline, "[t]heir task was to produce bodies that were both docile and capable."[6] The government was committed to what it called "the *pure oral intuitive* method," which was held to be the modern method. The new oralism expressed a Republican pessimism concerning the deaf, which upheld the purity of the human voice as part of a struggle against degeneration.[7] In 1888, the Ministry of the Interior decreed that all teachers of the deaf must take a course in articulation, which had the intentional side-effect of excluding deaf people from the profession.[8] Hearing educators believed that a "normal" intelligence would be formed, as long as there was no intermediary, such as a sign, between the word and the thing. From the start of the course, pupils were subject to a rigorous discipline:

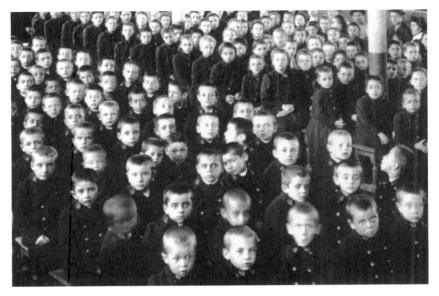

54. The Disciplined Deaf: *Pupils at the Institute for the Deaf, c. 1895* (Paris, INJS)

"As soon as a young deaf-mute arrives at the School, he is first of all the subject of a meticulous examination from the point of view of his physical and intellectual state." More pupils than ever were rejected at this stage. Even so, the numbers of later explusions for "idiocy" and "incapacity" rose rapidly under the new regime.[9] In order for the body produced by the Institute for the Deaf to be truly docile it was essential that one must "arrest the development of the language of signs."[10] In the first year, it was envisaged that 50 to 100 vocal substantives would be learnt, as well as the numbers up to ten.[11] If a deaf student mastered all the elements of instruction offered, he (in the case of the Paris Institute) would have had a vocabulary of five to seven thousand words, out of a total French vocabulary of 53,000 words.[12] The administration believed that this figure compared favorably to the vocabulary of peasants, which might consist of only a few hundred words, and was equivalent to that of "a modern worker who has received elementary primary instruction." Even these arbitrary standards show the low expectations oralist educators had of their own program.

Morality was further equated with hygiene, that obsession of late nineteenth-century medicine and government. In 1885, Dr. Jules Richard announced that: "Hygiene [has] conquered public opinion. Its language is intelligible to everyone, and its results are evident, concrete, and mathe-

matical."[13] More precisely, its procedures were exact and perceptible. The report on the Institute for the Deaf provided a wealth of statistics and detail on "hygienic care and precautions," long before any mention of education. Reviving Itard's fear that sign language caused lung disease, the administration had introduced Swedish gymnastics, accompanied by shouted counting, as a means of exercising the body and the "underused" lungs of the deaf child. Baths were taken fortnightly in 30 degree running water, seven and a half centilitres of wine at twelve degrees proof was served at lunch and dinner, and so on.[14] In the determined pursuit of such details, it was possible to ignore the difficulties that the students were encountering with the "pure" oral method. Indeed, it was the essence of the "modern" method that it concentrated upon the detail at the expense of the whole.

Oral education was a very time consuming process. Both Epée and Sicard's desire to see deaf students understand religion, and the active training in the arts provided by the Institute, were now rejected. Bernard Thollon, a professor at the Institute in the early twentieth century, opined: "It is right that we should make a choice, to neglect the terms relating to science, to art, to literature, to trades, and only keep those words relating to things and the ordinary events of domestic and social life."[15] The oral Institute no longer prepared deaf students for work, but only to survive in the home. In 1912, state industries were banned from employing all those with an "infirmity," defined to include all the categories of the "abnormal" and degenerate, such as stammerers, orphans, and the deaf. This edict even applied to the printing industry in which deaf people had excelled for over a century. With due cynicism, the ban was lifted during the First World War, only to be reimposed after the Armistice.[16] As the Taylorist production line process came to dominate manufacturing, employers looked to hire "hands" who were equally capable and interchangeable. There was neither room nor need for those classified as abnormal in the new automated process. Factories required dependable, unvarying conformity and did not want their employees using their hands for such unregulated activity as signing.[17]

THE DEAF ARTISTS AND THE MUSEUM

The reorganization of the Institute had a devastating effect on the training of deaf artists. In 1894, the deaf journalist Adolphe Drouin highlighted the decline in the arts in his review of changes since the Milan Congress:

"In the sculpture workshop [at St Jacques], I defy you to find one pupil who is capable of executing a work in the Renaissance, Gothic or Louis XIV style etc., because no-one deigns to teach them."[18] In the deaf section of the International Congress on the Deaf in 1900, the deaf artist René Hirsch proposed that professional deaf artists could supply this want but their resolution was ignored by the hearing section.[19] The number of deaf artists working in Paris nonetheless continued to grow. Deaf journalists urged their artistic colleagues to continue their efforts: "It is only art, despite all the objections and critiques, which is capable of putting the deaf in a position to make a situation in life. Only, art is no longer taught to the deaf as it should be."[20] At the Salon of 1894, no less than twenty-two deaf artists exhibited.[21] Oralist educators no longer regarded the fine arts as a potential career for deaf people, and recast art education for the deaf as therapy rather than training. For the British art teacher Albert Woodbridge, the deaf were "but a few degrees removed above the brutes. . . . [Nonetheless] a knowledge of drawing and painting will act as a purifier and cleanser of thoughts."[22] The arts were now just one more weapon in the hygienists' war against the impurity of deafness.

However, a museum was opened at the Institute for the Deaf in 1890, with the imposing title of the Musée Universel des Sourds-Muets (fig. 55). Rather than promote the achievement of deaf artists, the museum sought to commemorate the modern triumph over deafness. Although an art gallery had been opened at the Institute in 1875, the new Museum was an initiative of the Interior Ministry, led by the oralist Théophile Denis. According to Denis, the Museum allowed the public to "discover a new world: the world of the deaf-mutes, still so misunderstood."[23] The echo of European colonial expansion was quite deliberate, for just as African dancers performed before the sardonic gaze of the Parisian crowds in public parks, so did the Museum allow visitors to discover another "inferior" race, the deaf-mute. This was an ethnographic museum, whose objects were not selected for artistic reasons, as one critic has recently argued: "Objects become ethnographic by virtue of being defined, segmented, detached, and carried away by ethnographers."[24] Denis frankly admitted that the Museum's mission was not primarily artistic: "It has a humanitarian goal. By tangible and material evidence, through an illustrated and seductive history, it will be conducive to rendering this double service: destroying the ignorance and prejudice of some; and rendering the victims of this ignorance and prejudice the place which is their due in society." Denis did not mean that the deaf were to be considered the equals of the hearing. Rather, he intended to show that, with appropriate institutional

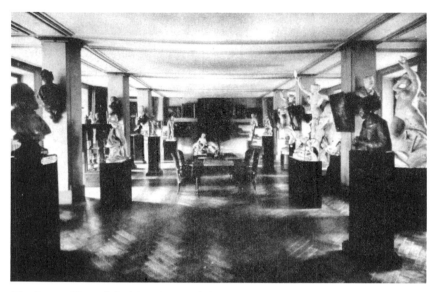

55. Anon., *View of the Musée Universel des Sourd-Muets* (Paris, INJS)

care, the deaf could play the "useful and honest" role discerned for them by Adolphe Franck after the Milan Congress.[25]

The Museum was part of new direction in museology, towards the recording of the Other. The art museum itself was a new feature of the nineteenth-century city, which was quickly joined by museums for curiosities and ethnography, such as Sarti's successful Museum of Pathological Anatomy in London.[26] In what has been described as the "heyday of natural history," the ethnographic museum truly came into its own in the late nineteenth century.[27] Subaltern culture was not celebrated in these institutions, but classified and made explicable for the "civilized." Jean-Martin Charcot famously described his Salpêtrière hospital as "a sort of living pathological museum" for the display of hysteria.[28] His renowned public demonstrations of hysterics on Tuesdays, attended by the young Sigmund Freud, explained the meaning of his "collection." Similarly, at the Museum of Natural History, the public display of the anthropology collection doubled from 4,198 objects in 1867 to 9,560 objects in twelve rooms by 1898, each exhibit clearly labelled with essential documentary details. The galleries led from prehistory, via the history of the Mediterranean basin, the physiological and pathological variations in the skulls and skeletons of the "white" races, to the "yellow" races and, finally, to "the blacks of Africa and Oceania, to return with the Australians to our point

of departure"—that is to say, prehistory.[29] As James Clifford has re-marked: "The value of exotic objects was their ability to testify to the concrete reality of an earlier stage of human Culture, a common past confirming Europe's triumphant present."[30] It was also a return to the origins of French anthropology, for the first anthropological expedition organized by the Société de l'Observateurs de l'Homme in 1802 had been to Australia. That expedition had been advised to use sign language to communicate with the natives, just as evolutionist anthropologists were doing in the late nineteenth century. The ethnographic museum subordi-nated its objects to its narrative, so much so that one American museum director of the period asserted that "the most important thing about an exhibition was the label."[31] For the museum visitor, these objects were only important in so far as it reinforced his or her sense of belonging to an advanced society, which had left such primitive beginnings so far behind that it could now perceive its "civilized" duty to record and preserve these artifacts.

The new museum at the Institute for the Deaf exhibited a variety of pathological anthropology for the same audience that supported colonial expansion, and were intrigued by Charcot's displays and anthropological discoveries alike. A catalogue was published in order that the visitor could comprehend the significance of the displays. The Museum became the public face of the Institute for the Deaf, replacing the sign language dis-plays of Epée and Sicard and was an essential stop for those touring the Institute, such as President Félix Faure, who visited the Museum in 1897. Soon after its opening, a museum journal noted that "the subject is all the more new for the public, as there exists no similar gallery in any coun-try."[32] For the general audience, one report commented that: "This is not a cold, glacial museum, with the airs of a necropolis, where dead relics are assembled. This museum has a soul, in which every frame makes a com-plaint and resounds with thanksgiving."[33] In short, it was a "living mu-seum," like that of Charcot, which made deafness and the deaf-mute explicable and visible at the precise moment when they were believed to be on the verge of extinction.

The Museum's displays opened with a series of views of the Institute for the Deaf, and other deaf educational establishments in France and abroad. The hapless visitor was next presented with one hundred and eighty por-traits of the abbé de l'Epée in various media, followed by almost five hundred portraits of the directors and personnel of the deaf institutes, together with those of important figures in deaf education and some dis-tinguished deaf people. The Museum concluded with a display of the

work of deaf artists, mostly donated by the artists themselves, amounting to nearly four hundred pieces by 1896.[34] The Museum therefore narrated a history in which the deaf institutions, inspired by the example (if not the method) of the abbé de l'Epée, had made it possible for the deaf to create works of art. The art gallery was intended to be illustrative of the therapeutic skills of the deaf professionals, rather than make any statement for or by the deaf artists themselves. Nonetheless, deaf activists intervened in the Museum's affairs for their own ends. In 1894, the one hundred and fifty guests at the banquet of that year arranged to celebrate Epée's birthday met for a private view of the Museum's artistic display. The deaf engraver Auguste Colas worked in the deaf community to extend the collection of deaf art and pressured the Institute to extend the display.[35] In 1904, the new director M. Collignon acceded to these requests and moved the Museum to larger premises on the ground floor, which enabled the entire collection to be displayed.[36] Such serious intent was undermined by the attitude of the general museum-going public, as Henry C. Shelley's account of the British Museum in 1911 revealed: "Perhaps the hilarity with which the ordinary visitor regards the object lessons of ethnography arises from his overweening conceit of the value and importance of his own particular form of civilization."[37] In sharp contrast to the pleasures of the visual sign celebrated by the deaf artists, the visitor to the ethnographic displays of the Museum may well have treated them as a variety of freak show.

GESTURE AND HYSTERIA

The place formerly occupied by the deaf in the public eye was now held by the hysteric. Charcot's analysis of hysteria, and the public displays that illustrated it, formed one of the key determinants of the visual in the late nineteenth century. His diagnosis of the various stages and types of hysteria was above all a visual taxonomy, and, as has been widely documented in recent studies, Charcot believed his work was close to that of the artist.[38] His pupil Henri Miège wrote in 1893: "For Charcot, the artist went hand in hand with the physician." Sigmund Freud understood Charcot as being "*visuel,* a man who sees," like the Impressionists.[39] Salon artists depicted Charcot's displays of the hysterics, just as they had earlier painted Epée and Sicard.[40] This visual culture of hysteria expanded so as to encompass the deaf and their sign language. For one doctor of the insane, Alexandre Cullerre, there was no "definitive barrier between reason and

madness," generating a new category, the *demi-fou* for medical attention,[41] a cousin to the *demi-sourd* identified by Itard, and grandparent to the Nazi's racial category *Mischling*. Resistance to treatment in either case indicated the presence of serious mental illness or mania. Mimicry was a symptom of deafness, and so too did it become a symptom of hysteria, as in Charcot's description of the onset of hysterical hallucinations: "The patient becomes a character in a scene and it is easy to follow all the sudden changes of the drama he believes himself to be unfolding, and in which he plays the principal role, by the expressive and animated mimicry to which he has given himself over."[42] Mimicry had moved from Darwin's description of anatomical processes to being a fully fledged pathological symptom of hysteria in its own right. The silent screen on which deafness had been constituted was now entirely filled by pathology, from the point of view of the hearing, rendering all other manifestations of deaf culture symptoms of that pathology.

Charcot's work suggested a new means of defining the deaf as mentally defective. Itard's preliminary definition of deafness as related to mental incapacity had been given greater force by evolutionism, and now appeared to find observational proof in Charcot's case studies. In his studies of hysterical aphasia, Charcot pursued Ribot's hypothesis that memory existed only in localized form. His patient, M. X . . . from Vienna lost his visual memory, following some difficult business deals, even failing to recognize his own reflection in a mirror. However, he retained his intelligence: "[D]eprived of *mental vision,* it became necessary for him to have recourse to *interior speech,* and to the movements of articulation of the tongue and the lips to comprehend the lines that he read." In this way, he was once again able to read and write. Charcot's explanation stemmed from his definition of aphasia as affecting "the faculty which man possesses of expressing his thought by signs (the *facultas signatrix* of Kant)." M. X's verbal amnesia forced him to develop his previously neglected auditory memory: "[F]or him, the *auditive equivalent* replaced the *visual equivalent* of the word. Here then is another example of those 'supplements' [*suppléances*], which one finds without doubt in each case of aphasia."[43] The consequences of Charcot's diagnosis were considerable for the deaf. It was now possible to argue that, unless the deaf were educated orally, they would never achieve a complete range of memory, as the auditory memory would be lacking. Nor could sign language act as the supplement to speech, for Charcot argued that: "The word being, in effect, a *complexus,* one can recognize in it at least four fundamental elements in educated individuals: the commemorative auditory image, the visual im-

age and finally two motor elements, that is to say belonging to the category of muscular sense, namely: *the motor image of articulation* and the graphic *motor image.*"[44] A handshape in sign language could only contain the visual image, and perhaps the graphic motor image. Sign language was now scientifically determined to be half as good as speech. At last it was possible to define *surdi-mutité,* which, in the words of the *Practical Manual,* afflicted "a child who, becoming deaf before a certain age, cannot fix in his brain the auditory verbal memory, or who, born deaf, can never acquire it." Oralism could improve the "motor force" of the deaf brain, but without auditory memory "the marked inferiority of the deaf-mute with regard to the hearing" was inevitable.[45]

Charcot's ideas were officially frowned upon under the Second Empire and the hysteria profession came to identify closely with the Republican cause. Just as the triumph of the Third Republic entailed the success of the oralists in deaf education, so did it ensure governmental support for the modern school of Charcot and his followers. The popular fascination with hysteria cost the deaf the popular support they had traditionally enjoyed. Gesture itself was portrayed as an evolutionary throwback, or a symptom of hysteria, which was inherently anti-Republican. The downgrading of gesture was accepted even by those who resisted the new sciences. In 1892, Charles Hacks published a study of gesture, in order to refute Darwin's *Expressions.* He argued that gesture had once signified action but now: "The act has become the gesture and action has been replaced by mimicry. We no longer *gesture* or *act* as we did before—today we gesticulate; the diminutive has intervened and imposed itself so well that, from decadence to decadence, following the act, gesture itself has altered. It has become sickly, worthless, ill—hysteria has taken hold of it. It is the characteristic of our times. Act, gesticulation, hysteria: an entire physical and moral history of humanity is contained in these three words."[46] For Hacks, women were to blame for this unfortunate history of degeneration: "Woman is the eternal pastiche of gesture. . . . Hysteria in women, at least the little attack, is the yawn or the sneeze of gesture, the safety valve of gesture, it is in a word, the necessary relaxation."[47] The medicalization of gesture as a feminized symptom, which had begun with the Ideologues during the French Revolution, was complete. To the anticlerical republican, the implication was clear—a restrained, minimal gesture was more patriotic and advanced than an exaggerated one. The docile body of the advanced modern French man did not make gestures, which were in themselves a sign of inferiority. At the 1900 International Congress for the Study of Questions of Education and Assistance for the Deaf,

the Italian oralist Ferreri summed up the complex nexus of medico-psychology now encompassed by the modern treatment of deafness: "The modern school of deafness has recognized that this psycho-pathological condition cannot be clearly delimited either by simple direct observation of mental faculties or by the examination of the probable anatomo-physiological alterations of the affected organs of speech. It is therefore necessary to unite and compare the observations of the doctor and the results of experimental psychology with the data of pedagogy and teaching."[48] The deaf section of the Congress, meeting next door, were not allowed to comment, vote, or make resolutions in the hearing section.[49]

DEAF REPUBLICANS

The generation of deaf activists that came of age in this era of republican anthropology were aware that the traditional cultural politics of mimicry were unable to respond to this concerted level of hostility. The deaf republicans abandoned the medical professionals and now concentrated on their work with socialist and other left groups, arguing for deaf equality as a republican principle mandated by the French Revolution. The deaf claimed that sign language was modern and that oralism was an outdated, clerical procedure. Noting that oral methods of deaf education had been pioneered in the sixteenth century, the deaf republicans promoted sign language as a modern means of communication, inspired by the rational, secular principles of the Enlightenment: "Artificial speech has been replaced by the mimic language for over a century, just as the sailing ship has been replaced by the steam ship for at least three-quarters of a century."[50] In his essay on mimicry, Rambusson argued that mimicry was uniquely well-placed to assist "all the people of the world gathered in the temple of industry." As the development of railways and the telegraph created a more global community, Rambusson argued that the practical need for a universal language to permit communication from the most "civilized" to the lowliest "savage" was ever greater: "There is only one natural language common to all the human race . . . and that language is the natural mimic language." He rejected fears that this language of analogy could not be understood by comparing the widespread use of the periodic table and chemical symbols. No one mistook the symbol H for the substance hydrogen but equally everyone could understand the signification.[51] In a review of this work for the photographic journal *La Lumière,* the soldier Pécoult reported his own travels in West Africa ac-

companied by a deaf person and agreed that it was a universal language: "Everyday one sees deaf strangers, cr people who have learnt the mimic language, understand each other perfectly, even when their signs are different."[52]

Deaf republicans reinforced this claim of modernist utility with political arguments. They argued that the law of 1832, guaranteeing primary education for all, had not been carried out with respect to the deaf. At the 1895 Congress of the Deaf in Val-Des-Bains, Meissonier protested that only 2500 of the 35,000 deaf actually received any education. The following year, Henri Jeanvoine used the statistics provided by army call-up returns to extrapolate a deaf population in the region of 60,000,[53] meaning that less than five percent of French deaf people received an education, whereas the Institute claimed that only a thousand deaf people of school age (8–17) were not being provided for.[54] The connection between left politics and sign language was often explicit. In 1873, the deaf professor Léopold Balestié was sacked by oralists because of his sign language education method and because of his socialist politics. By 1886, he was reduced to poverty, dependent upon the charity of the deaf community.[55] On all fronts, however, the hopes of deaf republicans met similar disappointments. While certain individuals on the left gave active support to the deaf, the mainstream did not espouse their cause, being more concerned with the elimination of degeneracy than achieving equality.

In order to generate support, the press became crucial to this new political strategy. The deaf engraver René Hirsch (b.1853) organized what was to become the leading deaf periodical, the *Journal des Sourds-Muets*, the only one of the flurry of deaf-edited periodicals which commenced publication in the last decades of the ninteenth century to survive for more than a few years, finally closing in 1906.[56] At the 1893 Congress for the Deaf in Chicago, Remy set out four goals for the new paper: "1) To make the public aware of the physical and mental state of the deaf-mute; 2) to destroy the prejudices against them given out by a great number of people; 3) to make them become useful citizens of society; 4) to occupy itself with proving the superiority of the teaching method of the famous abbé de l'Epée over the artificial speech, . . . and to appeal for the kindness and protection of the government towards them [the deaf]."[57] These goals might almost have been endorsed by the government, had it not been for the commitment to sign language. Of course, the *Journal's* assessment of the deaf was very different from that of the Ministry of the Interior, as can be seen from the Pilate case. In 1896, a deaf man named Pilate, who had been a pupil of the Institute for the Deaf in Paris, was

HENRI GAILLARD, Paris, France,
Editor of le Gazette des Sourds-Muets.

56. *Portrait of Henri
Gaillard* (Paris, INJS)

convicted of the brutal murder of a woman, but found not responsible for his actions. For Joachim Ligot, the case "was a product of pure oralism. . . . Can he be blamed if he has sat under the manchineel-tree of pure oralism? The poisonous shade of that tree has weakened, obliterated and atrophied his intellect."[58] With telling effect, Ligot neatly reversed the official line that only the voice could inculcate morality.

The deaf republicans now sought political equality rather than cultural equivalence. The deaf journalist and activist Henri Gaillard (b.1866), editor of the *Journal des Sourds-Muets,* sought to convince politicians of the republican case for deaf political rights: "For a long time we have not ceased to proclaim that the Deaf-Mutes differ in no respect from the Hearing-Talking."[59] A left-leaning Parisian, Gaillard did not oppose the teaching of lip-reading and of speech, both skills that he possessed, but argued that sign language was the essential preliminary stage in deaf education (fig. 56). As a central part of its campaign to destroy prejudices against the deaf, the *Journal des Sourds-Muets* attacked the anthropologists and appealed to popular political culture rather than elite science, led by Eugène Née a spokesperson for the "silent socialists" (fig. 57). In 1895, Née dismissed anthropologists as "*les snobs-philosophes*" who had failed in their physiological endeavours: "So have you modern or pre-historic

I. Eugène NEE, un des Leaders du Monde Sourd-Muet. (Dessin de William M.)

57. *Portrait of Eugène Née*
(Paris, INJS)

Brocas, I say, ever analysed the essence of a *soul* with your spiritual scalpel?"[60] Née emphasized that anthropology was still incapable of defining humanity in such a way that the equality he claimed for the deaf could be denied on any other grounds than prejudice. In a book published soon afterwards, the Danish anthropologist Holger Mygind admitted that "the pathological condition called deaf-mutism is based upon a symptom, the extent of which cannot be measured with any degree of certainty."[61]

Mygind added two new ingredients to the pathology of deafness, which were to produce some of the most impassioned exchanges of this long and sorry debate. Firstly, he played upon the rise of anti-semitism: "It is a well-known fact that the Hebrew race produces a larger number of individuals than the European races amongst which it lives. It seems, also, at least in many places to produce a comparatively larger number of deaf-mutes."[62] This equation of the deaf and the Jews, which had been evolving throughout the century, became an undisputed staple of eugenic literature on the subject. As Sander Gilman has explained, the Jews were considered mentally defective by definition:

> Some views using the model of biological determinism had it that the Jew was at risk simply from inheritance; some views sought after a sociological explanation. But both views, no matter what the etiology,

saw a resultant inability of the Jew to deal with the complexities of the modern world, as represented by the Rousseauian city. It is the city . . . which also leads to the pathologization of the psyche. And the source of the madness of the Jews lies in the Jew's sexuality—in the sexual practices of the Jews as well as in the configuration of the Jew's sexual drives. They are as perverse as is the form of his circumcised penis.[63]

If one changed the word "Jew" for "deaf," and replaced the disturbing symptom of circumcision with that of sign language, the comment could equally well apply to late nineteenth-century views of the deaf. Both groups could occasionally "pass" for the normal, but would inevitably be betrayed. Both were hereditary but dispersed groups, who threatened society with their "uncivilized" sexual impulses. It was thus logical for Mygind to add the conclusions of an American eugenicist named Wines "that deaf-mutes have four times as great a disposition to insanity, as individuals in general." The (presumed) insanity and hyper-sexuality of the Jews confirmed that of the deaf, because the Jews were prone to deafness, and vice-versa. The argument was perfectly circular and brooked no response. In the (literally) hysterical atmosphere of fin-de-siècle Paris, this was a potent mix of allegations.

Mygind's work came to French attention when he presented a paper to the Academy of Sciences. Mygind now condensed his arguments into an assertion that the the deaf were simply mad: "because their infirmity is the outcome of lesions in the brain entailing: insensibility, idiotism, disposition to tuberculosis, children infallibly predisposed to these illnesses, to these softenings of the brain; and, because of their fault, so are their more or less direct descendants; and it is amongst the deaf and blind that the majority of the mad in the lunatic asylums of Germany and France can be found." This astonishing claim provoked despair from Née: "What good are our artists, what good are our writers, what good are our just social claims? We are madmen, cretins, we will all be finished *by science* behind the bars of a padded cell, on a hospital bed, flesh for the medical student, meat for dissection, bones to the charnel-house."[64] Née's vehemence stemmed from his sense that the cultural politics which had sustained the deaf community for seventy years had finally lost its purchase against the doctrine of medico-psychology, with its political and anthropological support.[65]

Née presented a report on Mygind's paper at the Congress of the Deaf in Geneva later that year: "Accustomed as one may be to smiling at the more or less fantastic diagnostics of *Monsieurs les Anthropologistes,* their

58. *Congrès Internationale des Sourds-Muets 1888* (Paris, INJS)

science is too uncertain, their judgements rest on too fragile a base, their statistics are built on too indulgent equations, to not protest loudly against this insult which has been so gratuitously dispatched against us." Following Berthier's earlier lead, Née rightly accused the anthropologists of being ignorant of sign language and of overlooking the works of deaf artists, which proved the capacities of the deaf. His audience of over two hundred deaf delegates from around Europe resolved to take action (fig. 58). The new Committee for the Popularization of the Manual Alphabet in Paris sought to appeal to the wider population by distributing cards with the manual alphabet as a means of attracting publicity to the deaf cause. Their key demand was the renewed insistence that the deaf be transferred from the Ministry of the Interior to that of Public Instruction: "That which I demand is that the deaf, alias idiots and madmen, who are rotting in the *établissements d'assistance* maintained by clerics should be freed. For my part, I can speak with full knowledge of this situation, for I was there . . . and I suffered there" (original ellipsis).[66] Finally, Née called for unity amongst the deaf. He recognized, however, that the prestige of *Monsieur le Docteur* was undiminished, especially in the countryside. The lack of communication between the Parisian deaf community and the provinces, which had not formerly seemed important, now stood in the way of united action.

DEAF ARTISTS AND THE THIRD REPUBLIC

In the arts, it was as if no progress had been made in the hearing understanding of deaf visual culture. The psychologist Sanjuan performed a diagnosis of a Spanish deaf artist, concluding that mimicry had permanently distorted the cortexes of the brain. He therefore claimed that the artist manifested "the particularity common to other deaf-mutes, that he is incapable of composing any subject whatever, however simple it might be. Copy, yes: to perfection."[67] Yet again a hearing intellectual concluded that the physiology of deafness made it impossible for deaf artists to be anything other than copyists. On the other hand, the deaf critics did not find the sculpture and painting of the established deaf artists sufficiently modern for their tastes. Deaf artists continued to work and be trained in the classical style which they now studied at the *Académie Julian* in Paris. French Artists such as Pilet, Baudeuf, and Félix Plessis joined deaf artists from around the world at the Julian,[68] a commercial art school, founded by Rodolphe Julian in 1873, modelled on the teaching of the Ecole des Beaux-Arts. For 40 francs a month, students received a classical artistic training without having to pass the competitive entrance examinations of the Ecole. Artists such as Matisse, Derain, and Léger all took classes at the Julian. Leading Academic artists, such as Jean-Paul Laurens (1838–1921) and J. J. Benjamin-Constant (1845–1902), were hired to give weekly classes, and Laurens learnt sign language to communicate with his deaf students.[69] However, when younger deaf artists depicted modern subjects, or used new media, such as lithography, the deaf critics were as dismayed as any mainstream art journal might have been. The innovative and modernist work of deaf photographers was not even discussed in the deaf press.

Oralists found the depiction of their program in traditional artistic media no easier than the deaf artists, a dilemma revealed in an 1897 painting by Andricus Jacobus Burgers, who taught art at the Institute for the Deaf and exhibited at the Salon (fig. 59). It shows a demonstration of speech at the Institute for the president of the French Republic, Félix Faure, highlighting the confluence of Republican politics and deaf educational institutions that had produced the switch to oralism. The French flag and a bust of the abbé de l'Epée dominate the scene from above. The president stands in the foreground, clearly distinguished from the rest of the crowd. The deaf children are conspicuous in their blue uniforms, while their teachers wear the frock coats of the bourgeoisie. The demon-

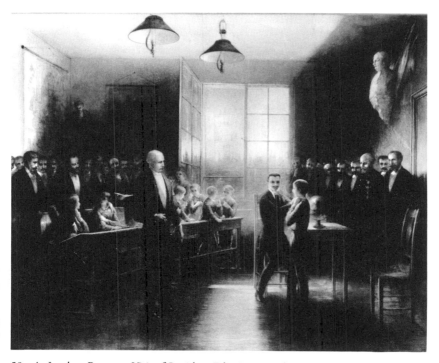

59. A. Jacobus Burgers, *Visit of President Félix Faure to the Institut National des Sourds-Muets,* 1887 (Paris, INJS)

stration proceeds at the right and, in a very different way, it is once again to the advantage of the artist that this is a silent work. A contemporary journalist reported a similar scene at the Bordeaux Institute: "You have to know these voices of the deaf to know how moving they are. In place of the clear and flexible babble of children, one hears a distinct but raucous sound, hesitant and without nuance. The machine functions with a terrible effort. A clumsy, vulgar machine, less successful than scientific apparatus. An admirable and distressing caricature of those whom nature has made in conformity with ordinary types. The President was visibly moved."[70] Without the camouflage of mimicry, the deaf had been exposed in nineteenth-century discourse, with the result that they were no longer the likeness of the hearing but a caricature. Mimicry had been reinterpreted not as camouflage but as mockery.

The official report of the visit declared that, when President Faure asked questions of a pupil: "The deaf-speaker [*sourd-parlant*] easily grasped the questions, and replied appropriately to them in a well-articulated voice."[71] It seems that the Institute, keen to avoid the embarrassment suffered in

Bordeaux two years earlier, had selected only its best pupils to respond orally to the president. The full story was, however, not included in the official report or in Burgers' picture. Charles Dauzat reported on the event for *Le Figaro:* "That which seemed to have most struck the President was the extraordinary facility with which the pupils responded, some *by gestures,* others even by voice, to the questions which he had posed to them orally on very diverse subjects, questions whose expression they grasped by the movement of lips alone, as quickly as we understand it ourselves by oral articulation" [emphasis added].[72] Even at the height of the oralist period, the officials at the Institute for the Deaf were forced to rely on sign language in order for the majority of students to communicate effectively. Indeed, in the background of Burgers' painting, children can be seen signing to each other. They are the only point of movement in the work. For, as everyone else stands stock still in the presence of presidential authority, these children continue their silent conversation. The president cannot be aware of them as he is looking at the speaking child, just as he may not have been aware of sign language interpretation of his questions. They seem to be finger spelling, probably the only manual language Burgers knew: the child on the right spells L and on the left G. But what do these signs signify? We cannot know and nor can the president. No doubt Burgers wished to show the atavistic sign language that the young deaf children used before mastering speech in later years. In that sense, the background of his picture represents the backward state, which the oral child in the foreground has already escaped. But it is equally possible to read the picture as evidence both that sign language was a natural language for the deaf, and of its continued use even in the heyday of oralism. In 1906, Paul Choppin produced a sculpture of the oral method of Jacob-Rodrigues Péreire, a seeming endorsement of the oral method (fig. 60). The eighteenth-century dress of both Péreire and his pupil, complete with ornate wig, could also suggest that oralism was an outdated and old-fashioned procedure. It was precisely this kind of ambiguity within the classical form that led both oralists and deaf activists to seek a modernist representation of deafness.

Deaf artists and critics striving towards modernism in the traditional arts could not sustain the close relationship that Jouin and Martin, or Berthier and Peyson had enjoyed. The deaf republican leader Henri Gaillard wrote reviews of the work of deaf artists at the Salon and was severely critical in his search for a modernist deaf art. At the Salon of 1895 (Société des Artistes Françaises), Paul Choppin exhibited *The Washerwoman,* a sculpture showing a woman kneeling and beating out a piece of laundry,

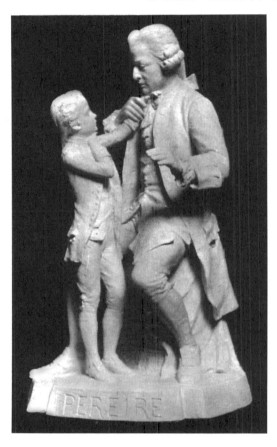

60. Paul Choppin, *Jacob-Rodrigues Péreire* (lost)

which was purchased by the city of Paris, and placed in the popular parc de Montsouris in the 14th arrondissement (fig. 61). This combination of public display and a subject derived from everyday life seems designed to elicit a favorable response from the left, but Gaillard did not oblige: "The expression on her face says nothing. . . . We must not believe that the daughters of the people work without thinking anything, their brain empty, their heart dead. On the contrary, manual labor is extremely stimulating for their mental forces and it is when they are in the heat of their work that physiognomists—the deaf-mutes are almost all physiognomists—can divine who they are or what they have."[73] Gaillard reasserted the value of manual labor, a key point for socialists and sign language activists. However, he wanted the deaf to be physiognomists and, at the same time, refused any visible physiognomy of deafness. He endorsed the classic physiognomy, which, in opposition to Lombroso's

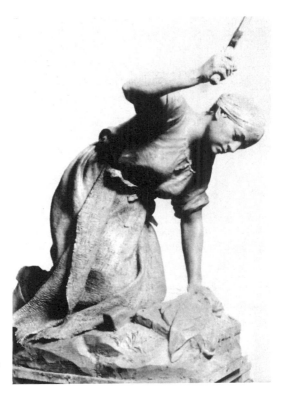

61. Paul Choppin, *The Washerwoman* (lost)

hereditary theory, believed that social cause and effects were mirrored on the body. The contradictions of this textual position could not be resolved by any artist. Pressured by eugenic criticism from the official art world, and social reponsibility and physiognomy from the left, it was impossible for Choppin to please his entire audience.

In the same Salon, Gaillard praised Fernand Hamar's (1869–1943) *Hunting the Falcon:* "It is completely his impression, a rapid and fugitive impression." The term "impression" was, of course, borrowed from pictorial criticism to which it is better suited. Hamar's sculpture of a young boy collecting an animal killed by his falcon has a pleasing sense of movement, but his expression is every bit as blank as that of Choppin's *Washerwoman.* At the Salon of 1900, the sculptor Félix Plessis (b.1869) presented his sculpture *Gloria Gallis* (fig. 62), to considerable acclaim in the mainstream press: "It is a svelte *académie* of a laborer, who has unearthed the helmet of a warrior, and, gasping for joy, lifts up this heroic trophy."[74] On the base, Plessis had carved: "Independence through arms, riches through labor," and his patriotism was cited in his award both of a mention

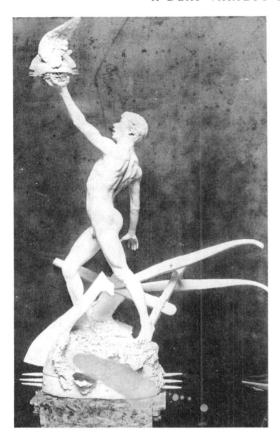

62. Félix Plessis, *Gloria Gallis* (lost)

honorable and of the rank of officier d'académie.[75] Only such general themes as the patriotism and support for the army evoked by Plessis could command uncontroversial support for deaf artists in the Third Republic.

Gaillard turned from sculpture to the properly modern medium of painting in the hope of finding a modernist deaf art. The landscapist René Princeteau was often praised as the leading deaf artist, despite his relatively infrequent showings, precisely because he had moved away from the classic style to concentrate on loosely handled rural scenes. Gaillard especially praised the work of two Americans, Humphrey Moore and Granville Redmond, who were students at the Julian. Moore's *News of the War at Mellila,* an Orientalist depiction of an artisan in Morocco reading the Spanish newspaper the *Coreo,* supplied that which Choppin lacked: "It is certain that M. Humphrey Moore has the secret of appropriating physiognomies." Redmond's first Salon entry, *Winter Morning,* showed a barge moored near the Pont d'Austerlitz in winter, done in the style of the

official "Impressionists," like Bastien-Lepage and Carolus-Duran. Gaillard was enthusiastic: "[T]he spectacle will chill and sadden you. . . . I like to think that he worked on this painting in his hours of spleen."[76] The use of Baudelaire's term "spleen" is suggestive of Gaillard's innovative attempt to create a modernist deaf criticism.

In fact, the deaf engravers Auguste Colas (1845–1915) and his pupil René Hirsch did treat modern subjects in their work, but their graphic work carried insufficient prestige to do the cultural work sought by deaf activists. Both used the *Journal des Sourds-Muets* to advertise their work. Hirsch offered portraits in a variety of media, and Colas produced visiting cards in the manual alphabet. For his Salon debut in 1887, Colas reworked a scene by the Dutch artist Cogghe, transforming a depiction of a cockfight into a conflict between the white cock of monarchy and the red of the Republic. In the audience were various well-known politicians and writers of the day, making the political allegory clear (fig. 63).[77] Hirsch, on the other hand, represented *The Artist's Studio* (fig. 64) in a moment of pure spleen. The exhausted artist sits for a moment in his dark rooftop apartment, pausing in his work on a panel entitled *CAFE,* depicting a coffee-pot. No doubt this was either an advertisement or a shop sign for a less than elite establishment. The artist's overalls and the open bottle on the table provided rather too accurate a guide to the daily life of the average deaf artist for Gaillard's liking.

Gaillard actively disliked the work of Armand Berton, perhaps the French deaf artist who most deserved to be called a modernist. Commenting on his work at the alternative Salon at the Champ de Mars, Gaillard fumed: "It is eternally the same style, a style which can only be understood by pure artists and fine intellectuals. Armand Berton is above all a painter of the flesh, and of a certain flesh, a flesh which is only seen and loved by those of exquisite taste and visionaries enamored with troubling forms."[78] Gaillard's dislike of Berton's treatment of the nude was strikingly similar to that of the oralist Denis in its hostility to both subject matter and style, which they felt could only appeal to a Bohemian minority. Both also ignored the Salon contributions of two deaf women artists, Mlle Gauthier, a watercolorist, and Marthe Volquin, who worked in pastel and showed a daring study of a woman artist drawing a male nude.[79] Their dismissal of neurasthenic intellectuals was similar to that personified by the critic and author Joris-Karl Huysmans, whose writings on Degas' nudes delighted in: "the ardent, deaf [*sourde*] color, the mysterious, opulent tones of these scenes. . . . This is no longer the slick, even, always nude flesh of goddessses, . . . it is real, living, undressed flesh, flesh seized

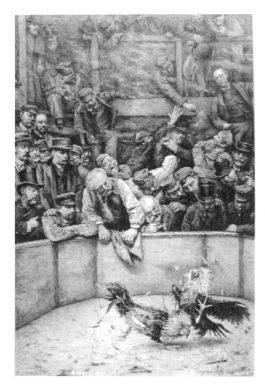

63. Auguste Colas, *The Cock Fight* (Paris, INJS)

64. René Hirsch, *The Artist's Studio* (Paris, INJS)

in its ablutions, goose-pimpled and deadened with cold."[80] Huysmans' obsession with the everyday female form was exactly the visionary transcendence Gaillard rejected, for it was this hysterical vision that perceived the deaf as abnormal. And Huysmans found Degas' color to be just that—deaf.

By 1906, Camille Vathaire, who wrote sympathetically on deaf artists for the *Revue Générale de l'Enseignment des Sourds-Muets,* the official publication of the deaf profession, concluded his review of that year's Salon entries with the regret that deafness artists now formed "a small Pleaid, whom the public does not distinguish from the others."[81] This unexceptional equality was the goal of the oralist establishment, but it certainly did not meet the aspirations of the deaf artists. However, it was by now no easy feat to be noticed in the art world. In 1890, the official Salon, sponsored by the Société des Artistes Françaises, and its rival the Société nationale des beaux-arts, displayed 4,653 paintings, making reviews and commissions hard to come by even in the world of Academic art.[82] Perhaps the deaf artists were also victims of their own success. When Peyson and Deseine first exhibited, it was a sensation. Now it was more of the same to blasé reviewers. The deaf artists sought to attract attention by holding an exhibition open only to deaf artists on the two hundredth anniversary of Epée's birth in 1912.[83] This exhibition, which opened at the same time as the Salon, was notable for the emergence of a number of deaf women artists, joining Marthe Volquin who had been exhibiting at the Salon since the mid-1890s.[84] Regrettably, none of their work has yet been rediscovered. In 1926, deaf artists inaugurated the Salon Silencieux (fig. 65), an international exhibition which sought to recapture public attention by holding group shows in Madrid (1928), Brussels (1930), and New York (1934).[85] However, none of these ventures attracted the attention that the work of Peyson, Choppin, and Martin had generated. The deaf were now perceived as "abnormal," and their art was no more than a curiosity.

Despite these cultural dilemmas, the deaf Republicans did have notable successes. Joseph Weber, who held a seat on the Paris municipal council for the Revolutionary Socialist Workers Party, was a strong supporter of the Parisian deaf community. He campaigned for the establishment of a deaf school at Asnières and ensured that Gaillard and Joseph Cochefer, director of the Appui fraternel des Sourds-Muets, had seats on the board. Weber promoted the right of deaf people to work for the Seine municipality. He organized the purchase of Paul Choppin's *Washerwoman* and René Princeteau's *Return* by the city of Paris in 1895. However, the Inte-

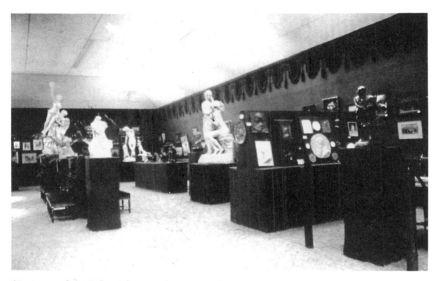

65. *View of the Salon Silencieux* (Paris, INJS)

rior Ministry refused his proposal that copies of the manual alphabet be distributed to all primary schools because oralism rendered dactylology unnecessary.[86] Unfortunately, he lost his seat in the municipal elections of 1896.[87] The deaf Republicans at once gained a far more influential supporter when Paul Deschanel, the Progressiste vice-president of the Chamber of Deputies was guest of honour at the Republican banquet of July 1896. Gaillard's opening address reiterated the long-standing demand that deaf education be transferred from the Ministry of the Interior to the Ministry of Public Instruction, and for the introduction of the "mixed method." Deschanel noted that Jules Ferry had considered the question of a transfer in 1882 and urged the deaf to unite so that "no one can dispose of your fate without you." In general, Deschanel declared : "We are and we will remain the devoted and faithful sons of the French Revolution. And we intend to perfect and crown its work."[88] The promise of that moment, so often referred to in the deaf press, was never fulfilled, as the Progressistes swung sharply to the right during the Dreyfus Affair.

THE DEAF AND THE DREYFUS AFFAIR

The Dreyfus Affair polarized the French Third Republic, making traditional notions of fraternal equality irrelevant. It became above all a test of

citizenship in modern France. The fact that Dreyfus was Jewish transformed the importance of the Affair and rendered it a test case of the preeminence of race in political culture. For the deaf, now so closely associated with the Jews, the Affair marked a final removal from the political scene. After Dreyfus, no leading politician was to be associated with the deaf activists in the manner of Deschanel, Prieur de la Marne, and Félix Faure. Furthermore, the Affair was not just a political scandal, but a medicalized question of competing visual regimes, which inevitably had ramifications for deaf artists. For some Dreyfus was visibly guilty because he was a Jew, a view that many, including the deaf republicans, rejected. The Affair was a crisis of representation, in all its senses, which served as a catalyst in deaf politics, as it did throughout society, forcing an entire generation to take sides. Deaf artists had pursued Classic technique and subject matter throughout the nineteenth century, exploiting its ambiguities and aporia even when it had endorsed the anthropological representation of the body. But when the xenophobia of the 1890s, fuelled by anti-semitism and French colonial expansion, erupted into the Affair, there was no longer any room for ambivalence.

Captain Alfred Dreyfus was arrested on charges of spying for Germany in 1894. From the outset, his guilt was in doubt and it soon became clear to many that there was no case to answer. For the Right, the Army, and the Church, Dreyfus' guilt was incontestable, evidenced by his Jewish background. The Dreyfus Affair provoked an astonishing increase in French anti-semitism and divided a generation around the questions of nationality and citizenship. The Army's case against Dreyus rested on the famous forged *bordereau,* a French government document, which had been recovered by French espionage from a German staff officer. The *bordereau* was the concrete evidence of spying but was a palpable forgery. However, its authenticity was attested to by the anthropometrist Alphonse Bertillon, a noted anti-semite, who concoted the remarkable thesis that Dreyfus had deliberately disguised his own handwriting, using characters derived from his family's handwriting.[89] After hearing Bertillon's arguments, President Casimer-Perier concluded that the anthropometrist was "a reasoning madman." But Bertillon's view that his proof was "absolute, complete and without any reservations" won the support of handwriting experts, the Army, and the courts. Any empirical evidence could be accommodated within the rationalized irrationality of race science, demonstrating that, in the words of Emily Apter "the French public, as if afflicted by hysterical vision (itself the apparent result of a blinding nationalism), refused to believe the evidence of its own eyes: that the mem-

oranda used to inculpate Dreyfus were obvious forgeries."[90] Vision and visual interpretation were now politicized as never before. This new political conflict overlaid and reinforced pre-existing conflicts. Thus, the Dreyfusard position was supported by sign language advocates as it refused any necessary or hereditary visual, or visualizable, physical difference between the normal and the pathological. The signing deaf now had a vested interest in refusing connections between Jewishness and pathology, as the Jews and the deaf were so closely connected by anthropologists. For the anthropological belief in the inherited legibility of the body, which convicted Dreyfus on the grounds that he was a Jew, was also instrumental in constructing the *sourd-parlant*.

As Sander Gilman has pointed out, the Jew represented the feminized Other, a category that could be applied to any number of people. During the Dreyfus Case, Otherness was a fluid category embracing Jews, Germans, socialists, anti-clericals, and intellectuals, who were all, like the deaf, constructed as abnormal, visible, and pathological. The central question at stake was that of the identity of the true French, a debate that would continue until the end of the Second World War.[91] In 1898, the Jewish periodical *Archives israélites* defined the issue for its readers: "They only want to see in our coreligionists Jews and not citizens, not Frenchmen, which is a sovereign injustice."[92] It was precisely this injustice that the deaf republicans had been protesting since the establishment of the Institute for the Deaf. However, the question of national identity now took on a broader importance. Assertions of anti-semitism and anti-Dreyfusard positions became one means for those with marginal status to assert their Frenchness. After Emile Zola published his famous defence of Dreyfus in January 1898, French settlers in Algeria staged anti-semitic riots, leading to two deaths and many injuries and loss of property. The mayor of Algiers exulted: "No one can doubt any longer that the most pure French blood runs in the veins of the Algerians [the colonists]. The sudden emotion of the mother country vibrated immediately in your hearts. . . . You have shown superbly your French fury."[93] Claiming Mother France, embodied in the maternal French language, was now the central issue of the Dreyfus Affair.

For the deaf, this problematization of citizenship was disastrous. Deaf republicans had always claimed citizenship on the basis of the principles of equality, embodied in the Declaration of the Rights of Man. In the climate of the Dreyfus Affair, it became clear that being considered pure French was a precondition of access to such rights. As a result, the disagreements within the deaf community between deaf nationalists and the

left Republicans were as nothing compared to the emnity between deaf Dreyfusards and their opponents, which at once concretized the split in the deaf community between Paris and the provinces. For Gaillard, like so many other Republicans, the Dreyfus case was a rallying point and a defining moment: "The Affair brings face to face the Age of Yesterday and the Age of Tomorrow. It is Injustice against Justice, Lies against Truth, Evil against Happiness, Routine against Progress."[94] Gaillard concluded: "This man is innocent." Soon François Douard extended the Dreyfusard case to the question of deaf education, arguing that, just as the clergy attacked Dreyfus in contradiction to the principles they preached, so did they continue to oppose the mixed method in deaf education and to conceal the failures of oralism.[95] For the Republicans, overturning the verdict in the Dreyfus case was a precondition for claiming the rights of the deaf and overturning oralism.

For others in the deaf community, the Affair offered a means to claim full French citizenship by expressing their patriotism through an acceptance of the Republican policy of oralism and the verdict in the Dreyfus case alike. The deaf anti-Dreyfusards used this cause to dispute the definition of the deaf citizen and to reject Parisian ascendancy in the deaf community. After Gaillard had welcomed Zola's famous 1898 article *J'Accuse,* open warfare began in deaf politics between those supporting Dreyfus, represented by the *Journal des Sourds-Muets,* and those against, represented by the *Sourd-Muet Illustré,* edited by Chazal and Berthet. On 16 April 1898, the *Journal* defined the conflict: "The *Journal des Sourds-Muets* which is not, and will never be, a religious paper has as its overriding principle to give information on that which might interest its numerous readers, and to highlight the merit and above all the intellectual capacities of those deaf-mute *militants* who make up its staff."[96] The *Sourd-Muet Illustré* denied the charges, but shot back that the *Journal* was "an anti-patriotic and immoral paper." On 7 June 1898, a fire broke out at the press owned by the *Journal:* "Everyone's opinion was that the cause was not natural."[97] Suspicions that the *Sourd-Muet Illustré* might have been involved were reinforced by the remarkable appearance of a full-page illustration in its next edition, published only a few days after the fire, showing a caricatured Gaillard obstructing the fire brigade. In the text, Jean Olivier attacked the *Journal:* "I am waiting for something other than a simple reprimand for this handful of foolish Parisians, who have pretences to leading deaf France, who have permitted themselves to send compliments *in the name of all* to the insulter of the army, of the fatherland, of religion and of morality, the improvised defender of the traitor

Dreyfus [Emile Zola]. . . . All the provinces have shown their profound indignation on this occasion."[98] Olivier spoke for the Union Française des Sourds-Muets, who opposed the "anti-patriotic socialists" connected with the "pornographic" *Journal des Sourds-Muets* and the Parisian *Alliance Silencieuse*. The Union prided itself on being pro-Church, pro-oralism and anti-Dreyfus.[99] These choices were logically consistent and represented an attempt to claim citizenship for the deaf who aspired to full participation in the body politic as oral *sourds-parlants,* not signing *sourds-muets.*

Marcel Mauduit founded the *Reveil des Sourds-Muets* to represent pro-oralist views in the deaf community in 1899, during Dreyfus' second trial. The paper featured frequent testimony from self-identified *sourds-parlants* as to the virtues of oralism.[100] For Mauduit, there was an important principle at stake: "The time is past when these narrow and hidebound spirits could govern the deaf-mutes *like petty kings governing savage tribes.*"[101] Like the colonizers in Algeria, Mauduit saw the Affair as a means of claiming French citizenship for the rural deaf. Berthier's unashamedly elitist concept of the deaf nation led from Paris had collapsed under attacks from left and right within the deaf community. The medicalization of the deaf had separated them from mainstream politics. As the Institute for the Deaf was now an undisputed bastion of oralism, the "methods question," with all it implied, had been displaced into the wider deaf community. The dramatic expansion of the deaf press after 1880 was both the symptom and site of that controversy. It was no longer possible to assume a consensus in deaf France on education methods, let alone political and cultural allegiances. Divided among themselves, the deaf community were not to reclaim their place in French national politics until the 1970s.

For the Dreyfusards, Gaillard now undertook a multiply defiant act of revenge against anthropometry, anthropology, and the conservative ideology of purity, whether expressed as pure oralism or pure Frenchness. Fifty years previously, Berthier had seen a natural analogy between the oppression of the Jews and that of the deaf. In his defence of Dreyfus, Gaillard did not make any such analogy. His case was that of any Dreyfusard, with one exception. For he claimed that, with the aid of the superior eyesight of the deaf, he could see that the *bordereau* was not in Dreyfus' handwriting, thereby removing the sole piece of concrete "evidence" against Dreyfus. By so doing, Gaillard made an exception to his usual position that the deaf were the equals of the hearing. For the anti-Dreyfusard, Maurice Barrès, it was Dreyfus who suffered from what he called "optical aphasia" with the result that "[h]e is not remotely susceptible to the feelings aroused in us by our land, our forefathers, the flag or the word 'honor.'"[102] These

terms are strikingly similar to the accusations of anti-patriotism levelled by Adolphe Franck against the deaf, reinforcing the connection between the deaf and the Jews. Oralist deaf groups could endorse such views precisely because they no longer felt themselves to be "savage" *sourd-muets* long denounced by doctors and philosophers, but the first representatives of a new being, the *sourd-parlant,* whose command of speech rendered them as patriotic as any French citizen. The left Republican deaf groups, on the other hand, shared the Dreyfusard conviction that social deviance was not the product of heredity, either of the Jews or of the deaf. Gaillard opposed the clarity of vision he associated with the signing deaf to the nosological gaze of the anti-Dreyfusards and the *sourds-parlants.*

The difficulties facing deaf artists were immeasurably increased by this polarization within and without the deaf community, as the split between the artistic and political goals of the deaf community became irreparable. The Academic vision within which so many deaf artists had worked was unequivocally associated with the anti-Dreyfusards, and the avant-garde took on on the mantle of progressivism. At the Salon of 1898, the Academic artist Edouard Debat-Ponson showed his *Nec Mergitur* (Amboise, Musée de l'Hôtel de Ville, 1898) depicting Truth struggling to emerge from a well, as two masked figures symbolizing the Church and the Army try to restrain her. The allegorical reference to the Dreyfus Affair was inescapable, for pro- and anti-Dreyfusard cartoons on the same subject had already appeared in the popular press.[103] Debat-Ponson paid dearly for his Dreyfusard stance, as both family members and numerous clients for his portraiture disowned him. Official art no longer provided any resources for artists to make any reference, however slight, to progressive politics. As the Affair reached its height, the deaf sculptor Hippolyte Montillié exhibited a bas-relief depicting none other than Gaillard himself, against the background of a copy of the *Journal des Sourds-Muets,* at the Salon of 1899.[104] Montillié's piece was unmistakeably a gesture of support for Gaillard's Dreyfusard position, but it was unlikely to have resonated with the wider Salon audience. Deaf artists, who had mostly worked in classical styles and forms, now found an uncrossable gulf between this artistic agenda and the modernist political objectives of the signing deaf community.

EUGENICS AND THE DEAF

The medicalized political situation of the deaf community continued to worsen in the late nineteenth century as the pessimistic prophets of de-

generation were transformed in the 1880s into eugenicists campaigning to control the breeding habits of humanity. Eugenics, in George Stocking's view, "was an attempt to compensate for the failure of natural selection under the conditions of advanced civilization."[105] A radical group from the United States and Great Britain initiated an active eugenic program in order to breed out impurities and "keep the lifestream pure," to use the slogan of the Psychopathic Laboratory in Chicago.[106] It was the inventor of the telephone, Alexander Graham Bell, who initiated this change with regards to deafness. Bell's father, Alexander Melville Bell, had invented an oral method of deaf education, which he called visible speech. Bell himself first travelled to the United States in order to teach deaf children in Boston. His invention of the telephone arose from his attempt to manufacture an artifical mouth for his oral education techniques. It transformed his personal circumstances and put him at liberty to pursue his oralist goals, which he did with remarkable energy and persistence.[107] Bell presented a visual representation of deafness in graphic form, which took the exclusion of sign language for granted.

In 1883, Bell presented a paper to the National Academy of Sciences in Washington, D.C., entitled "Upon the Formation of a Deaf Variety of the Human Race." Bell took data, which he himself admitted were incomplete, subjected them to a "worst-case scenario" and thus produced a graph which demonstrated that: "The indications are that the congenital deaf-mutes of the country are increasing at a greater rate than the population at large; and that the deaf-mute children of deaf mutes at a greater rate than the congenital deaf-mute population."[108] Mapped on the graph, the deaf children of the deaf seemed to be dramatically outbreeding the hearing for Bell assumed that intermarriage among the deaf was a modern phenomenon not anteceding 1832, caused by the growth of institutions for the deaf. Here he ignored the evidence of his own research at Martha's Vineyard, where a very high incidence of deafness had led to an integrated hearing and signing community.[109] Bell attributed the rise of this problem to the deleterious effects of sign language which "causes the intermarriage of deaf-mutes and the propagation of their physical defect." No evidence was advanced to support this theory, which was given credence by the long-standing belief in the sexual deviancy of deafness. Bell further raised the specter that a signing, deaf nation might be established in the West, noting ominously that "24 deaf mutes, with their families, have already arrived [in Manitoba] and have settled upon the land. More are expected next year."[110] The use of sign language would lead to more marriages, more deaf people and eventually a "deaf variety of the human race" might be established in the American West.

In a time of great concern over new European immigration into the United States, Bell's extravagant argument found ready ears in his adopted country. By 1900, Bell was entrusted with writing a special report on the deaf and the blind for the census of that year. Unfortunately for his argument, the census recorded 89,287 people with seriously impaired hearing, compared to 121,178 in 1890. Rather than admit that there was no evidence to support his thesis, Bell claimed the figures as a victory for oralism, showing "that a great and beneficial work has been accomplished by our special schools for the deaf in imparting artificially, by instruction, the power to articulate speech to large numbers of the deaf and dumb." In other words, oralism had prevented the intermarriage of the deaf with a concommitant reduction in the number of deaf offspring. The obvious alternative, that the figures were incorrect, "cannot be entertained." In his report, Bell concluded that if deaf intermarriage had not been restrained, a hereditary deaf population of 1,170,000 would have resulted, in the overall population of 26 million. Such headline figures were highly effective, as can be seen in the figures Bell provided for education methods in deaf schools. The number of deaf children educated orally had risen from 2041 (27%) in 1884 to 7601 (67.2%) in 1904. The decline of sign language culture in the United States can be directly attributed to Bell's campaign.[111]

In France, degeneracy theory had already prepared the ground for such maneuvers. By 1896, the Institute for the Deaf was fully committed to a hereditary theory of deafness: "Many of the deaf are the offspring of the degenerate, scrofulous, idiots, alcoholics etc. and among those whose heredity is beyond reproach, the majority have become deaf following cerebral illness."[112] The defective deaf brain was held to be the result of either social deviancy or disease. Although some hearing professionals in the deaf world were active eugenicists, eugenics simply confirmed the direction taken by the French government in seeking to make deafness disappear. The British Royal Commission on the Deaf of 1889 accepted Bell's evidence over that of Thomas Gallaudet, arguing that the deaf themselves could not know what was best for them. The Commission recommended oral education and advocated that deaf intermarriage be strongly discouraged for: "The passions of the deaf and dumb are undoubtedly strong."[113] They felt no need to advance any evidence for this proposition, which was now part of the "common sense" of the profession. Although the London schools for the deaf were already oralist by this time, most provincial schools for the deaf were still using sign language, so the effect of the Royal Commission was to enact the Milan Congress' resolutions in Britain.[114]

If his policy towards the deaf was not new, Bell's rendering of information into statistics and graphs marked a radical break in the visualization of deafness. Bell's strategy was a fusion of the modern and the classic.[115] The modern problem of locating deafness to a particular site in the body, and making deafness organically visible, was resolved by his use of the graphic grid. The traditional association of line and voice renders the grid a Classic, linear device, which dignifies the voice above all else. Ferdinand de Saussure made it clear in his *Course on General Linguistics* (1906) that: "Linguistic signs, though basically psychological, are not abstractions; associations which bear the stamp of collective approval—and which added together constitute language—are realities that have their seat in the brain." Thus the original form of words is arbitrary, but once there is general agreement that d-o-g signifies a barking quadruped, then this relationship becomes natural and physiological.[116] Saussure developed his interpretation of language by declaring that his second principle is "the linear nature of the signifier. The signifier, being auditory, is unfolded solely in time from which it gains the following characteristics: a) it represents a span and b) the span is measurable in a single dimension; it is a line."[117] A graph, then, is a depiction of signifiers in their natural state. It is to speech what a musical score is to song, a form of notation. Bell's use of graphs was entirely in keeping with his oralist project. We have been here before, for the Ancients' position in the ancien régime Academy upheld the joint primacy of voice and line. For the conservative wing of modernism this position was, one might say, classically modern with its three watchwords, progress, eugenics, and imperialism.

Controlling the interpretation of such statistics and graphs proved to be less easy than had been hoped. In 1902, two doctors from the Salpêtrière engaged in a detailed anthropometric study of the pupils at the Institute for the Deaf, hoping to find a correlation between their observations of the "stigmas of degeneration" and the intelligence of the pupils. They took 116 different measurements of the students and found an average of between 3.84 and 5.44 "malformations" per pupil. These observations included such data as "ears too big on both sides," affecting 1.88 percent of the "passable" students, or "index finger too short on the left," which plagued 5.26 percent of those classified as "weak." Boyer and Feré admitted that: "The anthropological examination should not constitute the unique base for the selection of the young deaf-mutes, from the point of view of educability, and, in certain cases, the anthropological data can even induce errors in appreciation of the intellectual state of the subject."[118] Professional eugenicists remained uneasily aware of the gap between their rhetoric and evidence.

In presenting a collection of eugenic studies, including deaf-mutism [sic], the British eugenicist Karl Pearson cautioned that "[i]t is not always possible to maintain a proper balance between the graphic and the verbal descriptions; but I wish most strongly to insist on the point that neither are to be interpreted *alone;* they are component parts of one whole, and the reader who draws conclusions from the engraved pedigrees without consulting the verbal accounts is certain to be led into error."[119] In order to signify correctly, the eugenic sign required a correlation of visual representation and critical assessment, in which the latter was dominant over the former. In Chapter Four, I suggested that the sculptural program of the Third Republic was structured in similar fashion, with the critical commentary always in advance of the sculptural form on display, constantly demanding new amendments and corrections. It is at this point that the logic of the binary system could assume that which Jean-François Lyotard has referred to as the terror of modernism. For the gap between reality and desire, which the eugenic program was constantly seeking to close, could never be overcome, leaving a resort to violence as the only hope. As Pearson remarked, it was "so much easier to suggest means of eliminating the manifestly unfit as factors of race perpetuation, than to advocate acceptable methods of emphasizing the fertility of the socially most valuable members of the community."[120] The elimination of the deaf could only be achieved by force.

For the growing eugenic movement in the United States, Bell's work was one of the few pieces of seemingly empirical evidence available. From the movement's founding days in the late nineteenth century, until it became discredited by association with the Nazis in the 1940s, Bell was repeatedly cited by eugenicists.[121] Eugenic theory operated on the belief that Gauss' Law of the Frequency of Error could be applied to human "errors" and that, by scientific controlled breeding such problems could simply be eliminated. Eugenics inspired legislation in 30 states of the Union by 1914. Marriages of the "unfit" were prohibited and doctors were given powers to sterilize those in state hospitals and other welfare institutions. By 1928, over 9000 citizens of the United States were sterilized under such legislation with the majority of operations being carried out in California.[122] In a legal and medical handbook for eugenicists, Harry Laughlin, Expert Eugenical Agent of the House Committee on Immigration and Naturalization, set out their agenda for population control:

> As modern society is organized it has to take cognizance of many individuals who, on account of defective or handicapping inheritance, or

other misfortune, are unable, despite training, to maintain themselves without much social direction and help. They thus constitute a handicap to the well-being of the body politic. Specifically these social inadequates may be classed as follows: 1) Feeble-minded; 2) Insane (including the psychopathic); 3) Criminalistic (inc. the delinquent and the wayward); 4) Epileptic; 5) Inebriate (including drug habitués); 6) Diseased (including the tuberculous, the syphilitic, the leprous and others with chronic infections and legally segregable diseases); 7) Blind (including those with seriously impaired vision); 8) Deaf (including those with seriously impaired hearing); 9) Deformed (including the crippled); and 10) Dependent (including orphans, ne'er-do-wells, the homeless, tramps and paupers).[123]

The deaf were now classified amongst those "unfit" to take their place in modern society. Such apparently random chains of association, which had been used by Condillac to demonstrate the arbitrariness of language, were now held together by the common designation "unfit." By 1941, over 36,000 such Americans had been sterilized.[124]

The tragic consequences of these misguided actions reached their height in Nazi Germany. Acting on similar principles to those used in the United States, Hitler passed a Eugenic Sterilization Act in 1933, which made sterilization compulsory for those with hereditary disabilities such as deafness. By 1939, 320,000 sterilizations had been carried out, including at least 17,000 deaf people.[125] Over one third of these were under eighteen, and 9 percent of the deaf women sterilized were previously forced to have abortions. In 1905, Governor Samuel W. Pennypacker of Pennsylvania vetoed one of the first American sterilization bills because: "It is plain that the safest and most effective method of preventing procreation would be to cut off the heads of inmates."[126] While democratic systems could not entertain such a possibility, the Nazi dictatorship was less inhibited. At least 1600 deaf people died in the extermination camps and "euthanasia" centers at Hadamar, Sonnestein, and Grafeneck, a drop in the ocean of the holocaust, but nonetheless a futile and pointless slaughter. Eugenic legislation is still on the statute in twenty-two states of the union.

Modernism cannot simply be reduced to eugenics, and nor were the deaf always on the Other side of modernism. The graph was only one of the many new forms of visual representation that emerged in the nineteenth century, such as photography, film, the stereoscope, the kaleidoscope, and so on. A small group of professional deaf photographers, who made im-

portant artistic and technical contributions to the history of photography, indicate that a deaf modernism was not only possible but functioned with considerable success, even though the deaf were effectively excluded from avant-garde painting. Rather than criticizing these artists for not being painters, the fault lies in our reductive use of the term modernism. The reception of Walter Benjamin's work in nineteenth-century art history has led to the creation of a monolithic sense of modernism in France, defined by Haussmanization, the *flâneur,* and the arcades, in which painting has become the privileged medium. Even within painting, only the canonical Impressionist and Post-Impressionist work receives serious critical attention despite the intentions of the revival of social art history in the 1970s to diversify the canon of art history. As such work became an established variant of the discipline, Academic art, prints, and other materials have been increasingly used only to highlight certain aspects of already canonical painting. This limited sense of modernism as belonging only to avant-garde painting erases the historical contests as to the meaning and definition of modern visual culture.

In a series of recent interventions, the German philosopher Peter Bürger has sought to complexify our understanding of modernism by distinguishing between avant-garde practice and an aesthetic modernism derived from Kant. Bürger sees the latter as "institution art," which announced the historical development of self-criticism within the bourgeoisie, and has become the primary target of avant-garde practice.[127] This important distinction nonetheless offers only a binary opposition within the category of modern, one that can only be determined by the sensibility of the critic. Rather than seek to reinscribe the narrative of modernism within more discriminating terminology, a history of visual culture should seek to determine the limits of possibility constructed by the discourse of modernism in any given period. This is not the familiar and widely accepted call for a contextualization of art practice but a move to rethink the disciplinary formation of visual culture as a field. The binary oppositions that are so often used to explain modernism—such as high/low, avant-garde/modern, Academic/modern—are better understood as constitutive of modernism's (inevitable) exclusions, rather than as analytic tools. Modernism, like any other discursive practice, is defined as much by its exclusions as by its membership. If in the eighteenth century it had seemed natural for both Diderot and the abbé de l'Epée to consider sign language in the same moment as discussing painting, such comparisons became literally unthinkable in the High Modern period. The deaf contestation of that taxonomy is one small example of the process of

disciplinary definition at work, in which deafness and sign language were excluded from late nineteenth- and twentieth-century modern visual culture.

As sign language, theorized as mimicry, is itself disruptive of such binaries, deaf modernism can be a test case of this approach without being— or seeking to be—paradigmatic of the dispersed and decentered field of modern visual culture. As Walter Benjamin argued, it is only by moving like ragpickers over the discarded remnants of modernism that we can fully understand what was at stake in the modernizing imperative of the nineteenth century. Recent studies have focused on the diversity of early twentieth-century modernism, demonstrating that popular culture, music, photography, and non-pictorial media all had a part to play in this contested story.[128] This more complex and contested definition of modernism did not, however, suddenly spring up in the twentieth century but is also central to the understanding and importance of the discursive practice of modernism in the nineteenth century. Within deaf culture, this story runs parallel to the Classic forms of artistic representation used by deaf artists in traditional media and is a counterpoint to that narrative, indicating that there can be no one history of "the" deaf, any more than there is one all-encompassing history of visual culture.

DEAF MODERNS

Photography was of course central to the transformation of visual representation in the nineteenth century. Artists and critics alike realized that the existence of photography problematized the functions of the traditional visual arts in a variety of ways. In France, the artistic property law of 1879 continued to deny photography the status of art, so ardently desired by certain of its practioners.[129] Deaf artists at once saw the possibilities of the new medium which, like sign language, was a visual means of representing reality. Just as the mimickers proposed that sign language could be a universal language, so did many see photography as fulfilling that Enlightenment dream. Towards the end of de Gérando's tome on deaf education, he had speculated on the difficulties facing the teacher of the deaf in conveying the details of everyday life: "What then will he do? First, he will not limit his teaching to the walls of his classroom; he will in effect transport it, as far as he can, into the theater of real things; next, he will act in such a way that his class itself will become a sort of *camera obscura,* if one will permit the term, in which the scenes of real life will come to repeat

themselves once more; the lesson will be a drama."[130] Sign language created the visible world in the same fashion as the pinhole of the *camera obscura:* almost the same, but not quite. His words were to be recalled many times once technology had transformed the reproduction of visual images, by both hearing professionals and deaf artists. If avant-garde painting had excluded the deaf, the preeminently modern medium of photography offered deaf artists new ways to be equal to modern, hearing artists.

The career of Alexis-Louis-Arthur Gouin (d. 1855), the first deaf photographer of note, was exemplary of this trajectory of deaf cultural politics from painting to photography. He was born in Guadeloupe, but came to France to be taught by Laurent Clerc. He painted portraits in New York for a while and then became a pupil of the artist Girodet, where he would have known Edouard and Fanny Robert. He was soon at the heart of deaf politics and was a founder member of Berthier's Comité des Sourds-Muets. At the second banquet in honor of the abbé de l'Epée, he proposed a toast to "our old teacher Clerc."[131] One guest at the first banquet was Louis Daguerre. Was it simply coincidence that Gouin soon abandoned painting and became one of the first to be involved in photography, or did he make friends that night with the inventor of the diorama and future photographer? Gouin set up a studio at 50 Basse-du-Rempart in 1849 and moved to 37 rue Louis-le-Grand by 1850, where he produced daguerreotypes and later stereoscopes.[132] He exhibited ten portraits, of which eight were colored, in the Universal Exhibition of 1851 in London, and he also showed in Amsterdam in 1855.[133] His *Portrait of a Woman in a White Dress* (fig. 66), a hand-colored daguerreotype, is a fine example of his work. The sitter is posed exactly in the middle of the frame, as in a conventional portrait. Her hair, pose, and dress all suggest a portrait by Ingres. But her expression is warm, with a gentle smile and her eyes, rather than being downcast as in so many Ingrist works, look directly into the camera. Gouin colored in the flowers and corsage to add further relief from the severity of the traditional pose. As Charles Gaudin wrote in *La Lumière,* an early photographic journal: "One cannot conceive of arriving closer to perfection. These figures live, their flesh palpitates before our eyes. It's nature taken in the very act and poeticized by the painter."[134] Léon Cogniet, an old friend of the deaf, remarked on seeing Gouin's work: "Art could never do better." His obituaries (1855) noted Gouin's invention of a rapid plate-polishing machine, and his use of actinic photographs.[135] But none of these reports mentioned Gouin's deafness, which is known only through the deaf press and archives.[136] Similarly, in 1855, a

66. Alexis Gouin et
al., *Portrait of a
Woman in a White
Dress*, c. 1855
(Rochester, George
Eastman House)

deaf man named Richardin won a Second Class medal at the Universal
Exhibition of that year, for his daguerreotype-polishing machine. His
achievement was heralded at the banquet for that year, but again his deaf-
ness was not recorded by the mainstream press.[137] Gouin was able to
work in public and be active in the deaf politics of the day, without being
judged in terms dependent upon his deafness. Perhaps the very strength of
his critical reception depended on that ignorance. His modernity stems
not only from his choice of medium but the lack of reference to deafness
in his work. Gouin sought and achieved the equality with the hearing
aspired to by deaf republicans throughout the nineteenth century. Photo-
graphy's mimicry was so exact that it saturated the visual field, excluding
the possibility of "seeing" the pathology of deafness. In this fashion,
the deaf photographers used the anthropologist's own preferred medium
against their visions of pathology.

Gouin's obituaries also revealed that he had established something of a
cottage industry in his studio. Gouin had worked in close association with
his wife Marie and daughter Laure Mathilde, who had done much of the
work. In the words of Ernest Lacan: "When praise was in order, they

67. "Alexis Gouin,"
Portrait of Saint-Saens,
c. 1858 (Rochester,
George Eastman
House)

allowed themselves to be ignored."[138] However, this secrecy allowed the
two women to continue to work under Gouin's name after his death.
From 1857, Mme Gouin also sold a successful line of artists' colors and
other goods. In 1856, Mlle Laure Mathilde Gouin had married the deaf
photographer Bruno Braquehais (d. 1875), a former pupil at the Institute
for the Deaf, and they began to work together from the studio in rue
Louis-le-Grand.[139] In 1863, they moved to 11 boulevard des Italiens, an
address made fashionable for photography since 1854 by Disdéri's calling
card business.[140] Attribution of their work is more than usually difficult,
given the retention of Gouin's name by his surviving family, in which
Braquehais may have also participated.[141] The studio produced a stereo-
scopic portrait of the composer Saint-Saens (fig. 67), which can be dated
to c.1858 from the visible score of Berlioz's *Lelio,* which Saint-Saens tran-
scribed for piano. The portrait is a striking instance of the possibilities of
stereoscopic photography, giving a new force to the traditional portrait
pose, in which the sitter is "caught" in the middle of a characteristic
activity. Gouin's work has increasingly come to be recognized as an impor-

tant moment in the history of photography. It is equally important to the history of the deaf in repudiating the modernist hostility to deaf culture on modernism's own ground. But who took the picture? Not Alexis Gouin to whom it is usually attributed, for he was dead.[142] The impossibility of answering the question indicates its irrelevance. A small family group of deaf photographers created a successful business, which rendered their individual identities—and hearing capacity—beside the point.

Braquehais began his career in 1850 offering colored daguerreotypes from his studio at 10 place de la Madeleine. In 1854, he began a series entitled *Musée Daguerrien,* which featured tastefully posed nudes for the use of art students at the Ecole des Beaux Arts and others.[143] In one example, a naked woman is depicted lying on a couch, covered with a transparent veil from head to foot. Her face is only half visible, but a range of artistic accessories, such as a plaster Venus de Milo, a suit of armor, an oriental vase, and an oil painting can clearly be seen. The photograph is on the borders of art and popular imagery. The Venus indicated the erotic dimension to the scene, with the oriental accessories hinting at the Odalisque theme, made popular by Ingres, while the veil and the painting suggested a more refined, artistic goal. Depending on the perspective of the individual viewer, Braquehais' photograph could thus carry a number of distinct meanings.[144] This collodion work attracted some attention from Ernest Lacan, editor of *La Lumière,* and a partisan of art photography: "It is impossible to handle collodion with more skill. His prints are of extreme limpidity. . . . M. Braquehais has the happy idea of arranging his models with somber draperies, which make high-toned foregrounds and which constitute studies in themselves. However, we regret to see figuring, in all his prints, a Venus in plaster, which distracts the eye. . . . Except for this useless accessory, his prints are the most beautiful, most complete of their kind that we have seen." But this useless accessory did serve some purpose, for it effectively "signs" the work as being by Braquehais. The plaster statue may have served like the "S.M." attached by deaf painters to their signature, as a means of indicating authorship. It is, however, a coded and symbolic reference, only open to those aware of its meaning. These initiates would have included deaf activists, for Braquehais showed an album of his work at the Banquet of 1863: "Animated gestures were exchanged from one end of the room to the other, in the middle of oral conversations, while an elegant album of photographs, the work of the deaf-mute Braquehais, successor and son-in-law of another deaf man A. Gouin, circulated from hand to hand winning as many clients as admirers."[145] If deafness was thus knowable in Braquehais' photo-

68. Bruno Braquehais, *Musée Daguerrien* (New York, New York Public Library)

graphs, it was only in a coded and concealed form, far removed from earlier claims to universality. It was nonetheless functional, for this "signing" has enabled me to identify a hitherto unattributed stereoscopic image from the *Musée Daguerrien* (fig. 68). It depicts two lightly clad women, seated in front of the statue of Venus. All three are garlanded with flowers, suggesting an allusion to the Three Graces theme of Botticelli's *Primavera*. The theatricality of the scene is enhanced by the rather badly draped curtain behind the statue. The stereoscopic effect gives a strong sense of recession, separating the three figures into different planes of the picture field. Like many other photographic pioneers, Braquehais here strove for artistic effect and reference in the stereoscopic medium.

Braquehais is, however, best remembered for his least characteristic work. For during the Paris Commune, Braquehais abandoned his tightly controlled studio scenes and took to the streets. His resulting album of 92 photographs, *Paris during the Commune,* is one of only two photographic records of the Communards during the insurrection. The photographer Jean-Claude Gautrand points out that: "Braquehais is one of the first photographers to have taken the camera from the confined atmosphere of the studio in order to project it onto the screen of life in the street."[146] This perceptive comment acquires further resonances in the light of Braquehais' deafness. He reversed de Gérando's idea of turning the classroom into a *camera obscura,* so that the world was now a classroom for the Communards. From the typically Haussmann address of the Boulevard des Italiens, Braquehais moved back onto the streets and defied the multi-

69. B . . . te Guerard, *View of the Place Vendôme* (New York, New York Public Library)

ple disciplinary forces of the Second Empire. His record of the Commune refused the architectural constraints of the new Paris, the medical construction of the deaf as abnormal beings fit only for institutional care, and the move towards apolitical art photography. If, as many have said in Lenin's wake, the Commune was a *fête populaire* of the oppressed, the deaf certainly played their part.[147] The deaf were to be found on the side of the Communards, just as they had supported the insurgents in 1830 and 1848. Even the affluent artist René Princeteau served in the artillery.[148] As Parisians reclaimed their streets, Braquehais refused to be depicted on the "silent screen" of deafness. Instead, Paris became a screen for his anonymous camera, intervening in and recording that tremulous moment, in which the possibility of another way was briefly glimpsed.

In order to appreciate the re-envisioning of Paris undertaken by Braquehais, I will concentrate on one specific, highly symbolic site: the place Vendôme. Braquehais and many other photographers had produced a stream of stereoscopic images of Paris under the Second Empire. These views continued to be popular right into the twentieth century, and in their obsessive reiteration of the tourist sites and sights of Paris, these stereoscopes can be said to have created the modern tourist theme-park of Paris. The place Vendôme and its famous column of Napoleon was and is one stop on such tourist itineraries, whether made by stereoscope or camcorder. In an early stereoscope by B . . . te Guerard (fig. 69), we can see the square before Haussmanization. A row of uneven buildings, almost all

seeming to be shops at ground level, leads up to it. The street is crowded with people and building work causes an obstruction in the road, as if in anticipation of the future barricades. The column appears less as the culmination of a grand vista than as a convenient device to give extra depth to the stereoscopic field. But after the construction of the Haussmann facades, the street simply became a setting for the column. In numerous views, it is seen deserted, without shadows or distracting details, as the embodiment of the new Empire, built upon the foundations of Napoleon's city but with similar delusions of grandeur, which were to be Louis-Napoleon's undoing.

The destruction of the Vendôme Column by the Paris Commune on 16 May 1871 was one of its most dramatic and controversial acts. Braquehais' album contained a series of carefully orchestrated photographs of the event. The initial decision to destroy the column was taken by the Commune on 17 April and the materials of the column were put up for sale a few days later. But the urgent priority was to defend the city and the column remained standing. By 28 April, the place Vendôme was fortified on all sides, creating inside "not only a fortress but a permanent camp and a monstrous canteen," using no less than forty ovens.[149] Braquehais recorded the barricade on the rue Castiglione, which was featured in Guerard's stereoscope and later views of the Column. His picture shows Haussmann's pillars as convenient reinforcements for the dry stone construction of the barricade, topped with logs and mattresses. The central placement of the artillery piece shows that the clear line of fire constructed by Haussmann's boulevards worked both ways. The evident discipline and order apparent in this photograph counter the characterization of the Commune as a blood-thirsty mob.

It was not until the military situation became hopeless that the Commune proceeded with the destruction of the Column, as a symbolic gesture with an eye to the verdict of history. Before the act was even accomplished, the radical paper *Le Cri du Peuple* declared: "Here's the response of conquered France to victorious Prussia; of Paris, republican and socialist to the partisans of militarism and of monarchy."[150] The column's destruction attracted a huge crowd. The square itself was cleared of all but those engaged in the demolition and spectators packed the side roads, behind the barricades which were breached for the occasion; more sat on the roof of buildings in the rue de la Paix, and some were even clinging to the chimneys.[151] The excitement was too much for one Glais-Bizoin, who removed his clothes "in a movement of juvenile ardor."[152] At 3 p.m. military bands played the Marseillaise and the *Chant du Départ* to

mark the commencement of activities. A group of National Guards and regular soldiers gathered at the foot of the column for photographs taken by Braquehais. The first scene is relatively disciplined, with a red flag waving overhead (fig. 70), but in the next shot one man blows a trumpet, and others beat drums, while a child rolls on the floor in excitement (fig. 71). Participants were arranged along a curious rope-covered mattress, raised on a cart in order to catch the falling bronze statue of Napoleon. In the end, it served only as a photographic prop for Braquehais, who also arranged smaller group photographs around the "bed," as it was called (fig. 72). The "bed" was never moved into position, perhaps because the Communards wished to see the statue broken or because the platform of earth which had been raised to break the column's fall was considered sufficient. In the event, one arm snapped and the head was, in one writer's phrase, "providentially decapitated." A worker dressed in red placed a tricolore on the column so that it would fall with the emperor. At 3:30 three cables were attached to the column and tightened by capstans, one of which immediately broke. After a long delay to find and attach a new capstan, the pulling began again at 5:15: "The attention was immense. Everyone held their breath." Rumors had been circulating that the destruction of the column would bring down the walls of Paris, or at least cause widespread devastation. For a quarter of an hour, the ropes were pulled, long enough for Braquehais to photograph the moment (fig. 73). Finally, "[i]t fell at the hour of the *crépuscule,* in front of an enormous crowd come to be present at the execution of this false and odious glory, condemned by history and saluted in its fall by the immense *Vivat* of deliverance issuing from ten thousand throats."[153] From Braquehais' photograph, taken immediately after the fall, we can see that the column missed the earth designed to receive it and broke into rubble (fig. 74). Already a group of Communards had scaled the pedestal with a ladder and raised the red flag.

After the column's fall, Braquehais took some general shots showing the celebrations around the fallen statue, where the crowds had now gathered round. Another group shot focused on the men and women, who had overthrown the symbol of empire. A worker and two National Guards solemnly shake hands at left, as if aware of the portentous moment. Others wave their hats in celebration. The debris of the column served only as a stand for a group of National Guardsmen in the second tier of the photograph. Workers, soldiers, artisans and even top-hatted bourgeois lined up behind one of the ropes that had pulled down the column. The picture shows evidence of the Gouin-Braquehais sense of pictorial compo-

70. Bruno Braquehais, *The Destruction of the Vendôme Column*

71. Bruno Braquehais, *The Destruction of the Vendôme Column*

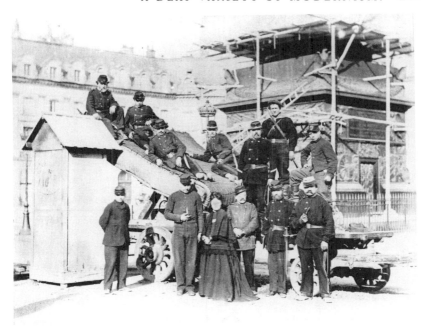

72. Bruno Braquehais, *The Destruction of the Vendôme Column*

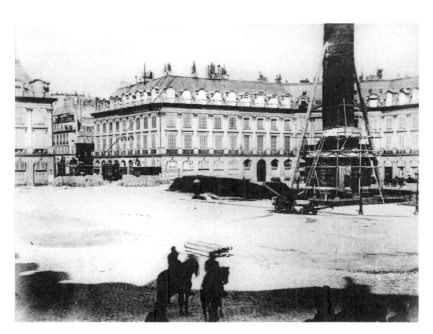

73. Bruno Braquehais, *The Destruction of the Vendôme Column*

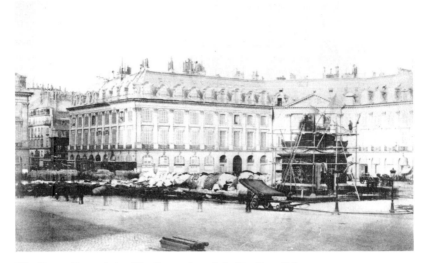

74. Bruno Braquehais, *The Destruction of the Vendôme Column*

sition and photographic construction of depth. Now the Second Empire buildings appear ethereal and insubstantial, reduced to a backdrop for the human heroes of the hour. The image is given further depth and shape by the use of foreground space, marked by the rope, and the traditional pyramidical arrangement of the group. The National Guardsman standing at the apex of the pyramid seems aware of his importance to the composition and stands self-consciously straight, in marked contrast to the man below him, who is sticking out his tongue. The placement of two children at the front of the group further suggests that this seemingly natural moment was carefully orchestrated by the photographer. The children symbolize the future for which the Commune strove and which the Empire had betrayed. Their position recalls Manet's lithograph *The Balloon* (1862), in which a small boy, who has to use a trolley to supplement his useless legs, gazes brightly at the viewer (fig. 75). Manet's doubts about the costs of progress, represented by the balloon, reverberate across this photograph. In this case, the person with a "disability" is not the object of the artist's symbolic imagination, but is himself the artist. The reversal of control in Paris was also the reversal of many personal destinies, albeit briefly. Perhaps just as remarkable is the event of the photograph itself, in which a group of revolutionaries lined up to be photographed by a deaf camera-

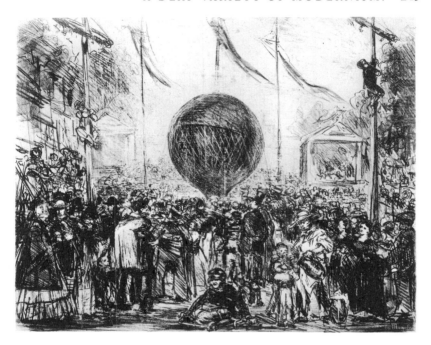

75. Edouard Manet, *Le Ballon* (New York, New York Public Library)

man. The photograph is the testament of a deaf modernism which, even if it was never allowed to flourish because of external circumstances, already had Braquehais' achievement as an indication of what might have been. It was no coincidence that Braquehais worked in photography, a means of visual representation which, like sign language, defied and disrupted the established categories.

The artist most associated with the Commune was the painter Gustave Courbet. In Braquehais' second photograph showing the fallen statue of Napoleon surrounded by the Communards, the man in the second row wearing a hood may be Courbet (fig. 76). An 1871 photograph of Courbet seems to bear a good resemblance to the small figure, but the face in Braquehais' picture is too small to be certain.[154] This headdress is distinctive, unmatched by any other participant. Clearly, this is a more official portrait than the group photograph. All of those present are in uniform, or wear middle-class clothing. The National Guards at left are smiling but calm, and there are none of the antics of the earlier photograph. All the faces are carefully arranged so as to be visible and, being placed in a frieze-like line, equal. This symbolic import of these upstanding men, posing

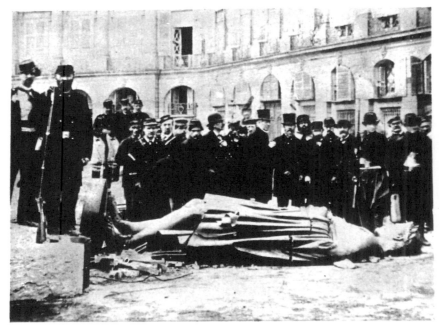

76. Bruno Braquehais, *Fallen Statue of Napoleon*

behind the fallen idol, was only too clear. In these circumstances, it would seem more surprising if Courbet, as head of the artistic section of the Commune, were not present than if he were. Let us suppose it was Courbet, for there then arises a curious twist of history. In 1794, the first Revolution recorded the presence of Etienne Courbet, a deaf boy of twelve in the town of Ornans. Now in 1871, in what was to be the last of the Jacobin uprisings, a deaf photographer, educated as a consequence of the Republican commitment to deaf education, recorded the presence of Etienne's descendant Gustave in his survey of the Commune.

All the Communard reports reveled in the historic significance of the moment, typified by Henri Rochefort's declaration: "That which had made the place Vendôme famous for so long was always without excuse in our eyes, first because it was built in Empire style, the most intolerable of all styles, and secondly because it was erected with the immoral aim of perpetuating the most intolerable of governments."[155] However, radicals had hoped for "a little of the symbolism of [17]93, in which a mother would have given the first hammer blow to the column and a child would have burnt its history." For the column's destruction was not seen as vandalism but as the inauguration of a new form of history: "The history of

man belongs to the law which he has established on earth. The rest is barbarism."[156] Consequently, wrote another journalist, "history must be remade. Forward the innovators! the Diderots, the Prudhons, the Schillers, the Jacobys! Down with the killers and dissipaters! And when their names appear in historians' writings as a sinister accident, how they will be condemned!"[157] Braquehais' photographs were the visual accompaniment to this history and should be considered as an integral part of it. The careful staging of his scenes, the meticulous recording of all stages of the event, and the access he had to areas prohibited to the public make it clear that these were not opportunistic snaps, but a planned visual record of an event staged by the Commune as its testament to history.

The force of these photographs was such that the victorious Versaillais immediately banned them and all other representations of the Communards. A stereograph view taken very soon after the recapture of Paris by "Q.V." showed the full length of the fallen Vendôme Column (fig. 77). The crowds recorded by Braquehais have disappeared. Only one man is visible, with his coat draped casually over a fallen block of stone. The bronze reliefs have been removed, leaving only two sections close to the base. The stereoscopic view brings the fallen blocks with their irregular, abstract shapes into sharp relief. The grass of the square also takes on an unreal intensity, seeming to emphasize the fragile nature of the city. The stereoscope did not produce the unequivocally condemnatory representation of the Commune's destruction sought by the new government. By contrast, an album of photographs by J. Wulff, entitled *The Ruins of 1871,* gave a far more precise image. Wulff focused on the still-standing base, taken from the other side of the column so that the fallen stones were invisible. Unlike the stereoscope, Wulff's photograph was very sharp and precise, and the inscription of the base is clearly legible. A door into the column rests open. The clean-up of Paris was now sufficiently advanced that a spiked, iron fence had been installed around the remains of the base. No longer the rubble recorded by "Q.V.," the Vendôme Column had once again become a monument, now testifying to the excesses of the Communards. Alphonse Liebert published a general view of the fallen column later that year. His long-range shot minimizes the individuality of the Communards and restores the grandeur of Haussmann's facades. The Column, with the statue at its head, is indistinctly seen. The important message now came from the accompanying text: "Here is the great crime. A day came, whose memory will never be forgotten, when a gang of adventurers calling themselves French tore down a monument made of bronze and glory in the face of the Prussians who still guarded our gates.

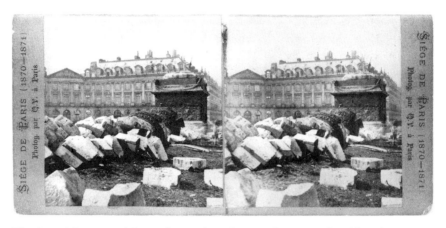

77. Q.V., *The Ruins of the Vendôme Column* (New York, New York Public Library)

This monument had responded to our present defeat calmly, contemptuously, impassively, by evoking past glory and serenely promising revenge to come."[158] Replete with allusions to Horace, Liebert opposed his Classical, patriotic approach to the vandalism of the Commune.

Braquehais himself did not long survive the Commune. In 1872, he took a photograph of the bust of the abbé de l'Epée by Deseine for Martin Etcheverry, director of the Institute of the Deaf. A caption placed on the base records Braquehais' deafness and is the only one of his works to do so. When he donated some works to the nascent gallery of deaf art at the Institute, they were not photographs but lithographs. His secretiveness has been effective, for although Braquehais is often mentioned in histories of photography, his deafness has heretofore been unrecognized. Although other deaf artists, such as René Hirsch, also practiced photography, the only significant successor to Braquehais was Henri Desmarest, a wealthy amateur and deaf activist. He was a member of the elite Photo Club de Paris, along with such luminaries as Robert Demachy. At the Salon of Photography in 1896, Desmarest exhibited a hunting scene, entitled *Pond in the forest of Fontainebleau,* which was opposed to Demachy's Romantic work by the Club's reviewer as "an agreeable specimen of classic photography. . . . The scene itself is animated and very happily taken. But the tonalities are gray, uniform, the fault no doubt of the somewhat limited lighting of a winter's day."[159] As the art photographers gained headway, so did Desmarest's style lose favor and, in 1898, he was criticized at the Salon for failing to make "a sufficient artistic effort."[160] Desmarest continued to work as a photographer, taking many pictures of deaf cultural life and

becoming editor of the *Journal des Sourds-Muets* after Gaillard. The fact that his editorship, beginning in May 1900, promised to avoid all questions of politics or religion shows how differently he perceived the role of a deaf photographer to Braquehais.

In 1901, at the height of the Dreyfus Affair, the radical Armand Dayot published a sympathetic account of the Commune, using Braquehais' photographs as significant evidence. He reprinted Braquehais' shot of the fallen statue of Napoleon and added this excerpt from the *Journal Officiel de la Commune:* "The decree of the Commune which ordered the demolition of the Vendôme Column was carried out yesterday to the acclamation of a large, serious, reflective and assisting crowd. It was the fall of an odious monument raised to the false glory of a monster's ambition. The first Bonaparte immolated thousands of children in his thirst for domination and slaughtered the republic after swearing to protect it. . . . The Paris Commune had the duty to demolish this symbol of despotism in order to replenish itself. It proves that the Commune places law above force and prefers justice to order."[161] Dayot perceived a modern, republican ethic embodied in Braquehais' photograph of the Communards, which was both historically informed and highly sensitive to the power of representation. In the Classical, anti-Communard view, an impassive, disciplined monument gave a pure, unchanging meaning. On the other side, signs signify in contested, historical context, evoking violence and requiring regeneration. Both were modern Republican views, the former of the Third, the latter of the First Republic. The triumph of the pure sign, whether photographic or phonic, was to be the end of the deaf culture of silent poetry.

TECHNOCRATS, FILM, AND CHRONOPHOTOGRAPHY

Once the Third Republic was safely established, oralists also found uses for photography. They inserted machines between the deaf student and the hearing teacher, visualizing speech by photography and later chronophotography. In the 1920s, film was used as a means of preparing the deaf student for everyday life. In technologizing of speech and its reproduction both by the deaf person and by machines, these technocrats reverted to an older definition of the deaf as automata. Instead of regenerating the deaf "automaton," as the French Revolution had hoped to do, they sought to modify it into a talking machine. Technocratic oralism turned to photography as a mechanical means of reproduction, and could never think of

photography as art. Its mechanical therapy was accompanied by a mechanistic view of the human body, which envisaged speech as a muscular exertion, rather than divine inspiration. This technologized and professionalized view of deafness has remained in force among hearing professionals to the present day. Denying speech disorders any difference to other physical pathologies, this view inevitably rejects the notion that deafness might be a culture. For such technocrats, the body is a perfectible machine and any glitches in the prostheses used to achieve this perfection are simply temporary and will be rectified. It was not until Western culture began to lose its faith in the redemptive powers of the machine and, more recently, in clinical medicine, that the long-standing rejection by the deaf themselves of such devices could finally be heard (pun intended).

In 1875, Léon Vaisse, a former director of the Institut, regular attendee at the Société d'Anthropologie, and director of the Société de Linguistique, became aware of the work of Etienne-Jules Marey, the pioneer of the graphic method, which involved producing a graphic trace of movement using a mechanical device.[162] Marey believed that his graphic observations were far more accurate than human perception. For Vaisse, the graphic method offered the possibility that speech could be taught by machine, rather than by the arduous process of demonstration, touch, and copying then used. He approached Marey to see if the graphic method could be applied to the movements made in speech. Marey conducted a successful experiment and published the results in 1876. But the heat generated by the Milan Congress' defense of traditional oralism precluded any immediate use being made of these traces by the Institute in its teaching.

In 1882, Hector Marichelle (1862–1929) began teaching at the Institute. A partisan of the new technology, he proposed a very different concept of speech to that upheld in Milan: "What is speech from the physiological point of view? Is it not a rapid succession of *movements?*" For Marichelle, teaching the deaf to speak was simply a matter of instructing them in the correct movements. The new means of representation, pioneered by Marey, held the possibility of being able to show students each element of speech individually. In April 1886, the deaf journal *La Defense des Sourds-Muets* commented that the "Christian Schools," as it disparagingly referred to the post-Milan Institutes, were now using photographs to teach articulation, with a picture representing each letter. For the deaf journalist, this was further proof of the failure of oralism.[163] Ironically, Marichelle, who was no doubt responsible for the innovation, might have agreed. Marey's development of chronophotography seemed

to open the way towards Marichelle's project. Having read of the process, Marichelle hastened to the famous physiological station in the Parc des Princes, where Marey had built a special studio to photograph movement. Using a specially designed camera, Marey obtained numerous shots of a particular movement, enabling him to analyze its composition.[164] This device seemed the answer to Marichelle's dreams, as he attempted to teach the movements of speech to those without hearing: "The new method permits one to seize from the life those fugitive movements [of speech], without restricting its organs in any way, a quality which the first inscribing machines did not possess." Marey seconded his deputy Georges Demeny to work on the project. After some initial difficulties, Demeny announced success to the Academy of Sciences in July 1891: "I have executed an instrument which is specially designed to give the illusion of speech. I have called it the phonoscope." He accepted that the speech produced was difficult to read, but argued that deaf students, who had lip-reading practice, could decipher the words.[165] Marichelle testified that several of his pupils, brought before the phonoscope, were able to read the phrase *Je vous aime,* "almost as easily as on the living mouth."

In his article in *La Nature* for April 1892, Demeny went still further. Although he accepted that the deaf "readers" were confused when the phrase could not be started in the right place, Demeny claimed that "if I slowed the rotation, the child slowed the speech; if I stopped, he stopped. . . . In a word, I played the deaf-mute like one plays a barrel-organ. I made a bad joke by turning the handle backwards and the reading was impossible."[166] Demeny used the redefinition of the deaf as automata to prove the exact functioning of his machine, and his image seems to suggest that the deaf reader was little more to him than a monkey dancing on top of a barrel-organ. The popular press was captivated by Demeny's device. Thomas Grimm showed his astonishment in an article in the *Petit Journal:* "A turn of the zootrope, and, o incredible surprise! you *see* photography speak, the lips opening and contracting, the teeth closing, the tongue advancing or retiring, following the syllables pronounced." Grimm saw the device as the culmination of the oral program: "The vocal education of deaf-mutes, up until now done by observation of speaking subjects, can henceforward be, if not entirely done, at least helped and completed by the means of photographed alphabets. . . . Henceforward, we must definitively strike from our dictionaries the word *sourd-muet.* The deaf-mute already speaks. Thanks to photography of speech, his tongue will be untied for evermore. Will we ever render his sleeping ear sensible? The miracle would then be complete. Who knows

that is not possible, given all that we see today?"[167] Itard's old dream seemed to be on the verge of realization. The *sourd-muet* was dead, the *sourd-parlant* lived and, with any luck, deafness itself would disappear altogether. This mechanical modernism was profoundly optimistic, in sharp contrast to the eugenicists.

A lesser-known testimony suggests that Demeny's achievement was rather less than he and Marichelle claimed. In September 1891 one A. Dubranle, a colleague of Marichelle's, paid another visit to Demeny's workshop. Accompanying him were three deaf boys, aged thirteen to fourteen. J . . . , the first student to attempt to read from the phonoscope, succeeded in reading *Je vous aime* "almost immediately, that is to say, after two or three repetitions." The second, D . . . , "read after long hesitations, *Je mous aime*," which was regarded as proof that he tried not to understand, or to copy but to read. The final reader, M . . . , was not shown the phrase from the beginning, because the phonoscope provided no indication of the starting point, and produced *vous aime mieux*. Dubranle was far more sanguine about the prospects for the device: "If it is not the last word, one can nonetheless hope that it will be of some use in the teaching of lip-reading."[168] This cooler view prevailed at the Institute for the Deaf, who in Marichelle's words, "were completely disinterested."

However, when Désiré Giraud became director of the Institute in the late 1890s, Marichelle found his new methods in favor. In 1895, Marichelle and a fellow professor named Leguay attempted to use the phonographic trace produced by Marey in their teaching, indicating a striking faith in visuality as the key to human understanding.[169] The written trace of speech, provided by the mechanical transcribers, was supposed to clarify the task of sound emission for the deaf student. Despite the inevitable pedagogical failure of these narrow, wobbly lines, Marichelle wrote: "Phonetics lacks tools; the *graphic method* has recently offered itself to supply them; it now possesses therefore measuring instruments which preserve the trace of observed phenomena, which *writes* down all its phases and which advances its analysis as far as the least details. *Verba volant, scripta manent*. Speech flies away. The inscribing machines will make them permanent to the great profit of the science of language." The phonograph was also used to record the pupil's own voices, as a means of checking their progress. The new technocrats were undismayed by practical failure for they believed that only fine-tuning of their machines was required to achieve success. Giraud was resoundingly optimistic, predicting a glorious future for what he called "labiocinetography": "Chronophotographic films will show us the fugitive forms of lip-reading in all their details; they

will reveal the secrets and the multiple transformations of this moving alphabet. . . . They will finally restore to us, by means of the kinora or the cinematograph, the *étincelle* of life, which they can reveal on the lips of the speaker."[170]

At the Universal Exhibition of 1900 in Paris, the Institute's display highlighted Marichelle's new techniques. The exhibit was a simulacrum of the Institute. Its entrance was flanked by copies of two plaques of dedication honoring benefactors from the Institute's main staircase. Within were reduced copies of Martin's statue and Privat's picture of the abbé de l'Epée. Each workshop at the Institute—typography, cabinet-making, shoe-making, tailoring, and gardening—was represented by a mannequin of a pupil at work. The pupils themselves were represented not in life but by machines. A phonograph played the voices of the pupils, while a kinora showed moving pictures of speech. The *Revue Générale* commented: "The project, so closely studied by our colleague M. Marichelle, of installing a cinematograph, combined with the phonograph, was not accepted by the administration of the Exhibition."[171] Talking pictures, like the phonoscope, were conceived by Marichelle, not as entertainment, but as a machine to demonstrate speech to the deaf.[172] The display won a Grand Prize from the organizers of the exhibition and was visited by President Loubet, giving the seal of official approval to the technocrats.

The consequences of such inventions, ostensibly intended for the benefit of the deaf, were far more dramatic for the hearing. For there is a direct line of evolution from Demeny's device to Lumière's invention of the cinematograph and the subsequent spread of cinema as the dominant mass medium of the first half of the twentieth century. This is not the place to tell that story, but two points should be made. From its inception, cinema was always connected directly to the physiology of speech.[173] Long before the invention of the "talkies," cinema was considered an oral medium. In fact, in both the articles that appeared following Lumière's first demonstration at the Salon Indien, speech was a central topic, despite the silent showing: "When these cameras become available to the public, when all are able to photograph their dear ones, no longer merely in immobile form but in movement, in action, with their familiar gestures, with speech on their lips, death will no longer be final."[174] The mechanically reproduced moving image was marked from the beginning by its association with speech and with the cure of physiological trauma, even death.[175]

The power of this association with speech was such that film was never used by hearing people to record sign language, for which it was the ideal

medium. In an article in *La Nature,* the chronophotographer Félix-Louis Regnault described the existence of a "primitive" language of gestures in Africa:

> [T]here exists a science of gesture as interesting as that of language. However, all savage peoples make recourse to gesture to express themselves; their [spoken] language is so poor it does not suffice to make them understood: plunged in darkness, two savages . . . can communicate their thoughts, coarse and limited though they are. With primitive man gesture precedes speech. . . . The gestures that savages make are in general the same everywhere, because these movements are natural reflexes rather than conventions like language.[176]

Whereas Regnault filmed the physical movements of African people, such gesture language had no place even on silent film. His terminology was similar to that used by the abbé de l'Epée in describing the "natural" state of the deaf as "the gloomy shadows in which they were enslaved." The crucial difference was that Epée believed that all language was conventional and that sign language was just as capable of educating people as spoken language. For Regnault, only speech was language. "Savage" gesture was interesting, but formed an undifferentiated mass of natural movements, unlike the abstract variety of spoken language. Plato's poles of natural and conventional language continued to function, but only for spoken language.

Silent films were nonetheless extremely popular with deaf people. Here was a form of mass culture in which the deaf could participate as equals. Ruth Sidransky records how her deaf mother played truant from school and plucked chickens all morning in order to be able to see a Rudolph Valentino movie. The painter Granville Redmond became an actor in silent films and worked on a number of films with Charlie Chaplin, including *City Lights* and *A Dog's Life.* In this film, Chaplin himself used a number of signs, such as those for "children" and "baby." In 1929, the *California News,* a deaf periodical, reported that: "Chaplin is fond of Redmond because no oral conversation is possible between them. Instead, they talk in signs which is soothing to Chaplin, who tries to avoid people who talk too much."[177] Other deaf actors in the silent movie era included Emerson Romero (stage name Tommy Albert), Albert Baillin, Louis Weinberg (stage name David Marvel), and Carmen de Arcos.[178] Redmond also reported that director Eddie Sutherland and cinematographer Roland Totherok were excellent signers. He later appeared with Douglas Fairbanks in *The Three Musketeers.* Deaf journalist Alice Terry claimed:

"The movies has [sic] no use for speech and lip-reading. On the contrary, the movies is pre-eminently the place for pantomimes or signs."[179] Four hundred years of popular entertainment featuring deaf characters now culminated in the twenty-year reign of the silent cinema.

However, not only were the deaf badly placed to take advantage of the opportunity offered by cinema, it was also inevitable that cinema would gain sound, because the medium was so closely associated with speech. Indeed, the Institute for the Deaf collaborated with Pathé Films to produce a series of short films for use in oralist education. In 1918, Professor Bernard Thollon took de Gérando's old suggestion that the classroom should become a *camera obscura* literally and made a series of films dedicated to everyday life. For the deaf, he suggested, life is like being "enclosed in a sealed room, comparable to a spectator who, seated in the orchestra stalls of a naturalist theater, waits for someone to lift the curtain and to play a comedy or drama, in which is shown *a representation* of the scenes of real life."[180] Only the cinema could offer such a representation, for the use of engravings or other visual images suggested the idea of an object, not the thing itself. Nor could the deaf be trusted to carry out such scenes themselves, because the teacher could not be sure that they could understand the actions they performed: "Only cinematographic projection can give us this faithful and complete representation of reality." It was the final twist in the metaphor of the "silent screen" of the deaf, for with these films they became reduced to spectators of the drama of their own lives, watching a screen saturated with oralism.[181]

By 1921, the plan was underway and a number of titles were produced in the coming years, such as *Going to the table, Café au lait, Chocolate and cocoa* and the snappily titled *Bread, Flour, the Bakery and the Miller*. These films completed the mechanical oral program. Marichelle now had twenty chronophotographic films, given to him by Marey, with which to teach speech. Each film had about thirty images, and ran at 16 frames a second. Marichelle used all six hundred images in isolation to teach his pupils to speak. He took seventy-nine in particular and had them enlarged and mounted. He claimed a number of advances on previous methods of articulation training, for the films revealed that letters spoken in combination as words are produced with different mouth shapes to individual letters taken alone. Written texts of the words being taught supplied another tool and the films completed the agenda: "[Oral] program, texts, and films represent the three stages of one construction," said Thollon. The Institute for the Deaf was now a factory with specific tools. The raw product entered, namely the *sourd-muet* [deaf-mute]. After product qual-

ity control, the oral program converted those found suitable into the half-finished *sourd-démutisé* [demuted-deaf]. With the aid of the films, the final product could now be constructed, the *sourd-parlant* [the deaf-talker]. Readers may now appreciate the strange irony for the deaf in Al Jolson's famous words from the first talkie, *The Jazz Singer* (1927): "You ain't heard nothing yet."

The talking picture ended the age of silent poetry, which had been inaugurated in the Renaissance, but knew its most important moments in the late eighteenth and nineteenth century. At first, nineteenth-century deaf artists were close to the center of artistic practice, working with such elite figures as Ingres, Cogniet, Cabanel, and Girodet. By the early twentieth century, this relationship had disappeared. No such connections can be made between the leading figures of the Parisian avant-garde, such as Braque and Picasso, and deaf artists. This process of marginalization tells a key history of the visual sign in modern France. For while Condillac and Diderot perceived the sign to be arbitrary in the sense that a gesture would serve as well as a spoken word, Saussure limited the arbitrariness of the sign to speech. The arbitrary nature of the sign had become an exclusive and disciplinary procedure, prioritizing speech over all other forms of communication. The signifier in Saussure depends upon its phonic content, by definition excluding gestural signs or other non-verbal communication. Furthermore, the visual sign became inseparable from speech, as evidenced by the constant parallels between modern art and music and the immediate assumption that film was a verbal medium. When a critic such as Clement Greenberg claimed that the intent of modernism was "to render substance entirely optical," he did so on the precondition that the visual was saturated with speech.[182] Recent attempts to redirect criticism of the avant-garde by the application of Saussurean linguistics do not therefore change this fundamentally phonocentric precondition for modern avant-garde culture.[183] The existence of sign language and deaf culture indicates, however, that speech is not and cannot be the lone, essential referent of the visual sign. It is for this reason that modern culture tried so hard to disclaim the existence and significance of deaf culture. Deaf modernism asserted a modern visual culture which was not dependent upon speech and, in so doing, offered some fundamental lessons about the nature and functions of visual culture, which are only now being understood.

EPILOGUE

There can be no simple conclusion to this history, because it is not yet over. The release of *The Jazz Singer* marked the end of silent poetry as a metaphor for the visual image in general, if not for painting in particular, and thus serves as a convenient caesura to end this narrative. But in the time during which I have researched and written this book, deaf culture and sign language have once again come into focus as an arena for social debate. The old controversy between oralism and sign language has been reopened by the deaf community and has found its way in the last year onto the front pages of the *New York Times* and the *Atlantic Monthly,* as well as onto British and French television screens. Deaf culture now finds itself in the clash of past and present, known to Walter Benjamin as *Jetztzeit,* "a past charged with the time of the now."[1] The questions remain the same as they were for nineteenth-century republicans: How crucial is speech to culture? What is the real meaning of equality? How should questions between majority and minority cultures be resolved? Then as now, deaf artists are claiming the right to live deaf, in a sign language culture, while medical science hopes to eliminate deafness. Then as now, the outcome will say as much about the hearing majority as it does about the deaf minority. This book is obviously a contribution to that debate, which might be seen as stemming from the 1990 Americans with Disabilities Act. By including the deaf in the category of the disabled—much to their surprise, it might be added—the United States government once again named deafness as a part of society in which the state had a vested interest. The current wave of interest in the deaf stems from this moment of reprised recognition. The "silent screen" of deafness is again in operation, making deafness newly visible to the hearing community. By way of concluding this history, then, I intend to revisit the four sides of the frame to that screen which have been pursued in this book.

ANTHROPOLOGY AND PHILOSOPHY

It may seem that the frame is no longer constituted in the same way, for the phonocentric race-centered anthropology, which had such a delete-

rious effect upon the deaf community, has been consigned to the dustbin of history. Anthropology is currently exercised over the very conditions of possibility for its discipline, examining the impact of the observer on the observed, and everywhere locating the damaging effects of past racial assumptions.[2] However, by the early twentieth century, anthropology had abandoned its totalistic claims to culture and turned over its role in the study of deafness to what was then called medico-psychology, now represented by the twin bastions of the establishment, medicine and psychology. The medical view of deafness remains broadly unchanged. The deaf person is still seen as metonymically represented by his or her "pathological" ears, with no consideration that the condition might actually be a culture. Once again doctors claim to have invented a cure for deafness in the form of cochlear implants, an electronic device that seeks to replicate the function of the auditory nerve with mixed results. Deaf activists reply that, as with all of oralism's procedures, implants are only effective for those who have become deaf but grew up hearing. For the profoundly deaf from birth, implants offer no more than high powered glasses would for the blind. Still more worrying, in this view, is the threatened elimination of sign language culture. It can hardly be doubted that the issue of implants is only a forerunner to the eventual suggestion of the genetic elimination of deafness. The Human Genome Initiative, which is busy detailing every aspect of the human gene, may make it possible to identify —and perhaps eliminate—the "deafness" gene itself. As so many of the causes of accidental deafness are now curable with antibiotics and vaccines, the old medical dream of an end to deafness is now an all-but practicable reality. Despite the work being done by contemporary psychologists to affirm that the deaf use as much of the brain as hearing people, and that sign language is acquired in exactly the same manner as other languages, there seems little possibility that the medical community will alter its viewpoint. As in the nineteenth century, the task of winning the support of the hearing for the deaf community falls to culture.

More precisely put, it is again necessary to assert the existence of deaf culture outside the domain of pathology. The philosophical contribution to the screen of deafness ought to be as pertinent now as the early modern rethinking of perception and understanding was to the creation of deafness as a category in Western thought. Indeed, the *philosophes* provide one model of a culture that could at least entertain the notion of relative difference in sensual perception without consigning those affected to an absolutely different category of existence. Despite his confusions over sign

language, Diderot did recognize that all perception is relative and that there is something for the hearing to learn from the deaf. However, the nineteenth century saw philosophy embrace a concept of language and knowledge that was exclusively based on speech and thus denied sign language any role other than as an atavistic relic of evolution. Language is still the dominant subject in current Anglo-American philosophy but the possible role of signed languages in such discussions has been ignored. In this sense, the dialectic of Enlightenment has not fully played itself out, but has returned to something close to the original point of departure. My work has instead benefitted from a combination of the archaeological investigations of Michel Foucault and Jacques Derrida's deconstructive critique of phonocentrism. This doubled focus on the disciplinary institution and the privileged place of speech in Western culture enabled this book to be written, contrary to suggestions that poststructuralism is inimical to history.

Nonetheless, this book would not be described by most readers as straightforwardly poststructuralist because it clearly seeks to make an intervention in the current debates over deaf culture. As the center of this dispute is whether deafness is a culture or a pathology, it is appropriate that I have approached it from the point of view of cultural studies. The question of the identity, location, and politics of culture is central to the cultural studies project as I understand it. As Stuart Hall remarks:

> It does matter whether cultural studies is this or that. It can't be just any old thing which choses to march under a particular banner. It is a serious enterprise or project and that is inscribed in what is sometimes called the "political" aspect of cultural studies. Not that there's one politics already inscribed in it. But there is always something *at stake* in cultural studies in a way that I think and hope is not exactly true of many other very important intellectual and critical practices.[3]

The culture of deafness and its meanings for the hearing culture which has designated the deaf as different are one striking example of that which is at stake in cultural studies. But in order to understand this very contemporary dilemma it has been necessary to return, as Raymond Williams did, to the eighteenth century. Cultural studies must certainly keep its political edge, but that will involve becoming more not less historical. If cultural studies allows itself to become redefined as the study of contemporary mass culture, it will have failed.

ART HISTORY

The notion and functions of high culture that motivate art history are called into question by the history of deaf artists. The deaf artists worked for the most part within the Classical dictates handed down by the Academy and yet produced work that cannot be dismissed as dull or lifeless. The first wave of what was called New Art History in the 1970s saw the understanding of the Academy and Academic art as central to its reinterpretation of modernism. But with the rise of an art market for such work, and its adoption by cultural conservatives, this aspect of art historical endeavor has dropped out of fashion. The mimicry of mimesis practiced by deaf artists indicates that Academic art held a far greater range for expression and representation than it is often given credit for. Indeed, one can only wonder how many other such stories are concealed in the lengthy Salon catalogues of the period. It is not my intention to suggest that the usual categories of art historical judgment be reversed, so that Academic art becomes seen as "good," while modernist art is reclassified as "bad." Rather it is to suggest that the overly neat categories of interpretation used by art historians need to be more carefully examined, especially insofar as they become intertwined and interactive. The visual sign in its various forms is always disruptive of overly neat categories and binary oppositions. It calls into question our certainties in ways that will not always be welcome.

Uncovering this history produces a different view of the rise of modernism in Europe. It is certainly not my intention that this history and the works of art discussed in this book should in some naive way replace the established canon. It is to suggest that there was not one modernism but many modernisms, which were in conflict with one another for the ownership of this privileged term. One variety of modernism was represented by the seventeenth-century Moderns who placed sign language at the heart of their inquiry; another by the deaf modernists, who upheld sign language as a modern means of communication, which might form a universal language for the industrial age; and still another by the philosophical anthropologists who asserted that the evolutionary triumph of speech over gesture mandated the elimination of signed languages, which should henceforth be consigned to the museum. The twentieth-century dominance of an aesthetic variety of modernism was not inevitable or ordained but the outcome of an interplay of social, intellectual, and politi-

cal forces. The hegemony of this aesthetic modernism was prepared by the wide-ranging cultural politics of the nineteenth century, which validated speech over sign, writing, and non-European languages as the sole means of human communication. High Modernism was not without its costs and one of them was the culture of mimicry. In this postmodern era, it is appropriate that we should now take such histories into account in our evaluation of the modern period. It is now the task of cultural studies—in historical periods as well as in contemporary work—to explain, contextualize, and diversify the discourse of modernism in the visual arts. Beyond this revisionist goal lies a more challenging opportunity to question the ends and definitions of visual culture.

One indication of the revived visibility of deafness has been the recurrence of sign language and fingerspelling in the work of various hearing artists. What might have seemed a completed episode ten years ago has been re-opened by the appropriations of postmodernism. In Barbara Kruger's *Untitled* (We will no longer be seen and not heard) from 1985, she makes direct use of sign by using photographs of various hand gestures to reinforce her printed text, ranging from a child thumbing its nose to handshapes from sign language. One critic has recently described how her work "[a]ttempts to place art within its cultural context, as social signs existing alongside other social signs in order to disrupt repressive cultural codes."[4] Like the eighteenth-century fictional deaf woman artist Mutine, who used sign when she was unable to speak, Kruger places sign language between the purely visual and the written and, by implication, spoken language of the hearing. Her image is a visual sign, representing written and signed language. The text rebels against those who would see but not understand. Due to the reassertion of the value of sign language by the deaf community, the gestural sign has regained at least the possibility of metaphorical usage by artists. For the first time since Girodet, Cogniet, and Cabanel had deaf students in their studios, a major contemporary artist has engaged with the deaf because it seems an inescapable part of her work.

By contrast, artists like Sam Messer and Martin Wong have used fingerspelling in their work in ways that simply appear tokenistic. Joseph Grigely is unimpressed by the use of such fingerspelling: "Why is it that I absolutely fail to see any charm or redeeming value in Sam Messer's use of fingerspelling in his paintings? . . . Perhaps my problem is with the painting's lifeless two-dimensionality—a travesty of the three-dimensional dynamics of sign language."[5] Grigely's comment echoes Bébian's dislike of

painting as a medium for signed language. There is an uneasy feeling that fingerspelt text may be a condescension and even a subtle collusion with the notion that only English is a real language, for fingerspelling is simply a visual code for the phonetic alphabet, with no relation to sign language proper. Fingerspelt art is a classic example of art that believes itself to be motivated by the purest of political causes and yet is found by many to be bad art. Nineteenth-century deaf artists initially sought to make deafness visible within their work without resorting to the direct depiction of manual languages. Their aim was to remind the spectator of the convergences and interdependences between the deaf and the hearing. Deaf artists only turned to depicting fingerspelling when the entire practice of signing was under threat in the 1870s. Martin's statue of the abbé de l'Epée used fingerspelling as part of his assertion of the value of sign language culture. However, the affirming value of that moment was immediately undercut when oralists used the statue as part of their campaign to demonstrate that sign was outdated and primitive.

The deaf artists described in this book sought to contribute to the political endeavors of the deaf community through their manipulation of artistic form. If the medium is the message, then the medium is political. In other words, an effective political work of art needs to address "formal" concerns as well as its message. Nineteenth-century deaf artists turned from painting to sculpture and photography in their quest for an art that could satisfy both the formal and political exigencies of the day. A striking example of the politics of cultural form can be found in the distinction between film and video in deaf culture. Film was always associated with speech and, despite the efforts of individual filmmakers, has remained so. Film has always claimed to be in some sense natural and the Oscar ceremonies perenially proclaim it to be the universal language, a role once claimed for sign language. The evidently artificial and human video has not been so ideologically overdetermined. Although video has a sound-track incorporated into the videotape itself, it has been far more congenial to sign language. The new Deaf poetry movement, led by such poets as Clayton Miles and Dorothy Valli, has been disseminated and popularized on video, giving a new meaning to the old phrase silent poetry. Video has also been used to record Deaf "oral" history, as in the Video Archive for Holocaust Testimonies at Yale, which includes several testimonies from Deaf people. Similarly, the growing importance of electronic mail and other computer environments diminishes the sense of the telephone as the only "natural" means of long-distance communication. The TTY and TDD devices used by the deaf are closer to the fax ma-

chine, the e-mail message, and computer bulletin boards than Bell's telephone. In cyberspace, no-one knows if you can hear.

DEAF CULTURE

The majority of deaf artists were also political activists and saw no contradiction in this dual role. The political agenda of deaf activists revolved around the elusive and slippery notion of equality, which was at the heart of deaf activism in the nineteenth century, inspired by the rhetoric and practice of certain moments in the French Revolution. Yet it is now clear that unimpeded equality of action is not universally possible. The mutually contradictory desires of the Deaf community to strengthen and develop sign language culture and the medical imperative to heal the "pathological" ear cannot be equally achieved. Majority rule is in this case rule by what Foucault termed bio-power, the nexus of medical, legal, and political authority. In order to resolve such conflicts, the social agent— the citizen of the French Revolution—must be redefined, in Chantalle Mouffe's words, "as the articulation of an ensemble of subject positions, corresponding to the multiplicity of social relations in which it is inscribed."[6] There is still an implicit challenge in the abbé de l'Epée's recognition of the sign language of two deaf sisters in the impoverished streets of pre-revolutionary Paris. Epée glimpsed the possibility of a notion of humanity that was not essentialist, and could envisage human potential including being deaf and using sign language. Although he never acted on the more radical possibilities of that moment of recognition, it was that insight that led the French revolutionaries to hail Epée as a benefactor of humanity and to enable the continuation of his vision. The revolutionary promise of equality contained what Christian Cuxac has called "the right to live deaf."

The term and strategy multi-culturalism has also made use of equality as one of its guiding principles. It is, however, important to distinguish between concerns over social policy and intellectual practice. Multiculturalism is at its best and most important as a policy for the composition of institutions, such as universities and government bodies, where it is obviously right that the affiliated membership should reflect the wider population and attempt to counteract discrimination in that society. However, it is less clear what effects multi-culturalism may have as an intellectual strategy. In academia, multi-culturalism has often come to mean the use of race, gender, class, and sexual preference as means of

historical interpretation of culture. In practice, a good deal of work concentrates "for reasons of space" on only one of these components. Multiculturalism in the academy has rarely concerned itself with the "disabled," but it will be of little use if the disabled are added to the ever-expanding shopping list of multi-culturalism's concerns. Still worse would be a "theory" of the deaf or the disabled which might somehow produce the deaf as a category for critical theory in order to vindicate certain intellectual turf wars. For such theorization would again produce the deaf as dependent on their condition of deafness, or reduce them to a symbol for the convenience of the hearing. Accepting that the deaf have a culture means recognizing that deaf identity is as complex as that of the hearing and cannot be reduced to a simple formula or metaphor. In his discussion of the problems involved in such work, Kobena Mercer has argued that "[o]ne way of acknowledging such complexity is to repeat the all-too-familiar 'race, class, gender' mantra, but in my view such rhetoric, however necessary, inadvertently conceals the conceptual and political difficulties of theorizing 'difference' in a way that speaks to the messy, incomplete, and ambivalent character of the 'identities' we actually inhabit in our lived experiences."[7] In this case, the situation is still more complicated because the primary means of communication between the deaf protagonists, their sign language, is irrevocably lost. All deaf history prior to recent times can only ever be partial.

Furthermore, there is a risk that the multiple categories of difference celebrated by multi-culturalism may end up in a seemingly egalitarian circle, endlessly rotating around what is alternately termed the absent center, the subject, or simply the white male. The deaf cultural politics of the nineteenth century in both Classic and Modernist modes offered ways of rethinking the construction of the center itself, which may not be viable in present day circumstances, but whose strategic vision is still acute. These subalterns neither wished to speak nor to claim alterity. In creating the idea of a deaf nation, they imagined a diaspora without an origin to challenge a society without a center. Sign language was defined as mimicry, in supplemental relation to speech, revealing the lack in speech and offering a means of completion. In responding to scientific diagnoses of primitivism, they responded by producing high art in the form of oil paintings and monumental statues. The always already absent center will not, by its very nature, be conquered by cultural practice, or even by Gramscian wars of maneuver. But it may be possible that in constantly demonstrating the ways in which the center deconstructs itself and fails to hold, new forms of cultural and social practice can emerge, which do not

rely on either the normal or the pathological as their underpinning. For the ultimate goal remains the disappearance not of the deaf but of the constructed notion of deafness, floating off our screens from the History painting to the photograph and the computer, revealing once again the pleasure of the visual sign.

NOTES

INTRODUCTION

1. Spoken language has signs that resemble their signifieds, namely any word that is onomatopoeic, such as "moo," "ouch," or "bang."

2. See N. D. Mirzoeff, "Pictorial Sign and Social Order in France 1638–1752: L'Académie Royale de Peinture et Sculpture" (Ph.D. diss., Warwick University, 1990).

3. Harlan Lane, *When the Mind Hears: A History of the Deaf* (New York: Random House, 1984). Other pioneering works on deaf history include Christian Cuxac, *Le langage des Sourds* (Paris: Payot, 1983), Nora Ellen Groce, *Everybody Here Spoke Sign Language: Hereditary Deafness on Martha's Vineyard* (Cambridge MA: Harvard Univ. Press, 1985), Peter Jackson, *Britain's Deaf Heritage* (British Association for the Deaf, 1990), and Arlan Neisser, *The Other Side of Silence: Sign Language and the Deaf Community in America* (New York: Knopf, 1983).

4. F. Xéridat and L. Primel, *Catalogue au musée universelle des Sourds-Muets* (Paris: Institution nationale des Sourds-Muets de Paris, 1947).

5. I therefore have avoided the fashionable taxonomy of Charles Sander Pierce, precisely because the icon/index definition of the sign seems to me to give precedence to the linguistic sign.

6. See Carol Padden and Tom Humphries, *Deaf in America: Voices from a Culture* (Cambridge MA: Harvard Univ. Press, 1988), pp. 42–44.

7. William Stokoe, quoted by Naomi S. Barron, *Speech, Writing and Sign: A Functional View of Linguistic Representation* (Bloomington: Indiana Univ. Press, 1981), p. 12.

8. Gilles Deleuze and Félix Guattari, *Qu'est-ce que la Philosophie?* (Paris: Minuit, 1991), p. 12.

9. Deleuze and Guattari, *Qu'est-ce que la Philosophie?*, p. 22 and p. 24.

10. Immanuel Kant, *Anthropology from a Pragmatic Point of View*, trans. Mary J. Gregor (The Hague: Martinus Nijhoff, 1974), p. 9 and p. 34.

11. Jacques Lacan, *The Four Fundamental Concepts of Psychoanalysis*, trans. Alan Sheridan (New York: Norton, 1981), p. 107. David Carrier has usefully characterized Lacan's argument: "Perception, Lacan is saying, is not a dualistic relation between perceiver and perceived, but a triangular structure in which the

three positions are occupied by the subject, the gaze looking at that subject, and the screen, or image, which comes from superimposing the two dualistic relationships: subject looking at gaze; gaze looking at subject. When I look at another person, I see him or her seeing me." David Carrier, "Art History in the Mirror Stage: Interpreting *Un Bar Aux Folies Bergères*," *History and Theory* XXIX, no. 3 (1991): 309.

12. "The gaze is outside, I am looked at, that is to say, I am a picture," Lacan, *Four Fundamental Concepts*, p. 106.

13. Jacques Derrida, *The Truth in Painting*, trans. Geoff Bennington and Ian McLeod (Chicago & London: Univ. of Chicago Press, 1987), p. 68.

14. This theme could be pursued at length in a re-reading of Maurice Merleau-Ponty's *Le Visible et l'Invisible, suivi de notes de travail* (Paris: Coll. Tel, 1964) with Paul de Man's "The Rhetoric of Blindness," in *Blindness and Insight: Essays in the Rhetoric of Contemporary Criticism*, 2nd ed. (Minneapolis: Univ. of Minnesota Press, 1983) and Jacques Derrida's essay accompanying his exhibition catalogue, *Mémoires d'aveugle: L'autoportrait et autres ruines* (Paris: Réunion des musées nationaux, 1990).

CHAPTER ONE

1. See Dorothy Johnson's important essay "Corporality and Communication: The Gestural Revolution of Diderot, David and the 'Oath of the Horatii'," *Art Bulletin* LXXI (March 1989): 92–116. Johnson nonetheless overlooks the contribution of deaf sign language.

2. Leonardo da Vinci, *Treatise on Painting*, trans. Philip McMahon (Princeton: Princeton University Press, 1956), vol. 1, p. 105.

3. Yves Bernard, "Silent Artists," in Harlan Lane, ed., *Looking Back: A History of Deaf Communities and their Signed Languages* (Washington DC: Gallaudet Univ. Press, 1992), p. 67.

4. Roger Jones and Nicholas Penny, *Raphael* (New Haven: Yale Univ. Press, 1983), p. 31.

5. See A. Karacostas, ed., *Le Pouvoir des Signes: Sourds et Citoyens* (Paris: INJS, 1989), pp. 8–17.

6. Antonio Palomino, *Eminent Spanish Painters and Sculptors*, trans. Nina Ayala Mallory (Cambridge & New York, 1987; orig. 1724), p. 24.

7. See Henri Chardon, *Les Frères Chantelou* (Paris, 1867) and N. D. Mirzoeff, "Pictorial Sign and Social Order in France 1638–1752," (Ph.D. diss., Warwick University, 1990), chapters one and three for details on de Chambray and the printing of the Leonardo manuscript.

8. Cited by Jacques Derrida, "La philosophie dans sa langue nationale (vers

une 'licterature en françois'),'" in *Du Droit à la Philosophie* (Paris: Galilée, 1990), p. 290.

9. See Catherine Denure, "The Paradox and the Miracle: Structure and Meaning in 'The Apology for Raymond Sebond,'" in Harold Bloom, ed., *Michel de Montaigne* (New York: Chelsea House, 1987), pp. 135–153.

10. *The Complete Works of Montaigne. Essays. Travel Journal. Letters.*, trans. Donald M. Frame (Stanford: Stanford Univ. Press, 1957), p. 332. This passage was highly influential on later treatises on gesture. See Thomas Wilkes, *A General View of the Stage* (London, 1759), which is obviously a borrowing: "[The hands]speak of themselves, they demand, they promise, call, threaten, implore, detest, fear, question and deny. . . . All nations, all mankind understand their language," quoted by Janet A. Warner, *Blake and the Language of Art* (Kingston & Montreal: McGill-Queens Univ. Press, 1984), p. 47.

11. See Jean Starobinski, *Montaigne in Motion,* trans. Arthur Goldham (Chicago: Chicago Univ. Press, 1985), pp. 161ff. See chapter two below for a discussion of Rousseau's ideas on gesture and language.

12. Marc Fumaroli, "Le corps eloquent: une somme d'*actio et pronuntiatio rhetorica* au XVIIème siècle, les *Vacationes* du P. Louis de Cressolles," in "Rhétorique du Geste et de la voix à l'age classique," *XVIIème Siècle* 132 (juillet-sept. 1981): 238.

13. *The Philosophical Writings of Descartes,* trans. John Cottingham, Robert Stoothoff, and Dugald Murdoch, vol. 1 (New York: Cambridge Univ. Press, 1985), p. 151.

14. Derrida, *Du Droit à la Philosophie,* pp. 284–86.

15. Descartes, *Philosophical Writings,* vol. 1, p. 140.

16. This debate can be compared to Mikhail Bakhtin's currently influential distinction between the grotesque and the classical body in early modern Europe: "The grotesque body . . . is a body in the act of becoming. It is never finished, never completed; it is continually built, created, and builds and creates another body." Such bodies "are ugly, monstrous, hideous from the point of view of 'classic' aesthetics, that is the aesthetics of the ready-made and the completed." Speech can be read as Classical, but sign language was not necessarily grotesque. Montaigne's celebration of sign language accords well with Bakhtin's sense of the carnivalesque and popular entertainment, but Descartes' rational definition is altogether different. Mikhail Bakhtin, *Rabelais and his World,* trans. Helene Iswolsky (Cambridge MA: MIT Press, 1968), p. 317 and p. 25.

17. Fumaroli, "Le corps éloquent": 240.

18. Louis Marin, "Towards a Theory of Reading in the Visual Arts: Poussin's *The Arcadian Shepherds,*" in Norman Bryson, ed., *Calligram: Essays in New Art History from France* (New York: Cambridge Univ. Press, 1988), p. 70.

19. Cited by Louis Marin in *La Critique du Discours* (Paris: Minuit, 1975), p. 69.

20. Abbé Deschamps, *Cours Eléméntaire d'Education des Sourds et Muets* (Paris: Debure, 1779), p. 3.

21. Quoted in Michel Foucault, *The Order of Things: An Archaeology of the Human Sciences* (London: Tavistock, 1970), p. 63.

22. In Joshua Reynolds' edition of du Fresnoy, the phrase *muta poesis* is rendered as "silent poetry," a usage that avoids the negative connotations of "mute." See Joshua Reynolds, *The Works,* ed. Edmond Malone (1797; rpr. Hildesheim & New York: Georg Olms, 1971), vol. II, p. 230–31.

23. Quoted in Diderot, *Oeuvres Complètes* (Paris: Hermann, 1978), tome IV, n.48 p. 148. Translation by John Dryden, *De Arte Graphica: The Art of Painting by C. A. du Fresnoy* (London: J. Hepinstall, 1695), p. 129.

24. Noel Coypel (d.1707) was Director of the Academy of Rome from 1672 and became Director of the Academy itself in 1695. His son, Antoine Coypel (1661–1772), became First Painter to the King in 1715, a job that his son Charles-Antoine Coypel (1694–1752) took over. On the Coypels, see Thierry Lefrançois, "L'influence d'Antoine Watteau sur l'oeuvre de Charles Coypel," in Pierre Rosenberg, ed., *Watteau 1684–1721: le peintre, son temps et sa legènde* (Paris, 1984), pp. 68–71, and Antoine Schnapper, "Musées de Lille et de Brest: A propos de deux nouvelles acquisitions: 'Chef d'oeuvre d'un Muet', ou La Tentative de Charles Coypel," *Revue du Louvre* (1968): 253–264. Even with the word "mute" in his title, Schnapper made no allusion to deafness.

25. Antoine Coypel, *Discours prononcez dans les Conférences de l'Académie Royale de Peinture et Sculpture* (Paris: Jacques Collombat, 1721), p. 167. Translated by Margaret Morgan Grasselli and Pierre Rosenberg, *Watteau (1684–1721)* (Washington D.C.: National Gallery of Art, 1984), pp. 437–38.

26. Antoine Coypel, "L'excellence de la Peinture" (7 December 1720), rpr. in Henri Jouin, ed., *Conférences de l'Académie Royale de Peinture et Sculpture* (Paris: A. Quantin, 1883), p. 217.

27. Coypel's own work showed a marked awareness of gesture and its interaction with expression—see his *Adieux d'Andromaque et d'Hector* (Musée de Troyes).

28. Quoted in Jacques Derrida, *The Archaeology of the Frivolous: Reading Condillac,* trans. John P. Leavey (Lincoln and London: University of Nebraska Press, 1987), p. 109.

29. Foucault, *The Order of Things,* p. 57

30. Our grid of reading has been formed by what Foucault has termed "[t]he medical bi-polarity of the normal and the pathological," dating from the early nineteenth century. Sign language was thus read as pathological. Quoted in Rob-

ert Nye, *Crime, Madness and Politics in Modern France: The Medical Concept of National Decline* (Princeton: Princeton Univ. Press, 1984), p. 47.

31. See Paul de Man, "The Rhetoric of Blindness," in *Blindness and Insight; Essays in the Rhetoric of Contemporary Criticism* (Minneapolis: Univ. of Minnesota Press, 1983).

32. Charles-Antoine Coypel, "Parallèle de l'Eloquence et de la Peinture," *Mercure de France* (May 1751): 33–34.

33. It is clear from the context that, although Coypel was a man of the theater, his reference to actors meant painted characters and not real thespians. See his definition of *disposition:* "N'est-ce que de placer les Acteurs de la scène, que notre tableau doit representer, dans le rang qui convient à chacun?" Ibid., p. 13.

34. See "Le Sourd, son varlet et l'Iverogne," in Leroux de Lincy et Francisque Michel, eds, *Receuil des Farces, Moralités et Sermons Joyeux* (Paris: Techener, 1837), the original ms dating from c.1500–1550.

35. Charles-Antoine Coypel, "Sur l'Exposition des Tableaux dans le Sallon du Louvre, en 1747," rpr. in *Mercure de France* (Nov. 1751): 71–73.

36. Quoted by Shearer West in *The Image of the Actor: Verbal and Visual Representation in the Age of Garrick and Kemble* (New York: St Martin's Press, 1990), p. 3.

37. John Weaver, *The History of the Mimes and Pantomimes, with an Historical Account of Several Performers in Dancing, Living in the Time of the Roman Emperors. To Which Will Be Added a List of the Modern Entertainments* (London: J. Roberts, 1728), p. 28 and p. 56.

38. Coypel wrote a play that featured a cameo appearance by the king, a storm, dancing, seduction, kidnap, stage directions for gestures and the characters of Don Quixote and Sancho Panza, *Les Folies de Cardenio: Pièce Heroi-Comique, Deuxième Ballet dansé par le Roy dans son Château des Tuileries* (Paris: J-B-C Ballard, 1720).

39. Quoted by Antoine Schnapper, "Musées de Lille et Brest": 260, who reproduces the works discussed here unless otherwise indicated.

40. I have treated this theme at greater length in "Framed: The Deaf in the Harem," in Jennifer Terry and Jacqueline Urla, eds., *Deviant Bodies* (Bloomington: Indiana Univ. Press, forthcoming).

41. Paul Rycaut, *The Present State of the Ottoman Empire* (1668), ed. Harry Shwartz (New York: Arno Press and the New York Times, 1971). French trans. 1669.

42. Denys Sutton, ed., *France in the Eighteenth Century* (London: Royal Academy of Arts, 1968), p. 62, fig. 141. Schnapper corrects the attribution to his uncle, Noel Nicholas, "Musées de Lille et Brest": 255 n.31.

43. Mary Sheriff, *Fragonard: Art and Eroticism* (Chicago and London: Chicago University Press, 1990), pp. 149–151.

44. See Sheriff, *Fragonard,* pp. 141–49.

45. Oliver Goldsmith, from *Retaliation, a Poem,* cited in Brian Grant, ed., *The Quiet Ear: Deafness in Literature* (Boston: Faber & Faber, 1988), p. 212.

46. Nicholas Penny, ed., *Reynolds* (New York: Harry N. Abrams Inc., 1986), pp. 340–41, cat. no. 170.

47. Reynolds, *Works,* vol. II, pp. 230–231.

48. Wills, *De Arte Graphica; or, the Art of Painting, Translated from the Original Latin of C. A. Du Fresnoy* (London: R. Francklin, 1754), p. 22

49. On the gendering of political culture in England, see Kathleen Wilson, "Empire of Virtue: The Imperial Project & Hanoverian Culture," in Lawrence Stone, ed., *An Imperial Nation State at War* (London: Routledge, 1993).

50. John Barrell, "The Birth of Pandora and the Origin of Painting," in his *The Birth of Pandora and the Division of Knowledge* (Philadelphia: University of Pennsylania Press, 1992), p. 163.

51. Michael Duffy, *The Englishman and the Foreigner: The English Satirical Print 1600–1832* (Cambridge: Chadwyck-Healy, 1986), pp. 194–95.

52. Sutton, *France,* p. 96, fig. 154. Diderot, *Salons de 1759, 1761 1763,* ed. J. Seznec (Paris: Flammarion, 1967), vol. I, p. 11.

53. Diderot, *Lettre sur les Aveugles,* in *Oeuvres Complètes,* ed. Jacques Chouillet (Paris: Herman, 1978), tome IV, p. 27.

54. Diderot, *Lettre sur les Sourds et sur les Muets,* 1755, reprinted in *Oeuvres Complètes,* tome IV, pp. 142–43.

55. Ibid., p. 146.

56. Ibid., p. 185. See Dubos' similar theory (1720): "The signs with which painters address us, are not arbitrary or instituted, such as words employed in poetry. Painting makes use of natural signs, the energy of which does not depend on education," *Critical Reflexions on Poetry, Painting and Music,* trans. Thomas Nugent (London: J. Nourse, 1748), vol. I, p. 322.

57. For an interesting discussion of Diderot's *Lettre,* see Jeffey Mehlman, *Cataract: A Study in Diderot* (Middletown CT: Wesleyan Univ. Press 1979), pp. 15–26.

58. Dandré-Bardon, *Traité de Peinture* (1765; rpr. Geneva: Minkoff, 1972), p. 60.

59. Abbé Charles Michel de l'Epée, *La Véritable Manière d'Instruire les Sourds et Muets* (1784; rpr., Paris: Fayard, 1984), p. 9.

60. See Walter J. Ong, *Orality and Literacy: The Technologizing of the Word* (New York: Routledge, 1988), pp. 117–22, and Elizabeth Eisenstein, *The Printing Press as an Agent of Change: Communications and Cultural Transformations in Early Modern Europe* (New York: Cambridge Univ. Press, 1979).

61. See Christian Cuxac, *Le langage des Sourds* (Paris: Payot, 1983), p. 18, and Lane, *When the Mind Hears,* p. 63.

62. Ruth Sidranksy remembers that in the New York of the 1920s any deaf person could still get work on city newspapers simply by showing up, *In Silence: Growing Up in a Silent World* (New York: St Martin's Press, 1990).

63. Abbé Charles-Michel de l'Epée, *Institution des Sourds et Muets* (Paris, 1776), p. 136. Despite its greater degree of philosophical sophistication, this first version of Epée's work has been somewhat overlooked since the re-issue of the 1784 edition, *La Véritable Manière.* The two texts will be distinguished by original date of publication in subsequent citations.

64. See Charles Adam and Paul Tannery, *Oeuvres de Descartes* (Paris: Vrin, 1986), tome I, pp. 76–82, and Louis Couturat, *Opuscules et fragments inédits de Leibniz,* (Hildesheim: Georg Olms, 1961), p. 278.

65. *G. W. Leibniz: Philosophical Essays,* ed. and trans. Roger Arien and Daniel Graber (Indianapolis & Cambridge: Hackett, 1989), p. 8. See J. Cohen, "On the Project of a Universal Character," in *Mind* LXIII (1954): 49–63, for the history of the idea of universal language.

66. Cited by James R. Knowlson, "The Idea of Gestures as a Universal Language in the XVIIth and XVIIIth centuries," *Journal of the History of Ideas* xxvi, no. 4 (1965): 499.

67. Christopher Columbus himself believed that the "Indians" he encountered had difficulties with spoken language, see Craig Owens, "Improper Names," in *Beyond Recognition: Representation, Culture, Power* (Berkeley: Univ. of California, 1992), p. 284

68. Cited in Maryse Bézagu-Deluy, *L'Abbé de l'Epée. Instituteur gratuit des sourds et muets 1721–1789* (Paris: Seghers, 1990), p. 175.

69. Cited by Edward Burnet Tylor, *Researches into the Early History of Mankind and the Development of Civilisation* (London: John Murray, 1865), p. 44. For Tylor's anthropological investigations into sign language, see below, chapter four.

70. See Lane, *When the Mind Hears,* p. 55 for details of this encounter.

71. Epée (1776): 184. See Carol Padden and Tom Humphries, *Deaf In America: Voices from a Culture* (Cambridge MA & London: Harvard University Press, 1988), chapter two on the Epée myth.

72. Epée (1776): 74.

73. *Arrêt du Conseil d'Etat du Roi concernant l'éducation et l'enseignement des sourds et muets,* A.N. F15/ 2584.

74. Condillac, *Essai sur les origines des connaissances humaines,* précédé par *L'Archéologie du Frivole* par Jacques Derrida (Paris: Galilée, 1973), pp. 128–131.

75. The gestural origins of language were widely accepted throughout the eighteenth century. Rousseau argued that gesture fulfilled the animal needs, speculating that animals, such as beavers and ants, have a gestural language: Jean-

Jacques Rousseau, *On the Origin of Language,* trans. John H. Moran and Alexander Gode (Chicago: Chicago Univ. Press, 1966), pp. 9–10.

76. Condillac, *Essai,* pp. 168–69.

77. Quoted by Derrida, *The Archaeology of the Frivolous,* p. 111.

78. Epée (1784):141.

79. Epée (1784): 9.

80. For Deseine, see Georges Le Chatelier, *Deseine le Sourd-Muet. Claude-André Deseine, statuaire (1740–1823). Notice biographique* (Paris: Atelier Typographique de l'Institut National des Sourds-Muets, 1903).

81. Epée (1776): 181–82.

82. Quoted by Derrida, *Archaeology of the Frivolous,* p. 82.

83. Ibid., p. 112.

84. Jacques Derrida, *Of Grammatology,* tr. Gayatri Spivak (Baltimore: Johns Hopkins University Press, 1974), p. 145.

85. For a description of this phonologism, see Jacques Derrida, "Signature, Event, Context," *Glyph* I (1977): 172–198. Derrida quotes Condillac: "Men in a state of communicating their thoughts by means of sounds, felt the necessity of imagining new signs, capable of perpetuating those thoughts and making them known to persons who are absent" (p. 176). But, in the evolutionary scheme of language implied here, it was not possible for those who only used the primitive communication ("mimicry") of sign language to proceed directly to writing with no intermediate stage.

86. Harlan Lane and Franklin Philip, *The Deaf Experience* (Cambridge, MA: Harvard University Press, 1984), p. 61.

87. Francine Markovits, "L'Abbé de l'Epée: du langage intérieur au langage des gestes," in Karacostas, ed., *Le Pouvoir des Signes,* p. 42.

88. Abbé Deschamps, *Cours Eléméntaire,* p. 3.

89. The works in question are J. P. Bonet, *Reduccion de las Letras y Arte para Ensenar à Ablar los Mudos* (Madrid: Abarca de Angulo, 1620), a manual alphabet, and J. C. Amman *Dissertatio de loquela Surdorum et Mutorum* (Amsterdam: Wetstenium, 1692), a textbook on oral education.

90. Pierre Desloges, *Observations d'un Sourd et Muet sur un cours élémentaire d'éducation des sourds et muets* (Paris: B. Morin, 1779), p. 14.

91. Abbé Charles-Nicolas Deschamps, *Lettre à M. de Bellisle* (Paris, 1780), p. 35 and p. 20. Saboureux's publication was in the *Journal de Verdun* (Oct-Nov. 1765).

92. Desloges, *Observations d'un sourd,* p. 45.

93. Henri Gaillard, *Essai d'Histoire d'Enseignment des Sourds-Muets. Réponse à M. Cochefer* (Asnières: Paul Scagliola, 1916), p. 9.

94. Bernard Truffaut, "Etienne de Fay," *Cahiers de l'Histoire des Sourds* 0–6 (1991).

95. Cazeaux, "Discours prononcé à l'Académie royale des Belles-Lettres de Caen, le 22 novembre 1746," rpr. in *Mercure de France* (Aug. 1747).

96. Desloges, *Observations d'un sourd*, p. 13.

97. See Thomas E. Crow, *Painters and Public Life in Eighteenth Century Paris* (New Haven and London: Yale Univ. Press, 1985).

98. Anon, *Le Miracle de Nos Jours: Conversation écrite et receuillie par un sourd muet et la bonne lunette, dans lequel on trouvera non seulement la critique des ouvrages exposés au Sallon, mais la critique de nos peintres et sculpteurs les plus connus* (1779), Collection Deloynes, tome XI, no. 219, p. 5.

99. Epée (1776): 30.

100. Condillac, *Essai sur les Origines des Connaissance Humaines*, II, xiii, #128.

101. Rousseau, *Origin of Languages*, p. 9. On the Maid, see Ann Bermingham, "The Origin of Painting and the Ends of Art: Wright of Derby's *Corinthian Maid*" in John Barrell, ed., *Painting and the Politics of Culture* (Oxford: Oxford Univ. Press, 1992).

102. Rousseau, *Origin of Languages*, p 18.

103. Bernadette Fort, "Voice of the Public: The Carnivalization of Salon art in pre-Revolutionary pamphlets," *Eighteenth Century Studies* 22, no.3 (spring 1989): 368–97.

104. [R. M. Lesuire] *La Muette qui parle au Sallon de 1781* (Amsterdam, 1781) & Coll. Deloynes no. 257, p. 1.

105. On the symptom in the visual image, see Mary Ann Doane, *The Desire to Desire: The Woman's Film of the 1940s* (Bloomington & Indianapolis: University of Indiana Press, 1987), p. 44.

106. Robert Rosenblum, "The Origin of Painting: A Problem in the Iconography of Romantic Classicism," *Art Bulletin* XXXIX (Dec. 1957): 288.

107. See Crow, *Painters and Public Life*, pp. 241–54.

108. "M. Vincent et M. David peuvent être regardés comme ayant produit les deux chefs d'oeuvres du salon [de 1783]" quoted by Henry Lemonnier, "Notes sur le Peintre Vincent," *Gazette de Beaux Arts* 32 (Oct. 1904): 293.

109. Félibien, "Le Portrait du Roy," *Description des divers ouvrages de Peinture faits pour le Roy* (Paris, 1671), p. 111. For important discussions of this text, see Louis Marin *The Portrait of the King*, trans. Martha Houle (London, 1988) and Norman Bryson, *Word and Image: French Painting of the Ancien Régime* (Cambridge: Cambridge Univ. Press, 1981).

110. See Crow, *Painters and Public Life*, pp. 191–95 on the *Molé*. On the revolutionary Academy, see Philippe Bordes, *Aux Armes et Aux Arts* (Paris, 1989).

111. Robert Rosenblum, *Transformations in Late Eighteenth Century Art* (Princeton: Princeton Univ. Press, 1967), pp. 22–23.

112. Plato, *Symposium*, 189e–199e. This passage was later quoted by Freud in

his *Beyond the Pleasure Principle*, trans. James Strachey (New York: W. W. Norton, 1961), pp. 69–70. See Samuel Weber, *The Legend of Freud* (Minneapolis: University of Minnesota Press, 1982) for a discussion of this relationship between Plato and Freud.

113. See Nancy K. Miller, "Rereading as a Woman: The Body in Practice," in Susan R. Suleiman, ed., *The Female Body in Western Culture* (Cambridge MA & London: Harvard University Press, 1986), pp. 354–62, for a discussion of Valmont's writing to the Presidente *on* Emilie who "must remain invisible since her function is merely and classically to facilitate the exchange of women and/or signs," p. 358n.5.

114. On the notion of a scene of representation, see Jacques Derrida, "Freud and the Scene of Writing," in *Writing and Difference*, trans. Alan Bass (London: Routlege Kegan Paul, 1978), pp. 196–232.

115. Derrida, "Freud and the Scene of Writing," p. 212.

116. *Le Moniteur universel*, no. 205 (23 July 1791): 202. See also *Mercure Universelle et Correspondance Nationale*, same date, and Le Hodey, ed., *Journal des Etats Généraux Convoqués par Louis XVI le 27 Avril 1789 aujourd'hui Assemblée Nationale Permanente*, tome 30, p. 208.

CHAPTER TWO

1. See Harlan Lane, *When the Mind Hears: A History of the Deaf* (New York: Random House, 1984) for details.

2. Mona Ozouf, "Regeneration," in François Furet and Mona Ozouf, eds., *A Critical Dictionary of the French Revolution*, trans. Arthur Goldhammer (Cambridge MA: Belknap Press, 1989), p. 782.

3. On the old regime, see Robert Darnton, *Literary Underground of the Old Regime* (Cambridge MA: Harvard Univ. Press 1982) and Lynn Hunt, ed., *Eroticism and the Body Politic* (Baltimore and London: Johns Hopkins University Press, 1991).

4. Quoted in Furet and Ozouf, *A Critical Dictionary,* p. 793.

5. Cited by Antoine de Baeque, "L'homme nouveau est arrivé. La 'régénération du Français," *XVIIIème Siècle* 20 (1989): 204.

6. Cited by Nicole Pellegrin, "L'uniforme de la Santé. Les Médécins et la réforme du costume," *XVIIIème Siècle* 23 (1991): 139.

7. Mona Ozouf, "La Révolution Française et l'idée de l'homme nouveau," in Colin Lucas, ed., *The Political Culture of the French Revolution*, vol. 2 of *The French Revolution and the Creation of Modern Political Culture* (Oxford and New York: Pergamon, 1988), p. 217.

8. *Receuil des Définitions et Réponses les plus remarquables de Massieu et Clerc Sourds Muets, aux divers questions qui leur ont été faites dans les Séances Publiques à*

Londres, trans. J. H. Sievrac (London: Cox & Baylis, 1815), pp. 6–7, my emphasis.

9. See Michel Foucault, *The Birth of the Clinic: An Archaeology of Medical Perception,* trans. Alan Sheridan (New York: Pantheon, 1973), idem, *Madness & Civilization: A History of Insanity in the Age of Reason,* trans. Richard Howard (New York: Pantheon, 1965).

10. Ozouf, "La Révolution Française," p. 229.

11. Harlan Lane, *When the Mind Hears,* p. 423.

12. See Jean Ehrard, *L'idée de la Nature en France dans la première moitié du XVIIIe siècle,* 2 vols. (Paris, 1963), tome I, p. 252.

13. Goethe (1798), quoted by Lorraine Dalston and Peter Galison, "The Image of Objectivity," *Representations* 40 (fall 1992): 87.

14. Both quotations from Ozouf "La Révolution Française et l'idée de l'homme nouveau," p. 220 and 222.

15. Mona Ozouf, *L'Homme Régénéré. Essais sur la Révolution Française* (Paris: Gallimard, 1988).

16. Ibid., p. 10.

17. Quoted by Keith Michael Baker in "Representation," in Keith Michael Baker, ed., *The French Revolution and the Creation of Modern Political Culture,* vol. I (Oxford: Pergamon, 1978), p. 484. There is a wealth of work on the question of the body and the revolution. See G. S. Rousseau, ed., *The Languages of Psyche: Mind and Body in Enlightenment Thought* (Berkeley: University of California Press, 1990), Part III: "The Politics of Mind and Body-Radical Practioners and Revolutionary Doctors"; Dorinda Outram, *The Body and the French Revolution* (New Haven: Yale Univ. Press, 1989); Lynn Hunt, *Politics, Culture and Class in the French Revolution* (Berkeley: Univ. of California Press, 1984).

18. Michel Foucault, *Discipline and Punish: The Birth of the Prison,* trans. Alan Bass (Harmondsworth: Penguin, 1977), p. 138.

19. Quoted by Elizabeth Roudinesco, *Théroigne du Méricourt: a Melancholic Woman during the French Revolution,* trans. Martin Thom (London: Verso, 1991), p. xi and p. 166.

20. Compare François Furet, *Interpreting the French Revolution,* tr. Elborg Foster (Cambridge: Cambridge Univ. Press, 1981), p. 12: "The Gulag is leading to a rethinking of the Terror precisely because the two undertakings are seen as identical."

21. Cited by Ozouf, "Regeneration," p. 786.

22. Prieur's comments seem to contradict Prof. Dora Weiner's assertion that "the nation was obligated by its new mandate of fraternity and equality to aid those citizens whom nature had shortchanged at birth," in "The Blind Man and the French Revolution," *Bulletin of the History of Medicine,* 48, no. 1 (spring

1974): 67. Rather than a prototype health care system, Prieur offered a short term investment capital to the Institute.

23. Jan Goldstein, *Console and Classify: the French Psychiatric Profession in the Nineteenth Century* (Cambridge and New York: Cambridge Univ. Press, 1987), emphasizes Pinel and Esquirol's different experiences in the Revolution as significantly determining their attitudes to *aliénation mentale* and its treatment. See pp. 67–80 for Pinel and pp. 121–22 and 128–47 for Esquirol. See also Roudinesco, *Théroigne du Méricourt,* pp. 157–168.

24. *Notice sur l'Institution Nationale des Sourds-Muets de Paris depuis son origine jusqu'à nos jours (1760–1896)* (Paris: Typographie de l'Institution Nationale, 1896), pp. 91–94.

25. Théophile Denis, "Deseine, sculpteur sourd-muet, élève de l'abbé de l'Epée," *Revue Française de l'Education des Sourds-Muets* 5ème année, no. 1 (Avril 1889):6–8.

26. Félix Martin, "Le Livre d'Or des Artistes Sourds," *RG* 19e année, no. 8 (Mai 1918):154.

27. *Journal de Paris* (14 May 1791), quoted by Georges le Chatelier, *Deseine Le Sourd Muet. Claude-André Deseine statuaire (1740–1823). Notice Biographique* (Paris: Atelier Typographique de l'Institut National des Sourds -Muets, 1903), p. 14.

28. See Foucault, *The Birth of the Clinic.*

29. *Journal de Paris* (30 July 1791), quoted by Le Chatelier, *Deseine,* p. 13.

30. "Petites Affiches du Paris," MS, Collection Desloynes, tome XVIII, no 456.

31. Collection Desloynes, tome XVIII.

32. *Journal des Débats et de la correspondance de la Société des Jacobins,* no. 355 (15 Fev. 1793), quoted by Le Chatelier, *Deseine,* p. 15.

33. Adrien Cornié, *Sur l'Institution Nationale des Sourdes-Muettes de Bordeaux 1786–1903* (Bordeaux: F. Pech, 1903), p. 7.

34. *Exercices que soutiendront des sourds et muets de naissance les 12 et 15 Septembre 1789 dans la Salle du Musée de Bordeaux, dirigés par M. l'abbé Sicard* (Bordeaux: Michel Racle, 1789), p. 5. This exhibition took place three months before Cicé committed the National Assembly to the care of the deaf: perhaps the example of these women inspired that undertaking.

35. Virginia Woolf, *A Room of One's Own* (New York: Harcourt Brace Jovanovich, 1957), p. 51.

36. Roch-Ambroise Sicard, *Cours d'Instruction d'un Sourd-Muet de Naissance pour servir à l'education des Sourds-Muets* (Paris: Le Clerc, an VIII), p. 21.

37. Vernet, "Reflexion Rapide sur l'Etablissement qu'on se propose de faire aux celestins [sic] pour l'education des sourds et muets," MS, 11 October 1790, A.N. F15/ 2584.

38. Roch-Ambroise Sicard, letter to abbé Sylvan, 26 June 1791, A.N. F15/ 2584.

39. Prieur de la Marne, *Plan Général d'une Ecole de Sourds et Muets,* MS, A.N. F15/ 2584.

40. Quoted in *Journal des Débats et des Decrets,* no. 792 (22 July 1791).

41. Prieur, *Plan Général.*

42. Prieur's speech as reported in the *Moniteur universel,* no. 205 (22 July 1791), p. 203.

43. [Anon] "Preuves de l'Utilité des Beaux-Arts. Nécessité de les perfectionner," in *Décade Philosophique* (10 Messidor an II).

44. Minutes of the *Section de l'Arsenal,* 3 July 1793, A.N. 15/ 2584.

45. *Moniteur universel* (5 Jul. 1793).

46. The women were Le Sueur, Bliot, Dancret, Vaucher, Prevost, Petellier, Valdier, Chateau, Dale, Mouroy, Broche, Gidiot (all identified as *sourde-muette* in the letter) and the men were Jean Massieu, Courtebray, Louis Alexandre, Peyre, Rigoire, and Antoine Fontaine. A.N. 15/2584.

47. The fall of the Robespierre government may have had a benefical effect on the Institute. The Committee had been due to meet on the morning of the 9 Thermidor to discuss the debt incurred by the Institute and, given the history of radical suspicion of Sicard, the outcome could not have been assured. Laurent Clerc later petitioned Napoleon on Sicard's behalf, when the latter was in considerable political trouble with the Imperial regime in May 1814. Folder 1, LCP.

48. An example of this letter is preserved in A.N. F 15/2584.

49. Le Hodey, *Journal des Etats-Généraux Convoqués par Louis XVI les 27 Avril 1789, aujourd'hui Assemblée Nationale Permanente,* tome XXX (22 July 1791):208. Government estimates of the number of deaf people under the Empire were in the order of 22,000.

50. The papers of the *Comité* can be found in A.N. F15/2584–2587. Alexis Karacostas, *L'Institution nationale des sourds-muets de Paris de 1790 à 1800* (Thèse pour le doctorat en médecine, Paris V, 1981) provides full documentation of the inquiry but takes a more gradualist approach than the present writer, believing that the changes in policy did not have important ideological meaning but simply dealt with the practical difficulties involved. However, within a discourse of regeneration, the very experience of practical difficulty has an ideological connotation.

51. Cornié, *Sur l'Institution,* p. 11.

52. Perier, *Réponse aux observations du Citoyen Raffron sur les établissemens proposés par les Comités de Secours et Instruction Publique en faveur des Sourds-Muets* (Paris: Institut National des Sourds-Muets, an III), p. 8. Raffron's comments of 24 vendemiaire an III quoted on p. 18.

53. Ibid., p. 19.

54. Cornié, *Sur l'Institution,* p. 12.

55. *Moniteur universel* (18 Nivose an III): 447–48.

56. Quoted by Henri Gaillard, *Le Droit des Sourds-Muets au Travail* (Paris: Gaston Vialatte, 1923), p. 3.

57. Hilaire, letter to the *Comité des Secours Publiques,* n.d., A.N. F15/2584.

58. J-M Lequinio de Kerblay, *Voyage Pittoresque et physio-économique dans le Jura* (Paris, 1801), quoted by Noël Barbe, "'Ethnographie' et révolution. Lequinio de Kerblay (Sarzeau 1755-Newport 1813) et le Jura: Le discours 'ethnographique' comme instrument de pédagogie politique," *Gradhiva* 8 (1989): 12.

59. A.N. F 15/2584.

60. Georges Canguilhem, *The Normal and the Pathological* (1966), intro. Michel Foucault, trans. Carolyn R. Fawcett (New York: Zone, 1991), p. 246.

61. *RG,* 40ème année, no. 1 (Jul.-Sep. 1939):151.

62. Quoted by Jean-René Presneau, "Oralisme ou langage des gestes: La formation des sourds au XIXe siècle," in Jacques Derrida, ed., *Les Sauvages dans la Cité: Auto-Emancipation du peuple et instruction des prolétaires au XIXe siècle* (Paris: Champ Vallon, 1985), p. 145.

63. Matthew Ramsey, *Professional and Popular Medicine in France 1770–1830: The Social World of Medical Practice* (New York: Cambridge Univ. Press, 1988), pp. 77–79.

64. Bouvoyer [sic], "Mémoire sur les Sourds et Muets de naissance" in *Décade Philosophique* 29 (20 Messidor an VIII): 89.

65. On the Wild Boy, see Harlan Lane, *The Wild Boy of Aveyron* (Cambridge MA: Harvard Univ. Press, 1986).

66. Foucault, *Madness and Civilization,* p. 252.

67. Allan Sekula, "The Body and the Archive," *October* 39 (1986):14.

68. Quoted in Emmet Kennedy, *A Cultural History of the French Revolution* (New Haven & London: Yale Univ. Press, 1989), p. 66.

69. Paul Rabinow, *French Modern* (Cambridge: Cambridge Univ. Press, 1989), pp. 18–24.

70. E. T. Hamy, "Les débuts de l'anthropologie en France," *Revue Scientifique,* 4 série, tome XVI, no. 11 (14 Sep. 1901):322.

71. J-M de Gérando, "Considérations sur les méthodes à suivre dans l'observation des peuples sauvages," rpr. in Jeans Copans and Jean Jamin, eds., *Aux Origines de l'Anthropologie Francaise: Les Mémoires de la Société des Observateurs de l'Homme en l'an VIII* (Paris,1978), p. 131.

72. L. F. Jauffret, "Introduction aux Mémoires de la Société des Observateurs de l'Homme," in Copans and Jamin, *Aux Origines,* pp. 73–85.

73. Gayatri Spivak, "Three Women's Texts and a Critique of Imperialism," in

Henry Louis Gates, ed., *"Race," Writing and Difference* (Chicago: Chicago Univ. Press, 1985), p. 267.

74. De Gérando, "Considerations," in Copans and Jamin, *Aux Origines,* p. 140.

75. Hamy, "Les Débuts de l'Anthropologie," p. 323.

76. See George Stocking, "French Anthropology in 1800," in *Race, Culture and Evolution: Essays in the History of Anthropology* (Chicago and London: Chicago Univ. Press, 1982), p. 36.

77. See Claude Blankaert, "On the Origins of French Ethnology: William Edwards and the Doctrine of Race," in George Stocking, ed., *Bones, Bodies, Behaviour: Essays on Biological Anthropology,* History of Anthropology, vol. 5 (Madison: Univ. of Wisconsin Press, 1988), pp. 18–55.

78. Destutt de Tracy, *Elémens d'Idéologie,* 3rd ed. (Paris, 1817), vol. I, p. 370. Tracy held that gesture was a part of the original "language of action" along with cries and touches, but was not a separate stage in the evolution of language, as Condillac and Rousseau had argued, ibid., pp. 302–88.

79. Cited in Robert Nye, *Crime, Madness and Politics in Modern France: The Medical Concept of National Decline* (Princeton: Princeton Univ. Press, 1984), p. 47.

80. See Foucault, *Discipline and Punish,* p. 193.

81. See George Levitine, *The Dawn of Bohemia: The Barbu Rebellion and Neoclassical France* (University Park: Penn. State Press, 1978).

82. Louis Hautecœur, *Louis David* (Paris: La Table Ronde, 1954), p. 225.

83. Michaud, *Biographie Universelle, ancienne et moderne,* tome 77 (Paris, 1845) pp. 387–88

84. Daniel and Guy Wildenstein, *Documents complémentaires au Catalogue de l'oeuvre de Louis David* (Paris: Fondation Wildenstein, 1973), p. 260.

85. See Lane, *When the Mind Hears,* p. 44 and the 1802 Salon catalogue rpr. in H. W. Janson, *Catalogues of the Paris Salon 1673–1881,* 60 vols. (New York & London: Garland, 1977).

86. Charles-Michel de L'Epée, *La Véritable Manière d'Instruire les Sourds et Muets* (1784; rpr. Paris: Fayard, 1984), p. 86.

87. It is unclear how Ponce-Camus knew sign language or how well he knew it. None of his contemporaries described him as deaf nor did they refer to his having taken any lessons with Epée as asserted by Harlan Lane, whereas nearly every time Deseine, for example, is mentioned his deafness was mentioned. Nor did the deaf historians of the nineteenth century, so meticulous in searching out their ancestors, ever refer to Ponce-Camus as a deaf artist. An article in the *RG* 17, no. 2 (Nov. 1915):44, also denied that he was deaf.

88. For example, the frontispiece to Augustus von Kotzebue, *Deaf and Dumb;*

or the Orphan, trans. Benjamin Thompson (London: Vernor and Hood, 1805) or the print reproduced by Alexis Karacostas in *Le Pouvoir des Signes,* 1989 (Paris, INJS), p. 49. Cruikshank also engraved this scene, again without using sign language.

89. Stephen Bann, *The Clothing of Clio: A Study of the Representation of History in Nineteenth-Century Britain and France* (New York: Cambridge Univ. Press, 1984), pp. 54–76.

90. Barbara Johnson, *A World of Difference* (Baltimore: Johns Hopkins University Press, 1989), pp. 6–7.

91. *Annales du Barreau Français, ou choix des plaidoyers et mémoires les plus remarquables,* tome VI (Paris: B. Warée, 1825), p. 217. There is a curious similiarity between Tronson's defence and the verdict in the sixteenth-century Martin Guerre case: "And in truth there is nothing between men more detestable than feigning and dissimulating, though our century is so unfortunate that in every estate, he who knows best how to refine his lies, his pretenses and his hypocrisy is often the most revered," quoted by Natalie Zemon Davis, *The Return of Martin Guerre* (Cambridge MA: Harvard Univ. Press, 1983), pp. 102–3.

92. Ferdinand Berthier, *L'Abbé de l'Epée* (Paris: Michel Levy, 1852), p. 107.

93. Lane, *When the Mind Hears,* pp. 43–66.

94. Eude, *Rapport du Procès Solar, Concernant l'élève sourd et muet de l'abbé de l'Epée* (Paris, an VIII), p. 20.

95. Ibid., p. 29.

96. For example, Eude noted that although 72 witnesses denied that Joseph was Solar, 50 thought he was and 62 saw some resemblance. Mme Combette and her daughters recalled meeting Solar with Cazeaux at the end of July which would have made the later chronology possible, as opposed to fourteen other witnesses who put the time as later but did not agree as to exactly when—and so on. But without the signs of the boy Joseph, the story must remain incomplete—but intriguing.

97. Berthier, *Epée,* p. 147.

98. Eude, *Rapport,* p. 3.

99. "Salon de l'an X," *Journal des Débats* (Oct., an X):227

100. [Anon] *Revue du Salon de l'An X ou examen critique de tous les tableaux qui ont été exposés au Museum* (Paris: Surosne, 1802), p. 184.

101. [Anon] *Arlequin au Museum ou Critique des Tableaux en Vaudevilles* (Paris: Marchant, 1802).

102. Eugène Dandrée, *A M. Denon. Lettres Sur le Salon de 1806* (Paris: Brasseur, 1806), pp. 1–4.

103. "Salon de l'An X," *Journal des Débats* (Octobre, an X).

104. *Mercure de France* (Messidor, an X): 130–31.

105. Jean-Nicolas Bouilly, *L'Abbé de l'Epée: comédie historique* (Paris: P. André, an VIII), pp. ix–x

106. Vernet, *Réflexion Rapide,* n.p.

107. *Mercure de France,* loc. cit.

108. Mona Ozouf, *Festivals and the French Revolution,* trans. Alan Sheridan (Cambridge MA: Harvard Univ. Press, 1938), p. 223.

109. Ozouf, *Festivals,* p. 220.

110. See Ozouf, *Festivals* on the failure to control religion, and Michel de Certeau, D. Julia, and J. Revel, *Une Politique de la Langue. La Révolution française et les patois. L'enquête de Grégoire* (Paris: Gaillard, 1975) on the survival of *patois* and the attempts to control it.

111. Carol Blum, *Rousseau and the Republic of Virtue: The Language of Politics in the French Revolution* (Ithaca & London: Cornell Univ. Press, 1986), p. 161. See pp. 160–75 for a fuller discussion of this central Republican dilemma.

112. Cited by Mona Ozouf, "Public Spirit," in Ozouf and Furet, eds., *A Critical Dictionary,* p. 771.

113. *Decade Philosophique* 23 (20 Floréal, an VII): 285–94.

114. See Gilbert Stengler, *La Société Française Pendant le Consulat* (Paris: Perrin, 1905), tome IV, "Les Ecrivains et les Comédiens," for details of Josephine's salon. Bouilly, *Recapitulations* (Paris: L. Janet, 1835), p. 168 notes David, Gérard, and Girodet as regular habitués.

115. Foucault, *Discipline and Punish,* p. 217.

116. Michael Fried, *Courbet's Realism* (Chicago: Univ. of Chicago Press, 1990), p. 22.

117. On the theatricality of David—in a very different tenor to that of Michael Fried—see Michel Thévoz, *Le Théâtre du Crime: Essai sur la peinture de David* (Paris: Minuit, 1989).

118. I distinguish such paternalism, which I see as a constituent part of the disciplinary system of power that had just emerged, from patriarchy, which I take to be a trans-historical domination of the female by the male.

119. Carol Duncan, "Fallen Fathers: Images of Authority in Pre-Revolutionary French Art," *Art History* 4:2 (June 1981):186–202.

120. See Dorothy Johnson, "Corporality and Communication: The Gestural Revolution of Diderot, David and 'The Oath of the Horatii,'" *Art Bulletin* LXXI (March 1989): 92–114, for a discussion of David's use of gesture, especially in the *Horatii.*

121. Thomas Holcroft, *Deaf and Dumb, or the Orphan Protected,* 4th ed. (London: J. D. Dewick, 1801). See also the German version by Augustus von Kotzebue of 1805 which was then retranslated into English by Benjamin Thompson as *Deaf and Dumb; or the Orphan* (London: Vernor and Hood, 1805) in a version that was in fact much closer to Bouilly's original.

122. The play also transferred with success to the provinces. In Yorkshire alone it had sixteen performances; see Linda Fitzsimmons and Arthur W. Mc Donald,

The Yorkshire Stage 1766–1803 (Metuchen NJ & London: Scarecrow Press, 1989), pp. 913 and 1041.

123. Holcroft, *Deaf and Dumb,* p. 82.

124. *Morning Chronicle* (5 March 1801). See also 6 March, 11 March, 18 March, and 20 April 1801 for further comments in this vein.

125. See Peter Jackson, *Britain's Deaf Heritage* (British Association for the Deaf, 1990) for the history of the deaf in Britain. For Johnson's visit to the Braidwood school in Edinburgh, see Brian Grant (ed.), *The Quiet Ear: Deafness in Literature* (Boston: Faber and Faber, 1988), p. 15.

126. Jane Austen, letter to Cassandra, 27 December 1808, cited in Grant, *Quiet Ear,* p. 74.

127. My thanks to Susan Alon, archivist at the Washington University School of Medicine,MI, for drawing my attention to the Northcote.

128. Miss St. Clair's identity is a problem. She ordered no less than seven portraits from Northcote between 1800 and 1803, and was also painted by the miniaturist Elizabeth-Ann Paye, a specialist in theatrical portraits. No actress of that name appeared on the London stage in the period, although a Mrs. Sinclair acted in Belfast in 1794–95. Nor did any of the branches of the noble St. Clair family have a daughter of sufficient age to have posed for these portraits. There is a very strong resemblance between Northcote's portrait and John Barry's minia-ture of Maria Theresa de Camp (b.1774), later Mrs. Charles Kemble, who played Julio in Holcroft's translation of Bouilly's play that year at Drury Lane. She was one of the few actresses rich enough to afford so many commissions. Given that the Kemble family were at this time preventing her marriage to Charles Kemble (which finally occured in 1804), she may have had need of an alias at this time. Furthermore, Northcote not only knew Holcroft, but they were both contribu-tors to *The Artist* magazine a few years later. It is unlikely that the nobility would have patronised Miss Paye, an artist little-known outside theatrical circles. She did however paint both Mrs. Siddons and Miss de Camp, the latter on several occasions, which seems to give further credence to the identification of Miss St Clair as Maria de Camp.

129. Henry Fuseli, *Lectures on Painting, delivered at the Royal Academy* (Lon-don: J. Johnson, 1801), p. 44.

130. *The Artist* XX (25 July 1807): 3.

131. Philippe Grunchec, *Les Concours des Prix de Rome 1797–1863,* 2 vols. (Paris: Ecole Nationale Supérieure des Beaux-Arts, 1989), tome II, pp. 40–41.

132. Albert Soubies, *Les Membres de l'Académie des Beaux-Arts depuis la fonda-tion de l'Institut: Deuxième série 1816–1852* (Paris: E. Flammarion, 1909), pp. 185–86.

133. Foucault, *Discipline and Punish,* p. 200 and p. 205.

134. Ferdinand Berthier, *L'Abbé Sicard* (Paris: Charles Douniol et cie, 1873), p. 63.

135. Jacques Derrida, *Of Grammatology*, trans Gayatri Spivak (Baltimore: Johns Hopkins University Press, 1974), p. 144. See ". . . That Dangerous Supplement . . . ," pp. 141–164 for a full discussion of this important point, which informs my discussion of Langlois.

136. Soubies, *Les Membres de l'Académie*, p. 186.

137. Laurent Clerc to J-M Langlois (9 Nov. 1815), folder 1, no. 3, LCP.

CHAPTER THREE

1. This phrase is borrowed from Homi Bhabha, "Of Mimicry and Man: The Ambivalence of Colonial Discourse," in *October The First Decade 1976–1986*, ed. Douglas Crimp et al. (Cambridge MA: MIT, 1987), pp. 317–25. This essay informs my use of the term mimicry throughout; see also Robert Young, *White Mythologies: History Writing and the West* (New York: Routledge, 1990).

2. See Jacques Derrida, "The Double Session," in *Dissemination*, trans. Barbara Johnson (Chicago: Univ. of Chicago Press, 1981), pp. 173–286. Derrida's work on mimicry has been highly influential in post-colonial studies and it constitutes a major theoretical point of reference for this chapter.

3. R. J. Durdent, *L'Ecole française en 1814* (Paris, 1814), p. 108.

4. Cited by C. Mareille, "Notice sur Mathieu Cochereau. Peintre Beauceron," in *Mémoires de la Société Archéologique d'Eure et Loir*, tome VI (1876): 54.

5. Despite the fact that Massé's finished version hangs next to it, Cochereau's work is bizarrely titled *Prévost et ses panoramas* by the Chartres Museum, a striking incidence of the "invisibility" of deaf artists' work.

6. R-A Bébian, *Essai sur les Sourds-Muets et sur le langage naturel* (Paris: J. G. Denton, 1817), p. 63.

7. Ferdinand Berthier, *L'Abbé Sicard, célèbre instituteur des sourds-muets, successeur immédiat de l'Abbé de l'Epée, Précis Historique sur sa vie, ses travaux et ses succès* (Paris: Charles Douniol, 1873), p. 57.

8. Auguste Bébian, *Mimographie, ou Essai d'Ecriture Mimique, Propre à regulariser le langage des Sourds-Muets* (Paris: Louis Colas, 1825), p. 28.

9. Derrida, *Dissemination*, p. 187.

10. Paillot de Montabert, *Traité Complet de la Peinture*, tome V (Paris, 1829), p. 425.

11. Ibid., p. 445.

12. All materials cited from the file "Lefebvre" in A.N. F 15/ 2587. Lefebvre's case echoes that of Grivel, discussed at the end of chapter two.

13. Jean-Pierre Bonnafont, *De la Surdi-Mutité. Discours Prononcés à l'Académie Impériale de Médicine* (Paris: J.-B. Baillière, 1853), p. 3.

14. Adrien Cornié, *Sur l'Institution Nationale des Sourdes-Muettes de Bordeaux 1793–1903* (Bordeaux: F. Pech, 1903), p. 67. The remaining pupil was expelled for "very bad eyesight."

15. Philippe Pinel, *Traité Médico-Philosophique sur l'Aliénation Mentale ou la Manie* (Paris: Richard, Caille et Ravier, an IX), pp. 165–69.

16. Robert's dictionary suggests 1833 as the introduction for this term.

17. See Harlan Lane, *The Mask of Benevolence: Disabling the Deaf Community* (New York: Alfred A. Knopf, 1992), pp. 212–13 for details of Itard's procedures.

18. [Berthier et al.], *Les Sourds-Muets au XIXème Siècle* (Paris: Institut National des Sourds Muets, 1846), p. 10.

19. J. C. Hoffbauer, *Médécine légale relative aux aliénés et aux sourds-muets,* trans. A-M Chambeyron (Paris: J-B Baillière, 1827), with notes by Itard and Esquirol, p. 181.

20. Ibid., pp. 210–11.

21. Harlan Lane, *When the Mind Hears: A History of the Deaf* (New York: Random House, 1984), p. 134

22 Quoted by Christian Cuxac, *Le langage des Sourds* (Paris: Payot, 1983), p. 121.

23. Thomas H. Gallaudet, *A Sermon on the Duty and Advantages of Affording Instruction to the Deaf and Dumb* (Concord MA, 1824), p. 8.

24. *Journal des Débats* (8 April 1837), quoted by Jan Goldstein, *Console and Classify: The French Psychiatric Profession in the Nineteenth Century* (New York: Cambridge Univ. Press, 1987), p. 279, whose chapter on the law is very thorough, pp. 276–321. For an extraordinary commentary on the law from one of its "beneficiaries," see Louis Althusser, *L'Avenir Dure Longtemps* (Paris, 1992) in which the psychiatric patient rails against the terms of his imprisonment.

25. De Gérando, *De l'Education des Sourds-Muets de Naissance,* 2 vols. (Paris: Méquignon, 1827), vol. 2, p. 594.

26. James Hunt, "On the Negro's Place in Nature," in *Journal of the Anthropological Society of London,* vol. II (1864): xvi. See also Henry Louis Gates, Jr., "Authority, (White) Power, and the (Black) Critic; or, it's all Greek to me," in Ralph Cohen, ed., *The Future of Literary Theory* (New York: Routledge, 1989), p. 326.

27. Quoted by Tamar Garb in *"L'Art Féminin:* The Formation of a Critical Category in Late-Nineteeth Century France," *Art History* 12 (March 1989): 62n.41. Although Garb's example is from 1907, the attitude has a much longer history.

28. The theorization of mimicry can be found in the works of Bébian, Berthier, and de Gérando who all influenced each other. Given that Berthier's work did not appear in print until the 1830s but that he was closely connected with Bébian's initiatives from 1817 to 1830, the same period in which de Gérando was researching and writing his text, I have not attempted to construct a chronology for mimicry or to ascribe "influences" from one text to the next: this

is a very practical example of the workings of intertextuality, given that a discernable body of ideas arises whose authorship and origin are nonetheless open to question.

29. Berthier, *Sicard,* p. 59

30. Michel Foucault, *The Order of Things: An Archaeology of the Human Sciences* (London: Tavistock, 1970), p. 286.

31. Cited by Donald Preziosi in *Rethinking Art History: Meditations on a Coy Science* (New Haven: Yale Univ. Press, 1989), p. 100.

32. On polygenetic theories of race, see George Stocking, *Victorian Anthropology* (New York: Free Press, 1987), chapter two.

33. Charles Nodier, *Notions élémentaires de linguistique* (1834) cited in Gérard Genette, *Mimologiques: Voyage en Cratylie* (Paris: Seuil, 1976), p. 159. See Genette's chapter on Nodier "Onomatopoétique," pp. 149–82. This belief was shared by many polygenists, such as Louis-Antoine Desmoulins—see Claude Blankaert, "On the Origins of French Ethnology: William Edwards and the Doctrine of Race," in George Stocking, ed., *Bones, Bodies, Behaviour: Essays on Biological Anthropology,* History of Anthropology, Vol. 5 (Madison: Univ. of Wisconsin Press, 1988), p. 32. On *milieu,* see Paul Rabinow, *French Modern: Norms and Forms of the Social Environment* (Cambridge MA: MIT Press, 1989), pp. 17–57.

34. Bébian, *Essai,* p. 106.

35. Foucault, *The Order of Things,* p. 296.

36. Ferdinand Berthier, *Les Sourds Muets avant et depuis l'Abbé de l'Epée* (Paris: J. Ledoyen, 1840), p. 53.

37. Adolphe Franck in [Anon], *Statue de l'Epée* (Paris: Institut National des Sourds-Muets, 1879), p. 46.

38. Bhabha, "Of Colonial Mimicry," p. 318.

39. Nancy Leys Stepan has argued that, in the nineteenth century "meaning is a product of the interaction between the two parts of a metaphor," in "Race and Gender: The Role of Analogy in Science," *Isis* 77 (1986):261–77.

40. Jacques Lacan, *The Four Fundamental Concepts of Psychoanalysis,* quoted by Bhabha, "Of Colonial Mimicry," p. 317

41. As Derrida has argued in a well-known passage: "Classical thought concerning structure could say that the structure is, paradoxically, *within* the structure and *outside it.* The center is at the center of the totality, and yet, since the center does not belong to the totality (is not part of the totality), the totality *has its center elsewhere.* The center is not the center," in "Structure, Sign and Play," in *Writing and Difference,* trans. Alan Bass (London: Routledge Kegan Paul, 1978), p. 279. This argument on totality depends on the reading of the supplement I have outlined in chapter one. The structure is related to the center like the whole to the supplement: it is both complete without it, and needs it to be complete.

42. Aristotle, *Rhetoric,* quoted by Jacques Derrida in "White Mythology: Metaphor in the Text of Philosophy," *Margins of Philosophy,* trans. Alan Bass (Chicago: Univ. of Chicago, 1982), p. 242.

43. For Condillac, see chapter one, pp. 35–38. Kant, *Critique of Judgement,* quoted by Craig Owens in *Beyond Recognition: Representation, Power, and Culture* (Berkeley: Univ. Of California Press, 1992), p. 36.

44. Bébian, *Essai,* p. 43.

45. De Gérando, *De l'Education,* vol. I, p. 18.

46. De Gérando, *De l'Education,* p. 23.

47. Bébian, *Essai,* p. 58.

48. De Gérando, *De l'Education,* p. 278. See Derrida's observation that "metaphor then is what is proper to man," in "White Mythologies," p. 246.

49. De Gérando, *De l'Education,* p. 144, see pp. 145–48 for details.

50. Bébian, *Essai,* p. 98

51. De Gérando, *De l'Education,* pp. 225 and 228

52. Lane, *When the Mind Hears,* chapter eight.

53. *Address Written by Mr Clerc and read by his request at a public examination of the pupils in the Connecticut Asylum before the Governor and both Houses of the Legislature, 8 May 1818,* (Hartford: Hudson, 1818), p. 12.

54. De Gérando, *De L'Education,* vol. II, p. 343.

55. Quoted by Nigel Glendenning, *Goya and his Critics* (New Haven: Yale Univ. Press, 1977), p. 55.

56. Glendenning provides examples of all these categories of analysis.

57. For example, in an otherwise meticulous work, Janis A. Tomlinson's *Goya in the Twilight of Enlightenment* (New Haven & London: Yale Univ. Press, 1992) does not discuss his deafness at all as part of her move away from biographical approaches. For the other artists mentioned, see John House, *Monet: Nature into Art* (New Haven: Yale Univ. Press, 1986) and Patrick Trevor-Roper, *The World through Blunted Sight: An Inquiry into the Influence of Defective Vision on Art and Character* (Indianapolis & New York: Bobbs-Merill, 1970); Norma Broude, *Impressionism: A Feminist Interpretation* (New York: Rizzoli, 1991).

58. Quoted by Spanish deaf artist Valentin de Zubiaurre, *Les Arts Silencieux: Bulletin Périodique du Salon Internationale des Artistes Silencieux* 17 (10 Dec. 1950):3. For the *Salons Silencieux,* see chapter five below.

59. Antoine Court de Gébelin, *Allégories Orientales,* in *Monde Primitif, analysé et comparé avec le Monde Moderne, considéré dans son génie allégorique,* vol. I (Paris: Boudet et al., 1773), p. 55.

60. Glendenning, *Goya,* pp. 288–90.

61. F. Xéridat and L. Primel, *Catalogue du musée universel des sourds-muets* (Paris: Institution nationale des sourds-muets de Paris, 1947), cat. nos. 1490–1492, p. 48.

62. F-L Bruel, "Girodet et les Dames Robert," *Bulletin de la Société de l'Histoire de l'Art Française* (1912): 80–81.

63. [Anon], *Notice Historique de Ce qui s'est passé A L'Institution des Sourd-Muets et à celle des Aveugles-Nés les jours où S. S. le Pape PIE VII a bien voulu visiter ces deux institutions* (Paris: Imprimerie des Sourds-Muets, 1805), p. 6.

64. Robert's exhibited works were: *Laure* (1831), a drawing derived from Petrarch, *Portrait de Mme Nodier* (1833), drawing, *Portrait de Mme Cécile Cottin* (1833), *Portrait de M. Paulmier* (1835), drawing, *Portrait de Mme Elise B . . .* (1835).

65. De Gérando, *De l'Education,* vol. I, p. 87 and p. 116.

66. "Discipline" file, Archives *INJS.*

67. Laurent Clerc to Sicard (10 May 1816), LCP.

68. Letter of Charles Vielles to the Director announcing the escape of Knop, following that of Paul, n.d. [c.1832]; note dated 26 Sep. 1834 remarking the disappearance of Dupont for the fifth time; 18 April 1847, Renon expelled after jumping over the back wall. "Discipline," *INJS.*

69. *Les Sourds-Muets au XIXème siècle.* p. 17

70. Ferdinand Berthier, *Notice sur la vie et les ouvrages de Auguste Bébian* (Paris: J. Ledoyen, 1839), p. 24.

71. E. Graff, "Ferdinand Berthier" in *La France des Sourds-Muets* 6 (1 Mar. 1904): 124.

72. Berthier was paid 800 fr. as compared to Valade-Gabel's 1600 in 1831—see A.N. F 15/ 3891.

73. The revolt is recorded in Imbert's obituary, *JSM* 46 (28 Oct. 1896): 326.

74. Berthier et al., *Adresse des Sourds Muets au Roi* (Paris, 1830), p. 3.

75. Quoted by Cuxac, *Le Langage des Sourds,* p. 98.

76. Maxime Du Camp, "The Paris Institution," trans. from *Revue des Deux Mondes* (15 April 1873), in *The American Annals of the Deaf* vol XXII, no. 1–2 (Jan. & Apr. 1877):77.

77. E. Graff, *La France des Sourds-Muets* 7 (1904):129.

78. Michel Foucault, *Power/ Knowledge: Selected Interviews and Writings 1972–77,* trans. Colin Gordon et al. (Brighton: Harvester, 1980), p. 81.

79. Gayatri Chakravorty Spivak, "Can the Subaltern Speak?" in Cary Nelson and Lawrence Grossberg, eds., *Marxism and the Interpretation of Culture* (Urbana and Chicago: Univ. of Illinois, 1988), pp. 271–313.

80. [Anon], *Aperçu Historique des Banquets annuels des Sourds-Muets en honneur de la naissance de l'Abbé de l'Epée* (Paris: la Société d'Appui Fraternel des Sourds-Muets de France, 1913), pp. 3–4.

81. [Anon], *Banquets des Sourds-Muets réunis pour fêter l'anniversaires de la naissance de l'Abbé de l'Epée* (Paris: Jacques Ledoyen, 1842), p. 33 and p. 47 [here-

inafter refered to as B]. Victor Hugo and Lamartine later accepted invitations but did not attend.

82. See the articles by Bernard Mottez, "Les Banquets de sourds-muets et la naissance du mouvement sourd," and Guy Jouannet, "Des Artistes Militantes," in Alexis Karacostas, ed., *Le Pouvoir des Signes* (Paris: Institut National des Jeunes Sourds, 1989).

83. B, pp. 11–17. The full list of names: Peyson, Léopold Loustau, Darroux, Charles Ryan, Henry Ryan, Perrand, Louis Mosca, Arthur Gouin, Joseph de Widerkehr, Bézu, Adolphe Koerdel, Pierre Mosca, Hennequin, Bonnet, Lemercier, and Paoli, p. 27.

84. Henry Jouin, *Maîtres Contemporains* (Paris: Perrin, 1887), pp. 144–5.

85. See Pierre Georgel and Anne-Marie Lecoq, *La Peinture dans la Peinture* (Dijon: Musée des Beaux-Arts, 1982), p. 144, fig. 253.

86. *L'Artiste* (1836), quoted by Michael Marrinan in *Painting Politics for Louis-Philippe: Art and Ideology in Orléanist France 1830–1848* (New Haven: Yale Univ. Press, 1988), p. 116.

87. Marrinan, *Painting Politics,* p. 207 and p. 212.

88. B, p. 12. In a collection for the bust of Epée launched in 1839, Lhérie, Bouilly, and Auguste Veyron, manager of the *Théâtre des Variétés,* all made significant donations.

89. Théophile Denis, "Frédéric Peyson" in *Revue Française de l'Education des Sourds-Muets,* 5e année, no. 12 (Mars 1890):263–66.

90. Philippe Grunchec, *Les Concours des Prix de Rome 1797–1863,* 2 vols. (Paris: Ecole Nationale Supérieure des Beaux-Arts, 1989), vol 1, p. 286.

91. B, pp. 46–48.

92. Quotation from *Courbet à Montpellier* (Montpellier: Musée Fabre, 1984), p. 81.

93. B, p. 57.

94. B, p. 64.

95. For example, Epée used to refer to finger spelling as "writing in the air"; de Gérando explicitly refused the notion that writing was secondary to speech, *De l'Education,* p. 16, and Bébian initiated his project of *mimographie* to show that "the writing of the gesture is not a chimera," *Mimographie,* p. 7.

96. Bébian, *Journal de l'Instruction des Sourds-Muets et des Aveugles* (Paris: Institution Spéciale des Sourds-Muets, 1826).

97. Quoted in *RI* XII, no. 9–10 (Dec. 1896-Jan. 1897):288. Ordinaire was a hero to later 19th-century oralists.

98. *Le Commerce* 304 (31 Oct. 1838) and no. 307 (3 Nov. 1838).

99. *Le Moniteur universel* (5 Nov. 1838).

100. B, pp. 59–61.

101. Piroux, *L'Ami des Sourds Muets,* 1er année (Nov. 1838):15

102. B, p. 31

103. Berthier, *Itard*, p. 9.

104. Ibid., p. 31.

105. Sicard, *Cours d'Instruction,* pp. xxiii–iv: "Pourquoi ne seroient-ils pas civilisés? pourquoi n'auroient ils pas des lois, une gouvernement, une police, à la verité, moins ombrageuse que la notre?"

106. Benedict Anderson, *Imagined Communities,* 2nd ed. (London: Verso, 1991), p. 14.

107. A. Amet, *Aperçu Historique des Banquets Annuels de Juillet en l'honneur des Lois des 21 Juillet 1791 et 28 juin 1793* (Tours: E. Juliot, 1900), p. 3.

108. B, p. 203.

109. Amet, *Aperçu Historique,* p. 4 and B, p. 268.

110. *Courrier Français* 62 (2 Mars 1848).

111. *Courrier Français* 74 (14 Mars 1848).

112. *RG,* 30 année, no. 3 (Dec. 1928).

113. *Le Reveil des Sourds Muets* 16 (Fev. 1902).

114. Karacostas, *Le Pouvoir des Signes,* p. 83.

115. Quoted in Denis, "Peyson," p. 266.

116. *Le Commerce* (15 March 1839).

117. Denis, "Peyson," pp. 267–69. Later, he gave a number of works to the Musée Fabre in his home town of Montpellier, where they remain.

118. B, p. 164.

119. Théophile Denis, "Les Artistes Sourd-Muets au Salon de 1886," in *Etudes variées concernant les Sourds Muets. Histoire-Biographie-Beaux Arts* (Paris: Imprimerie de la Revue française de l'enseignement des sourds-muets, 1895), p. 27

120. [Anon], *Les Sourds-Muets au XIXème siècle,* p. 5.

121. See Stepan, "Race and Gender." Berthier was similarly silent about questions of gender.

122. Berthier, *Mimographie,* p. 6

123. Etcheverry, "Histoire d'un Tableau," in *Bulletin de la Société Centrale pour l'assistance et l'éducation des sourds-muets* (1874) is the source for all citations.

124. Marinnan, *Painting Politics,* p. 123.

125. *L'Ami des Sourds-Muets,* 3ème année (Nov. 1840): 7.

126. Léon Rosenthal, *Du Romantisme au Réalisme: Essai sur l'Evolution de la Peinture en France de 1830 à 1848* (Paris: Renouard, 1914), p. 44. See pp. 39–50 for details of the refusals and protests at the Salon.

127. *Journal des Artistes* cited by Rosenthal, *Du Romantisme,* p. 50n.3.

128. Auguste Borjot, "Salon de 1837," *La France Littéraire,* 2e série, tome II (1837):315.

129. Charles Blanc, "Salon de 1839," *Revue de Progrès* (1839): 268.

130. Wilhelm Ténint, *Album du Salon de 1842* (Paris: Challamel, 1842), pp. 1–2.

131. See Walter Benjamin, "The Work of Art in the Age of Mechanical Reproduction," in *Illuminations,* trans. Harry Zohn (New York: Shocken, 1968), pp. 217–52.

132. Quoted in Anne Coffin Hanson, *Manet and the Modern Tradition* (New Haven: Yale Univ. Press, 1977), p. 44.

133. Quoted by Bruel, "Girodet et les Dames Robert," p. 93.

134. Quoted by Genette, *Mimographie,* p. 152.

135. Thierry, *Moniteur universel* (6 Dec. 1853).

136. Lee Johnson, *The Paintings of Eugène Delacroix: A Critical Catalogue,* vol. I, *1816–1831: Text* (Oxford: Clarendon, 1981), p. 114.

137. Rosenthal, *Du Romantisme,* p. 41.

138. Johnson, *Paintings of Eugène Delacroix,* vol. III, *Movable Pictures and Private Decorations 1832–1863: Text* (1986), p. 80. For the influence of the eighteenth century on the Romantics, see Carol Duncan, "The Persistence and Re-Emergence of the Rococo in French Romantic Painting" (Ph.D. diss., Columbia University, 1969).

139. Baudelaire, CE, p. 129.

140. *Dictionnaire de l'Académie des Beaux-Arts,* tome VI (Paris: Firmin-Didot, 1858), pp. 114–118.

141. Mihai Spariosu, "Introduction,"in *Mimesis in Contemporary Theory: An Interdisciplinary Approach,* vol. I (Philadelphia and Amsterdam: John Benjamins, 1984), p. XXII.

142. Blanc, "Salon de 1839," p. 349.

143. Baudelaire, CE, p. 247.

144. Ibid., pp. 110 and 107.

145. The *juste milieu* has been widely explored by Albert Boime in his *Thomas Couture and the Eclectic Vision* (New Haven: Yale Univ. Press, 1980) and *The Academy and French Painting in the Nineteenth Century* (London: Phaidon, 1971). The controversy inspired by this work is tangential to my argument that critics sought a *juste milieu.*

146. Alex Potts, "The Verbal and the Visual in Winckelmann's Analysis of Style," *Word and Image* 6, no. 3 (Jul.-Sep. 1990): 237.

147. "Discipline" file, Archives *INJS.*

148. Jacques Rambusson, *La Langue Universelle* (Paris: Mme V. Belin, 1855), pp. 1–5.

149. J. Rambusson, *Langue Universelle. Langage Mimique mimé et écrit. Développement philosophique et pratique* (Paris: Garnier, 1853), p. 7.

150. Guéneau de Mussy and Gerdy, quoted in Berthier, *Itard,* p. 104.

151. Quoted by Judith Wechsler, *A Human Comedy: Physiognomy and Carica-ture in Nineteenth Century Paris* (Chicago: Univ. of Chicago, 1982), p. 28.

152. For an important reading of mimesis in the visual arts, see Louis Marin, "Mimesis et description," *Word and Image* 4:1 (Jan.-Mar. 1988):25–36.

153. Cited by Genette, *Mimologies,* p. 120. See Norman Bryson, *Vision in Painting: The Logic of the Gaze* (New Haven: Yale Univ. Press, 1983) for a discus-sion of the role of mimesis in art.

154. See Graham Duggan, "Decolonizing the Map: Post- Colonialism, Post-Structuralism and the Cartographic Connection," *Ariel* 20:4 (Oct. 1989):115–31.

155. For Daumier, see Wechsler, *A Human Comedy,* pp. 132–73. On Philip-pon, see Sandy Petrey "Pears," *Representations* 35 (Summer 1991): 52–71.

156. Derrida, "The Double Session," p. 194.

CHAPTER FOUR

1. Paul Broca, "Transactions of the Anthropological Society of Paris during 1865–67," *The Anthropological Review* 22 (July 1868):227–28.

2. See Marc Bloch, *The Royal Touch* (London, 1973).

3. Sébastien Guillé, quoted by William R. Paulson, *Enlightenment, Romanti-cism and the Blind in France* (Princeton: Princeton Univ. Press, 1987), p. 95.

4. Abbé C. Carton, *Le Sourd-Muet et L'Aveugle* (Bruges: Vandescasteele-Werbrouck, 1840), p. 1.

5. L. Couëtoux and Hamon de Fougeray, *Manuel Pratique des Méthodes d'En-seignement spéciales aux Enfants Anormaux (sourds-muets, aveugles, idiots, bégués etc)* (Paris: Félix Alcan, 1886), p. 131 and p. 19.

6. Thomas Arnold, *The Language of the Senses with Special Reference to the Education of Deaf, Blind, Deaf & Blind* (Margate, England: Keble's Gazette, 1894), pp. 9–15.

7. *La Defense des Sourds-Muets* 22 (Oct 1886): 105.

8. Collignon, quoted in *RG,* 8ème année, no. 3 (Mar. 1907): 150.

9. Michelle Perrot, ed., *A History of Private Life,* vol. IV (Cambridge MA: Belknap Press, 1990), p. 495.

10. Ad. Desbarrolles, *Chiromancie Nouvelle. Les Mystères de la Main revelées et expliquées* (Paris: E. Denton, 1859), p. 419.

11. Havelock Ellis, *The Criminal* (New York: Scribner & Warford, 1890), p. 83.

12. Ibid., p. 118.

13. G. Jelgersma, "Les caractères physiques intellectuels et moraux reconnus

chez le criminel né sont d'origine pathologique," *Actes du Troisième Congrès International d'Anthropologie Criminel* (Bruxelles: F. Hayez, 1892), pp. 32–33.

14. See Donald E. English, *Political Uses of Photography in the Third French Republic 1871–1914* (Ann Arbor: Univ. of Michigan, 1984), pp. 75–79.

15. Reproduced in John Szarkowski, *Photography until Now* (New York: Museum of Modern Art, 1989).

16. See for example the portraits of Birmingham prisoners from 1860–62 reproduced in John Tagg, *The Burden of Representation: Essays on Photographies and Histories* (Amherst: Univ. of Massachussetts, 1988), p. 58.

17. Edmond Duranty, "The New Painting: Concerning the Group of Artists Exhibiting at the Durand Ruel Galleries," in Linda Nochlin, ed., *Impressionism and Post-Impressionism 1874–1904: Sources and Documents* (Englewood Cliffs NJ: Prentice-Hall, 1966), p. 5.

18. Edgar Degas, "Notebooks," quoted in ibid., p. 62.

19. On the artist as a detective, see Carlo Ginzburg, *Clues, Myth and Historical Method* (Baltimore: Johns Hopkins Univ. Press, 1989).

20. Francis Galton, *Fingerprints* (London: Macmillan, 1892), pp. 2 and 14.

21. Quoted in *JSM* 16 (5 August 1985): 245.

22. This topic has been much discussed in recent scholarship. I have found these works particularly helpful: Anthea Callen, "Degas' *Bathers:* Hygiene and Dirt—Gaze and Touch," in Richard Kendall and Griselda Pollock, eds., *Dealing with Degas: Representations of Women and the Politics of Vision* (New York: Universe, 1992); Richard Shiff, "On Criticism Handling History," *History of the Human Sciences* 2, no. 1 (Feb. 1989): 63–87; John Barrell "*Venus de Medici*" in *The Birth of Pandora and the Division of Knowledge* (Philadelphia: Univ. of Pennsylvania Press, 1992).

23. Charles Rosen and Henri Zerner, *Romanticism and Realism: The Mythology of Nineteenth-Century Art* (New York: Viking, 1984), p. 229

24. Walter Benjamin, "The Work of Art in the Age of Mechanical Reproduction," in *Illuminations* trans. Harry Zohn (New York: Schocken Books, 1968), p. 233.

25. See also Guiliana Bruno, "Spectatorial Embodiments: Anatomies of the Visible and the Female Bodyscape," *Camera Obscura* 28 (Jan. 1992): 239–62; and Marcia Pointon, *Naked Authority* (New York: Cambridge Univ. Press, 1990), chapter two.

26. Maxime du Camp, *Le Salon de 1857* (Paris: Librairie Nouvelle, 1857), p. 105.

27. Camille Vathaire, "Salon de 1899," *RG,* 1ère année, no. 3 (1899):65.

28. Quoted in Anne M. Wagner, *Jean-Baptiste Carpeaux: Sculptor of the Second Empire* (New Haven: Yale University Press, 1986), p. 66.

29. Quoted by Alex Potts in "Male Phantasy as Modern Sculpture," *Oxford Art Journal* 15, no. 2 (1992): 40.

30. Henri Jouin, *La Sculpture aux Salons de 1881, 1882, 1883 et à l'exposition nationale de 1883* (Paris: Plon, 1884), p. 8 and p. 11. References to Jouin's *Salons* will be by year only hereafter.

31. Marcel Mauduit, *Le Reveil des Sourds-Muets*, 3e année, no. 15 (Jan. 1902): 3.

32. Auguste Boyer, *Félix Martin. Artiste Sculpteur. Chevalier de la Légion d'Honneur. Sourd Muet de naissance* (Paris: Atelier Typographique de l'Institut Nationale des Sourds-Muets, 1906), p. 1.

33. J. Theobald, "L'Atelier de Sculpture," *Bulletin de la Société Centrale d'Education et d'Assistance pour les Sourds Muets en France* 3 (Jan. 1875): 22.

34. Antoinette Le Normand Romain "Formation," in Philippe Durey et al., eds., *La Sculpture au XIXème Siècle* (Paris: Réunion des musées nationaux, 1986), pp. 36–38.

35. Gautier, *Journal Officiel* (19 Aug. 1869), quoted in Boyer, *Félix Martin*, p. 2.

36. George W. Stocking, *Victorian Anthropology* (New York & London: Free Press, 1987), p. 76 and see pp. 46–185 for a full account of the controversies surrounding evolution in Britain.

37. Charles Darwin, *The Origin of Species* (1859), rpr. *The Origin of Species and the Descent of Man* (New York: The Modern Library, n.d.), p. 450

38. Ibid., p. 148.

39. Ibid., p. 183.

40. Ibid., p. 148.

41. Edward Burnet Taylor, *Researches into the Early History of Mankind and the Development of Civilisation* (London: John Murray, 1865), p. 14.

42. Ibid., p. 16.

43. Ibid., pp. 53–54.

44. James Sibree, *Madagascar Before the Conquest: The Island, the Country and the People* (London: T. Fisher Unwin, 1896), p. 165. See pp. 166–70 for examples of the signs collected by Sibree.

45. Charles Darwin, *The Descent of Man and Selection in Relation to Sex* (1871), rpr. *The Origin of Species and the Descent of Man*, p. 497.

46. Ibid., p. 466.

47. Ibid., p. 465.

48. Ibid., p. 434.

49. Ibid., p. 62.

50. Ibid., pp. 351 and 353.

51. Darwin, *Origin of Species*, p. 448.

52. Nancy Leys Stepan, *"The Hour of Eugenics": Race, Gender and Nation in Latin America* (Ithaca & London: Cornell University Press, 1991), p. 67. See also

Ludmilla Jordanova, *Lamarck* (New York: Oxford University Press, 1984), pp. 100–112.

53. B. A. Morel, *Traité de dégénérescences physiques, intellectuelles et morales de l'espèce humain* (Paris, 1857). See Robert A. Nye, *Crime, Madness and Politics in Modern France: the Medical Concept of National Decline* (Princeton: Princeton Univ. Press, 1984), pp. 121ff.

54. On Taine's influence, see Hans Aarsleff, *From Locke to Saussure. Essays on the Study of Language and Intellectual History* (Minneapolis: Univ. of Minnesota, 1982). On Taine's influence on the Impressionists, see Richard Shiff, *Cézanne and the End of Impressionism* (Chicago: Univ. of Chicago Press, 1984).

55. Quoted by Patrizia Lombardo, "Hippolyte Taine between Art and Science," *Yale French Studies,* ed. E. S. Burt and Janie Vanpée, *Reading the Archive: On Texts and Institutions* 77 (1990):117.

56. Hippolyte Taine, *The History of English Literature,* trans. H. Van Laun (London: Chatto and Windus, 1871), p. 5. All references to this text are from the "Introduction," pp. 1–21.

57. Taine, *Histoire,* p. 9.

58. Taine, *De l'Intelligence* (1871), 3rd ed. (Paris: Hachette, 1878), p. 51.

59. Taine, *De l'Intelligence,* p. 30.

60. Shiff, *Cézanne and the End of Impressionism,* p. 42

61. Taine, *De l'Intelligence,* p. 41.

62. Jules Laforgue, "Impressionism," in Linda Nochlin, ed., *Impressionism and Post-Impressionism 1874–1904: Sources and Documents,* p. 17 (translation modifed). See T. J. Clark, *The Painting of Modern Life: Paris in the Art of Manet and his followers* (Princeton: Princeton Univ. Press, 1984), p. 16 and Michele Hannoosh, "The Poet as Art Critic: Laforgue's Aesthetic," *The Modern Language Review* 79:3 (July 1984): 553–69 for discussions of Laforgue's critique of Impressionism.

63. I do not wish to argue that Impressionism must be rejected as racist but simply to register that its reception in the nineteenth century was inevitably inflected by the prevailing racial theory of the period and that this had consequences for deaf artists in particular and for artists in general. See Griselda Pollock, *Avant-Garde Gambits 1888–1893: Gender and the Colour of Art History* (London: Thames & Hudson, 1992).

64. G. B. Duchenne (de Boulogne), *De l'Electrisation localisée et son application à la pathologie et la thérapeutique,* 2nd ed. (Paris: J-B Baillière, 1861), pp. 989–1030.

65. Quoted in André Jammes, "Duchenne de Boulogne: La Grimace Provoquée et Nadar," *Gazette des Beaux-Arts,* VIe période, vol. 192 (Dec. 1978): 215–20.

66. Charles Darwin, *The Expression of Emotions in Man and Animals* (London: J. Murray, 1872), p. 351.

67. O. G. Rejlander, quoted by Stephanie Spencer, "Art and Photography: Two Studies by O. G. Rejlander," *History of Photography* 9, no. 1 (1989): 49.

68. Charles Le Brun, *Méthode pour apprendre à dessiner les Passions* (Amsterdam, 1697).

69. Edouard Cuyer, *La Mimique* (Paris: Octave Doin, 1902), pp. 37–42.

70. Eugène Guillaume, *Ecole Nationale et Spéciale des Beaux-Arts. Conseil Supérieur. Rapport présenté au Conseil par M. le Directeur de l'Ecole au commencement de l'année scolaire 1874–5* (Paris: Imprimerie Nationale, 1875).

71. This *Cours d'Anatomie* is preserved in the *Bibliothèque de l'Ecole des Beaux-Arts,* Paris.

72. Cuyer, *Mimique,* p. 352.

73. E. Cuyer, *L'Anatomie Plastique* (Paris: Octave Doin, 1913), p. 284.

74. For example, Cuyer proudly declared that he had initiated the teaching of anatomy to women in 1877. Ibid., p. 2.

75. Quoted by Claude Blanckaert, "On the Origins of French Ethnology: William Edwards and the Doctrine of Race," in George Stocking, ed., *Bones, Bodies, Behaviour: Essays in Biological Anthropology,* History of Anthropology, vol. 5 (Madison: University of Wisconsin, 1988), p. 19.

76. Theobald, "L'Atelier de Sculpture," p. 23.

77. *Bulletin de la Société Centrale d'Education et d'Assistance pour les Sourds-Muets en France* (Mar. 1875):42.

78. Anne Wagner, "Outrages: Sculpture and Sedition after 1791," in Ann Bermingham and John Brewer, eds., *Consumption and Culture* (New York: Routledge, forthcoming).

79. *Courrier Français,* nos. 57–58 (26–27 Feb. 1848).

80. Quoted by Schiller, *Broca,* p. 291.

81. Charles Timbal, "Salon de 1877," *Le Correspondant* (31 May 1877).

82. Elie de Mont, *Cours à travers le Salon de 1877* (Charleville: A. Pouillard, 1877), p. 30. See Henri Houssaye's "Salon" in the *Revue des Deux-Mondes* for a dissenting view.

83. Maurice Agulhon, *Marianne au Pouvoir. L'imagérie et la symbolique républicaines de 1880 à 1914* (Paris: Flammarion, 1989), p. 119.

84. Quoted by Marina Warner, *Monuments and Maidens: The Allegory of the Female Form* (New York: Atheneum, 1985), p. 21; and requoted by Mark Lewis, "What is to be Done? Art and Politics After the Fall," in Arthur and Marilouise Kroker, eds., *Ideology and Power in the Age of Lenin In Ruins* (New York: St Martin's Press, 1991), p. 3.

85. Marina Warner, *Monuments and Maidens,* p. 37.

86. Jouin (1875):14 and 10.

87. Jouin (1879): 56.

88. Jouin (1873):19.

89. Jouin (1875): 6.

90. Jouin (1874):31.

91. Jouin (1873):26.

92. Jouin (1874): 24.

93. Jouin (1873):10.

94. Wagner, *Jean-Baptiste Carpeaux,* p. 23.

95. The word "eugenics" was first coined in 1883 by Francis Galton, but the "idea" of eugenics had been in the air for some time. Nancy Leys Stepan writes: "Evolution gave Galton ideas that, clustered together in a new fashion, formed the kernel of eugenics. . . . The implications . . . were worked out in more substantial, if substantially flawed, fashion in 1869 in *Hereditary Genius* [by Galton], a book that stills stands as the founding text of eugenics," '*The Hour of Eugenics*', p. 22.

96. Jouin (1877):26.

97. Albert Boime, *The Art of Exclusion: Representing Blacks in the Nineteenth Century* (Washington DC and London: Smithsonian Institution Press, 1990), p. 47.

98. Jouin (1873): 42–43.

99. *Bulletin de la Société Centrale d'Education et d'Assistance pour les Sourds-Muets en France* (Jan. 1875): 21.

100. See Stephen Jay Gould, *The Mismeasure of Man* (New York & London: Norton, 1981), pp. 97–98.

101. Jouin (1875):37.

102. On Clésinger, see Peter Fusco and H. W. Janson, eds., *The Romantics to Rodin: French Nineteenth-Century Sculpture* (Los Angeles: Los Angeles County Museum of Art, 1980), pp. 174–79.

103. Quoted by Bram Dijkstra, *Idols of Peversity: Fantasies of Feminine Evil in Turn-of-the-Century Culture* (New York: Oxford Univ. Press, 1986), p. 167.

104. Jouin (1875):10

105. Théophile Denis, "Frédéric Peyson," *Revue Française de l'Education des Sourds Muets,* 5ème année, no. 12 (Mar. 1890):270.

106. Adolphe Franck, quoted in [Anon], *Statue de l'Abbé de l'Epée, œuvre de M. Félix Martin* (Paris: Institution Nationale des Sourds-Muets de Paris, 1879), ɔ. 38.

107. Jouin (1875):36.

108. *Bulletin de la Société Centrale d'Education et d'Assistance pour les Sourds-Muets en France* (Jan. 1876).

109. Maxime du Camp, from *Revue des Deux Mondes* (15 April 1873), translated as "The Paris Institution," in *The American Annals of the Deaf* XXI, no. 1 (Jan. 1877): 9

110. Ibid., pp. 10–12.

111. Du Camp, "The Paris Institution (cont.)," *American Annals of the Deaf* XXII, no. 2 (2 Apr. 1877):76.

112. Ferdinand Berthier, *L'Abbé de l'Epée* (Paris: Michael Levy, 1852), pp. 284–86

113. Jouin (1876): 66.

114. Fusco and Janson, *The Romantics to Rodin,* p. 212.

115. Boime, *The Art of Exclusion,* p. 172.

116. Jouin (1877):31.

117. Roger de Piles, *Cours d'Instruction* (Paris, 1708) p. 3. For a longer discussion of the term, see N. D. Mirzoeff, "Seducing Our Eyes: Gender, Jurisprudence and Visuality in Watteau," *Eighteenth Century: Theory and Interpretation,* vol. 35, no. 2 (1994): 135–154.

118. For pertinent examples, see Ann Wagner, "Rodin's Reputation," in Lynn Hunt, ed., *Eroticism and the Body Politic* (Baltimore and London: Johns Hopkins Univ. Press, 1991), pp. 199–211.

119. Eugène Loudun, "Salon de 1877," *Le Mois Littéraire et Philosophique* (21 May 1877):343.

120. *Journal Officiel* (27 June 1877), quoted by Boyer, *Félix Martin,* p. 6.

121. *Statue de l'Abbé de l'Epée,* pp. 22–23.

122. Ibid., p. 37.

123. E. M. Gallaudet, *Proceedings of the 7th Convention of American Instructors of the Deaf and Dumb* (Indianapolis: Indiana Institution for the Deaf and Dumb, 1870), pp. 64–65.

124. Quoted by Francisque Sourcey. *XIXème Siècle* (Sep. 1874).

125. Du Camp, "The Paris Institution," *American Annals of the Deaf* XXII (1877):77.

126. Adrien Cornié, *Etude sur l'Institution des Sourdes-Muettes de Bordeaux 1786–1903* (Bordeaux: F. Pech, 1903), p. 54.

127. Quoted by Harlan Lane, *When the Mind Hears: a History of the Deaf* (New York: Random House, 1984), p. 391, who provides a detailed history of the Milan Congress, pp. 377–95.

128. Donald E. English, *Political Uses of Photography,* p. 75.

129. Quoted by Galton, *Fingerprints,* p. 169.

130. On degeneration, see J. Edward Chamberlain and Sander L. Gilman, eds., *Degeneration: The Dark Side of Progress* (New York: Columbia Univ. Press, 1985), which includes essays on topics ranging from anthropology to art, literature, and sociology.

131. Quoted by Pierre Sorlin, *Waldeck-Rousseau* (Paris: Armand Colin, 1966), p. 264. See also Stanford Elwitt, *The Making of the Third Republic: Class and Politics in France, 1868–1884* (Baton Rouge: Lousiana State Univ. Press, 1975).

132. Waldeck-Rousseau (1 March 1883), quoted by Nye, *Crime, Madness and Politics,* p. 81. See p. 86 for the question of regeneration.

133. *RG,* 1ère année, no. 3 (1899): 69.

134. André Regnard, *Contribution à l'Histoire de l'Enseignment des Sourds-Muets* (Paris: L. Larose, 1902), p. 70.

135. Ibid., p. 51. See Christian Cuxac, *Le Langage des Sourds,* pp. 144–47 for commentary on Regnard.

136. G. Ferreri, *Congrès Internationale pour l'Etude des Questions d'Education et d'Assistance des Sourds-Muets,* trans. Jules Auffray (Asnières: Institut Départmental de Sourds-Muets et de Sourdes-Muettes), p. 8.

137. Jan Goldstein, "The Wandering Jew and the Problem of Pyschiatic Anti-Semitism in Fin-de-Siècle France," *Journal of Contemporary History* 20 (1985): 530.

138. *Revue Bibliographique Internationale de l'éducation des Sourds-Muets* 6 (Mar. 1886).

139. *Revue Bibliographique Internationale de l'éducation des Sourds-Muets* 4 (Dec. 1885):65.

140. Henri Gaillard, *Le Sécond Congrès International des Sourds-Muets. Chicago 1983* (Paris: Journal des Sourds-Muets, 1893), p. 35.

141. See *Cahier de l'Histoire des Sourds* 4 (1990): 4.1.

142. *La Defense des Sourds-Muets* 9 (Sep. 1885): 65.

143. [Anon], *Aperçu Historique des Banquets annuels des Sourds-Muets en honneur de la naissance de l'Abbé de l'Epée* (Paris: La Société d'Appui Fraternel des Sourds-Muets de France, 1913), pp. 12–14.

144. *JSM* 8 (5 April 1895):120.

145. *Aperçu Historique,* p. 16. The artists who participated included Loustau, César Levert, Jean Levassor, Joseph Tronc, Ernest Martin, Victor Colas, Georges Martin, Jules Cochefer, and Paul Choppin.

146. Ibid., p. 17–18.

147. Gaillard, *Le Second Congrès,* p. 35.

148. Emile Begererat, "Salon de 1881," *Le Voltaire* (11 June 1881).

149. A. Legrand, "René Princeteau," *RG,* 15ème année, no. 9 (Mar. 1914): 176–77.

150. Denis, "Salon de 1886," p. 37.

151. As Cabanel was from Peyson's home town, Montpellier, one wonders if the deaf artist encouraged his famous colleague to train deaf students.

152. *RI* III, no. 4 (Jul. 1887): p. 99.

153. Denis, "Salon de 1886," p. 33.

154. Denis, "Salon de 1887," *Revue Française de l'Education des Sourds-Muets* 3 (Jun. 1887):55.

155. Two other Orientalist paintings by Bouchard, *The Intrigue* and *The Turk-*

ish Bath, are reproduced in Philippe Julian, *The Orientalists,* trans. Helga and Dinah Harrison (Oxford: Phaidon, 1977).

156. Quoted in Fusco and Janson, *The Romantics to Rodin,* p. 277.

157. Denis, "Les Muets du Serail," p. 134.

158. Quoted by Schiller, *Paul Broca,* p. 293.

159. Fusco and Janson, *Romantics to Rodin,* p. 316.

160. Quoted by Boyer, "Choppin," p. 5.

161. Paul Broca, *Sur le siège de la faculté du langage articulé avec deux observations d'Aphémie* (Paris: Victor Masson, 1861), p. 4.

162. *Le Figaro* (29 Jul. 1897).

163. *Le Figaro* (31 Jul. 1897).

164. G. de Mortillet, "La Statue de Broca," *L'Homme,* 4ème année, no. 15 (10 Aug. 1887): 452.

165. Soon afterwards, the Paris Council decided to replace the Broca with a statue of Danton, which still stands on the spot, and remove the offending anthropologist to the *Ecole d'Anthropologie.* See *L'Homme* 4, no. 22 (25 Nov. 1887): 749.

166. Octave Claveau (1881), quoted in his obituary, *RG* 6ème année, no. 5 (Nov. 1904):80.

167. Epée (1784), as quoted in Francine Markovits, "L'abbé de l'Epée: du verbe intérieur au langage des gestes," in Alexis Karacostas, ed., *Le Pouvoir des Signes* (Paris: Institut National des Jeunes Sourds, 1989), pp. 35ff.

CHAPTER FIVE

1. In order to clarify this distinction, I shall where necessary retain the original phrases in translation, against previous practice. Interestingly, the word *sourd-parlant* has disappeared from French dictionaries, such as the multi-volume Robert, and even the historical *Trésor de la langue française.*

2. [Anon], *Notice Sur l'Institution Nationale des Sourds-Muets de Paris* (Paris: Institution Nationale des Sourds-Muets, 1896), p. 27.

3. Bourneville, preface to Hamon du Fougeray and L. Couëtoux, *Manuel Pratique des Méthodes d'Enseignement spéciales aux Enfants Anormaux (sourds-muets, aveugles, idiots, bègües etc.)* (Paris: Alcan, 1896), p. xiii.

4. *Notice,* p. 31.

5. *JSM* 41 (12 Aug. 1896):245.

6. Michel Foucault, *Discipline and Punish: The Birth of the Prison,* trans. Alan Sheridan (Harmondsworth: Penguin, 1977), p. 294.

7. *Notice,* p. 45.

8. *Notice,* p. 57.

9. Four pupils were expelled from the Bordeaux institution in 1881, the year

after the Milan Congress. By 1889, sixteen pupils had been expelled. Adrien Cornié, *Sur l'Institution Nationale des Sourdes-Muettes de Bordeaux 1786–1903* (Bordeaux: F. Pech, 1903), p. 67.

10. *Notice*, p. 42.

11. *Notice*, pp. 43–44.

12. Bernard Thollon, *Rapport fait au nom de la commission chargée par la conférence de professeurs de reviser le programme de langue Française* (Paris: Institut National des Sourds-Muets, 1904), p. 30.

13. Jules Richard, *Annales d'hygiene publique* (1885), quoted by Robert Nye, *Crime, Madness and Politics in Modern France: The Medical Concept of National Decline* (Princeton: Princeton Univ. Press, 1984), p. 44.

14. *Notice*, pp. 35–40.

15. B. Thollon, *Education et Protection des Sourds-Muets* (Paris: Radiguet & Massiot, n.d. [c.1910]), p. 24.

16. See Henri Gaillard, *Le Droit des Sourds-Muets au Travail* (Paris: Gaston Vialatte, 1923).

17. Regnard, the inspector of the deaf institutes, was infuriated to discover that 14,000 francs per year were spent on each pupil, when many did not learn to speak at all. Albert Regnard, *Contribution à l'Histoire de l'Enseignement des Sourds-Muets* (Paris: L. Larose, 1902), p. 73.

18. Adolphe Drouin, "A Quand Les Réformes?" *L'Avenir des Sourds-Muets* 1 (15 Mar. 1894): 2.

19. Henri Gaillard et Henri Jeanvoine, *Congrès International pour l'étude des Questions d'Assistance et d'Education des Sourds-Muets (Section des Sourds-Muets)* (Paris: Imprimerie d'Ouvriers Sourds-Muets, 1900), pp. 32–33.

20. *JSM* 18 (5 Sep. 1895): 278.

21. *RI* IX:1–2 (Avril-Mai 1894): 19. The French artists were joined by an international contingent, including Douglas Tilden and Granville Redmond from the United States; John McNaughton from Canada; Collas and Saxton from England; and Gliatis from Greece.

22. Albert F. Woodridge, "The Art of Drawing and Its Importance to the Deaf-Mute," *American Annals of the Deaf* XXVI:1 (Jan. 1881): 27.

23. Théophile Denis, *La Musée des Sourds-Muets. Galérie Historique et artistique de l'Institut National des Sourds-Muets de Paris* (Paris: Bureaux de la RI des Sourds-Muets, 1891), p. 4.

24. Barbara Kirshenblatt-Gimblett, "Objects of Ethnography," in Ivan Karp and Steven D. Lavine, eds., *Exhibiting Cultures: The Poetics and Politics of Museum Display* (Washington DC: Smithsonian Institution Press, 1991), p. 387.

25. Adolphe Franck, *Rapport au Ministre de l'Intérieur et des cultes Sur le Congrès international réuni à Milan du 6 au 12 septembre pour l'amélioration du sort des sourds-muets* (Paris: Librairie des publications législatives, 1880), p. 27.

26. Kirshenblatt-Gimblett, "Objects of Ethnography," pp. 398–99. See also George W. Stocking, ed., *Objects and Others: Essays on Museums and Material Culture*. History of Anthropology, vol. 3 (Madison: Univ. of Wisconsin Press, 1985).

27. James A. Boon, "Why Museums Make Me Sad," in Karp and Levine, *Exhibiting Cultures*, p. 258.

28. J. M. Charcot, *Oeuvres Complètes: Leçons sur les maladies du système nerveux*, tome III (Paris: Lecroisnier et Babé: 1890), p. 5.

29. E. T. Hamy, "La Collection anthropologique du Museum National d'Histoire Naturelle," *L'Anthropologie* XVIII (1907): 276.

30. James Clifford, *The Predicament of Modern Culture: Twentieth-Century Ethnography, Literature and Art* (Cambridge MA: Harvard Univ. Press, 1988), p. 228.

31. Kirshenblatt-Gimblett, "Objects of Ethnography," p. 394.

32. *L'Intermédiaire des chercheurs et curieux* (1891), quoted in *RI* VII, no. 8 (Nov. 1891): 234.

33. *Le Petit Parisien*, quoted in *RI* IX:1–2 (Apr.-May 1894):17.

34. Théophile Denis, *Musée des Sourds-Muets: Catalogue Sommaire* (Paris: Imprimerie de l'Institut National des Sourds-Muets, 1896), p. 82.

35. *JSM* 2 (5 Jan. 1895):26.

36. *La France des Sourds-Muets* 10 (1 July 1904): 175.

37. Kirshenblatt-Gimblett, "Objects of Ethnography," p. 407.

38. See J.-M. Charcot, *Les Démoniaques dans l'art* (1887; rpr. Amsterdam: BM Israel, 1972). For commentaries, see Debora Silverman, *Art Nouveau in fin-de-siècle France: Politics, Psychology and Style* (Berkeley: Univ. of California Press, 1989), pp. 81–96; Jan Goldstein, *Console and Classify: The French Psychiatric Profession in the Nineteenth Century* (New York: Cambridge Univ. Press, 1987), pp. 322–77; Joan Copjec, "*Omni Flares et Dissipati Sunt*," in *October: The First Decade* (Cambridge MA: MIT Press, 1986); and Jann Matlock, *Scenes of Seduction: Prostitution, Hysteria, and Reading Difference in Nineteenth-Century France* (New York: Columbia Univ. Press, 1994), pp. 123–61.

39. Quoted by Silverman, *Art Nouveau*, p. 93–94. See also pp. 81–96.

40. See André Pierre Brouillet, *A Clinical Lesson of Dr Charcot at the Salpêtrière* (Harvard Univ., 1887), reproduced in Matlock, *Scenes of Seduction*, p. 134.

41. Quoted by Goldstein, *Console and Classify*, p. 333.

42. Charcot (1889), quoted by Silverman, *Art Nouveau*, p. 85.

43. M. X's case is told in Charcot, *Oeuvres Complètes*, tome III, pp. 178–90. The definition of aphasia is on p. 154.

44. Ibid., p. 190.

45. Du Fougeray and Couëtoux, *Manuel Pratique*, p. 8 and p. 13.

46. Charles Hacks, *Le Geste* (Paris: Marpon et Flammarion: n.d. [1892]),

p. 10. On Hacks, see Anne-Marie Drouin, "Un objet mal défini dans une science sans nom. La sémiologie du geste au XIXème siècle," *Communications* 54 (1992): 263–87.

47. Hacks, *Le Geste,* pp. 66–68.

48. G. Ferreri, *Congrès Internationale pour l'Etude des Questions d'Education et d'Assistance des Sourds-Muets,* trans. Jules Auffray (Asnières: Institut Départmental de Sourds-Muets et de Sourdes-Muettes), p. 52.

49. The detailed minutes of the Congress make depressing reading. Gallaudet moved the joint session and was rejected, pp. 38–39. It can usefully be compared with the minutes of the deaf section, which was again divided, with Marcel Mauduit and others defending oralism, Gaillard and Jeanvoine, *Le Congrès Internationale,* pp. 66–69.

50. *La Defense des Sourds-Muets* 21 (Sep. 1886): 96.

51. Jacques Rambusson, *Langue Universelle. Langage Mimique mimé et écrit. Développement philosophique et pratique* (Paris: Garnier, 1853), p. 6 and p. 30.

52. *La Lumière* 35 (1 September 1855): 132.

53. *JSM* 20 (25 Oct 1895): 332; and 44 (25 Sep. 1896): 294.

54. Thollon, *Education et Protection,* p. 9. Using the same figures, Auguste Boyer and Dr. Feré concluded that there were 2250 deaf children not receiving an education, *L'Examen Anthropologique des Jeunes Sourds-Muets et leur classification au point de vue de l'intelligence* (Paris: Atelier Typographique de l'Institut National des Sourds-Muets, 1902), p. 14.

55. *La Defense des Sourds-Muets* 23 (Nov. 1886): 121.

56. Hirsch had trained at the *Ecole des Beaux-Arts* with the Academic artists Pils and Bonnat. He later travelled to England, where he learned the new technique of photoengraving, and was a frequent exhibitor at the Salon. *JSM* 40 (30 Jul. 1896): 227.

57. Henri Gaillard, *Le Second Congrès International des Sourds-Muets, Chicago 1893* (Paris: Journal des Sourds-Muets, 1893), p. 50

58. *JSM* 44 (25 Sep. 1896): 291.

59. *JSM* 8 (5 Apr. 1895): 114.

60. Eugène Née, "Les Snobs Philosophes," *JSM* 19 (20 Sep. 1895): 290.

61. Holger Mygind, *Deaf-Mutism,* trans. Norris Wolfenden (London: F. J. Rebman, 1894), p. 234.

62. Ibid., p. 22.

63 Sander Gilman, *The Jew's Body* (New York: Routledge 1991), p. 80.

64. *JSM* 30 (25 Feb. 1896): 66.

65. Such was the opinion of Camille Holweck, a deaf-blind correspondent to the *Journal* a few weeks later: "Let's concentrate on our own concerns, paying no

regard to the words of madmen and hawkers, rather than losing ourselves in useless protests," *JSM* 33 (10 Apr. 1896): 116.

66. Eugène Née, *Les Sourds-Muets et les anthropologistes. Mémoire en réponse au Dr Mygind, présenté au Congrès de Genève* (Paris: Imprimeries d'Ouvriers Sourds-Muets, 1898), pp. 2–3.

67. All quotations from Dr. M. Sanjuan, *Sur les Hallucinations Symboliques dans les psychoses et dans les rêves des sourds-muets* (Paris: Publications du Progrès Médical, 1897), pp. 2–14.

68. See E.M.G.C., and *JSM* 18 (5 Sep. 1895): 278; V. Borie de Cambort, "Félix Plessis," *La Revue du Bien dans la vie et dans l'art* 5 (1 May 1903): 5; *Gazette des Sourds-Muets*, 2ème année, 3 (15 Dec. 1891): 39.

69. Mary Jane Haley, *Granville Redmond: A Triumph of Talent and Temperament* (Oakland CA: Oakland Museum, 1989), p. 29.

70. Gaston Steigler, *L'Echo de Paris* (7 June 1985), quoted in Alexis Karacostas, ed., *Le Pouvoir des Signes* (Paris: Institut National des Jeunes Sourds, 1989), p. 106

71. [Anon], "Visite de M. Félix Faure, Président de la République Français," MS, n.d., Archives de l'Institut National des Jeunes Sourds, p. 12.

72. Charles Dauzat, "Un Musée Inconnu," *Le Figaro* (15 Jan. 1897).

73. Henri Gaillard, "Salon de 1895," *JSM* 16 (5 Aug. 1895): 244.

74. V. Borie de Cambort, "Félix Plessis," p. 5.

75. Camille Vathaire, "Les Artistes Sourds-Muets au Salon de 1900," *RG*, 2ème année, 1 (May 1900): 5.

76. *JSM* 15 (20 July 1895): 229.

77. *Gazette des Sourds-Muets*, 2ème année, 3 (15 Dec. 1891): 39.

78. *JSM* 18 (5 Sep. 1895): 277.

79. *RI* IX: 5–6 (Jun.-Jul. 1984).

80. J. K. Huysmans, *Certains*, pp. 25–26, quoted and translated by Carol M. Armstrong in *Odd Man Out: Readings of the Work and Reputation of Edgar Degas* (Chicago: Chicago Univ. Press, 1991), p. 193.

81. Camille Vathaire, "Salon de 1906," *RG*, 8ème année, 3 (Jul.-Sep. 1906): 40.

82. George Lafenestre, "Les Salons de 1890," *Revue des Deux Mondes*, 3ème période (1890): 644.

83. *Exposition d'oeuvres d'artistes sourds, Français vivants. Organisé à l'Institut National des Sourds-Muets* (Paris: I.N.S.M.,1912).

84. Namely, the painters Jenny-Rebecca Bomsel (pupil of Richard, Mlle Rebeyrol, and Mlle Elmire Dubois), Marie-Thérèse Brès (pupil of Jules Adler and First Class prizewinner at the Marseilles exhibition of 1903), Mlle de la Touche (pupil of Mme Aubin), and the decorative artists Mme Marie-Célina Choppin

and Jeanne Léothaud. See also Dorothy Wise, a British sculptor; Gabriela Horalkova and Ilona Singer, Czech, painters; and the American photographer Clara Phoebe Simith (d. 1921). References from E.M.G.C.

85. File, "Salons Silencieux," Archives I.N.J.S. The Salon resumed activity after World War Two with exhibitions at Salzburg (1949) and Poitiers (1956). In 1957, an exhibition of Peyson's work was held at the Musée Fabre, Montpellier, to celebrate the 150th anniversary of his birth and the *Salon Silencieux* of that year, *Midi Libre* (6 Apr. 1957).

86. [Anon], *Joseph Cochefer: Notice Biographique rédigée par un groupe de sourds-muets* (Paris: Aux Bureaux de l'Echo des Sourds-Muets, 1904), p. 16.

87. *JSM* 39 (15 July 1896).

88. Quoted in *JSM* 41 (12 Aug. 1896): 247–49.

89. Jean-Denis Bredin, *L'Affaire* (Paris: Julliard, 1983), pp. 75–82.

90. Emily S. Apter, *Feminizing the Fetish: Psychoanalysis and Narrative Obsession in Turn of the Century France* (Ithaca: Cornell Univ. Press, 1991), p. 150.

91. See Herman Lebovics, *True France: The Wars over Cultural Identity 1900–1945* (Ithaca: Cornell Univ. Press, 1993).

92. Quoted by Pierre Birnbaum, *Les Fous de la République: Histoire politique des Juifs d'Etat de Gambetta à Vichy* (Paris: Fayard, 1992), p. 397.

93 Quoted by Elizabeth Friedman, *Colonialism and After: An Algerian Jewish Community* (South Hadley MA: Bergin and Garvey, 1988), p. 21.

94. Henri Gaillard, "Comment faut-il finir l'Affaire," *La République de Demain* 18 (Sep. 1899): 170–73.

95. *JSM* 81 (15 Jul. 1899): 332.

96. *JSM* 67 (16 Apr. 1898): 88.

97. *JSM* 68 (20 Jun. 1898): 99.

98. Jean Olivier, "Gaillard-Zola," in *Le Sourd-Muet Illustré,* 2ème année, no. 15 (Juin 1898).

99. See *Le Sourd-Muet Illustré,* 2ème année no. 19 (Oct. 1898)

100. See the articles by Jules Weill, deaf from birth, and Paul Tschek in *Le Reveil des Sourds-Muets,* 3ème année, no. 15 (Jan. 1902) and no. 17 (Mar. 1902), respectively.

101. *Le Reveil des Sourds-Muets,* 3ème année, no. 23 (Sep. 1902): 72.

102. Quoted in ibid., p. 151.

103. See Norman L. Kleeblatt, "Introduction—The Dreyfus Affair: A Visual Record," in his, ed., *The Dreyfus Affair: Art, Truth and Justice* (Berkeley: Univ. of California Press, 1987), p. 16. The cartoons are illustrated as pl. 46 and 47 on p. 178 and Debat-Ponson's picture appears as pl. 189 on p. 258.

104. See Camille Vathaire, "Les Artistes Sourds-Muets au Salon de 1899," *RG,* 1ère année, 3 (1899): 67.

105. George W. Stocking, *Victorian Anthropology* (New York: Free Press, 1987), p. 145.

106. The phrase is the dedication to Harry M. Laughlin's *Eugenical Sterilization in the United States: A Report of the Psychopathic Laboratory of the Municipal Court of Chicago* (Chicago: Psychopathic Laboratory of the Municipal Court, 1922).

107. For details of these debates, see Richard Winefield, *Never the Twain Shall Meet: Bell, Gallaudet and the Communications Debate* (Washington DC: Gallaudet Univ. Press, 1987).

108. Alexander Graham Bell, "Upon the Formation of a Deaf Variety of the Human Race," *Memoirs of the National Academy of Sciences*, vol. II (1883), p. 216.

109. For a modern account of Martha's Vineyard, see Nora Ellen Groce, *Everyone Here Spoke Sign Language: Hereditary Deafness on Martha's Vineyard* (Cambridge MA: Harvard Univ. Press, 1985).

110. Ibid., p. 221.

111. Alexander Graham Bell, "The Deaf," in *Department of Commerce and Labor. Bureau of the Census. Special Reports: The Blind and Deaf (1900)* (Washington DC: G.P.O., 1906), pp. 65–141. Figures quoted from pp. 65, 69, 88, and 141.

112. *Notice*, p. 48.

113. *Report of the Royal Commission of the Blind, Deaf and Dumb etc of the United Kingdom* (London: HMSO, 1889), p. lxxxii

114. See the table in *American Annals of the Deaf* XXVIII, no 1 (Jan. 1883): 52–53.

115. See Rosalind Krauss, "The Originality of the Avant-Garde: a Postmodern Repitition," reprinted in Brian Wallis, ed., *Art after Modernism* (New York, 1984), p. 16.

116. See Hans Aarsleff, *From Locke to Saussure: Essays on the Study of Language and Intellectual History* (Minneapolis: Univ. of Minnesota Press, 1982), esp. pp. 278–92 and 356–71.

117. Ferdinand de Saussure, *Course in General Linguistics*, trans. Wade Baskin (New York & London: McGraw-Hill, 1959), p. 15 and p. 70.

118. Boyer and Feré, *L'Examen Anthropologique*, p. 11. Figures from pp. 7–10.

119. Karl Pearson, "Introduction," *The Treasury of Human Inheritance* (London: Dulan, 1909), p. ix.

120. Pearson, *Treasury*, p. vii.

121. See Paul Popenoe, *Applied Eugenics* (New York: MacMillan, 1918); S. J. Holmes, *The Eugenic Predicament* (New York: Harcourt, Brace and Co, 1933), and Frederick Osborn, *Preface to Eugenics* (New York: Harper and Bros, 1940)

who all refer to Bell with approval as "the first scientific worker in eugenics," Popenoe (153).

122. See the excellent study by Daniel J. Kevles, *In the Name of Eugenics* (New York: Alfred A. Knopf, 1985), pp. 99–116.

123. Harry M. Laughlin, *Eugenical Sterilization*, p. 369.

124. Kevles, *In the Name of Eugenics*, p. 116.

125. Ibid., p. 117. Figures on the deaf in Nazi Germany from Karacostas, ed., *Le Pouvoir des Signes*, pp. 108–9.

126. Quoted in Laughlin, *Eugenic Sterilization*, p. 35.

127. Peter Bürger, *Theory of the Avant-Garde*, trans. Michael Shaw (Minneapolis: Univ. of Minnesota Press, 1984) and *The Decline of Modernism*, trans. Nicholas Walker (University Park PA: Pennsylvania State Univ. Press, 1992). For an important application of Bürger's thesis, see Andreas Huyssen, *After the Great Divide: Modernism, Mass Culture, Postmodernism* (Bloomington: Indiana Univ. Press, 1986).

128. See Molly Nesbit, *Atget's Seven Albums* (New Haven: Yale Univ. Press, 1992); Adrian Rifkin, *Street Noises* (Manchester: Manchester Univ. Press, 1992); & Christine Poggi, *In Defiance of Painting* (New Haven: Yale Univ. Press, 1992).

129. *Journal de l'Industrie Photographique* 8 (Aug. 1880): 118–25.

130. De Gérando, *De l'Education des Sourds-Muets*, vol. II (Paris: Mequinon, 1827), p. 532.

131. [Anon], *Banquets des Sourds-Muets réunis pour fêter l'anniversaires de la naissance de l'Abbé de l'Epée* (Paris: Jacques Ledoyen, 1842), p. 27.

132. Janet Buerger, *French Daguerreotypes* (Chicago: Chicago Univ. Press, 1989), p. 218.

133. *La Lumière*, première année: 21 (20 June 1851).

134. *La Lumière* (24 Feb. 1855): 30, quoted by Buerger, *French Daguerreotypes*, p. 130.

135. *Humphrey's Journal* (1 May 1855).

136. For example, a letter from Mme Gouin to Clerc, dated 1815, mentions his long years teaching her son and requests that Clerc reconsider his decision to move to the United States, LCP.

137. *Banquets des Sourds-Muets*, vol. II (Paris: Hachette, 1864), p. 108. *Bulletin de la Société Française de Photographie*, tome V (1859): 39.

138. Quoted by Buerger, *French Daguerreotypes*, p. 132.

139. Information on Braquehais from Michèle and Michel Auer, *Encyclopédie Internationale des Photographes de 1839 à nos jours* (Hermance, Switzerland: Camera Obscura n.d.), unless otherwise cited.

140. Elizabeth Anne McCauley, *A. A. E. Disdéri and the carte de visite Photograph* (New Haven: Yale Univ. Press, 1985), p. 23.

141. Mme Braquehais unusually produced stereoscopic daguerreotypes and prints on waxed canvas. She was one of the last practitioners in Paris to keep up with the medium, perhaps in order to keep the question of her identity open.

142. Janet Buerger dates all the work by Gouin in the International Museum of Photography to c. 1854 or later. Four out of the eleven are dated later than 1855, and five to 1855 itself, see *French Daguerreotypes*, pp. 218–19.

143. E. A. McCauley, *A. A. E. Disdéri*, p. 106.

144. See the collection in BN Etampes Eo 149. Other accessories used by Braquehais included a crucifix, a Greek vase, and, in one case, a mannequin of a male figure, made up of a mask, with frock coat and gloves.

145. *Banquets des Sourds-Muets*, vol. II, p. 186.

146. Quoted in Donald E. English, *Political Uses of Photography in the Third French Republic 1871–1914* (Ann Arbor MI: UMI Reseach Press, 1984), p. 26.

147. See T. J. Clark, *The Painting of Modern Life: Paris in the Art of Manet and His Followers* (Princeton NJ: Princeton Univ. Press, 1984), pp. 68–69.

148. *RG* 15 année: 9 (Mars 1914): 177.

149. *Le Mot d'Ordre* (28 Apr. 1871).

150. *Le Cri du Peuple* (14 May 1871).

151. *Le Vengeur* (17 May 1871).

152. *Le Mot d'Ordre* (18 May 1871).

153. *Le Cri du Peuple* (18 May 1871).

154. See English, *Political Uses of Photography*, pls. 22 and 23, who argues that the photograph proves the person not to be Courbet.

155. *Le Mot d'Ordre* (17 May 1871).

156. *Le Vengeur* (17 May 1871).

157. *Le Cri du Peuple* (14 May 1871).

158. *Les Ruines des Paris et ses environs* (1871); quoted by English, *Political Uses of Photography*, p. 54.

159. *Bulletin du Photo Club de Paris* 65 (Jun. 1896): 196.

160. *Bulletin du Photo Club de Paris* 88 (May 1898): 16.

161. *Journal Officiel de la Commune*, quoted by English, *Political Uses of Photography*, p. 62.

162. On Vaisse, see *RI* I: 9 (9 Dec. 1885): 244. On speech and photography, see the series of articles in the *RG* by Hector Marichelle, "La Chronophotographie de la parole," part 1 in 3ème année, 3 (July 1901), part 2 in 8 (Feb. 1902), and part 3 in 9 (Mar. 1902). All references to Marichelle's work are from the first article, pp. 150–52, unless otherwise cited.

163. *La Defense des Sourds-Muets* 16 (Avril 1886): 33.

164. See François Dagognet, *Etienne-Jules Marey: A Passion for the Trace*, trans. Robert Goleta (New York: Zone, 1992).

165. Gérard Turpin, "L'Homme qui parle: Notice sur les expériences de photographie de la parole menées par Georges Demeny (1891–1892)," in Karacostas, ed., *Le Pouvoir des Signes,* p. 136.

166. Demeny, *La Nature* (16 Apr. 1982).

167. Thomas Grimm, *Le Petit Journal* (16 Aug. 1891), quoted in *RI* VII: 6 (Sep. 1891): 164–65.

168. A. Dubranle, "La Photographie de la Parole," *RI* VIII: 4 (Jul. 1982): 109–13.

169. *RI* XI: 5–6 (Aug.-Sep. 1895): 173–74.

170. Désiré Giraud, *Revue Philanthropique* VIII (10 Dec. 1900): 243.

171. Ad. Bélanger, "Les Institutions des Sourds-Muets à l'Exposition Universelle de 1900," *RG* II: 5 (Nov. 1900): 127–28.

172. Indeed, all inventions of this kind were referred to the deaf. In 1896, a Dr. Gutzmann demonstrated a method of taking double-exposed photographs of speech to the Berlin Society of Medicine, announcing that "these double images are of great importance for the instruction of the deaf," and, inspired by Marey, he was now working on a "stroboscope" to show a series of moving images. *Bulletin du Photo Club de Paris* 62 (Mar. 1986): 108.

173. Lisa Cartwright has emphasized the connection between physiology, its recording on film, and avant-garde cinema practice. See her "Science and the Film Avant-Garde," *Cinematograph* 4: 11–20.

174. Quoted by Noel Burch, "Charles Baudelaire versus Doctor Frankenstein," *Afterimage* 8–9 (Spring 1981): 20.

175. See Giuliana Bruno's description of the films of Dr. Negro in Naples around 1908. A contemporary reviewer described how the film depicted a "poor hysterical woman who loses her speech every three months and who cannot speak again unless Prof. Negro hypnotizes her and orders her to speak." Diamond, Charcot, Duchenne, and Demeny all seem to be present here; "Spectatorial Embodiments: Anatomies of the Visible and the Female Bodyscape," *Camera Obscura* 28 (Jan. 1992): 255

176. Regnault, quoted by Fatimah Tobing Rony, "Those Who Squat and Those Who Sit: The Iconography of Race in the 1895 Films of Félix-Louis Regnault," *Camera Obscura* 28 (Jan. 1992): 275.

177. Haley, *Granville Redmond,* pp. 29–31.

178. John S. Schuchman, *Hollywood Speaks: Deafness and the Film Entertainment Industry* (Urbana & Chicago: Univ. of Illinois, 1988), p. 23

179. Alice T. Terry, "Moving Pictures and the Deaf," *Silent Worker* XXX: 9 (June 1918).

180. Bernard Thollon, "Le Cinématographe," *RG* XXIII: 1(Oct. 1921): 1–7.

181. See Paul Virilio, *La Machine de la Vision* (Paris: Galilée, 1988), pp. 18–19.

182. Quoted by Rosalind Krauss, "Using Language to Do Business as Usual," in Norman Bryson et al., eds., *Visual Theory: Painting and Interpretation* (London: Polity Press, 1991), p. 88. Krauss provides an interesting discussion of the linguistic debate in art criticism.

183. See Yve-Alain Bois, *Painting as Model* (Cambridge MA: MIT Press, 1990), pp. 83–89, who draws parallels between Saussure's linguistics and Cubism. In a note, Bois explicitly remarks that this parallel extends only to spoken language, p. 290.

EPILOGUE

1. Walter Benjamin, *Illuminations,* trans. Harry Zohn (New York: Shocken, 1968), p. 261.

2. See James Clifford, *The Predicament of Culture: Twentieth Century Ethnography, Literature and Art* (Cambridge MA: Harvard Univ. Press, 1988).

3. Stuart Hall, "Cultural Studies and Its Theoretical Legacies," in Lawrence Grossberg et al., eds., *Cultural Studies* (New York: Routledge 1992), p. 278.

4. Lita Barrie, *Love for Sale: The Work and Art of Barbara Kruger* (New York: Abrams, 1989), p. 14

5. Joseph Grigely, "Postcards to Sophie Calle," (full-length MS of *Parkeet* article of same name 17 [1993]), p. 24. My thanks to Prof. Grigely for letting me read this insightful piece in ms.

6. Chantal Mouffe, "Feminism, Citizenship and Radical Democratic Politics," in Judith Butler and Joan W. Scott, eds., *Feminists Theorize the Political* (New York: Routledge, 1992), p. 376.

7. Kobena Mercer, "Reading Racial Fetishism: The Photographs of Robert Mapplethorpe," in Emily Apter and William Pietz, eds., *Fetishism as Cultural Discourse* (Ithaca & London: Cornell Univ. Press, 1993), p. 324.

INDEX

Academy of Painting (France), 19–20, 43, 76, 160, 258

Academic art: and deaf artists, 3, 7, 30, 53, 89, 90, 91, 124–25; and sign language, 5, 31, 40, 46, 70, 71–73, 75, 78, 79, 81, 85–86

Académie Julian, 210

Africans, 51, 62, 67, 99–100, 181; depiction of, in art, 165–67, 172–73

Analogy, 103–5, 118, 124, 127

Ancients and Moderns dispute, 15–23, 27–30

Anderson, Benedict, 120

Anthropology, 9–10, 155–57, 179, 188–93, 255–57; and art, 154–62; and the deaf, 9–10, 67–69, 138–94, 227; uses of sign language in, 68

Aristotle, 15, 103

Arnold, Thomas, 141

Art History, 3, 5–6, 258–60

Austen, Jane, 80

Avant-garde: privileging of speech in, 254

Badeuf, René, 185

Bakhtin, Mikhail, 267n.16

Balzac, Honoré de, 136–37

Baudelaire, Charles, 127, 188

Bell, Alexander Graham, 224–26, 228

Bébian, Roch-Ambroise-Auguste, 93, 94, 101, 103, 104, 110–11, 115

Benjamin, Walter, 145, 231, 255

Berthier, Ferdinand, 94, 100, 101, 102, 111, 114, 115, 119–21, 127, 136

Bertilon, Alphonse, 143, 179, 220

Berton, Armand, 186–88, 216; *Eve* (1882), 186, 187; *The Temptation of Saint Anthony* (1886), 187; *Woman at the Mirror* (1887), 187–88

Bézu, Octave, 130

Bhabha, Homi, 102, 283n.1

Blanc, Charles, 131, 135

Blanchet, Dr., 98

Blindness, 141; compared to deafness, 140–41

Boime, Albert, 173

Bouchard, P. L.: *The Deaf in the Harem,* 188–89

Bougainville, Louis de, 33

Bouilly, Jean-Nicolas, 74–75, 76, 77, 79, 114

Braille, 141–42

Braquehais, Bruno, 235–47; and the Commune, 235–47; deafness of, 235, 246–47

Broca, Paul, 139, 161, 166; statue of, 188–93, 299n.165

Bürger, Peter, 230

Burgers, Andricus Jacobus, 210; *Visit of President Félix Faure to the Institut National des Sourds-Muets* (1887), 210–12

Camera Obscura: and deaf education, 232–33, 236, 253

Canguilhem, Georges, 65

Ceàn Bermùdez, Juan Antonio, 106–8

Center and margins, 102–3, 285n.41

Cerruti, 49

Chambray, Roland Fréart de, 15

Charcot, Jean-Martin, 142, 201–3; hysteria displays, 199

Chéron, Olivier, 185

Choppin, Paul, 151; *Paul Broca,* 188–93; *Jacob-Rodrigues Péreire,* 212; *Suzanna Surprised in Her Bath,* 184, 186; *The Washerwoman,* 212–14

Clere, Laurent, 50, 87–89, 94, 95, 105, 109–10

Clésinger, Auguste, 167

Cochereau, Léon, 91; *Interior of David's Studio,* 91

Cogniet, Léon, 114–15, 116, 254

Colas, Auguste, 151, 175, 201; *The Anniver-*